DRAWING

A
CONTEMPORARY
APPROACH

CLAUDIA BETTI

TEEL SALE

UNIVERSITY OF NORTH TEXAS

HARCOURT BRACE COLLEGE PUBLISHERS

FORT WORTH PHILADELPHIA SAN DIEGO NEW YORK ORLANDO AUSTIN SAN ANTONIO

TORONTO MONTREAL LONDON SYDNEY TOKYO

DRAWING

FOURTH EDITION

A
CONTEMPORARY
APPROACH

PUBLISHER	Christopher P. Klein
SENIOR ACQUISITIONS EDITOR	Barbara J.C. Rosenberg
DEVELOPMENTAL EDITOR	Helen Triller
SENIOR PROJECT EDITOR	Laura J. Hanna
PRODUCTION MANAGER	Cynthia Young
DESIGNER	Linda Wooton
PICTURE AND RIGHTS EDITOR	Carrie Ward
PHOTO RESEARCHER	Elsa Peterson, Ltd.

Cover image: Judy Pfaff, *Los Manos, I,* 1995. Ink and oilstick, 9¾" × 27¼". Courtesy André Emmerich Gallery. Photo: Steven Heller.

Harcourt Brace may provide complimentary instructional aids and supplements or supplement packages to those adopters qualified under our adoption policy. Please contact your sales representative for more information. If as an adopter or potential user you receive supplements you do not need, please return them to your sales representative or send them to: Attn: Returns Department, Troy Warehouse, 465 South Lincoln Drive, Troy, MO, 63379.

Requests for permission to make copies of any part of the work should be mailed to: Permissions Department, Harcourt Brace & Company, 6277 Sea Harbor Drive, Orlando, Florida, 32887-6777.

Address for Editorial Correspondence: Harcourt Brace College Publishers, 301 Commerce Street, Suite 3700, Fort Worth, TX 76102.

Address for Orders: Harcourt Brace & Company, 6277 Sea Harbor Drive, Orlando, FL 32887-6777. 1-800-782-4479, or 1-800-433-0001 (in Florida).

Printed in the United States of America

ISBN: 0-15-501580-X

Library of Congress Catalog Card Number: 96-76307

9 0 1 2 3 4 5 048 9 8 7 6 5 4 3

PREFACE

DRAWING PROVIDES A COMMON GROUND
for communication. It engages us on vital emotional, intellectual, and spiritual levels. Focusing on time, space, and energy, artists give material form to their ideas, and nowhere are these ideas more readily accessible than in drawings. Drawing extends both mind and spirit; it is an exciting activity that promotes a deep respect for looking and thinking.

The word *contemporary* in this book's title has two implications: First, the drawing methods are contemporary, and, second, the artistic concepts and concerns considered in the selection of the illustrations are current. We have emphasized art's multidimensional pursuit of significance, which frequently means going beyond the conventional rules of composition. It is our hope that students will begin to look at contemporary art in its relationship to earlier art in terms of continuity and challenge, and to recognize that today's art has its roots in a long-standing tradition. In our contemporary world we have been living through a cultural upheaval, and artists have turned their energies in new and different directions to frame their work in the context of the cultural changes.

In *Drawing: A Contemporary Approach* the formal elements are presented through a study of spatial relationships. The text is built around a series of related problems, each of which is designed to develop fluency in drawing, offer experience in handling media, foster self-confidence, and promote an understanding of the art elements and their role in the development of pictorial space. Further, the text introduces a vocabulary that reflects new concepts and current concerns in art.

Through our experience we know that drawing can be taught effectively using the approach set forward in this book, presenting rationally

determined problems in a logical sequence. This edition contains a large number of new problems, along with others that have been updated to reflect today's art practices. All have been especially designed to stimulate the student to make sensitive, intellectual, and emotive responses in solving them. A related series of fundamental steps, along with diverse techniques, lead student-artists to discover their own capabilities and powers of observation and execution. Especially relevant to this goal is the addition of a new section at the end of nearly every chapter that contains Sketchbook Projects related to the topic of the chapter.

In this new edition we have aimed for a full spectrum of drawing practices used by the present generation of artists. Traditional and innovative approaches go into the making of drawing today. Pictorial processes and analytical bases are amplified. We investigate the numerous means contemporary artists employ to overturn the structure of the common perception of an image, and how they extend the limits of conventional art space.

A renewal of more rigorous, disciplined styles can be detected in the art of the 1990s. Diligence and commitment to the practice of drawing are hallmarks of contemporary drawing. By expanding the number of illustrations of works on paper, prints, watercolors, paintings, photography, and even sculpture, we have presented the incredible range of possibilities open to present-day artists. This broad range of art production demonstrates to the student the indispensable role of drawing in every aspect of art making.

In keeping with current art trends, this edition includes the work of a large number of international artists, ethnic artists, and self-taught artists. Engagement with another culture's art is like learning another language; it enriches our understanding and offers us clues to cultural grounding.

The fourth edition of *Drawing: A Contemporary Approach* is the most complete revision since the text was first published in 1980. In addition to the many new illustrations that reflect current trends in the art of the nineties, new analysis and discussion of specific works convey current concerns with form and content. All the chapters have been revised to incorporate contemporary developments. The opening section of Part II, Spatial Relationships of the Art Elements, has been amplified with an extended discussion of spatial conventions, along with an accompanying section of color illustrations. The number of color plates in the chapter on color has also been increased. Major changes appear, as well, in Chapter 10, Thematic Development, where an involved overview of the theme of word and art is undertaken. New problems and ideas for thematic development using this word/art discussion are presented.

A consolidated view of contemporary art and related theories is an impossible task, yet major insights into the complexity of the art scene, we hope, can be gained through the survey presented in Chapter 11, A Look at Art Today. In this chapter we have discussed artists who have played seminal roles in inventing new and significant definitions that have circulated in art over the past decade. In addition we have explored key issues such as the discourse concerning modern and postmodern art; the role of feminism and art; rethinking the concepts of originality, invention, innovation, and appropriation; the relevance of art in a sociopolitical context; and new attitudes to old and new themes—abstraction and landscape.

Our teaching methods are not rigid and can accommodate a range of approaches. We are convinced that students' involvement in their own work,

along with familiarity with concerns and styles of other artists, will lead them to develop an exciting and personal expression. We hope this book will direct students along an ambitious path that involves growth in visual, intellectual, imaginative, and aesthetic responses; we hope it will help them recognize that art is the mirror of our times and that it is our duty to consider carefully the reflected images.

We wish to thank those who have assisted and encouraged us in preparing this book. We would like as well to express appreciation to our editor, Barbara Rosenberg, and to Helen Triller, Susan Petty, Laura Hanna, Linda Wooton, and Cindy Young. Finally, we are indebted to our students whom we have taught and who in turn taught us. This book is written for all those who will make a life around art.

DEDICATION

For Antonella and in memory of Len.

C.B.

Affectionately and gratefully dedicated to my parents,
Eva and Beryl,
and my husband, Rick.

T.S.

CONTENTS

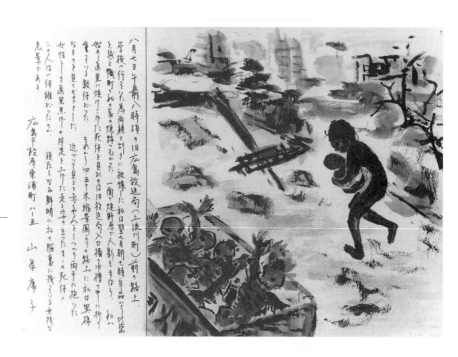

PART II
SPATIAL
RELATIONSHIPS OF
THE ART ELEMENTS

CHAPTER 3 *Shape/Plane and Volume* 79

CHAPTER 4 *Value* 105

CHAPTER 5 *Line* 137

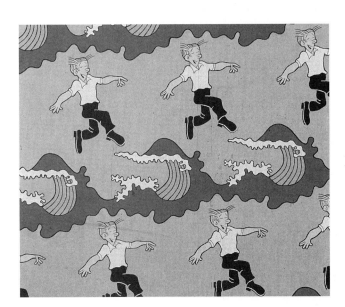

PART III
A CONTEMPORARY
VIEW

CHAPTER 9 *The Picture Plane* 239

CHAPTER 10 *Thematic Development* 259

CHAPTER 11 *A Look at Art Today* 283

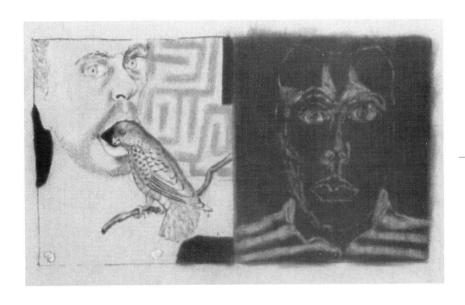

PART IV
PRACTICAL
GUIDES

DRAWING

A
CONTEMPORARY
APPROACH

INTRODUCTION
TO
DRAWING

DRAWING: THOUGHTS AND DEFINITIONS

Drawing has been the most basic of all art skills from prehistoric times to the present, and today in the late twentieth century it remains the most popular art form for artists and amateurs alike. Drawing is essential to all art disciplines: painting, sculpture, printmaking, crafts, architecture, and even for the performance arts. We are all attracted to drawing because it offers us an exciting channel for our imaginations.

A drawing can address a particular experience, and while it does not make the relationship between the personal and the universal fully and completely explicit, the drawing can afford insightful glimpses into that experience. It can evoke memories; it can elicit feelings; it can shed light on life's impulses—on death, love, power, play, intellectual pursuits, work, and on our dreams and emotions. What wrenching memories the drawing in Figure 1.1 elicits! It was made by a 49-year-old Japanese survivor of the "unforgettable fire" caused by the atomic bomb dropped on Hiroshima in 1945. Accompanying the drawing is a written description of that fatal event. Although it was not drawn by a professional artist and, in fact, was made more than 30 years after the event, the impressions the drawing conveys reverberate with the horror and immediacy of the moment.

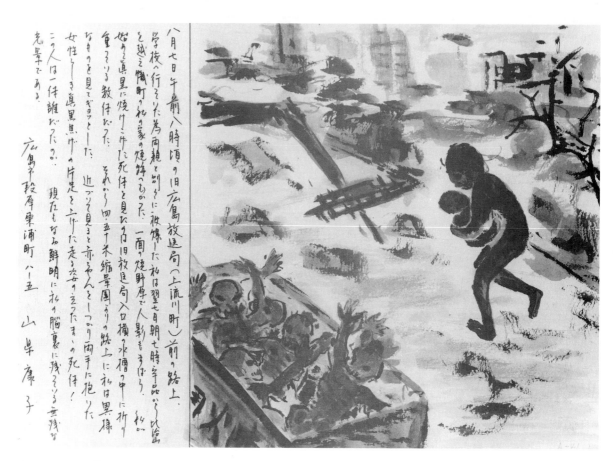

八月七日午前八時頃の旧広島放送局（上流川町）前の路上。学校へ行くため両親と別々に被爆した私は翌七日朝七時半ごろ比治山を越え幟町の私の家の焼跡へ向かった。一面の焼野原で人影もまばら。私は悩みも真黒に焼けこげた死体と見たうち旧放送局入口横の水槽の中に折り重なりし数体だった。それから四・五十米縮景園よりの路上に私は異様なものを見てぎょっとした。近づいて見ると赤ちゃんをしっかり両手に抱いたなおうつ伏せに倒れ息たえている若き母親。その黒焦の片足を失った跑裂死体！女性らしき真黒焦の片足をもぎり走る姿よ、そうになった死体！この人は一体誰だったか。現在もなお鮮明に私の脳裏に残る無残な先輩である。

広島市段原東浦町八五　山鼻康子

1.1. YASUKO YAMAGATA. From *Unforgettable Fire, Pictures Drawn by Atomic Bomb Survivors.* Hiroshima Peace Culture Foundation, Hiroshima.

The concentration required in looking and in questioning the appearance of objects and the sheer exuberance of making things has not changed since the earliest drawings were made. We humans have had a long history of making our marks on the world, an impulse that began in prehistoric times and continues to the present. The engaging rock drawing from Tassili-n-Ajjer in Algeria is such a prehistoric work (Figure 1.2), and while the intent is different from the graffiti drawing done in our time (Figure 1.3), both drawings share an exuberance regarding what it is like to be alive. In some deeply satisfying way, mark-making affirms our presence in the world. The directness and physicality of drawing are basic to its nature. The notion of mark-making is key to the identity of the medium.

Art, especially the discipline of drawing—along with philosophy, history, and literature—helps us interpret our experiences visually, emotionally, and aesthetically. As mature human beings we try to create a wholeness in ourselves; one recognized way of achieving that goal is through the creative process, and for the visual artist, drawing lies at the very core of that process.

Drawing is the most democratic of all art forms; it is a common denominator for peoples worldwide. Drawings are valued not only for their accessibility but for their intimacy and their potentiality to work through ideas. This is called *visual thinking*, and along with much practice at making and looking at drawings comes the more evolved stage of visual literacy.

Drawings can have their effect with the most modest of means—one only need think of the childhood pleasure that came from making marks in the sand. It is not only artists who make drawings, of course; people of all ages and from all walks of life can participate joyfully in this activity. Elizabeth Layton, a woman in her nineties, came to art late, but she has made a successful career making art whose subject is youthful old age. In her drawing (Figure 1.4) we encounter a new old Cinderella. This fresh interpretation is a fantasy based on a childhood story; the shaky line comes from a hand that may be trembling but whose direction is sure. Layton's vivacious and imaginative art is like child's play, finding symbolic, emotional meaning in objects and situations. Through her art we have a foretaste of what it is like to be old and to have a great sense of humor.

Across time and across cultures drawing has ranked high among the visual arts. From the Renaissance to the end of the nineteenth century, drawing was regarded as a conservative medium, seldom the subject of innovation. It was seen as a first step in the early idea of a work, a support to painting, sculpture, and architecture. In the Renaissance, drawing was particularly suitable for visually describing the newly emerging disciplines of anatomy, perspective, and geometry, and it required the most stringent intellectual application. Artists made drawings to show their prospective patrons what the finished work would look like.

While artists have always valued other artists' drawings, in the seventeenth century collectors other than artists began to display drawings in rooms called "cabinets," rooms with especially built storage drawers, where drawings could be taken out, admired, and studied. Drawing, no longer a subsidiary to painting, sculpture, and architecture, was established as a major discipline in its own right. Artists made careers out of drawing alone. The attention paid to drawing continued to the twentieth century, and from midcentury to the present there has been a graphic explosion unlike any other

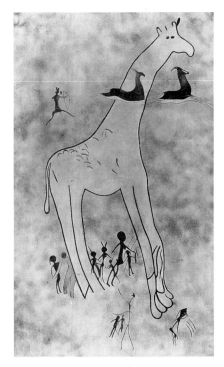

1.2. *The Large Giraffe.* Adjefou, Tassili-n-Ajjer, Algeria. Prehistoric. Fresco, 5'2⅜" × 3'5" (1.6 × 1.05 m).

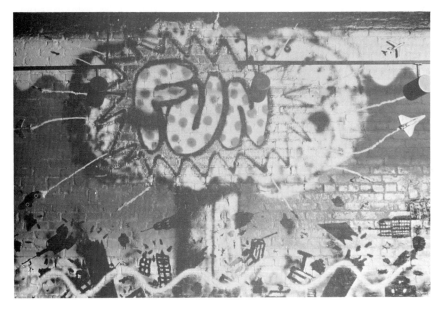

1.3. KENNY SCHARF. *Untitled (Fun).* 1982. Spray paint on wall. Tony Shafrazi Gallery.

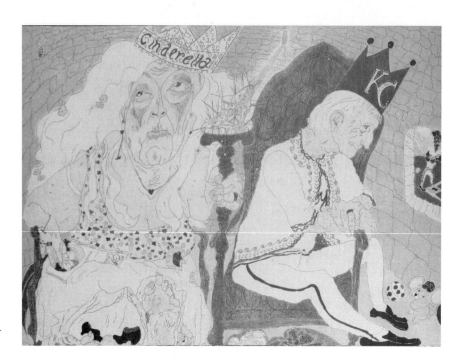

1.4. ELIZABETH LAYTON. *Cinderella.*
1986. Lithograph, 22 × 30″ (56 × 76 cm).
Lawrence Arts Center.

period in art. Think of how many graphic images in the media one comes in contact with on a daily basis.

Traditionally we can classify drawings into four types:

1. Those that investigate, study, and question the real world—the visible, tangible world.
2. Those that record objects and events.
3. Those that communicate ideas.
4. Those that are transcriptions from memory—a way of collecting and keeping impressions and ideas, a way of making visible the world of our imagination.

The sketch has been a traditional first step in a long path that leads to a more finished work of art, and while artists still use sketches as preliminary steps, drawing as an independent activity, as an end in itself, is an emphasis of the twentieth century.

Drawing has an infinite variety of purposes: from psychological revelation to dramatic impact, from social commentary to playful, inventive meandering, from accurate transcription to vigorous, informal notation. Increased freedom in all art forms is a characteristic of this century, and certainly, drawing has been a leader in this innovation. Lebbeus Woods is a visionary architect who uses drawings to propose making something constructive out of a destructive event. His architectural fantasies are generated by the exploding buildings seen nightly on the news (Figure 1.5). His drawings convey the belief that civilization should retain the memory of the violence it has experienced. Woods suggests architectural reconstruction should not smooth over damaged surfaces. While the solution to this problem offered in his sinister drawing is extreme, it is an innovative and thought-provoking idea, an appropriate illustration of how drawing can contribute to a lively social ex-

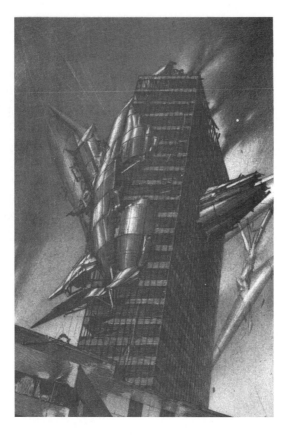

1.5. LEBBEUS WOODS. "Meditation" from *War and Architecture Series.*

change in a field like architecture that traditionally articulates social and cultural ideals.

New technologies have been introduced to art in the twentieth century, and because drawing has proven to be a flexible discipline for experimentation, it has gained a strength and vitality from its newly found role. We might even classify computer-generated images as drawings: They make use of graphic means, and they are on paper (Figure 1.6). So as not to limit its definition to pure graphic means (a more traditional definition), the term *Works on Paper* is used by museums, galleries, and art critics to designate a standard category, but even this expanded classification does not fully cover the role of drawing. As we have seen in graffiti and prehistoric rock drawings, mark-making can be done on any surface—clay, glass, fabric, or even on the earth itself. In Michael Heizer's *Circular Surface Planar Displacement* (Figure 1.7), the lines of the "drawing" are made on the earth by motorcycle wheels.

The immediate past plays a historically important role in the formation of more recent art. Impressionism in the late nineteenth century pointed the way for drawing in its path toward independence. Certainly in Edgar Degas's body of work, his drawings are not subsidiaries of the paintings (Figure 1.8). Modernist concerns, those that are still pertinent today, occupied Degas: how to fit the figure into the limits of the paper, how to resolve a composition that is divided, how to compress an illusionistic three-dimensional form onto a two-dimensional surface. These are only a few of many considerations and problems that face the artist in a single work.

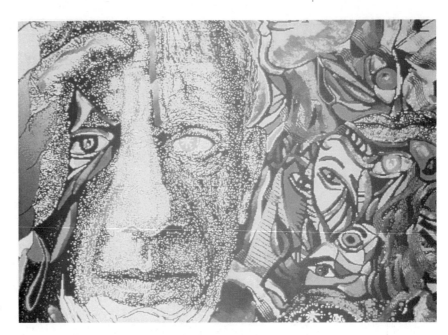

1.6. JOSEFA LOSADA-STEVENSON. *Dreaming Picasso 1.* 1989. Color thermal transfer and lithograph from computer-generated image, 20 × 17″ (51 × 43.4 cm). Courtesy of the artist.

It was the Post-Impressionist Georges Seurat who clearly stated his ambition to make drawings that were equal in importance and in finish to his paintings. He aimed for an independence of draftsmanship, not drawing that was secondary to or preparatory for a painting. In Figure 1.9, we see one of a group of drawings Seurat made in the 1880s. His work is classically composed using verticals and horizontals and suggests a mysterious isolation. It is exact, thoughtful, exquisitely controlled, and highly poetic.

The first work of an artist to be displayed in a public exhibition was a large drawing by a friend of Seurat, Amán-Jean. It was exhibited in the Salon des Independants of 1883. It is difficult for us to realize that not until the mid-eighteenth century were drawings framed and hung on walls. From that time to the end of the nineteenth century, the nature of drawing's traditional role was firmly established.

Our aesthetic has undergone radical change during this fast-paced century. As modern viewers came to accept fragmentation in real life, many drawings that previously were seen as unfinished came to be accepted as complete. It was Paul Cézanne, often acclaimed as the father of modern art, who pointed us in this new direction. He affirmed the role that intelligence and conceptualization play in art; he called art "personal perception." The study of Cézanne's work reveals the concentration and freshness of purpose he brought to each work of art. He aimed at integrating line and color; he saw drawing as a means of structurally organizing space and volume in both his drawings and his paintings (Figure 1.10). His approach to painting was first to draw in lines and then gradually to construct the planes. In *View of a Bridge* Cézanne requires the viewer's full participation to relate line and shape. His "lost-and-found" line must be filled in mentally by the viewer.

While contemporary artists have not relinquished drawing's traditional functions, they have seriously reconsidered the nature of drawing and its uses. In the years before World War I, a real innovation in drawing was the

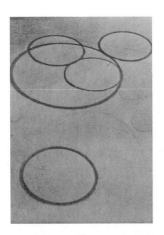

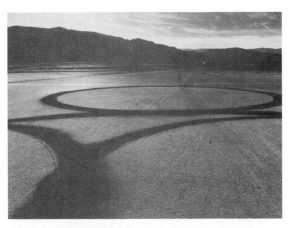

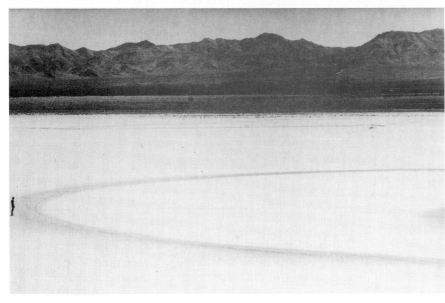

1.7. MICHAEL HEIZER. Three views of *Circular Surface Planar Displacement.* 1971. Earth construction, Jean Dry Lake, Nevada, 400 × 800′ (121.92 × 243.84 m). Courtesy Sam Wagstaff.

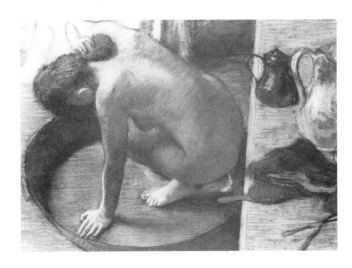

1.8. EDGAR DEGAS. *The Tub.* 1886. Pastel on cardboard, 28⅜ × 32⅜″ (73 × 83.2 cm). Musée d'Orsay, Paris.

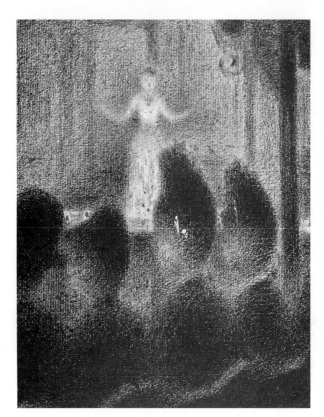

1.9. GEORGES-PIERRE SEURAT. *At the "Concert Européen."* c. 1887. Conté crayon, 12¼ × 9⅜" (31.1 × 23.9 cm). The Museum of Modern Art, New York. Lillie P. Bliss Collection. Photograph © 1997 The Museum of Modern Art, New York.

introduction of collage into fine art by Georges Braque and Pablo Picasso (Figure 1.11). This technique asks an important art question: What is real, and what is illusion? Collage has been called by some critics the most notable innovation in drawing in three hundred years. In the 1960s artists began an in-depth appraisal of drawing and its role in art. Due to expansive, even explosive, trends in contemporary art, drawing has a wider and more active role than ever before. Many artists in the second half of the century have reputations built primarily on their drawing ability; among them are Claes Oldenburg and William Wiley (see Figures 2.3, 4.34, 5.14, 6.9, and 7.15).

The process of creating art may seem complex to the beginning student. A way through this complexity is to recognize that art has certain categories or divisions. The focus here is on *drawing*, one of the major areas of artistic activity. Drawings, however, are not of interest to artists only; illustrators, designers, architects, scientists, and technicians make use of drawings professionally. Just as there are different uses for drawings, there are many types of drawings.

SUBJECTIVE AND OBJECTIVE DRAWING

In its broadest division drawing can be classified as either subjective or objective. *Subjective* drawing emphasizes the artist's emotions. In *objective* drawing, on the other hand, the information conveyed is more important than the

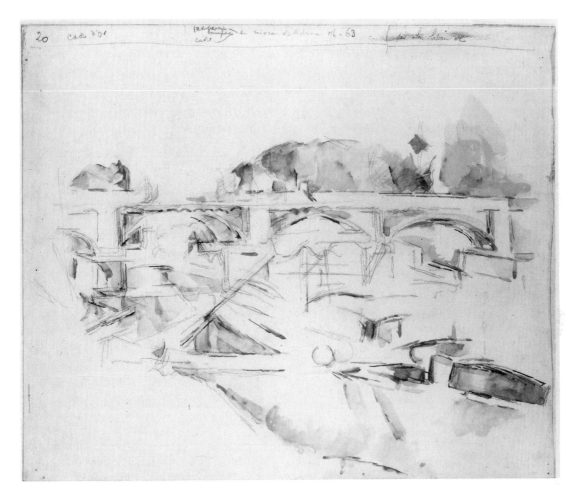

1.10. PAUL CÉZANNE. *View of a Bridge.* c. 1895–1900. Watercolor over black chalk, 19¼ × 23⁹⁄₁₆″ (489 × 598 cm). Yale University Art Gallery. The Philip L. Goodwin, B.A. 1907, Collection.

artist's feelings. The left half of the drawing by the humorist Charles Addams (Figure 1.12) is an elevation of the façade of the Carnegie Mansion, and it is concerned with design information—such as measurement, scale, proportion between parts—and thus belongs to the objective category. The right half of the drawing, however, is highly subjective, ridiculous and playful in its embellishment of what is today the Cooper-Hewitt Museum. Addams has ensconced his macabre cartoon characters in and under the mansion. A group of artists was invited to commemorate the museum's seventy-fifth anniversary by altering the architectural drawing of the building. Artists were to use an architectural drawing, an elevation of the museum itself, as a backdrop for their art. The additive images stand in sharp contrast to the mechanical rendering of the museum.

Another set of drawings that clearly contrasts the subjective and objective approach can be seen in two skull drawings. For an anatomical illustration (Figure 1.13), it is important that every part be clearly visible and descriptive. The illustrator has employed such devices as receding spaces, noted by darker value, and small groups of lines to indicate the bulging features of the skull.

The skull has always been a popular artistic and literary image because of its emotionally loaded content. Jean-Michel Basquiat depicted his

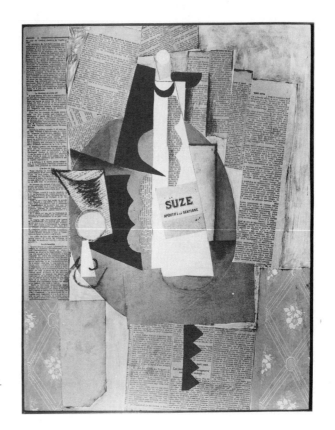

1.11. PABLO PICASSO. *Bottle of Suze.* 1912. Charcoal, gouache, and pasted paper, 25¼ × 19¾" (64 × 50 cm). Washington University Gallery of Art, St. Louis. University purchase, Kende Sale Fund, 1946.

masklike skull using a primitive, crude technique that is characteristic of his work (Figure 1.14). The images are drawn with a childlike naïveté that is in contrast to their underlying content. Basquiat's cryptic imagery takes on the appearance of a secret, symbolic, hieroglyphic language. We imagine the artist working in a frantic, obsessive mode as if an automatism inside Basquiat were

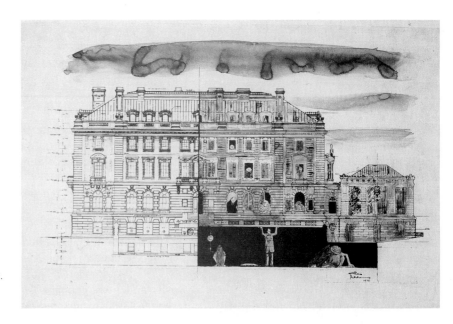

1.12. CHARLES ADDAMS. (United States, 1912–1988). *Embellished Elevation of the Carnegie Mansion.* 1975. Watercolor on photostat, 18¹/₁₆ × 25⁷/₁₆" (45.9 × 64.6 cm). Cooper-Hewitt Museum, Smithsonian Institution; gift of Nino Luciano.

directing the drawing. The play on the word "flea" and its homonym or sound twin, "flee," gives us a clue to unraveling the artist's coded message. The trailing lines suggest a pathway leading off the page; the petrol pumps are a power source for movement, and together the images reinforce the idea of "fleeing." The repeated phrase "All men return to dust" further reiterates the idea of a journey. The dominant death's head or skull leaves the viewer in no doubt that the journey Basquiat has in mind is the final one.

This highly subjective drawing not only conveys the heightened feelings of the artist but engenders a heightened response from the viewer as well. Basquiat's work shares its content with other highly expressionistic work, and his seemingly untrained handling of the media supports the raw and unwelcome message. Of course, not all subjective drawings are as extreme as Basquiat's, nor are all objective drawings as readily classifiable as the anatomical illustration.

Informational Drawing

The objective category is also called *informational drawing*. It includes diagrammatic, architectural, and mechanical drawings. Informational drawings may clarify concepts and ideas that are not actually visible. Many serious twentieth-century artists have used art as documentation and information. The husband and wife art collaborators Christo and Jeanne-Claude use Christo's drawing in their proposals and presentations requesting permission from authorities to execute their highly involved art work. Figure 1.15 is one

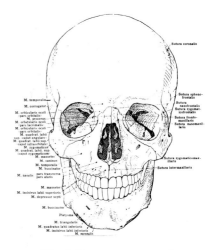

1.13. The skull; anterior view with muscular attachments. From Schaeffer *Morris' Human Anatomy* 10/e. Philadelphia: The Blackiston Co., 1942.

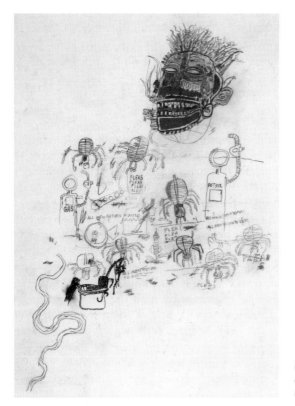

1.14. JEAN-MICHEL BASQUIAT. *Untitled (Fleas)*. 1986. Graphite, oilstick, and ink on paper, 42 × 29⁷/₈" (107 × 74 cm). Courtesy the artist.

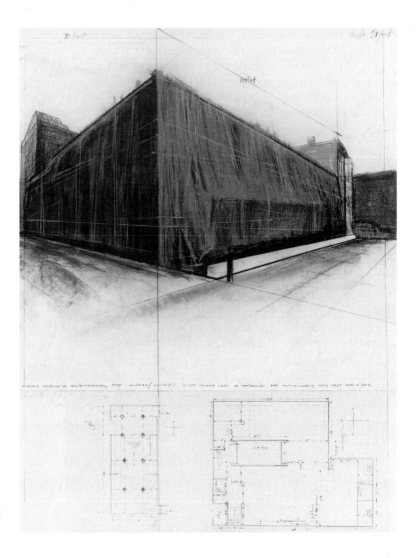

1.15. CHRISTO. *Wrapped Museum of Contemporary Art, Project for Chicago.* Drawing-collage. 1969–1981. Pencil, charcoal, crayon, floor map and technical data. 42⅛ × 32¾″ (107 × 83 cm).

such drawing done for a project in Chicago, wrapping the Museum of Contemporary Art. Christo combines collage and drawing to create an accurate visual description of the museum as if it were wrapped with tarpaulin fabric and rope. Included in the drawing are floor plans of the museum. The viewer is thus presented with two very different kinds of visual information. The wrapping both reveals the outer form and conceals the inner structure. Christo and Jeanne-Claude wrap existing structures, but a dramatic and unexpected sculptural form is the result. In order to receive permission for these highly complex projects, Christo and Jeanne-Claude must make appeals to multiple public entities. The drawings are an invaluable means of communicating complex spatial and engineering solutions to the authorities who grant permission. The interaction with the public is engaging on multiple levels: environmentally, politically, socially, culturally, educationally, and aesthetically.

Diagrammatic drawings, a type of working drawing, demonstrate a visual form of shorthand. They are used widely in designs for buildings and city planning. These plan drawings make use of a code or a key which relays essential data contained in the drawing, such as information concerning construction materials and scale as in the floor plans in Figure 1.15.

Patricia Johanson is an artist who uses diagrammatic drawings in her designs for public places, parks, fountains, gardens, and cities. She believes art must operate beyond the narrow markets of galleries and museums. Her projects deal directly with the environment; she bases her plans on naturalists' images of flora and fauna. Figure 1.16 is a site plan for the integration of a sewage station with a state park in San Francisco. In the proposed *Endangered Garden* she uses a garter snake as the shape for a network of paths that interconnect gardens, marshes, bird sanctuaries, and tidal pools. The snake form discernible from an aerial view would be experienced as a meandering walkway through this public space. Johanson first made diagrammatic drawings; later she created sculpture using nature to make new landscapes.

Just as there is a key to reading a diagrammatic drawing, there is a key to reading artists' drawings, and that key is to be open, alert, absorbed, and focused on the visual material at hand.

Schematic Drawing

Another type of objective drawing is the *schematic*, or *conceptual, drawing*. It is a *mental construct*, not an exact record of visual reality. A biologist's schematic drawing of a molecular structure is a model used for instructional purposes. Comic book characters and stick figures in instruction manuals are familiar examples of schematic drawings. We do not think of them as complicated, but they are schematic and conceptual; they are an economical way to give information visually. We know what they stand for and how to read them. They are *conventions*, just as the Western hero riding into the sunset is a literary convention. This conventional schematization is easily understood by everyone in American culture.

At this point the two broad categories of subjective and objective begin to overlap. A schematic, or conceptual, drawing may be objective, like the illustration of stick figures in an instruction manual. It may also be intensely subjective, like a child's drawing in which frequently the proportions

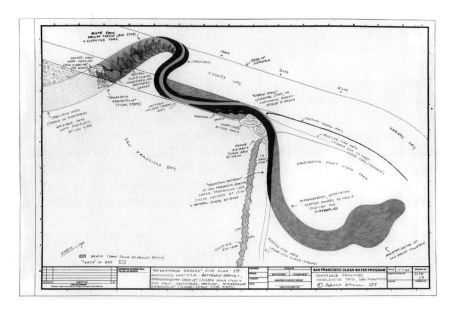

1.16. PATRICIA JOHANSON. *"Endangered Garden," Site Plan (Candlestick Cove, San Francisco).* 1988. Acrylic and ink, 22 × 34" (56 × 86 cm). Collection of the artist.

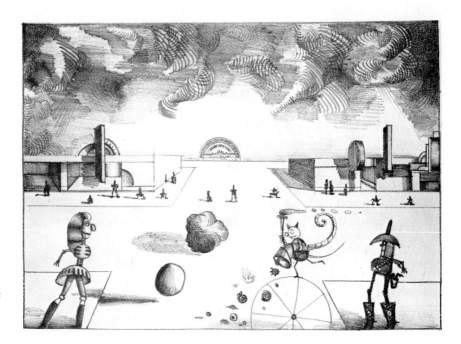

1.17. SAUL STEINBERG. *Main Street.* 1972–1973. Lithograph, printed in color, 15³/₄ × 22″ (40 × 56 cm). The Museum of Modern Art, New York. Gift of Celeste Bartos.

of the figure are exaggerated in relation to its environment. Scale is determined by importance rather than by actual visual reality.

Saul Steinberg, an artist involved with the philosophy of representation, uses the schematic approach in a subjective manner. In *Main Street* (Figure 1.17), he employs a number of conventions to indicate movement: The swirling lines in the clouds create a somewhat turbulent sky; the cloud and ball, trailing long shadows, seem to be scurrying along at a quicker pace than, for example, the rather static figure, whose thrown-back arms and billowing skirt are indicators of motion. Steinberg's humorous intent is intensified by his shorthand style. The emphasis is on idea, on concept, rather than on visual reality. A flourishing movement in contemporary art involves schematized drawings that employ apparently direct and simple means to carry sophisticated and subjective expression, such as the Keith Haring drawing in Figure 1.18. Haring's work is spirited and good-natured. His highly personal and recognizable style makes use of a perennial childishness paired with a not-too-hidden adult message. Certainly the Mickey Mouse image is readily recognizable, and the convention of depicting the television set is one with which we are all familiar. The two blank figures are more difficult to decipher: Are they holding up the television set, or are they viewers in front of the screen? It is easy for the viewer to come to subjective conclusions as to the figures' function. Is the artist commenting on our culture? Is Haring making an indictment against a bland world of television viewers, or is the message as playful as the first glance leads us to believe?

Pictorial Recording

Another important category in drawing is *pictorial recording.* The medical illustrator, for example, objectively records an image with almost photographic accuracy. Yet for some artists, imitating certain photographic techniques can

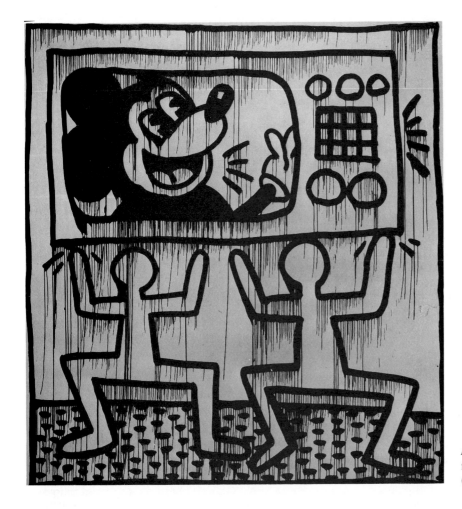

1.18. KEITH HARING. *Untitled (For Malcolm McClaren)*. 1982. Marker ink on found painted canvas, 8'1" × 7'8" (2.46 × 2.34 m). Private collection.

lead to highly subjective effects. A number of contemporary artists are concerned with duplicating what the camera sees—both its focus and distortion. This movement is known as *Photo-Realism*. The work of these artists suggests a bridge between subjective and objective art, for even in the most photographic drawing or painting, a part of the artist's personal style enters.

In the Photorealist portrait by Chuck Close (Figure 1.19), the strongest element of subjectivity is the technique used in the drawing: *Emily/Fingerprint*. We associate fingerpainting with children's activities, yet this portrait is far removed from a simple, naïve application of paint. Close is concerned with surface texture and with revealing what he calls the "personal identity of my hand." At first look we think the image may have been generated by a computer, but the structure of Close's work is a result of ordering the image through a use of grids. His innovative approach results in a contemporary look, one not usually associated with portraits. He is as interested in how an image is represented and perceived as much as he is with what is depicted.

Another example of pictorial recording can be seen in Claudio Bravo's pastel drawing entitled *Pamela* (Figure 1.20). The subject has been painstakingly and directly observed. The likeness is the result of an intense and accurate observation on the part of the artist. Bravo has faithfully recorded the

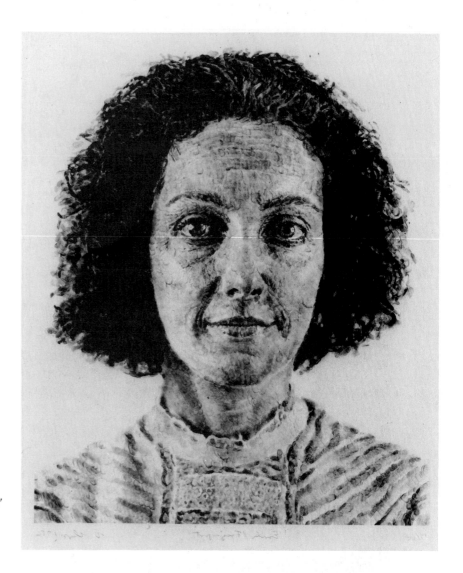

1.19. CHUCK CLOSE. *Emily/Fingerprint.* 1986. Carbon transfer etching, 46 × 36¹/₂″ (117.3 × 93.1 cm). Published by Pace Editions and Graphicstudio. © Chuck Close.

young person's appearance and has captured her personality. She seems to be somewhat vulnerable; the direction of her eyes leads us to believe she is not conscious of the artist (unlike the direct confrontation between Close's subject and the camera). Bravo has conveyed a tactile sense in the drawing—the texture of hair, scarf, shirt, and jeans is well observed and convincingly rendered. As in the Close portrait, subjectivity and objectivity are combined, but in a much more traditional format and style.

Subjective Drawing

Just as in every other human activity, artistic production carries with it a full range of the subjective element. Alice Neel is more interested in the psyche of her sitters than in a direct transcription of visual reality. Although she works from direct observation, she says she is more interested in "what people are like underneath how they look." Neel's style is spontaneous and energetic and obviously highly subjective. In the portrait of Andy Warhol (Figure 1.21), as in her other works, she uses distortion, an unfinished quality, and an un-

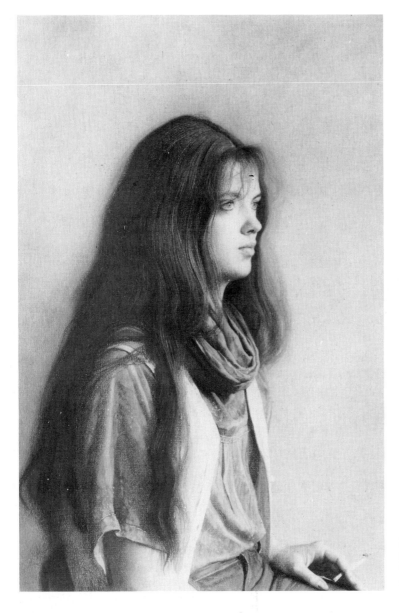

1.20. CLAUDIO BRAVO. *Pamela.* 1978. Pastel, 17⅛″ × 11½″ (44 × 29 cm). Courtesy Marlborough Gallery, New York. © 1997 Claudio Bravo/Licensed by VAGA, New York, NY.

comfortable arrangement of limbs and posture as theme and variation. Warhol's eyes are averted, the focus is internal, his vulnerability is suggested by the closed eyes and the scarred body. The psychological truth for Neel is more important than a literal realism.

A drawing, then, may be slightly or highly personal; there are as many degrees of subjectivity as there are artists.

THE VIEWING AUDIENCE

Another set of distinctions suggests the question: For whom is the drawing intended? Artists make some drawings only for themselves. The speed with

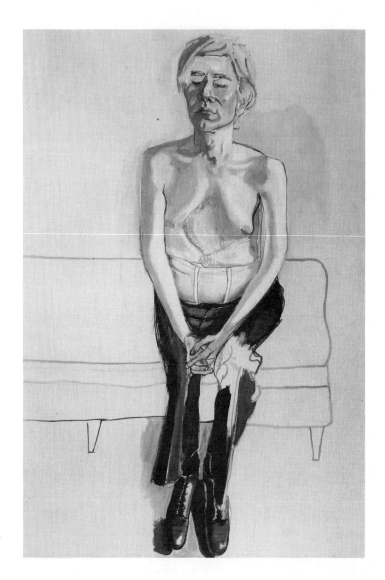

1.21. ALICE NEEL. *Andy Warhol.* 1970. Oil on canvas, 5' × 3'4" (1.52 × 1.02 m). Whitney Museum of American Art, New York. Gift of Timothy Collins.

which the sketch can be executed is in pronounced contrast to the painstaking detail a finished painting might require. A preparatory drawing is frequently executed in broadly drawn shapes, the idea conveyed economically and deftly. Changes can occur in scale and relationships between the initial sketched idea and the final painting, such as whether the format be enlarged, elongated, or narrowed.

Drawings not specifically intended for a viewing audience, however, do not prevent our enjoyment of them. Jean Tinguely's *Study of Machine* (Figure 1.22) gives the viewer an insight into the playful mind of the artist. Tinguely is a sculptor whose machine constructions are highly inventive. Their many moving parts with their unpredictable motions make a wry commentary on the role of the machine in our technological society. Tinguely's lighthearted drawing style conveys this idea of the machine's highly improbable actions. An intimate glimpse into an artist's sketch is often as satisfying as the look at a finished drawing.

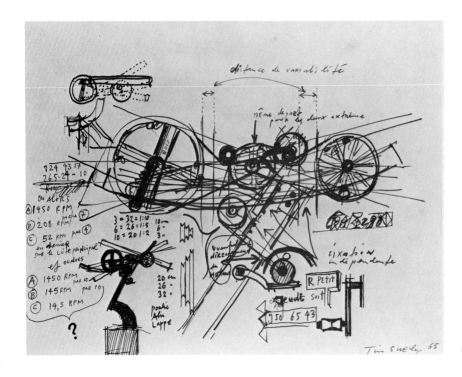

1.22. JEAN TINGUELY. *Study of Machine.* 1965. Ink, 12⅝ × 15⅞" (32 × 40 cm). Courtesy Iolas-Jackson Gallery, New York.

Of course, a drawing can also be a final graphic statement intended as an end in itself rather than as a preparation for other work. Claudio Bravo's pastel drawing *Pamela* (see Figure 1.20) is as ambitious and skillfully finished as any of his paintings.

Because his style is so widely recognized, we cannot view a work of art by Pablo Picasso (Figure 1.23) without many of his other works coming to mind. Perhaps we should say, "Because his *styles* are so widely recognized." In this etching we see three distinct styles, all hallmarks of Picasso's virtuosity as one of the premier draftsmen of this century. Not only is his style a personal one, his themes are stated in a highly personal way. Duality, a favorite subject for Picasso, is relayed by depicting opposite poles—male/female, man/beast, reveler/contemplator—each depicted with an appropriate line quality. The *anima*, the female figure on the left, emerges from a deep recess, certainly an appropriate representation of the unconscious. This figure is drawn in a complex network of lines, while the adjacent figure is simply and delicately presented. We see the man/beast in a transitional state; the lines are more tentative, not so exuberantly drawn as in the third figure, where the Minotaur reigns. In the Minotaur the frenzied, swirling, thick lines describing a drunken, Dionysian state overpower the man part of the figure with the delicately drawn upper torso and arms. The Minotaur myth is here given an updated, twentieth-century, Jungian interpretation.

Some works are more meaningful when viewed in relation to the works of other, earlier artists—that is, when seen in the perspective of art history or in the context of cultural differences. Art about art has always intrigued artists, and contemporary art has a lively concern with this subject. Our understanding of Rico Lebrun's drawing of Maria Luisa (Figure 1.24) is increased when we know the source of his image, Francisco Goya's *The Family of Charles*

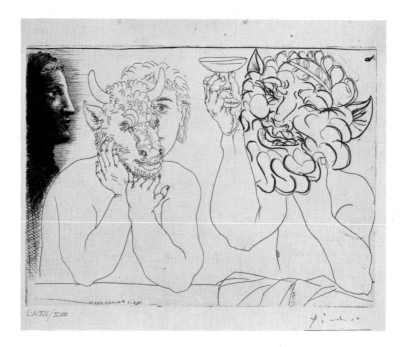

1.23. PABLO PICASSO. *Jeune Homme au Masque de Taureau, Faune et Profil de Femme.* March 7, 1934. Etching, $8^3/_4 \times 12^3/_8$" (22 × 31 cm). Courtesy Edward Totah Gallery, London.

IV. Goya, as court painter to Charles IV, suggested as much as he dared about the character of Charles's queen. Lebrun singles out Maria Luisa from the composition and makes a much more explicit and pointed statement about the queen's decadent character. Maria Luisa's face is quickly and deftly noted. The drawing becomes a caricature of a caricature.

SUBJECT AND TREATMENT

Another major determinant in a work of art is the subject to be drawn. Once the subject is chosen, the artist must determine how it is to be treated.

Innumerable modes of expression are subsumed under drawing. Landscape, still life, and figure are broad categories of subject sources. Nature is a constant supplier of imagery, both for the ideas it can offer and for the structural understanding of form it gives. Two widely different approaches to using natural subjects can be seen in the study *The Spiral Jetty* (Figure 1.25) by Robert Smithson and in the charcoal drawing by Steve Galloway (Figure 1.26). Smithson proposes changes to an existing landscape. His choice of a causeway in the form of a spiral is in keeping with the symbolic implications of the work. The spiral is an ancient form symbolic of continuity. For his earthwork Smithson chose a site in Utah that the Indians believed to be the hub, or navel, of the world. He proposed a jetty as a man-made form that is subject to the changes that nature imposes. So change and continuity are incorporated into a landscape that itself is continually changing.

Galloway's *Please Me (in the temple of frogs)* (Figure 1.26) is a different kind of landscape, a contemporary treatment of a traditional theme. While Smithson's work is symbolic, Galloway's is metaphoric. The eerie landscape carries a psychological depth. The brooding sky seems ominous and sheds a strange light on the rocky terrain. The composition is crowded with carefully

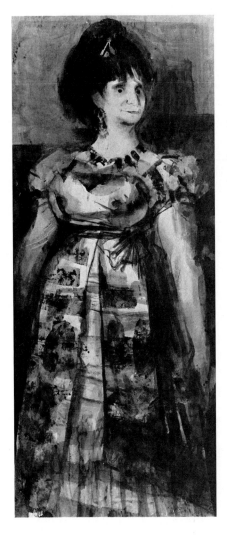

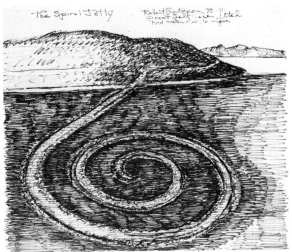

1.25. ROBERT SMITHSON. *The Spiral Jetty*. 1970–71. Black and red ink, 12½ × 15½" (32 × 39 cm). Estate of Robert Smithson, Courtesy of John Weber Gallery.

1.24. RICO LEBRUN. *Maria Luisa (after Goya)*. 1958. Ink wash, 7'2" × 3' (2.2 × .92 m). Private collection.

rendered details. The structural weight of the rocks and the heavy gathering clouds activate the surface. The splintered wooden planks and disassembled structure set the stage for an unsolved mystery. The primates seem to have momentarily stopped their task to look quizzically at the viewer. The finely finished drawing with its accurate rendering seems to raise more questions than it answers. It brings together an acute way of perceiving with a mode of imagining that is both real and surreal at the same time. The animals are leading a secret life of which we humans are permitted only a glimpse. In fact, it has been noted that "the secret life of art" is lived in drawings. Galloway's work attests to this claim.

The artist may choose an exotic subject, such as Masami Teraoka's allegories, which combine the traditional Japanese style with contemporary Western materialistic ideas (Figure 1.27). Teraoka looks back to seventeenth-century Japanese art for technique, style, and image and invests it with a modern message.

Some artists find significance in a commonplace subject, as in Irene Siegel's drawing of an unmade bed (Figure 1.28). Siegel's treatment of an everyday subject is nearly as texturally rich as the patterns in the Teraoka

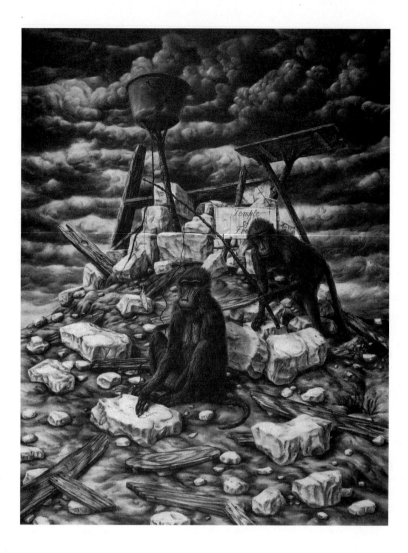

1.26. STEVE GALLOWAY. *Please Me (in the temple of frogs).* 1988. Charcoal on paper, 4′10½″ × 3′9″ (1.49 × 1.14 m). James Corcoran Gallery.

work. A recurring motif of folds appears in the pillows, sheet, spread, chair, lampshade, and even the flower on the table. Both the exotic and the commonplace may be equally provocative to the artist.

An image can be treated symbolically; it may stand for something more than its literal meaning, as in Yolanda M. López's *Portrait of the Artist as the Virgin of Guadalupe* (Figure 1.29). The artist gives explicit directions for interpreting her drawing by its title. López is a Chicana artist who seeks to undermine the clichés of her culture. In this drawing the Mexican symbol of the Virgin of Guadalupe is cast as a modern, athletic Chicana holding on to the serpent, a symbol of the nation, and to her star-studded cape as she literally bursts out of the flame-shaped halo.

While the artist takes a humorous approach, she intends serious political implications. López is among many multicultural artists whose goal is to make art that will enlighten and reshape human consciousness in order to bring about social change.

In Figures 1.30 and 1.31 a glass of water is given two different treatments by two contemporary artists, Roy Lichtenstein and Ben Schonzeit. Both artists have presented their subject frontally, centralized and balanced within

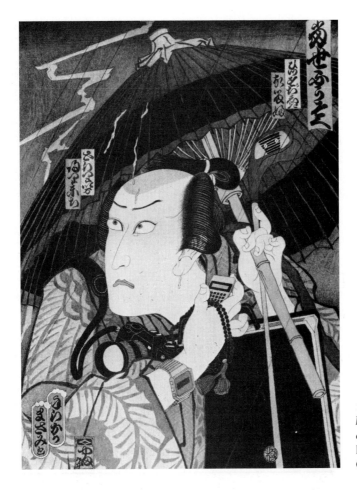

1.27. MASAMI TERAOKA. *Samurai Businessman Going Home.* 1981. Watercolor on paper, 13¼″ × 9¾″ (34 × 25 cm). Private collection. Pamela Auchincloss Gallery.

the frame. Both glasses are greatly magnified—the Schonzeit work is monumental in scale, 6 by 4 feet (1.83 × 1.22 m). Here the similarity ends. We are impressed with Schonzeit's ability to portray photorealistically the textural details within the glass. The magnified close-up focuses on the ice cube at the top of the glass, while the back, side, and bottom are blurred due to the shallow depth of field. Each minute detail is convincingly rendered. Lichtenstein, on the other hand, presents his glass in a stylized, abstract manner. We are at once struck by the repeating motifs of stripes and circular patterns (bubbles, tablet, background dots, air bubbles above the glass, and curvilinear swirls). The stripes compress the distance between the back of the glass and the front. Lichtenstein's style is readily recognizable—his trademark is the use of the Benday dots, a process associated with commercial reproduction and banal subject matter. His "billboard" style contrasts with Schonzeit's meticulous trick-the-eye textural effect. This contrast illustrates the fact that there is no end to the richness and variety in treatment of the same subject matter.

Images work on a variety of levels, on the rational as well as the irrational, on the conscious as well as the unconscious. They can have multiple, simultaneous, but different meanings: perceptual and formal, cultural and personal, experiential and imaginative, psychological and political. The manner in which an artist chooses to depict a subject can be extremely simple or

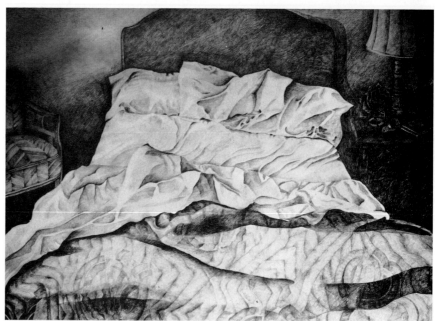

1.28. IRENE SIEGEL. *Unmade Bed, Blue.* 1969. Pencil, 20 × 40″ (76 × 102 cm). Private collection. Rubloff Inc., Chicago.

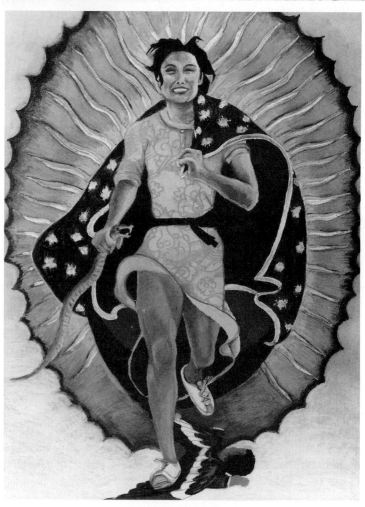

1.29. YOLANDA M. LÓPEZ. *Portrait of the Artist as the Virgin of Guadalupe.* 1978. Oil pastel on paper, 32 × 24″ (81 × 61 cm). Collection of the artist.

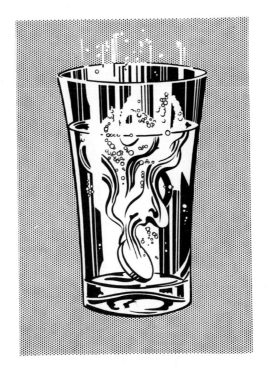

1.30. ROY LICHTENSTEIN. *Tablet.* 1966. Graphite and lithographic crayon pochoir on cream wove paper, 30 × 22″ (76.3 × 56.7 cm). Margaret Fisher Endowment.

highly complex. The image can be an object taken from the real world and then altered beyond recognition. In the oversized comic book style prints by Lichtenstein (Figures 1.32, 1.33, and 1.34), we see the bull abstracted through a number of stages. Lichtenstein selects his images from other sources; here he makes a wry comment mirroring the style of Piet Mondrian (Figure 1.35).

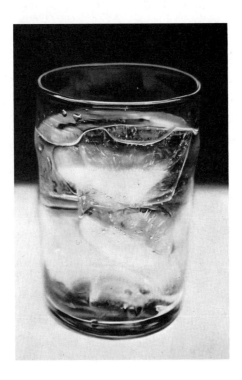

1.31. BEN SCHONZEIT. *Ice Water Glass.* 1973. Acrylic on canvas, 6 × 4′ (1.83 × 1.22 m). The Sydney and Francis Lewis Foundation, Richmond, Virginia.

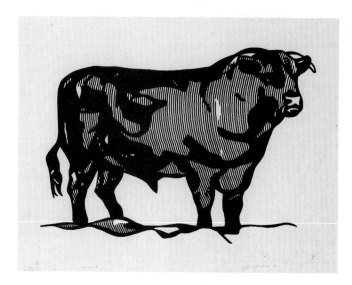

1.32. ROY LICHTENSTEIN. *Bull I* from *Bull Profile Series.* 1973. One-color linecut, 27 × 35″ (69 × 89 cm). Courtesy Gemini G.E.L., Los Angeles. © Roy Lichtenstein.

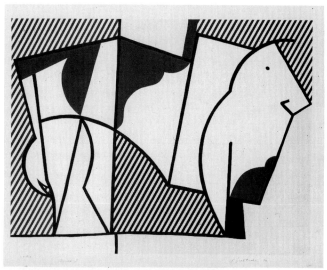

1.33. ROY LICHTENSTEIN. *Bull III* from *Bull Profile Series.* 1973. Six-color lithograph, screenprint, linecut, 27 × 35″ (69 × 89 cm). Courtesy Gemini G.E.L., Los Angeles. © Roy Lichtenstein.

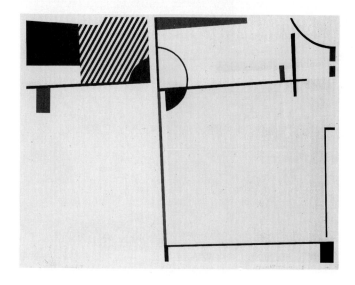

1.34. ROY LICHTENSTEIN. *Bull VI* from *Bull Profile Series.* 1973. Five-color lithograph, screenprint, linecut, 27 × 35″ (69 × 89 cm). Courtesy Gemini G.E.L., Los Angeles. © Roy Lichtenstein.

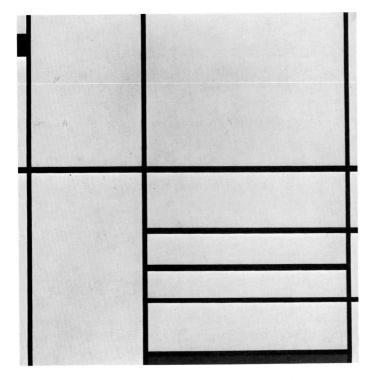

1.35. PIET MONDRIAN. *Composition in White, Black and Red.* 1936. Oil on canvas, 40¼ × 41″ (102 × 104 cm). The Museum of Modern Art, New York. Gift of the Advisory Committee.

Lichtenstein is fond of images that are clichés; he borrows images used by the popular media or by other artists and reinvests them with humor and irony. It is a dizzying path to follow—what looks like a rather simple strategy is layered in its content.

Mondrian's work evolved from recognizable images to a final, purely nonrepresentational stage. He strove for a neutral form using reductive means—lines, shape, and color. The arrangement of these nonobjective, geometric shapes becomes the subject of the work; associative meaning related to objects in the real world is avoided. Balance and stability, attained through a precise arrangement of vertical and horizontal elements, were crucial concerns for Mondrian.

An artist may deal with compositional options such as shape, scale, and placement. In fact, these compositional concerns may become the subject of the work, as in Louisa Chase's drawing on canvas (Figure 1.36). The confined geometric shapes recede into a field of vigorously stated, layered marks. These two modes—one using a simple geometric shape and the other asserting the obviously handmade, random mark—impose diametrically opposed orders. It is as if something had gone awry in a Mondrian painting. Could we be witnessing a graffiti attack on a modern Purist work?

CONCLUSION

The process of drawing develops a heightened awareness of the visual world, an awareness that is both subjective (knowing how you feel about things) and objective (understanding how things actually operate). Perception, the

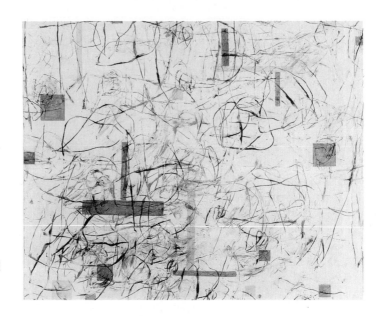

1.36. LOUISA CHASE. *Untitled.* 1987. Oil on canvas, 78 × 84″ (1.98 × 2.13 cm). Courtesy Brooke Alexander, New York.

faculty of gaining knowledge through insight or intuition by means of the senses, is molded by subjectivity as well as by the facts of the world.

Drawing affords you an alternative use of experience. It provides a new format for stating what you know about the world. Through drawing you are trained to make fresh responses and are furnished with a new way of making meaning. Finally, drawing teaches you to observe, distinguish, and relate.

The therapeutic value of art is well accepted; the intellectual benefits are many. Art is a way of realizing one's individuality. Creativity and mental growth work in tandem. The making of art, the making of the self, and the development of one's own personal style are all a part of the same process.

We have looked at a few of the many reasons why artists draw and a few of the many means available to an artist; now the exciting process of drawing begins.

CHAPTER 2

LEARNING TO SEE:
GESTURE AND
OTHER BEGINNING
APPROACHES

The mark that records the move-
ment of the artist's implement, a two-dimensional movement in space, is the
most basic feature of drawing. In addition to this spatial notation, drawings
evoke a time response—the time required to make the movement that cre-
ates the mark. Time is also involved in seeing and in scanning objects in space.
Think of the movement of your eyes as they dart back and forth, focusing
and refocusing on different objects at different times as you glance about the
room. So movement and time are two of the most essential features in mak-
ing and looking at a drawing.

We are so accustomed to seeing reproductions of art, reduced in size
and reproduced by mechanical means, that we often miss the handmade qual-
ity so valued in one-of-a-kind drawings. This handmade quality is called *fac-
ture*, a term that refers to the process or manner of making something. In art,
and especially in drawing, facture is of prime importance. The kinds of marks
artists make hold clues to unraveling the meaning of the drawing. We will
discuss this further in the succeeding chapters as we look at specific works

2.1. JOEL SHAPIRO. *Untitled.* 1968. Grease and graphite on paper, 18 × 23″ (48 × 58 cm). Private collection. Paula Cooper Gallery.

of art, but for now it is important to focus attention on the marks that go into the making of a drawing. Note what kinds of media are used and what kinds of tools made the marks. You will learn to build a descriptive vocabulary to discuss the quality and purpose of the marks, becoming aware of the speed or slowness with which they were made, registering their physical characteristics, and tracing the signs of facture in the drawing. (For example, the crosshatched line, the scribble, the faint, trailing line, the boldly stated, ripping mark—all are signs of facture.)

In the drawing by Joel Shapiro (Figure 2.1) facture is self-evident. The surface is built up of multiple overlaid marks that are scribbled over the entire surface. The expressive, loosely controlled marks point out the properties of the media—grease and graphite. This greasy substance is pushed to the edge of each mark; the center of the mark remains clean and white, thus giving dimension to each line—every line appears outlined. Row after row of overlapping marks create a unified field.

Viewers are left to make their own associations: a grassy field, a scribbled-out letter, a woven textile are some of the associations that come to mind. The ambiguity of what the marks could mean is an enticing part of this piece, but the real subject of the work is the act of mark-making itself. The randomness and rapid gestural marks affirm the hand of the artist and point to the artist's interest in the process, in what goes into the making of a work of art. Shapiro is classified as a Minimalist artist; Minimalism defines itself through the materials used, without allusion or illusions outside the work itself. It does not intend to represent a subject or an object in the real world; it is a drawing made for drawing's sake. We find many later twentieth-century artists like Shapiro whose subject is a philosophical investigation into what goes into the making of art.

Drawing takes into consideration intellectual awareness, somatic or body responses, consciousness at all levels. It is accessible to everyone; it is literally at the tips of your fingers.

Drawing plays a central role in the evolution of an artist's work, and nowhere is this more apparent than in the evolution of figurative work. Drawing provides a format for the development of formal ideas (as we have just seen in Shapiro's work, where the form takes precedence over other considerations), for iconographic ideas (*iconography* deals with the symbols used in a work of art), and for expressive possibilities. Not only does drawing offer a fresh point of view, it is truly the place where a maturation of ideas and forms takes place.

Whether an artist chooses to work abstractly or figuratively, learning to draw directly from the model and still life is essential.

We talked about time in our discussion of mark-making; another important aspect of time as it relates to drawing is memory. Both making and looking at drawings develop memory. (Your visual experience is enriched by learning to see through the practice of drawing.)

The two basic approaches to drawing both involve time. The first approach, called *gesture*, is a quick, all-encompassing overview of forms in their wholeness. The second, called *contour*, is an intense, slow inspection of the subject, a careful examination of its parts. Offshoots of these two basic approaches are *continuous-line drawing* and *organizational-line drawing*.

GESTURE DRAWING

In drawings we can detect the movement of the artist's hand, sometimes even the movement of the artist's eyes, because eye-to-hand coordination lies at the very core of drawing.

The formal definition of the word *gesture* amplifies its special meaning for the artist: the act of moving the limbs or body to show, to express, to direct thought. There is a physicality of motion in drawing that is not always visually evident in other art forms, and as a result of this physical energy, drawings communicate an emotional and intellectual impact. The gestural approach to drawing is actually an exercise in seeing. The hand duplicates the motion of the eyes, making a movement that quickly defines the general characteristics of the subject: placement, shape, proportion, relationship between the parts, a definition of planes and volumes as well as their arrangement in space.

In Käthe Kollwitz's self-portrait (Figure 2.2) the gestural mark connecting the hand and head is a carrier of meaning. Not only is this emphatic, quickly stated line symbolic of the energy that flows between the eye and hand of the artist, it is a manifestation of the movement of the artist's hand making the gestural motion of the zigzag.

Gesture is not unlike the childhood game of finding hidden objects in a picture. Your first glance is a rapid scan of the picture in its entirety; then you begin searching out the hidden parts. In Claes Oldenburg's monument drawing (Figure 2.3) the viewer is first struck by the highly active lines, which give a kinetic effect to the landscape. Our eyes are orchestrated by the movement of the line, weaving through and around the drainpipe building. The

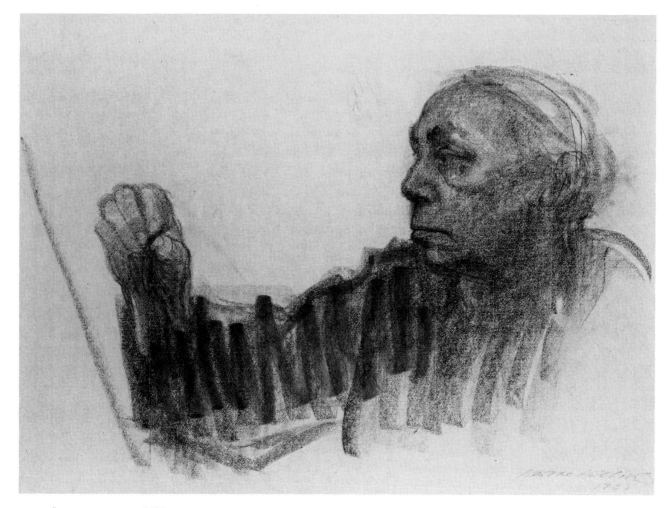

2.2. KÄTHE KOLLWITZ. *Self-Portrait,
Drawing.* 1933. Charcoal on brown laid
Ingres paper, 18³/₄ × 25″ (47.7 × 63.5 cm).
National Gallery of Art, Washington.
Rosenwald Collection.

marks are not contained within a form; they search out and quickly describe the entire setting. We can detect the quick wrist movements of the artist, who occasionally transforms the scribbles into written notations.

Gesture is indispensable for establishing unity between drawing and seeing. It is a necessary preliminary step to gaining concentration. We can recognize friends at a glance, and from experience we do not need to look at them further for identification. We perform an eye scan unless something unusual makes us look intently—unusual clothes, a new hairstyle, or the like. For most daily activities, too, a quick, noninvolved way of looking is serviceable. For example, when we cross the street, a glance at the light, to see whether it is green or red, is enough. We may add the precaution of looking in both directions to check on cars; then we proceed.

This casual way of screening information is not enough in making art, however. Even if the glance at the subject is quick, our eyes can be trained to register innumerable facts. In the subject to be drawn, we can train ourselves to see nuances of color, texture, lights and darks, spaces between objects—measurable distances of their height, width, and depth—the materials from which they are made, the properties of each material, and many more things as well.

In the page of gestural drawings by Georg Baselitz (Figure 2.4), we see examples of such observation. What appear to be meaningless scribbles turn into landscape studies (with one seated figure) when turned upside down. Baselitz's identifying style, his signature, is his upside-down images. His interest in abstract work and his desire to energize traditional subject matter gave impetus to this novel approach.

Through gesture artists translate much vital, early information into drawings. Gesture is the essential starting point.

Gesture is more than seeing and organizing; it is a metaphor for the energy and vitality of both the artist and the subject, a good example of which can be seen in the energized, electric work by Suthat Pinruethai (Figure 2.5). The marks pulsate back and forth across the five-unit grid; the scribbled, gestural lines not only move across the various units but seem to vibrate from front to back. Some lines seem to be in focus; others are blurred and shadowlike. The last lines that were drawn are the white ones, and it is through them the units are tied together. What can be the meaning of the missing module and of the one, much simpler, composition? Could the drawing be visually akin to the sound of some complex syncopated beat?

Another powerful example of the gestural marks serving as a means of communicating an idea is in Mario Merz's crudely drawn beast (Figure 2.6). Note the massive scale of the drawing which reinforces the metaphor for our brute nature. His use of animal imagery looks back to another fertile twentieth-century art period, German Expressionism, and like many of the artists in that movement, Merz sees the artist as a modern primitive, as a "vagabond" or "nomad." Note that this *animale terrible* has no eyes. Merz asserts illogic, disorder, chance, and change in his work, and what better means than the gestural approach to convey this anti-techno-scientific message? The artist has obviously not found this beast in the real, tangible world; rather it comes from the world of his imagination.

Artists throughout history have used the gestural approach to enliven and organize their work. The eighteenth-century artist Gaetano Gandolfi used this technique in establishing his composition (Figure 2.7). He translated the three-dimensional forms of the architectural setting and the groups of figures onto the two-dimensional arched frame of the paper, thereby establishing scale and proportion quickly. The drawing thus becomes a blueprint for further development. Gandolfi uses a progression from darker forms in the foreground to lighter ones in the background; by this means he both symbolically and literally highlights Christ, the main character in the drama. Although the front and sides of the figures and the recesses of the complex architectural stage are not explicitly developed, they are certainly indicated in such a way that we read this drawing as taking place in space—the illusion is solidly begun.

The sense of space in the drawing by the nineteenth-century Romantic artist Eugène Delacroix (Figure 2.8) is more limited than in the previous drawing. Here the focus is on movement; the forceful application of the swirling, dynamic marks is economically accomplished. We see how fitting the gestural technique is for quick brush-and-wash drawings. The ink wash has dissolved some of the underlying black chalk marks, thereby producing interesting tonal and textural changes. A sense of drama is the result of the contrast between light and dark. The title, *The Constable of Bourbon Pursued by His Conscience*, reveals Delacroix's narrative intent; the constable's conscience,

2.3. CLAES OLDENBURG. *Proposed Monument for Toronto: Drainpipe.* 1967. Pencil and watercolor, 40 × 26″ (101 × 60 cm). Private collection. Courtesy of the artist.

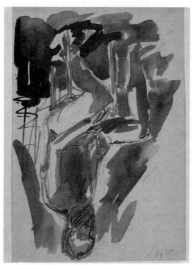
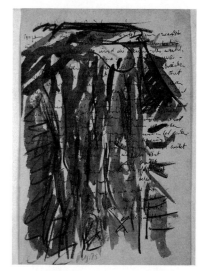

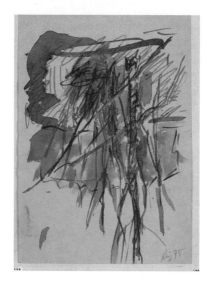
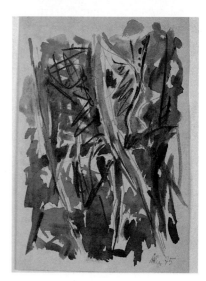

2.4. GEORG BASELITZ. *Sachsische Motive*
1971-75 (6 from a series of 54).
Watercolor, 9 × 6¼″ (23 × 16 cm).
Michael Werner Gallery.

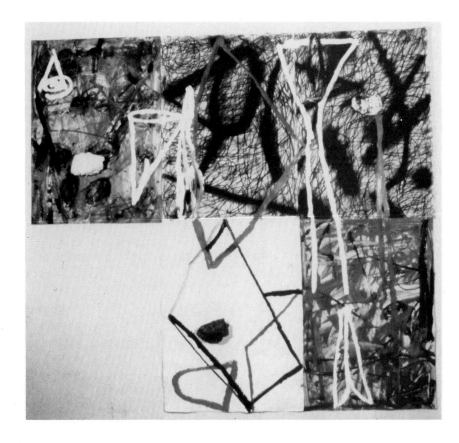

2.5. SUTHAT PINRUETHAI. *Pom Pom.* 1988. Monoprint, crayon, oilstick, and assemblage, 5′8″ × 6′2″ (1.73 × 1.88 m). Courtesy Gallery West, Los Angeles.

a pale, airy form, seems to have taken little hold on him. Technique and content are perfectly welded.

Honoré Daumier is classified as a nineteenth-century Realist whose major contribution as a draftsman is unparalleled. He documented the social ferment in the period following the French Revolution. In his hands gesture is a forceful tool for relaying a sense of movement, speed, and the agitation of the times (Figure 2.9). We see how adaptable gesture is for caricature. Daumier's satirical visual criticism of the period is a novel approach. His use of angle and confrontational close-up could be a precursor of the news camera.

Artists in contemporary times continue to be attracted to gesture as an aid to seeing, but the real attraction of gesture for the artist is the energized mark-making gesture provides. In Jody Pinto's gestural notation of her Native American landscape (Figure 2.10), the marks themselves take priority over the subject. The drawing is infused with a vitality and immediacy that make a connection between the artist and the Blackfoot hills. The vigorously stated marks organize the picture plane while indicating the weight of the hills. With a few deft marks a strong and dramatic sense of light and shadow is suggested. The spontaneously weighted lines are created by a pressure change on the drawing implement, a technique which helps define the spatial relationships between the near and far hills.

In all these drawings the strokes convey an immediacy and directness that give us an insight into the artist's vision. Gesture trains the eye and the hand, and it opens the door most effectively to unexplored abilities.

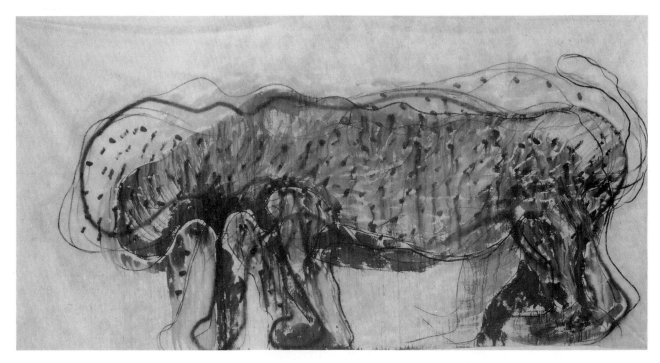

2.6. MARIO MERZ. *Animale Terrible.* 1979. Mixed media on canvas, 7'5³/₄" × 15'6" (2.3 × 4.75 m).

Before Beginning to Draw

Some general instructions are in order before you begin. Now is the time to consult Guide A, "Materials," which is found in the back of the book and which contains a comprehensive list of materials for completing all the problems given in this text. Before beginning drawing from the figure or still life,

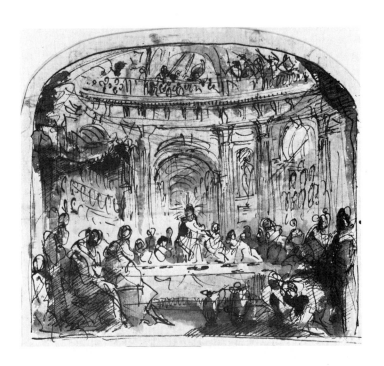

2.7. GAETANO GANDOLFI. *The Marriage Feast at Cana.* Late eighteenth century. Pen and ink with wash, 9³/₄ × 8¹/₈" (25 × 21 cm). The Pierpont Morgan Library, New York.

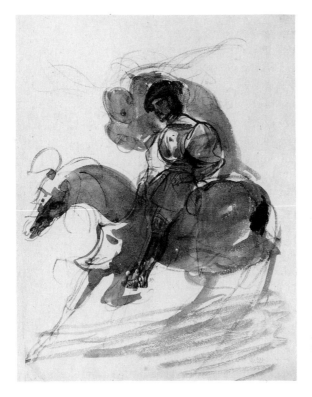

2.8. EUGÈNE DELACROIX. *The Constable of Bourbon Pursued by His Conscience.* 1835. Sepia wash over black chalk or pencil, 15½ × 8⅝" (39.5 × 22 cm). Öeffentliche Kunstsammlung, Basel.

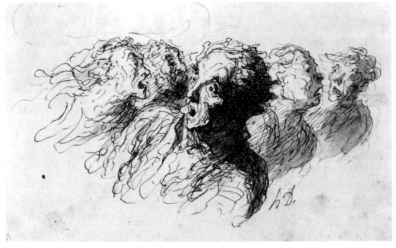

2.9. HONORÉ DAUMIER. *The Riot Scene.* 1854. Pen and wash, 6¼ × 10¼" (16 × 26 cm). Location unknown.

experiment with the media in your drawing kit: pencils, graphite sticks, pen and ink, brushes and ink, charcoal, crayons, and chalks. Remember the discussion on facture at the beginning of the chapter? Fill several pages in your sketchbook with some media experiments using the full range of implements. On each page group lines, changing the weight and pressure on your drawing implement. Vary the marks from long to short, from heavy to thin. After you have gotten the feel of each medium, noting their inherent character, make a unified field drawing, one in which the marks continue from side to side and cover the page from bottom to top. Refer to the Shapiro drawing in Figure 2.1. After you have made several pages of marks, lay the

2.10. JODY PINTO. *Blackfoot Landscape.* 1979. Graphite, gouache, crayon on paper, 30 × 40″ (76 × 101.5 cm). Collection of the artist.

drawings out side by side and make a list of words that describe the various line qualities you have made. Note which characteristics are a result of the medium itself and which characteristics are created by the hand that made them.

Now hold several pencils, or markers of any kind, in your hand at once, each implement in tandem with the others. Make broad gestural marks on your 18 × 24″ pad as in the drawing by Alan Saret (Figure 2.11). Saret is a sculptor whose three-dimensional work is like a gesture drawing in space, linear, multiple, grouped lines that are suspended in midair. It has been noted that Saret's work looks like sounds sound: percussive, soft, loud, rolling, crescendos with staccato accents. In fact, it is a good idea to make gesture drawings while listening to music. The music not only helps you relax, it encourages a rhythmic response.

As you have seen from your short introduction to gestural notations, gesture drawing can be done in any medium, but for making figurative drawings (drawings of the model, still life, or landscape) compressed stick charcoal, vine charcoal, or ink (with 1-inch or 2-inch [2.5 or 5 cm] varnish brush or a number 6 Japanese bamboo-handled brush) are recommended in the beginning. After you have learned the technique of gesture, begin drawing and experimenting with a full complement of drawing implements. Changes in media make for exciting results.

Gesture drawing involves large arm movements, so the paper should be no smaller than 18 inches by 24 inches (46 × 61 cm). Until you have fully mastered the technique of gesture, it is essential that you stand (not sit) at an easel. Stand at arm's length from your paper, placing the easel so that you can keep your eyes on the still life or model at all times. Make a conscious effort to keep the drawing tool in contact with the paper for the entire drawing; in other words, make continuous marks.

In the initial stage while you are becoming acquainted with the limits of the paper and with placement and other compositional options, you should

2.11. ALAN SARET. *Cirque Pass Ensoulment.* 1996. Pencil on paper. 20¼ × 26½". Collection of the artist.

fill the paper with one drawing. Later several gesture drawings can be placed on a page.

The drawings should be timed. They should alternate between 15- and 30-second gestures; then the time can be gradually extended to three minutes. Spend no more than three minutes on each drawing; the value of gesture is lost if you take more time.

When you draw from a model, the model should change poses every 30 seconds for a new drawing. Later the pose is increased to one, then to two, then to three minutes. The poses should be energetic and active. Different poses should be related by a natural flow of the model's movement. The goal is to see quickly and with greater comprehension. Immediacy is the key. Spend at least fifteen minutes at the beginning of each drawing session on these exercises.

Types of Gesture Drawing

You will be working with five types of gesture drawing in this chapter—mass, line, mass and line, scribbled line, and sustained gesture (Figures 2.12–2.21). The distinctions among the five, along with a fuller discussion of each of the types, follow.

MASS GESTURE EXERCISES

Mass gesture, so called because the drawing medium is used to make broad marks, creates mass rather than line.

Use the broad side of a piece of compressed charcoal broken to the length of 1½ inches (4 cm), or use wet medium applied with a brush. Once

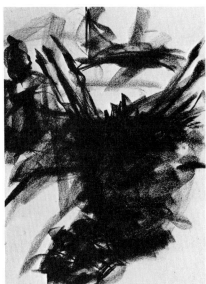

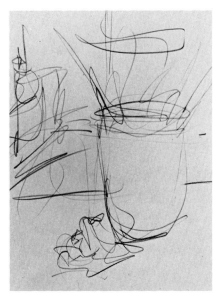

2.12. Mass gesture of still life. Example by Rick Floyd. 1984. Charcoal, 24 × 18″ (61 × 46 cm). Private collection.

2.13. Mass and line gesture of still life. Example by Rick Floyd. 1984. Charcoal, 24 × 18″ (61 × 46 cm). Private collection.

2.14. Line gesture of still life. Example by Rick Floyd. 1984. Charcoal, 24 × 18″ (61 × 46 cm). Private collection.

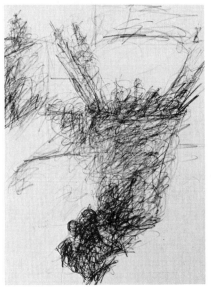

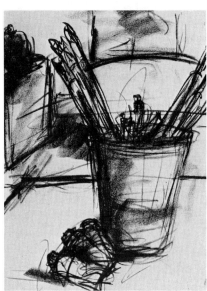

2.15. Scribbled line gesture of still life. Example by Rick Floyd. 1984. Charcoal, 24 × 18″ (61 × 46 cm). Private collection.

2.16. Sustained gesture of still life. Example by Rick Floyd. 1984. Charcoal, 24 × 18″ (61 × 46 cm). Private collection.

you begin, keep the marks continuous. Do not lose contact with the paper. Look for the longest line in the subject. Is it a curve, a diagonal, a horizontal, or a vertical line? Allow your eyes to move through the still life, connecting the forms. Do not follow the edge or outline of the forms. Coordinate the motion of your hand with the movement of your eyes.

In gesture you are not concerned with copying what the subject looks like. You are describing the subject's location in space along with the relationships between the forms. Keep your eyes and hand working together. Your eyes should remain on the subject, only occasionally referring to your

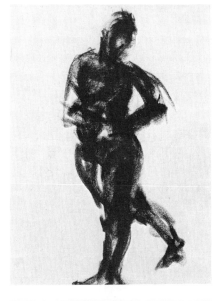

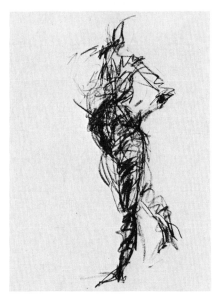

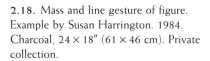

2.17. Mass gesture of figure. Example by Susan Harrington. 1984. Charcoal, 24 × 18″ (61 × 46 cm). Private collection.

2.18. Mass and line gesture of figure. Example by Susan Harrington. 1984. Charcoal, 24 × 18″ (61 × 46 cm). Private collection.

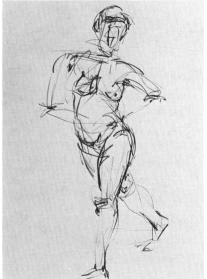

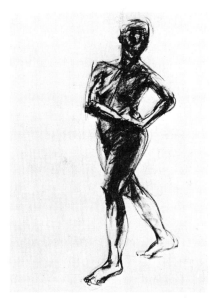

2.19. Line gesture of figure. Example by Susan Harrington. 1984. Conté crayon, 24 × 18″ (61 × 46 cm). Private collection.

2.20. Scribbled line gesture of figure. Example by Susan Harrington. 1984. Pencil, 24 × 18″ (61 × 46 cm). Private collection.

2.21. Sustained gesture of figure. Example by Susan Harrington. 1984. Charcoal, 24 × 18″ (61 × 46 cm). Private collection.

paper. This procedure will be uncomfortable at first, but soon you will learn the limits of the page and the location of the marks on it without looking away from the subject.

As you draw from the model, avoid a stick-figure approach. Begin your marks in the center of the forms, in the interior of the body, and move outward to the edges. Note the angles of the various body masses—upper and lower torso, upper and lower legs, angles of arms and head. Indicate the most obvious directions and general shapes first. Go from the large to the small. Begin at the core of the subject rather than at its outer edge.

2.22. HENRY MOORE. *Sheep Drawing* 40. 1972. Blue-black ball-point pen and pencil on paper 8¹/₄ × 9⁷/₈" (21 × 25.2 cm). Waddington Galleries, London.

Remember to keep the marks wide, the width of the charcoal stick or the brush. Try to create shapes as opposed to lines.

If you are drawing from a still life, place the several objects to provide intervals of empty spaces between the various parts. (A tricycle or tree branch, for example, might serve the same purpose, affording intervals of empty spaces between the parts.) In some of your mass gestures, draw in these blank *negative spaces* first. Emphasize the negative shapes in your drawing. You can use a figure for this exercise as well, but keep your focus on the negative shapes surrounding the figure and on the enclosed shapes (shapes formed between arms and body, for example).

In Henry Moore's *Sheep Drawing* 40 (Figure 2.22), the densely scribbled marks in the background or negative space seem to press down along the sheep's back, defining its outside edge. A reversal takes place in the lower part of the animal's body; the negative space is white and empty, while the curving gestural lines describe the sheep's bulging contours. Marks in the foreground negative space indicate grass and shadow and become more dispersed at the bottom edge of the picture plane. Moore uses a tighter network of lines to describe the face; the marks are more controlled, and they change their directions to indicate the facial structure. So convincing is Moore's spatial description that it is difficult to realize that the white positive space of the wool is literally on the same level as the white negative space surrounding the legs. Note the variety in the size of the marks, loops, and scribbles. In the areas of greatest weight and gravity, and in those of deepest space, the lines are more densely grouped; they become lighter and more spread apart as the forms project toward the viewer.

After you have become comfortable with the idea of looking at the shape of the negative spaces between the objects, note the depth between

them. You might make an arrangement of variously sized objects, arranging them in deep space. Early in the drawing note the base line of each object. The *base line* is the imagined line on which each object sits. Noting the base line will help you locate forms in their proper spatial relationship to one another.

In drawing it is easier to indicate height and width measurements of objects than it is to suggest the third dimension, depth. You are drawing on a surface that has height and width, so lateral and vertical indications are relatively simple. The paper has no depth, so you must find a way of indicating this important measurement. The use of diagonals, of angles penetrating space, is of prime importance.

Establish the gesture by pressing harder on the drawing implement when you draw the objects farther away; lighten the pressure for those objects nearer to you. By this means you will have indicated a spatial change; the darks appear to be farther back, the lights nearer.

In addition to the important spatial differentiation that mass gesture introduces into the drawing, mass gesture gives an early indication of lights and darks in the composition. These lights and darks unify the drawing. Rhythm and movement are suggested by the placement of the various gray and black shapes.

As you can see, mass gesture helps you translate important general information from the subject onto your paper—information dealing with spatial arrangement, measurement, relationships between the forms, and most importantly, your personal response to the subject.

LINE GESTURE EXERCISES

Related to mass gesture is *line gesture*. Like mass gesture, it describes interior forms, following the movement of your eyes as you examine the subject. Unlike mass gesture, it uses lines; these may be thick, thin, wide, narrow, heavy, or light.

Jasper Johns's pencil drawing of a flag (Figure 2.23) could be an inventory of gestural line quality. The lines range widely from thick to thin, light to dark, tightly grouped to more openly extended. Johns leads the eye of the viewer over the surface of the flag by use of lights and darks. If you squint your eyes while looking at the composition, you will see how the distribution of darks creates an implied movement and how stability is achieved by a concentration of heavier marks at the bottom of the drawing.

In line gesture the lines are tangled and overlapped, spontaneously and energetically stated. They may look like a scribble, but not a meaningless one.

The pressure you apply to the drawing tool is important; vary heavy, dark lines with lighter, looser ones. The darker lines might be used to emphasize those areas where you feel tension, where the heaviest weight, the most pressure, the most exaggerated shape, or the most obvious change in line direction exists.

As in mass gesture, the tool is kept in constant contact with the paper. Draw each object in its entirety even though the objects overlap and you cannot see the whole form. The same is true when drawing the figure; draw to the back side of the figure; draw the forms as if they were transparent.

2.23. JASPER JOHNS. *Flag.* 1958. Pencil and graphite wash on paper, 7¹/₂ × 10³/₈″ (19 × 26 cm). Private collection. © 1997 Jasper Johns/Licensed by VAGA, New York, NY.

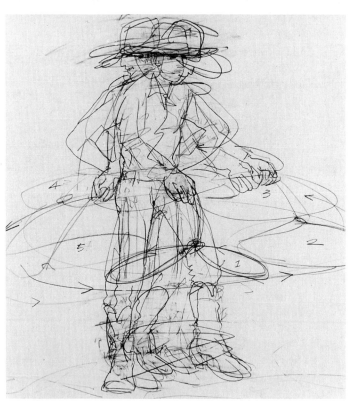

2.24. WALTER PIEHL, JR. *The Merry-Go-Round.* 1988. Pencil, 24 × 16″ (61 × 41 cm). Courtesy the artist.

It is a challenge for the artist to relay the effect of motion, and gesture is particularly effective in capturing the idea of motion. Have the model rotate on the model stand, making a quarter turn every 30 seconds. Unify the four poses in one drawing. Walter Piehl's rotating figure in Figure 2.24 depicts a cowboy with his lasso. A feeling of movement is especially pronounced in the areas of hat, hands, and boots.

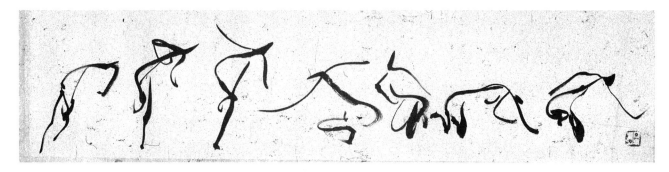

2.25. PARK YOOAH. *Movement II.* Meok (oriental ink) on paper, 13 × 55" (35 × 140 cm). Collection Park Ryu Sook Gallery, Seoul.

Another exercise especially appropriate for gesture drawing is one that has as its subject a continuous linear movement as in Park Yooah's series of seven quick poses of a figure in motion (Figure 2.25). They could be taken from a cinematic strip; each pose smoothly moves into the next as in a choreo-graphed dance. The Korean artist has captured the time sequence in an eco-nomical way using deft strokes related to oriental calligraphy. The means are extremely reduced yet the model's movement has been lyrically recorded.

Experimentation with linear media is encouraged. Any implement that flows freely is recommended. Both found implements and traditional ones are appropriate.

Try to avoid centrally placed shapes every time. Lead the viewer's eyes to another part of the page by different kinds of placement or by a concen-tration of darks in an area away from the center. Experiment with activating the entire surface of your paper by making the composition run off the page on three or four sides.

A good subject for gesture is fabric. Through a network of a variety of lines, try to convey the idea of folds, pleats, and creases using loose, slash-ing, gestural marks. Keep in mind the volume of the fabric as it rises and sinks, and try to indicate an idea of the form under the fabric that gives it shape. You may drape the fabric over a chair or some pillows, or you may draw a draped model.

MASS AND LINE GESTURE EXERCISES

This exercise combines mass gesture and line gesture. The masses or lines may be stated with charcoal or wet media with a wide brush. Begin with either mass or line, and then alternate between the two. Define the more im-portant areas with sharp, incisive lines. Michael Hurson has used mass and line in his *Room Drawing (Overturned Chair)* (Figure 2.26). The corners of the drawing are activated by the broad, gesturally stated triangles. The base lines of the chairs reinforce this angularity. The furniture is sketchily noted; the white central shape emphasizes the room's emptiness.

Indicating the forms as though they were transparent, restate the draw-ing; correct and amplify your initial image. You may wish to change the po-sition or placement of the forms or to enlarge or decrease the scale of cer-tain parts. Keep the drawing flexible, capable of change.

Try to fill the entire space, and do not neglect the empty or negative space. Begin laying the wash areas in the negative space, and then add the

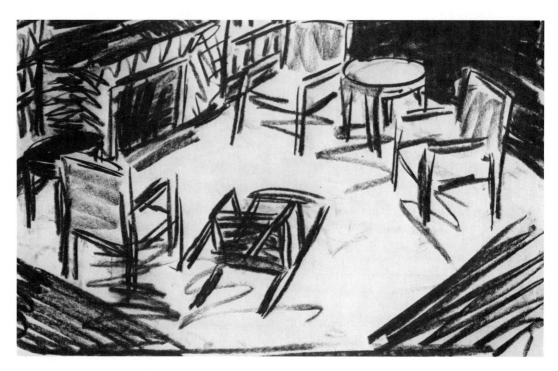

2.26. MICHAEL HURSON. *Room Drawing (Overturned Chair)*. 1971. Charcoal on paper, 7¹/₂ × 12″ (19 × 30 cm). Collection of the artist. Paula Cooper Gallery.

positive shapes. Let the wash areas or the mass gesture marks cross over both positive and negative space.

SCRIBBLED LINE GESTURE EXERCISES

The *scribbled line gesture* consists of a tighter network of lines than was used in the preceding exercises. The sculptor Alberto Giacometti's triple-head drawing (Figure 2.27) is a good example of this technique. The free-flowing ballpoint pen builds volume: The multiple, overlapping lines create a dense mass in the interior of the heads. The scribbles begin at the imagined center of the subject; the lines build on one another, moving from the interior to the outside edge of the form. This technique has a parallel in sculpture: the use of an armature or framework to support a volumetric mass of clay or plaster the sculptor is modeling. It is appropriate that Giacometti would use this scribbled line gesture for his head studies, since he was a sculptor. Drawing was also a major concentration of Giacometti. In his drawings we see the same concerns that occupied him as a sculptor, the ideas of weight and weightlessness and the ideas of spatial location and penetration.

In a scribbled line gesture, the outside of the form will be somewhat fuzzy, indefinitely stated. The darkest, most compact lines will be in the core of the form. The outer edges remain flexible, not pinned down to an exact line. As in the other gesture exercises, the drawing tool remains in constant contact with the paper. The scribbles should vary between tight rotation and broader, more sweeping motions.

Negative space is an appropriate place to begin a scribbled line gesture. The marks will slow down and be somewhat more precise as they reach the edge of the positive shapes. In Mac Adams's *Study for Three-Part Poison* (Figure

2.27. ALBERTO GIACOMETTI. *Diego's Head Three Times*. 1962. Ball-point pen, 8¹/₈ × 6″ (21 × 15 cm). Private collection.

2.28), the gestural marks in the bottom of the drawing are concentrated in the negative space surrounding the table and chairs. The lower half of the drawing is far less precisely stated than the upper section with its more refined and precisely drawn chandelier. This precision is counterbalanced by the swiftly drawn gestural marks that emerge from the darkness surrounding the light fixture. Without the gestural drawing in the negative space the objects would be static and inert. It is the activation of the negative space that enlivens the drawing and attracts our attention. By changing the pressure on the drawing tool, Adams creates a weighty, dominant mass on either side of the table and behind the chandelier. This concentrated mass of lines behind and around the chandelier is in contrast to the delicacy of line and shape in the lamp itself. For Adams the chandelier is a symbol of luxury and, therefore, is an inherent danger. He uses this image frequently in his work as a metaphor for art—the danger that lies in seeing art as mere luxury. In this drawing the focal point is clearly the chandelier. In order that the viewer not miss the point, Adams draws a precise arrow directing our eye to the lower left, to a schematically drawn bowl—the container of the poison?

If most of your drawings have begun in the center or top of the page, try to change your compositional approach and consider a different kind of placement, one that emphasizes the edges, sides, or bottom. You can develop a focal point by being more precise in one particular area of the drawing.

By varying the amount of pressure on the drawing tool and by controlling the denseness of the scribbles, you can create a range from white to black.

2.28. MAC ADAMS. *Study for Three-Part Poison.* 1980. Graphite on paper, 5'4" × 3'4" (1.63 × 1.02 m). Commodities Corporation, Princeton, N.J.

SUSTAINED GESTURE EXERCISES

The use of *sustained gesture* combines a description of what the object is doing with what it actually looks like. Verisimilitude was not a primary concern in the earlier exercises. Sustained gesture begins in the same spirit as before, with a quick notation of the entire subject. After this notation, however, an analysis and examination of both the subject and the drawing take place. At this point you make corrections, accurately establishing scale and proportion between the parts. In addition to drawing through the forms, you define some precise edges. The result is that the sustained gesture drawing actually begins to look like the object being drawn.

In Sandro Chia's *Man Seated at Table* (Figure 2.29), the gestural underpinning of the drawing is apparent throughout. The drawing offers the viewer a real insight into the artist's decision-making process. Faint traces of earlier figures, the altered scale of the head of the seated figure, a shift in the placement of the feet and table base—all are faint memories of various stages of the drawing. Chia has maintained the gestural approach throughout the drawing. In the final stage some edges have been strengthened by a darker contour line. The extended gestural approach reinforces the drawing's implied meaning: The shifting figure, the skull, and spiral indicate that change is its primary subject.

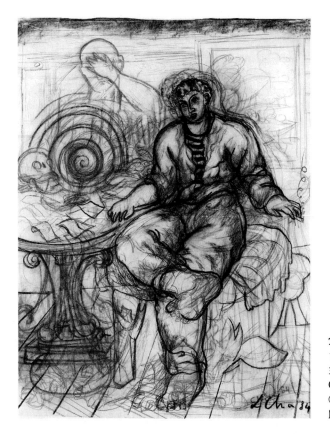

2.29. SANDRO CHIA. *Man Seated at Table.* 1984. Charcoal and pencil on paper, 38 × 30″ (97 × 76 cm). The Arkansas Arts Center Foundation purchase, 1985. © 1997 Sandro Chia/Licensed by VAGA, New York, NY.

Before drawing a still life, think of a verbal description of what it is doing. If you speak of a drooping flower, an immediate visual image comes to mind. This is a good way to approach sustained gesture. Look at the subject. Is the bottle *thrusting* upward into space? Is the cloth *languishing* on the table? Find descriptive terms for the subject and try to infuse your drawing with a feeling that is commensurate with the verbal description.

If you are drawing a figure, take the pose of the model yourself. Hold the pose for three minutes. Where do you feel the stress? Where is the most tension, the heaviest weight in the pose? Emphasize those areas in your drawing by using a darker line. Lighten the marks where there is less weight. Thinking of the attitude of the model and empathizing with the figure's pose will add variety and interest to the exercises and will help infuse the drawing with an expressive quality.

Quick gestures take from 30 seconds to 3 minutes. The sustained gesture takes longer—5, 10, even 15 minutes, as long as the spirit of spontaneity can be sustained.

In a sustained gesture you may begin lightly and darken your marks only after you have settled on a more definitely corrected shape. Draw quickly and energetically for the first two minutes; then stop and analyze your drawing in relation to the subject. Have you stated the correct proportion and scale among the parts? Is the drawing well related to the page? Redraw, making corrections. Alternate drawing with a careful observation of the subject. Avoid making slow, constricted marks. Do not change the style of the marks you have already made. Give consideration to the placement of the subject

on the page, to the distribution of lights and darks; look for repeating shapes; try to avoid overcrowding at the bottom or sides of the paper. Look for a center of interest and by a more precise line or by a sharper contrast between lights and darks in a particular area, create a focal point.

In this exercise, and in those to follow, it is imperative that you stand back and look at your drawing from time to time as you work. Drawings change with viewing distance, and many times a drawing will tell you what it needs when you look at it from a few feet away.

Of all the exercises discussed, you will find sustained gesture the most open-ended for developing a drawing.

Try to keep these nine important points in mind as you work on gesture exercises.

GUIDELINES FOR GESTURE EXERCISES

1. Stand while drawing.
2. Use paper at least 18 × 24 inches (46 × 61 cm).
3. Use any medium. Charcoal or ink is recommended.
4. Use large arm movements.
5. Scan the subject in its entirety before beginning to draw.
6. Be aware that the hand duplicates the motion of the eye.
7. Keep your drawing tool in contact with the paper throughout the drawing.
8. Keep your eye on the subject being drawn, only occasionally referring to your paper.
9. Avoid outlines. Draw through the forms.

OTHER BEGINNING APPROACHES

Other approaches that are helpful to the beginning student are continuous-line drawing, organizational-line drawing, and blind contour. Like gesture, these approaches emphasize coordination between eye and hand. They help translate information about three-dimensional objects onto a two-dimensional surface. They have in common with gesture the goal of seeing forms in their wholeness and of seeing relationships among the parts.

CONTINUOUS LINE DRAWING EXERCISES

The line in a *continuous line drawing* is unbroken from the beginning to the end. The drawing implement stays in uninterrupted contact with the surface of the paper during the entire length of the drawing. Jasper Johns's charcoal drawing *0 through 9* (Figure 2.30) is an example of this technique. The numbers are layered, stacked one on top of the other, all sharing the same outer edges. The numbers are transparent and slightly unintelligible, and the

2.30. JASPER JOHNS. *o through 9.* 1960. Charcoal on paper, 29 × 23″ (74 × 58 cm). Collection of the artist. © 1990 Jasper Johns/Licensed by VAGA, New York, N.Y.

overlapping intersecting lines create shapes independent of the numbers themselves.

Once you make contact with the paper (you may begin anywhere: top, bottom, side), you are to keep the line flowing. The completed drawing gives the effect that it could be unwound or unraveled. Rather than using multiple lines, you use a single line; however, as in gesture, you draw through the forms as if they were transparent. The line connects forms, bridging spaces between objects. Not only are outside edges described, internal shapes are also drawn. A continuous, overlapping line drawing has a unified look that comes from the number of enclosed, repeated shapes that naturally occur in the drawing. The resulting composition is made up of large and small related shapes.

Again, as in gesture, try to fill the entire surface of your paper. This, too, will ensure compositional unity. Let the shapes go off the page on at least three sides. Vary the weight of the line, pressing harder in those areas where you perceive a heavier weight or a shadow, or where you see the form turning into space, or in those areas of abrupt change in line direction (Figure 2.31).

Felt-tip pens, brush, pen and ink, and pencil are suggested media for continuous line drawing. Any implement that permits a free-flowing line is appropriate. The following box highlights some important points to keep in mind when doing continuous line drawing.

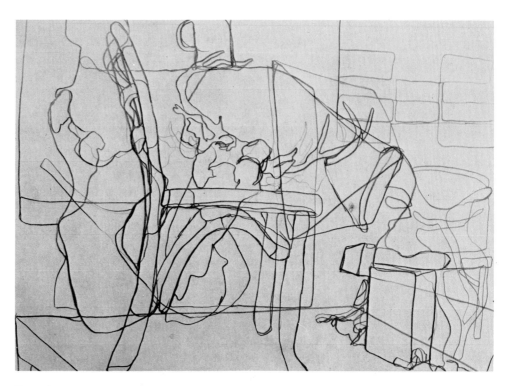

2.31. Continuous line drawing. Example by Rick Floyd. 1984. Pencil, 24 × 18″ (61 × 46 cm). Private collection.

GUIDELINES FOR CONTINUOUS LINE DRAWING

1. Use an implement that permits a free-flowing line.
2. Use an unbroken line for the entire drawing.
3. Keep your drawing implement constantly in contact with the paper.
4. Draw through the forms as if they were transparent.
5. Describe both outside edges and internal shapes.
6. Fill the entire surface of your paper, encompassing positive and negative shapes.
7. Vary the weight of the line.
8. Use continuous, overlapping lines.

ORGANIZATIONAL LINE DRAWING EXERCISES

Organizational line provides the framework for a drawing. This framework can be compared with the armature upon which a sculptor molds clay or to the scaffolding of a building.

Organizational lines take measure; they extend into space. Like gestural lines and continuous, overlapping lines, they are not confined by the outside limits of objects. They, too, are transparent; they cut through forms.

Organizational lines relate background shapes to objects; they organize the composition. They take measurement of height, width, and depth of the objects and the space they occupy. And like gesture, organizational lines are grouped; they are stated multiple times.

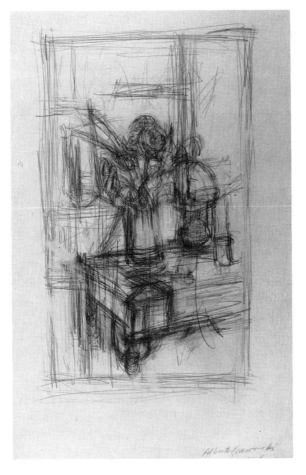

2.32. ALBERTO GIACOMETTI. *Still Life.* 1948. Pencil on paper, 19¹⁄₄ × 12¹⁄₂″ (49 × 32 cm). Collection of the Modern Art Museum of Fort Worth, Gift of B. Gerald Cantor, Beverly Hills, California.

To use organizational line choose a still life with several objects; include background space and shapes such as the architectural features of the room—ceiling, juncture of walls, doors, and windows. Begin with horizontal and vertical lines, establishing heights and widths of each object and of the background shapes.

Note Giacometti's use of organizational line in Figure 2.32. His searching lines extend into space beyond the confines of the objects to the edge of the picture plane. The objects themselves seem transparent; they are penetrated by groups of measurement lines. Multiple lines are clustered at the edges of forms, so the outer edge is never exactly stated; the edge lies somewhere within the cluster.

In your organizational line drawing, continue to correct the basic shapes, checking on proportion between the parts, on relative heights and widths. Look for diagonals in the composition; state the diagonal lines in relation to the corrected horizontal and vertical lines. Continue to refine the drawing, registering information about scale and space.

By closing one eye (to diminish depth perception) and holding a pencil at arm's length from you, you can measure the height and width of each object and make comparisons between objects. This is called *sighting* and is an important device in training yourself to quickly register proper proportion.

It is an indispensable aid for learning to translate three-dimensional objects onto a two-dimensional surface.

In addition to helping you establish correct proportion and placement between the parts, the buildup of multiple, corrected lines creates a sense of volume, of weight and depth in your drawing. After you have drawn for ten minutes or longer, and when you have finally accurately established proper proportion between the parts, you can then darken some of the forms, firmly establishing their exact shape. By this means you will have created a focal point; you will have directed the viewer to look for certain priorities that you wish to be noticed. You can direct the viewer's eyes through the drawing by means of these darker lines and more precise shapes.

Many artists use this analytical approach in the beginning stages of a drawing. The armature may not be readily apparent; it may be disguised under the completed work. Here are some important points to keep in mind when doing organizational line drawings.

GUIDELINES FOR ORGANIZATIONAL LINE DRAWING

1. Begin with horizontal and vertical lines, both actual and implied; add diagonal lines last.
2. Establish heights and widths of all objects and background shapes.
3. Allow lines to penetrate through objects, establishing relationships between objects.
4. Correct basic shapes.
5. Check on proportion and relative heights and widths.
6. Extend lines through objects and into negative space.
7. When you have established proportions, darken some of the forms, establishing their exact shapes.

BLIND CONTOUR EXERCISES

In contrast to the immediacy of the gestural approach, which sees forms in their wholeness, the contour approach is a slower, more intense inspection of the parts. A contour line is a single, clean, incisive line, which defines edges. It is, however, unlike outline, which states only the outside edge of an object. An outline differentiates between positive and negative edges. A contour line is more spatially descriptive; it can define an interior complexity of planes and shapes. Outline is flat; contour is *plastic*, that is, it emphasizes the three-dimensional appearance of a form.

A quick way to understand the difference between contour and outline can be found in the Benny Andrews drawing *Yeah, Yeah* (Figure 2.33). The artist has combined outline and contour to good effect in a single drawing. The figure is primarily outline; the exceptions are the left hand and features of the face, which, along with the guitar, are delineated in contour line. These three areas create a pyramidal focal area which supports the theme of the drawing, the intensity and single-minded focus which the musician applies to his playing. The "empty" figure sets up a sense of melancholy which is

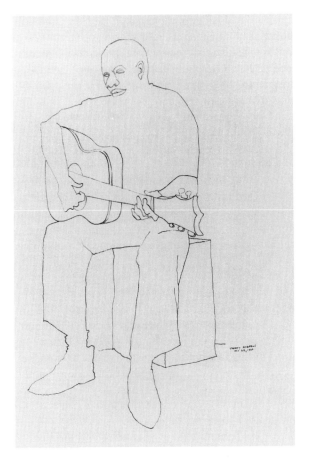

2.33. BENNY ANDREWS. *Yeah, Yeah.*
1970. Ink on paper, 18 × 12" (46 × 30 cm).
The Arkansas Arts Center Foundation
Collection; the Museum Purchase Plan of
the NEA and the Barrett Hamilton
Acquisition Fund, 1981.

similar to the feeling in music which the blues project. Simple means can produce powerful results.

Another effective way to distinguish between contour and outline is to imagine the difference in the outline of a pencil and the lines which make up its contours. If you were drawing a pencil using contour line, you would draw a line at the edge of every shift in plane. The ridges along the length of the pencil, the juncture of the metal holder of the eraser with the wood, the insertion of the eraser into its metal shaft—all are planar changes that would be indicated by contour line.

In addition to structural, or planar, edges, contour line can indicate the edge of value, or shadow, the edge of texture, and the edge of color.

There are a number of types of contour, several of which are discussed in Chapter 5, *Line,* but this chapter will concentrate on working with *blind contour,* an exercise that involves not looking at your paper.

Some general instructions are applicable for all types of contour drawing. In the beginning use a sharp-pointed implement (such as a 2B pencil or pen and ink). This will promote a feeling of precision, of exactness. Contour drawing demands a single, incisive line. Do not retrace over already stated lines, and do not erase for correction.

In blind contour, keep your eyes on the subject you are drawing. Imagine that the point of your drawing tool is in actual contact with the subject.

Do not let your eyes move more quickly than you can draw. Keep your implement in constant contact with paper until you come to the end of a form. It is imperative to keep eye and hand coordinated. You may begin at the outside edge of your subject, but when you see that line turn inward, follow it to its end. In a figure drawing, for example, this technique may lead you to draw the interior features and bone structure without completing the outside contour. Remember to vary the pressure on the drawing tool to indicate weight and space, to imply shadow, and to articulate forms.

Draw only where there is an actual, structural plane shift or where there is a change in value, texture, or color. Do not enter the interior form and aimlessly draw nonexistent planes or make meaningless, decorative lines. (In this regard, contour drawing is unlike a continuous, overlapping-line drawing, where you can arbitrarily cross over shapes and negative space.) When you have drawn to the end of an interior shape, you may wish to return to the outside edge. At that time you may look down and realign your drawing implement with the previously stated edge. With only a glance for realignment, continue to draw, keeping your eyes on the subject. Do not worry about distortion or inaccurate proportions; proportions will improve after a number of sessions dedicated to contour.

For this exercise choose a complex subject; in the beginning a single object or figure is appropriate, such as a bicycle, typewriter, or skull. Distortion and misalignment are a part of the exercise. Do not, however, intentionally exaggerate or distort. Try to draw exactly as you see. If you have a tendency to peep at your paper too often, try placing a second sheet of paper on top of your drawing hand, thereby obscuring your view of your progress.

Blind contour drawing should be done frequently and with a wide range of subjects—room interiors, landscapes, figures, still lifes (Figures 2.34 and 2.35). Here are some important points to keep in mind when doing blind contour exercises:

GUIDELINES FOR BLIND CONTOUR DRAWING

1. Use a well-sharpened pencil or pen and ink. Later, felt-tip markers and grease pencils can be used, but in the beginning use a sharp-pointed implement.
2. Keep your eyes on the subject.
3. Imagine that your drawing tool is in actual contact with the subject.
4. Keep eyes and hand coordinated. Do not let your eyes move more quickly than your hand.
5. Draw only where there is an actual structural plane shift, or where there is a change in value, texture, or color.
6. Draw only existent planes. Do not make meaningless lines.
7. Do not retrace over already stated lines.
8. Do not erase for correction.
9. Remember that contour line is a single, incisive line.
10. Vary the weight of the line to relay information about space and weight and to offer contrast.

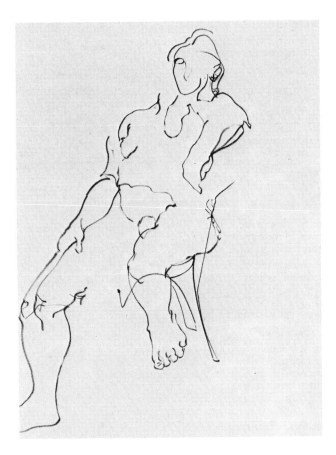

2.34. Blind contour of figure. Example by Susan Harrington. 1984. Pencil, 24 × 18″ (61 × 46 cm). Private collection.

SUMMARY

The Benefits of Gesture, Continuous Line, Organizational Line, and Blind Contour Drawing

Gesture drawing is a manifestation of the energy that goes into making marks. It is a record that makes a visual connection between the artist and the subject drawn, whether that subject be from the real world or from the world of the imagination. It can take place in the initial stages of a drawing and can serve as a means of early thinking about one's subject; it is an idea generator. Gestural marks can be the subject of the drawing or the carrier of an idea in the drawing. Gesture drawing, then, encourages empathy between artist and subject. The gestural approach gives the drawing vitality and immediacy. It is a fast, direct route to that part of us that has immediate recognition, that sees, composes, and organizes in a split second. Through gesture drawing we bring what we know and feel intuitively to the conscious self, and this is its prime benefit.

These basic approaches—gesture, continuous line, and organizational line drawing—train us to search out underlying structure. They are a quick means of noting planes and volumes and locating them in space. They help us to digest the whole before going to the parts, to concentrate in an intense and sustained way. The three approaches furnish a blueprint for a more sustained drawing and provide a compositional unity early in the drawing.

2.35. Blind contour of still life. Example by Rick Floyd. 1984. Pencil, 24 × 18″ (61 × 46 cm). Private collection.

Contour drawing, on the other hand, offers a means to a slow, intense inspection of the parts. It refines our seeing and leads us to a more detailed understanding of how the parts relate to the whole.

These beginning approaches introduce some ways of translating three-dimensional forms onto a two-dimensional surface. We are made aware of the limits of the page without our having to refer constantly to it. These approaches offer a means of establishing unity in the drawing, placing shapes and volumes in their proper scale and proportion; they introduce lights and darks as well as a sense of space into the drawing; they suggest areas for focal development, and they provide rhythm and movement.

Finally, these beginning approaches provide a flexible and correctable beginning for a more extended drawing. They give options for developing the work and extending the drawing over a longer period of time. They point to a route to a finished drawing.

SKETCHBOOK PROJECTS

At the conclusion of each chapter you will find recommendations for sketchbook projects to be done in tandem with the studio problems. Each and every one of these beginning projects is ideal for sketchbook work.

Before you begin, read the first two Practical Guides at the end of the book, those on materials and keeping a sketchbook.

Since the steps for each beginning technique have been thoroughly discussed in this chapter, it should be sufficient here to offer you some ideas appropriate for each project; then you are on your way to an exciting career in drawing.

PROJECT 1
Gesture Drawings

One major change from the instructions that were given previously in regard to gesture drawing involves scale. Since the sketchbook is so much smaller than your drawing pad, and since you will be drawing while seated rather than standing at an easel, you must remember that the gestural movement will be more limited. Your shoulder should still be relaxed and the wrist kept loose. It is recommended that you not hold the drawing implement in the same way you hold it for writing as this produces a constricted line. You want the impetus for the movement to come from the arm and wrist even though the motions are scaled down, so experiment with a loose handling of the drawing tool, holding it in the middle of the shaft or at the opposite end of the marker.

Here are some suggestions for subject matter for gesture drawings in your sketchbook:

Animals, your own pet or animals in a zoo
People in a shopping mall
Musicians
Sports events
Children in parks or playgrounds
Café scenes
People dancing
People waiting for buses
Landscapes (parks, waterscapes, city scenes)
Family members or roommates performing daily chores
Interior scenes, such as classrooms or dormitory rooms
Clothing hung in closets, draped on chairs, thrown on floor
Draped fabric

These are only a few suggestions for getting started; you will come up with your own personal list of favorite subjects in no time. It is daily dedication to gesture that will give a secure underpinning to your drawing skills. Devote at least fifteen minutes a day to gesture drawing outside the class.

PROJECT 2
Continuous Line and Organizational Line Drawings

Continuous line and organizational line drawings can be done with more static subject matter than gesture drawings. For more effective results you should choose subjects that are arranged in spatial relationships, such as a group of objects on a table, a room setting that involves a grouping of furniture, or a landscape scene. Keep in mind the idea of transparency; make the lines cut through forms and through space. It is the relationship between

the forms that should be foremost in your mind. Choose subjects that vary in size, height, width, and depth, and try accurately to relate them to each other. Proportion and scale will become second nature to you after a while.

PROJECT 3
Blind Contour Drawings

Literally anything and everything make appropriate subjects for contour drawings. Making contour drawings is a form of meditation. You can spend five minutes or an hour on a single drawing depending on your time and mood. You probably have played that childhood game of repeating a word so many times it lost its referential meaning and became pure sound. This could be an analogy for what happens in the process of a slow contour drawing. You are looking so intently at the object that you forget the name of the object being drawn. This is an ideal state in contour when you are so absorbed in looking that the object becomes pure form.

Here is a starter list for blind contour subject matter:

Hands
Feet
Gloves
Articles of clothing
Contents of drawers
Fruit or vegetables
Plants
Tools
Drawing implements
Desktop articles
Vehicles such as bicycles, motorcycles, automobiles, trucks
Toys
Friends—sleeping, reading, working, playing
Animals
Self-portraits
Contents of a refrigerator or a cabinet

With dedication and commitment to keeping a sketchbook you will be amazed at the progress you will make, at how skillful you become in drawing. Blind contour is a technique that pays off in a hurry. Note your improvement after the first 50 drawings, then after the first hundred. You will be amazed at how keen your observation has become and how much control you have gained in drawing.

Many artists have made the claim that drawings are closer to the bone than any other art form; that being so, your sketchbook should be a real anatomical volume.

SPATIAL RELATIONSHIPS OF THE ART ELEMENTS

DEVELOPMENT OF SPATIAL RESPONSE

WE SEE DRAWINGS NOT ONLY as two-dimensional marks on paper but as spatial notations, notations of objects and ideas in a spatial context. We instantaneously read these marks as forms in space. The predilection or propensity of humans to perceive pictorial depth is universal, but our emotional responses to depicted space change over time with differing cultures. Cultural differences affect our attitudes toward space, not simply the fact of virtual depth, but the way we perceive depicted, pictorial space. By *pictorial space* we mean the kinds of space that are used on the picture plane.

Art establishes a dialogue between the work of art and the viewer, and the syntax of that dialogue is made up of the formal elements of art: color, line, shape, value, and texture. Form in art is created by the

endless, fascinating, and changing arrangements of the elements, and a critical aspect of those elements is the way they create pictorial space. One looks at art not only through the subject matter but through the interconnections of form and content.

A crucial stage in learning about art is the development of a spatial response, an insight into the complex aesthetic and technical problems art presents. It is this knowledge that enhances the art experience and turns it into the meaningful experience it should be.

As we amplify our discussion throughout the text, your spatial knowledge will expand. Each chapter in Part II provides new building blocks for your own personal construction of space. Now let us take a look at a very complex topic: the different kinds of pictorial space and how they contribute to the meaning of a work of art.

We all have a subjective response to space; each of us experiences and interprets space in an individual way. A child's idea of space differs from an adult's. Children throughout the world are attracted to art because of the way it helps them make sense of the world and their place in it. In Color Plate 1 a Tunisian child has drawn a view of his home town, an orderly, happy, idealized place filled with people, places, and events important to him. Like other children's drawings, this one makes use of *conventionalized* or *symbolic space,* as opposed to *illusionistic, realistic,* or *naturalistic space.* Objects that are more important are larger, even though they occupy a more distant space. Objects at the bottom of the page are closer; objects at the top of the page are farther away. Fronts, sides, and roofs of buildings are depicted as if the viewer had an aerial view, while the mosque and the red building at the top of the page are drawn frontally. Figures, plants, and animals are depicted schematically; note the stick figure at the upper left. A puzzling inset, a picture-within-a-picture, is placed off-center just below the road. Two children appear to be looking out of the inset onto the scene unfolding in front of them; their bodies are cut off by the frame. Both people and objects inside this space-within-a-space are drawn in a much smaller scale than the objects outside. Very little overlapping occurs; it is as if each object in the young child's world occupied its own assigned position. Spatially this drawing carries the happy message that all is well in this world.

Space has been treated differently in different eras and cultures. A graphic example of this diversity can readily be seen in a 1994 drawing by Enrique Chagoya, *Uprising of the Spirit* (Color Plate 2), whose

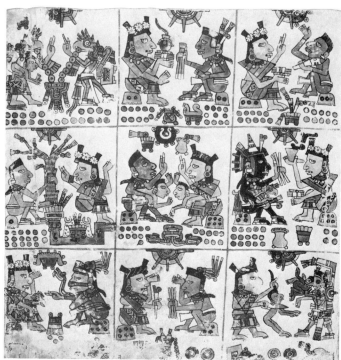

II.1. *Nine Pairs of Divinities.* Mixtec codex, Mexico. 14th–16th century. Vatican Library, Rome.

subject is the clash of two divergent societies, the collision of European and New World cultures. The tragic displacement and destruction of the indigenous Mexican culture by the invading Spaniards in the sixteenth century created a hybridization that continues even today with the imposed popular culture of Mexico's North American neighbor (represented in the drawing by the ironic entrance of a comic character, Superman). In this work we see the conflicting icons representative of three cultures, each occupying a different space. Chagoya has recontextualized images from three different times and geographical locations to signify the clash of three competing ideologies. Their spatial integration into a single work of art results in a format that is loaded with meaning, on a formal, artistic level, on a sociohistorical level, and on a personal level for the bicultural artist.

Chagoya's images originate from sixteenth-century sources whose spatial differences could not be more pronounced. The flattened space in a Mixtec codex, or manuscript book (Figure II.1), contrasts with the illusionistically deep space in a Renaissance drawing by Federigo Zuccaro (Figure II.2), although both were produced during the same period. In the Mixtec panel the space remains flat because of the use of

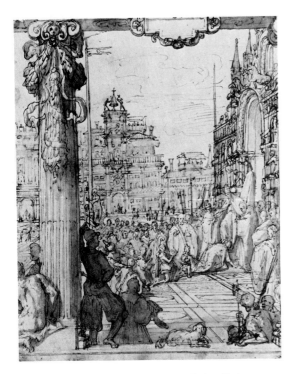

II.2. FEDERIGO ZUCCARO. *Emperor Frederic Barbarossa before Pope Alexander III.* Late 16th century. Pen and ink wash over chalk, 10⅜ × 8½" (26 × 21 cm). Pierpont Morgan Library, New York.

unmodeled, or flat, value shapes and outline. The figures share the same base line (the imaginary lines on which they stand). Hieroglyphs in each unit form a repeating pattern, which further flattens the space. The background is empty; the main focus remains on the positive figures and their static and symbolic relationship with one another. We see an example of *hierarchical space* in the lower right panel. The sacrificial victim is on a much smaller scale than the priest and god; the figures stand in symbolic relationship. The Mixtec artist was governed by a hierarchy of forms, both in his art and in his culture.

By contrast the Renaissance artist depicts a stepped progression of space. This effect is achieved by placing the figures and buildings in realistic proportion with one another, by making objects diminish in size as they recede into the distance, and by using darker washes and more precisely drawn lines in the foreground. The picture plane is penetrated by the diagonal lines (on the ground and in the building on the right) that point to a deep space. Column, figures, and building seem to be washed by a gentle light; soft grays and whites indicate various volumes. Unlike the

Mixtec artist, Zuccaro had as a goal the depiction of realistic, albeit idealized, space.

To help clarify some new terms with which to start building a vocabulary to discuss pictorial space, let's categorize some work according to spatial arrangements. In some drawings artists translate objects as they exist in real space, which has height, width, and depth, onto a flat surface, which has only height and width. The space conveyed can be relatively *flat* or *shallow*, or it can be *illusionistic*, that is, giving the impression of space and volume, or it can be *ambiguous*, not clearly flat or clearly three-dimensional.

In A. R. Penck's work (Figure II.3), his figures are stated in minimal terms; they are flat shapes; no depth is suggested. Penck even dispenses with overlap, a common device for conveying the idea of arrangement of forms in space. The shapes resemble cut-out forms with jagged edges. The work is abstract but highly personalized. Penck (a pseudonym; the original Penck was a geologist who studied the Ice Age) works in an autobiographical mode. His crossing over from East Germany to the West provided him with an archetypal theme of passage. The bleak images produce a powerful impact of primitive and mythic import. We classify this artist's space as flat, two-dimensional space.

CATEGORIES OF SPACE

A work that employs flat shapes while introducing overlap is the collage design *Roots Odyssey* by the Afro-American artist Romare Bearden (Figure II.4). A more complex space than used in the Penck work is achieved by a division of the picture plane to indicate various levels of space: sky, water, ship, land, and figure. The looming foreground silhouette on the right claims the dominant conceptual space. The outline of Africa and the slave ship seem to spring from the figure's imagination. The rising sun and the abstracted birds provide a sense of implied movement and symbolically represent Bearden's hope for freedom. Each shape is clearly two-dimensional, yet overlap and scale shift contribute to a limited or shallow space. The angle of the masts and the diagonal movement of the flat white birds offer a spatial relief from the static vertical stripes that indicate the figure's shoulder.

The two works just discussed are straightforward and logical when compared with the quirky, ingenious, and wildly complex spatial innovations of Jim Nutt (Figure II.5). In addition to being relatively flat or

II.3. A. R. PENCK. *T.III.* 1981. Dispersion on canvas, 6′7″ × 9′2½″ (2.01 × 2.81 m). Collection Martin Sklar, New York.

illusionistically volumetric, the space conveyed can be *ambiguous*, neither clearly flat nor clearly three-dimensional. Nutt's spatially ambiguous work has been compared to theatrical or puppet productions of surreal fairy tales, an appropriate description except for the very adult psychological realism it embodies. Dominating the work is the signature Jim Nutt frame; in his work large, pattern-painted frames nearly overpower the scenes they enclose. The frame in *Not So Fast* has a rather hypnotic effect with its vibrating gray dots that make up the pattern. (The painting is black, white, and subtle grays, so there is no complication of color interaction to further confound the viewer.) Large dark quarter-circles that resemble heavy reinforcement tabs tack down the four corners of the enclosed central scene. A shallow stagelike space is created by the perspectival wall and ceiling whose rigid diagonal grid flattens at the same time it indicates a spatial penetration of the picture plane. And what about that zany scale shift from hand to hand, from one body part to another (look at the ears and arms), not to mention the tiny toasting figure who occupies what logically should be the nearest space at the bottom of the picture plane? The patterning within the tie, suit, dress, hair, and inner ears is a flattening device, while the overlap of arms and hands is a spatial indication canceled out by the arm and hand in front being smaller than the shape they cover. Details of clothing and hair styles are specific to the 1930s: Could there be a reference to those films that dealt

with complex male-female relations? It is not only Nutt's subject matter and spatial arrangements that attract us; his inventive use of the formal elements and his refined technique contribute to the richness of the work. His spatial ambiguity is a perfect foil for his psychologically ambiguous content.

Another artist who exploits the spatial confines of the two-dimensional picture plane is Sandy Winters. In her work (Figure II.6) she conveys an illusion of volume by using modeling and cast shadow. Her images spill out from their background space; the bulging forms refuse to be visually contained by their background grids. Her subject matter is the wild and often violent flux of organic life. In the drawing *Court of Last Resort,* illusionistically three-dimensional shapes seem to have burst out from behind the picture plane and to be aggressively pushing through into the viewer's space. The cross-contour lines that encase these bizarre sculptural forms reinforce their extreme dimensionality; the riotous volumes advance out of the picture plane rather than recede into it. Winters has used volumetric or illusionistically three-dimensional space to underscore her disquieting message.

Twentieth-century artists have made many innovations with space, not the least of which is the combination of pictorial space and real, actual, three-dimensional space. Joseph Cornell is an artist who has brought this hybrid art form to a high level of achievement. Cornell's boxed tableaux contain a fantasy world and have been aptly called visual poetry (Color Plate 3).

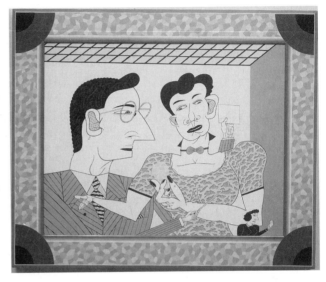

II.4. ROMARE BEARDEN. *Roots Odyssey.* 1976. Offset lithograph, printed in color, 28⅝ × 21″ (68.4 × 53.4 cm). Collection Ben and Beatrice Goldstein, New York; courtesy the Estate of Romare Bearden, ACA Galleries, New York and Munich.

II.5. JIM NUTT. *Not So Fast.* 1982. Acrylic on Masonite, acrylic on wood frame, 30¾ × 37½″ (78 × 95 cm). Private collection. Phyllis Kind Gallery.

His ready-made or found objects are juxtaposed to create metaphorical narratives. To look at Cornell's work is to look into a dreamworld. His work is preoccupied with a sense of infinite space; his images are taken from reproduced, printed images. The juxtaposition of the real with the unreal makes for symbolic, lyrical, and poetic connections. In this box created in honor of the artist Juan Gris, the walls are papered with printed collage fragments; the relationship between foreground (bird) and background (box) is an ambiguous one—like the spatial ambiguity found in Juan Gris's work (see Figure 5.16). Within the box, the bird and sky are clearly illusionistic and volumetric; the cockatiel and limb are realistically or naturalistically rendered; the sky forms a background for the exotic bird while at the same time it seems to penetrate the background space; it can be read as a window into space both on the formal and metaphorical levels. The

printed text provides a textured background for the black cutout shapes which are flat and two-dimensional; the container, ring, ball, and wooden bird support are actually three-dimensional. This ready-made combine is a compendium of space: two-dimensional, three-dimensional, and a combination of both, ambiguous. Again, Cornell's choice of ambiguous space is in perfect harmony with his coded message to Gris, a Cubist master of ambiguous space. And what better image for space than a bird who occupies both levels of our literal, environmental space, land and sky!

As we have seen in twentieth-century art, it is very difficult to confine an artist's use of space to one category. Donald Baechler's work is a combination of many spatial conventions (Color Plate 4). The centralized black-and-white flower is flat due to its heavy delineating outline. The background patterns of large and small dots create a limited depth; the larger dots

advance while the smaller ones recede within a shallow space. A variety of spatial treatments is used in the rectangular insets that surround the centralized image. In the lower left, a hooded head is treated traditionally with modeling and shading; an imitative or illusionistically three-dimensional space is the result. The same is true with the lemons and lime in the adjoining square; however, their isolation from the background makes them appear to float, so the spatial interpretation is a bit more ambiguous. Two small insets taken from cartoon strips employ relatively flat, conventional or symbolic space; the pair of silhouetted figures in the lower right are flat, two-dimensional shapes; the two sets of concentric circles create a spatial tension due to their shift in scale; and the pages of printed numbers invoke yet another kind of space. (We seldom think of words and letters occupying space; they are so integrated to their backgrounds we normally do not perceive a spatial context when we see printed textual material.) Baechler has achieved a subtle tension between all the parts of a rather complex work. Because the images and background texture are arranged in a vertical and horizontal format, the sense of movement and depth is limited. His big risk (and his big success) is to integrate that looming, clunky flower image with the subtle and disparate images that lie behind it.

PRECURSORS OF CONTEMPORARY SPATIAL DEVELOPMENT

The concept of space began its radical changes over the last quarter of the nineteenth century. Not only has the artist's concept of space changed, our ideas concerning real, physical space have changed. We have only to consider what speed alone can do to alter one's perception of space to realize that we have a very different spatial sense from that of our predecessors. Not only have theories about space changed, the very definition of our place in the cosmos is in contrast to our placement a hundred years ago.

Impressionism marks the time when artists began to lay claim to a painting as an object in its own right, autonomous, separate and different from its earlier function as imitative of the real world. And it was at this moment that art's release from its limited function of illusion began. The Impressionists declared in their work and in their writings that visual reality is not only

the imitation of the surface appearance of objects, but that visual reality is in a state of flux, altered by the quality of light and captured by the changing viewpoints of the constantly moving eye. These artists were scientific in their investigation of the properties of light and color, and they experimented with how (rather than what) we perceive.

It is interesting to note that one of the major influences on the spatial innovations of the Impressionists was the eighteenth-century Japanese Ukiyo-e artists—painters of the floating world (Figure II.7). The Impressionists were attracted to the very different spatial arrangement in Eastern art: the use of flat, unmodeled areas of color and pattern, an unexpected eye level, bird's-eye view, and cutoff edges. (This compositional device was particularly suited for the newly emerging camera.) And Japanese subject matter, like that of the Impressionists, dealt with intimate scenes. These works strongly influenced pictorial space in Western art.

New ideas of pictorial space, along with new scientific discoveries in the perception of light and color, occupied both the Impressionists and their successors, the Post-Impressionists. In their intense concentration on light and color, the Impressionists minimized the illusion of volumetric forms existing in an illusionistic three-dimensional space. The Post-Impressionists sought to revitalize pictorial space by recreating solids and voids while having them occupy a limited depth (Figure II.8). Georges Seurat sought to synthesize the findings of the Impressionists with ideas of traditional illusionistic space and structure. He placed his figures in an arrangement of diminishing perspective while unifying and flattening the surface of the painting with a pattern of colored dots. By this means he reconciled the flatness of the picture plane, maintained modern concerns of light and color, and introduced the objective of weight and volume into the composition. Seurat was interested in classical structure; he was especially attracted to Egyptian stacked perspective, where forms at the bottom of the picture plane are read as being closer to the viewer and those at the top are seen as occupying a deeper space.

The artist who was most influential in establishing twentieth-century concepts of space was Paul Cézanne. His space is not recognizable as natural space, but one can discern his complex idea of illusionistic space integrated on a flat surface (see Figure 1.10). The planes or edges of the objects slide into one another, thus joining surface and depth. His work is constructed with intersecting volumes. This new way

II.6. SANDY WINTERS. *Court of Last Resort.* 1993. Oil and graphite on canvas, 4′10″ × 6′10″ (1.47 × 2.08 m). George Adams Gallery.

II.7. ISODA KORYUSAI. *A Courtesan Playing the Samisen.* c. 1785. Hanging scroll, ink and gold on silk, 48 × 24⁵⁄₁₆″ (121.9 × 62.4 cm). Kimbell Art Museum, Fort Worth, Texas.

of depicting volumes as they exist in space opened the way for the revolutionary look of Cubism. Forms were distorted, segmented, analyzed, and revised in the way objects were depicted; space had to be dealt with in new ways. In Cubism natural objects were reduced to geometrical abstractions. The Cubists followed Cézanne's directive to "treat nature in terms of the cylinder, the sphere, and the cone"—in other words,

to interpret forms in their simple and broad dimensions.

In addition to introducing reductive, abstracted forms, Cubists shattered the traditional idea of perspective by combining multiple views of the same object in a single composition (see Figure 10.17). They drew side, top, inside, outside—collapsed and simultaneous views of a single subject and of the space

II.8. GEORGES SEURAT. *A Sunday on La Grande Jatte—1884*. 1884–1886. Oil on canvas, 6′9¾″ × 10′1¼″ (2.075 × 3.08 m). The Art Institute of Chicago; Helen Birch Bartlett Memorial Collection.

surrounding it. The resulting space is highly ambiguous, combining flat shapes with modeled volumes. The Cubists not only described objects in new ways, they depicted space itself as if it were made up of tangible planes and interlocking shapes. The work is complex in its arrangements; in a Cubist composition relationships proliferate—not only relationships among objects, but relationships between objects and space. These works could be considered as visual equivalents of Albert Einstein's theory of relativity. Cubism is closely linked with the "new ideas in the air," not only in art but in the world. It grew out of a volatile time.

Marcel Duchamp, an early innovator, developed his work along abstract lines (Figure II.9), a logical consequence of the development that took place at the turn of the century.

As we have seen, pictorial space has become more and more conceptualized in this century. Surrealism was another influential movement that disrupted the expectation of a logical, rational illusionistic space handed down to us by Renaissance artists. Surrealistic space is disjunctive, exaggerated (Figure II.10). Surrealism has an evocative power of eliciting an otherworldly space, which comes from the world of the subconscious. Scale shifts and unexpected juxtapositions characterize this style.

Joan Miró, the Spanish artist whose work bridged Cubism and Surrealism, built a repertory of abstracted, invented pictorial signs, using luminous, pure unmodulated color shapes. These biomorphic, organic forms furnished the means for his anti-style

and his self-avowed "assassination on painting." This attack is clearly evident in his *Portrait of a Man in a Late Nineteenth-Century Frame* (Color Plate 5). Miró challenged conventional art historical ideas of space (and bourgeois tastes) by effacing the found painting with his cryptic shapes, disembodied signs, and splatters of colors, while leaving the anonymous man's face and hands intact. This abraded, scratched, and altered portrait, done in a style popular at the turn of the century, contains a number of traditional spatial references: the spatial penetration by the window in the upper-right-hand corner has been canceled by the addition of Miró's mysterious lines and shapes; the photograph on the table suggests another reference to two-dimensional space; and finally, the religious painting on the back wall is all but obliterated and replaced with one of Miró's dark schematized, symbolic signs, seemingly suspended in air. The resulting space is a jolting combination of three-dimensional, illusionistic space and relatively flat, two-dimensional space. Miró's added flat shapes and lines insistently bring the viewer's attention back to the two-dimensional surface of the painting. The scumbled, sanded background creates a pulsating space that is not strictly confined to one definite plane. The two extreme styles, one traditional and conservative, the other abstract and radical, share an uneasy coexistence. By presenting the work in such an ornate, overdone heavy gold leaf frame Miró underscores his condemnation of end-of-the-nineteenth-century tastes and accepted conventions. His lifetime involvement with what has been labeled biomorphic

II.9. MARCEL DUCHAMP. *Virgin No. 1.* 1912. Pencil, 12½ × 9″ (31.8 × 22.9 cm). Philadelphia Museum of Art: The A. E. Gallatin Collection.

surrealism contributed to real breakthroughs in artists' use of space and imagery in the twentieth century.

The Abstract Expressionists carried the idea of pictorial space in another direction. Their vigorous, painterly attacks resulted in surfaces of rich complexity that force us to think of space in a totally new way. The painted surface is a record of the intensity of the process of painting itself. The images are not "images of" anything; they are a result of action. Rather than looking out into space, it is as if the artist were looking downward from an airplane to the flat surface of the earth. This radical change from looking through a deep illusionistic space to looking through a skein or web of paint makes a real departure in the viewer's spatial response to the work. Franz Kline's startling black-and-white configurations (Figure II.11), boldly executed, seem like patterns on the earth seen from miles away. It is up to the viewer to interpret these works. Artists frequently do not title their works so as to leave them even more nonreferential. Nonobjective art

serves as a concentrated emotional field, a place where the physical, individual marks are the subject themselves. Nonobjective art is purely visual, not tied to a narrative, or to an external reference. It simply refers to itself; it still, however, makes use of pictorial space, the space of the picture plane.

TWENTIETH-CENTURY SPATIAL DEVELOPMENT

Art has taken diverse directions in the latter half of the twentieth century, exhibiting a proliferation of styles, philosophies, and ideas. The result is a stylistic pluralism. Rather than one style replacing another in a historically linear fashion, today many styles exist side by side; therefore, we see all types of pictorial space currently in use.

An innovative use of pictorial space, and one peculiar to contemporary art, is that of the

II.10. MAX ERNST. "*. . . hopla! hopla! . . .*". 1929. Collage, 4 × 5⅝″ (10.2 × 14.3 cm). Collection of the Modern Art Museum of Fort Worth, Museum Purchase, The Benjamin J. Tillar Memorial Trust.

Photorealists. Tom Blackwell's *High Standard's Harley* (Figure II.12) is a study in representational clarity. The composition is tied together by a wide range of textures, all accurately represented, from the dull rubber tire to the reflective chrome and plastic surfaces. The picture plane is crowded with a multitude of small shapes in the foreground and larger, simple, blurred, value shapes in the background. Blackwell, in true Photorealist style, faithfully records the patterns that a camera sees—both its focus and distortion. Duplicating what the camera sees and how a photograph looks results in a space that is three-dimensionally illusionistic and flat at the same time. An unmistakable photographic flatness to the surface of these art works combines with the volumetric illusion that ultimately results in a distinctive new combination.

Minimalism, or Reductivism, focuses on art's formal properties such as color and shape, as in Color Plate 6. By drawing the geometric figures directly on the wall of a room, Sol LeWitt engages viewers not only on the visual or perceptual level, but involves

them in a physical and temporal participation as well. Site-specific work, such as this one, drawn on a museum wall, can only be complete when the viewer moves through its space. The aim of this type of work is to reinstate art to a total vital experience, not only by visual sensations, but other sensations as well, such as the quality of light in the room, the natural sounds occurring in the space, the way it feels to be contained in that space—these all become part of a unique experience, unique to each viewer.

LeWitt's images have a presence that is self-contained; that is, they are stripped of references outside the drawing itself. The planes which form the sides of the figures force a three-dimensional interpretation. In spite of their multisidedness there remains a sense of spatial ambiguity due to the extreme change in value, in light and dark, in the adjacent planes. The shaded side dominates, and if one concentrates on these gray planes intently, they seem to shift their positions spatially. In addition, the fact that they are suspended in space lends a sense of ambiguity to them. LeWitt

II.11. FRANZ KLINE. *Untitled*. 1954. Oil on paper, 11 × 8½" (28 × 22 cm). Collection of the Modern Art Museum of Fort Worth, Museum Purchase, The Benjamin J. Tillar Memorial Trust.

II.12. TOM BLACKWELL. *High Standard's Harley*. 1975. Acrylic on board, 22 × 15" (56 × 38 cm). Collection Louis K. and Susan Pear Meisel, New York.

confronts the viewer with questions concerning perception and thereby sets the stage for a real dialogue between the viewer and the art.

The gridded picture plane is a favored twentieth-century compositional device, favored in large part because of its possibilities for spatial ambiguity. The grid implies sequence and relationships between the parts. Minimalists have claimed the grid as a basis for sculpture and two-dimensional work. The British art team Gilbert and George use the grid in their monumentally scaled collaborative drawings (Figure II.13). Their goal is to make each person's marks indistinguishable from the other's, an "anesthetization" of visual art's traditionally based preferred aesthetic content. The grid affords them a practical solution to working with large works on paper, and additionally, it provides them with a serial format that parallels the universal or natural divisions they see in the world. This idea is made manifest in *The Total Mystery of Each Man-Layed*

Brick which carries the idea of life (and art) being constructed of sections based on discipline and order. Like life itself, the drawing appears to be unfinished. The light-valued grid at the bottom of the drawing reinforces the flatness of the picture plane and the format of the grid. The upper section disguises the grid somewhat. The resulting space is again ambiguous; the building and plants are drawn employing a more three-dimensional space than the lower third of the composition. The question of what is or is not complete lies at the center of the work and harks back to Cézanne's illusionistic space integrated on a flat surface.

In Andrea Way's *Shots* (Figure II.14) the space of the drawing seems to take place on a video-like screen. A shallow sense of space is achieved by the use of small and large triangular shapes, which activate the black background. Light and dark rectangular shapes seem to occupy two levels of space, while a web of finely drawn diagonal shapes unifies and connects the

THE TOTAL MYSTERY OF EACH MAN-LAYED-BRICK.

THE 'GENERAL JUNGLE'

II.13. GILBERT AND GEORGE. *The Total Mystery of Each Man-Layed-Brick.* 1971. Charcoal on paper, 9'2¼" × 7'4⅝" (2.80 × 2.25 m). Courtesy Sonnabend Gallery, New York.

horizontal shapes. Way creates rules for her drawings so that, as she claims, she can constructively depart from them. She merges "systems," imposing one on top of the other. The resulting space is a continuous one. If we imagine the drawing to be expanded in any direction, we would see a continuation of the "program," a contemporary innovation.

We could not have a discussion of pictorial space without including the contemporary artist Frank Stella, whose entire body of work has dealt with reinvigorating space as it is used in abstract painting (Figure II.15). Our traditional concept of the rectangle as background for a two-dimensional work of art is subverted by Stella's curved and expressively colored shapes that tilt out from the wall and occupy, rather than depict, actual, projective, three-dimensional

space. His works are on a large scale, eccentric and exciting. Stella has written that it is an emotional impact of space that he seeks; he believes that this emotive, new approach to pictorial space is "an antidote" to what he sees as the "barren imagery of abstraction."

Post-Modernism, a late twentieth-century development, is an attitude more than a style and employs the full range of pictorial space, flat, ambiguous, and illusionistic (sometimes even in the same composition). One particularly interesting development has been the overlay of images; even more innovative is the fact that the images are unrelated by technique, as in the Baechler drawing (see Color Plate 4).

Color Plates 7 and 8 share some of these Post-Modern characteristics. The heavily impastoed

II.14. ANDREA WAY. *Shots.* 1986. Ink on paper, 3′ × 4′3½″ (.91 × 1.31 m). Collection of George T. Moran.

II.15. FRANK STELLA. *Diavolozoppo* (#2, 4x). 1984. Oil, urethane enamel, fluorescent alkyd, acrylic, and printing ink on canvas, etched magnesium. Knoedler & Co.

bas-relief frame surrounds a work on paper by Robert Morris. The pastel and watercolor drawing seems completely overwhelmed by the massive border with its apocalyptic scenes of death and destruction. The artist has reversed our expectations of frame and contents; the recognizable imagery is presented in the frame; the picture plane itself is an abstract swirl of color and light. It is the frame which provides the means of interpretation. The images on the metallic-looking encasement are dimensional but jumbled in an illogical and disorderly manner. The frame's inner liner calls attention to the flatness of its contents. The work could be a detail from an earlier nineteenth-century Romantic painting such as a J.M.W. Turner work, for example. We interpret the inner space to be of epic proportions, a cosmic event. It is as if the frame is showing us explicit details from the aftermath. What a powerfully loaded content carried by a spatial

II.16. JENNIFER BARTLETT. *White House.* 1985. Oil on canvas, 10′ × 16′ (3.05 × 4.88 m); house: wood, enamel paint, tar paper, 3′9″ × 5′ × 4′10¼″ (1.14 × 1.52 × 1.48 m); fence: wood, enamel paint, metal, 3′ × 12′10¼″ × 5″ (91 cm × 3.92 m × 12.5 cm); pool: plywood paint, 7″ × 3′7¾″ × 31½″ (18 cm × 1.11 m × 80 cm). Private collection.

conflation of two extremely different but mutually endorsing styles!

The second work, a drawing by Vince Falsetta, employs a swirling, atmospheric space. Is this space on top of or behind the tiny diagonal grid that covers the surface? A totally different type of space defines the foreground images. Silhouetted leaping dogs, geometric forms, and linear configurations are flattened by multicolored diagonal stripes. What would otherwise be static images due to their shapes and flat colors seem to be bouncing around in a heavenly mist. Several spatial planes are implied within the foreground space; the larger shapes advance, the smaller ones recede. What a contrast between these two works! And both employ complex spatial arrangements to put their message forward.

Figure II.16 underscores the extremes to which artists' use of space has been taken in late twentieth-century art. Jennifer Bartlett's *White House*, like other recent works, is composed of actual three-dimensional painted objects that coexist with their two-dimensional counterparts on canvas. (A three-dimensional actual fence and model house stand in front of their two-dimensional depiction.) An interesting relationship is established between the two kinds of representation. You have only to compare the media required for this piece with that used in more traditional work to realize the enormous changes in the handling of space that have taken place in this century.

Before we conclude our discussion of space, let's come full circle and look at one more example of how space has been used by a nonprofessional artist. We

PLATE 1. Drawing by a Tunisian child, from *Their Eyes Meeting the World* by Robert Coles.

PLATE 2. ENRIQUE CHAGOYA. *Uprising of the Spirit.* 1994. Acrylic and oil on paper, 4′ × 6′ (1.22 × 1.83 m). Los Angeles County Museum of Art (partial and promised gift of Ann and Aaron Nisenson). Gallery Paule Anglim.

PLATE 3. JOSEPH CORNELL. *Untitled (Juan Gris).* 1954. Box construction, wood, cut papers, and found objects; 18½ × 12½ × 4¾″ (47 × 32 × 12 cm). Philadelphia Museum of Art. Purchased, the John D. McIlhenny Fund.

PLATE 4. DONALD BAECHLER. *Black Flower #1.* 1994. Gouache, gesso, and collage on paper, 4′11″ × 3′11″ (149.9 × 119.4) over-all. Sperone Westwater.

PLATE 5. JOAN MIRÓ. *Portrait of a Man in a Late Nineteenth-Century Frame.* 1950. Oil on canvas, with ornamented frame, painting 37⅞ × 31½" (96 × 80 cm); overall, including frame, 57½ × 49¼" (146 × 125 cm). Museum of Modern Art, New York; gift of Mr. and Mrs. Pierre Matisse.

PLATE 6. SOL LEWITT. *Multiple Pyramids.* 1986. Installation at John Weber Gallery.

PLATE 7. ROBERT MORRIS. *Untitled.* 1983–84. Cast hydrocal, graphite on paper, 6′4″ × 7′8″ (1.93 × 2.34 m). Courtesy of the Artist and The Solomon R. Guggenheim Museum, New York.

PLATE 8. VINCENT FALSETTA. *92-204.* 1992. Acrylic on paper, 41¾ × 29½″ (106 × 74 cm). Collection of the artist.

II.17. MARTIN RAMIREZ. *Untitled. (Horse and Rider).* c. 1950. Pencil on paper, 24 × 25″ (61 × 63.5 cm). Phyllis Kind Gallery.

began our introduction to space with a child's drawing; we will conclude with a look at a powerful drawing made by a self-trained artist.

Martin Ramirez was a mute and withdrawn psychotic for many years. Institutionalized as a schizophrenic for the last 30 years of his life, Ramirez turned to drawing as a sympathetic companion. Meager supplies forced him to improvise materials. He glued together old scraps of papers, cups, wrappers—anything he could find to create a drawing surface. Often he made glue from mashed potatoes and water, even from bread and saliva. His working methods reflected his psychotic nature; he kept his drawings rolled up, working on only a small exposed area at a time.

The space in his drawings reveal his inner thoughts (Figure II.17). Entrapped animals occupy spaces too small to contain them. Walls close in on the frightened personal stand-ins. In his *Horse and Rider,* a pencil drawing on paper, the horse has its head thrown back as if in anguish. The legs are peculiarly propor-

tioned; the back legs are longer and nearer the viewer than is logical. The stereotypical bandito character (he could be a relative of one of Picasso's cast) has his head completely twisted backwards. He wears a shoulder harness and bullets. Both he and the horse are taut with tension; they seem ready to run. But to where? The tomb-like space seems to be in the very act of closing in on them. The illogical space is psychologically loaded. Our body responds to the confinement and our hearts pound in empathy. Striking and moving work is being done throughout the world by artists who are outside the mainstream of art. Their work is eagerly sought by galleries, museums, and collectors alike. Sadly, much of Ramirez's work was destroyed intentionally by insensitive caretakers. We are fortunate that a few of his powerfully emotive works survive.

In this survey of some of the major changes in the development of pictorial space in the twentieth century, you can see the importance of spatial ideas for

artists. Whether the emphasis is on flat, shallow, illusionistic, actual, or ambiguous space, the concept of space is a challenge of lasting interest to all who are dedicated to art, makers and viewers alike. It holds the key to unraveling the manifold meanings art can have.

The chapters in Part II deal with the spatial relationships of the art elements, beginning with shape, value, line, texture, and color. In each chapter we will consider the way the elements can be used to create different kinds of space. At the end of each chapter you will find a summary of the spatial characteristics of that element. Part II concludes with a chapter dealing with spatial illusion and perspective. By the time you reach the end of this section, you will be well versed in the many uses of pictorial space.

SKETCHBOOK PROJECT

The sketchbook is flexible. It can be used as a drawing pad, as a notebook, and as a scrapbook. The following project encourages some informative collecting for spatial references to be used throughout your career as an artist.

PROJECT 1
Making a Space Folder

Find at least ten examples each of 1) three-dimensional, illusionistic space; 2) two-dimensional or relatively flat space; and 3) ambiguous space, a combination of both two- and three-dimensional space in the same work. You will be surprised how many examples you can find in everyday life from such sources as newspapers, magazines, postcards, not to mention books on art. Either make a photocopy of each work or cut out the actual illustration and make a Space Folder for them. Attach an accompanying page for each example, and write an analysis of how each kind of space has been created. You might begin simply by labeling each sample in your collection according to the three basic categories. Then jot down a few notes that indicate the characteristics that determine your decision. As we complete each chapter, look at your samples once again and amplify or correct your initial assessments. For example, after we have worked with some exercises in the following chapter on shape, you will have an expanded idea of how shape can be used to create various kinds of space.

Throughout the course as you run across other examples of spatial treatment that appeal to you, clip them and add to your file. You will soon have a folder of material to assist with your own work.

Simple exercises like this will open your eyes to new possibilities in looking at and making art, and they will be the means by which you build a solid critical vocabulary to use in art analysis and critiques, both of which are essential tools for the artist.

S H A P E / P L A N E A N D
V O L U M E

SHAPE

Tʜᴇ ꜰɪʀꜱᴛ ᴇʟᴇᴍᴇɴᴛ ᴛᴏ ᴄᴏɴꜱɪᴅᴇʀ ɪɴ learning to create pictorial spatial relationships is shape. A *shape* is a configuration that has height and width and is, therefore, two-dimensional. An object's shape tells you what that object is.

We will begin our investigation into pictorial space first with shape; then look at how shape can be converted to plane; and, finally, consider how shape and plane can be made to appear as volume. Shapes can be divided into two basic categories: geometric and organic. Squares, rectangles, triangles, trapezoids, rhomboids, hexagons, and pentagons, as well as circles, ovals, and ellipses are only a few of many *geometric shapes*, which are created by the mathematical laws of geometry dealing with the properties, measurement, and relationships of lines, angles, surfaces, and solids.

Abstract, nonobjective art frequently makes use of geometric forms. In 1910 the Russian artist Wassily Kandinsky was credited with being the first to create a totally abstract work. Kandinsky, a theorist, mystic, and teacher,

3.1. WASSILY KANDINSKY. *Orange.*
Lithograph. 1923. 16⅛ × 15″
(41 × 38 cm). The Solomon R.
Guggenheim Museum, New York.

believed the salvation of humanity lay in the rediscovery of the spirit and of
hidden laws of the universe. He felt that art should attain the same goal as
music; that is, that it be made more pure in order to communicate directly.
To this end he used lines, colors, and shapes to create an emotional effect.

In 1919 Kandinsky became a teacher at the Bauhaus, a German school
of creative art, design, building, and craftsmanship. The Bauhaus gave a new
direction to aesthetics. Form and harmony were the main tenets of Kandin-
sky's teaching and art. In Figure 3.1 we see a synthesis of geometric figures,
movement, balance, and unity. The shapes seem to have been captured in
this particular position only for a fleeting moment. Except for the checker-
board pattern in the upper left corner, the geometric shapes look to be in the
very act of shifting and changing position as we observe them. Repeating
shapes tilt and turn in space; their locations seem impermanent. The diago-
nally stated triangles further enhance the idea of movement. Spatial and com-
positional control is maintained by use of the interconnected and interrelated
shapes. Kandinsky would frequently make a composition from which a dancer
would devise movements in keeping with the spatial forms in the work.

A drawing that uses an even more reduced shape vocabulary is the one
by Dorothea Rockburne which emphasizes clarity and presence by use of tri-
angles and squares (Figure 3.2). *Modeling,* which is the change from light to
dark over a form, is employed at the edges of the triangles suggesting folded

3.2. DOROTHEA ROCKBURNE. *Stele.*
1980. Conté crayon, pencil, oil, and gesso
on linen. 7'7¼" × 4'3¼" (2.32 × 1.30 m).
Emmerich Gallery.

paper, but these volumes are contradicted by the insistence of the rigid black
outline that dominates the right side of the composition. Actually, this black
line is a continuation of the rectangle, which forms the center folds of the
origami-like shapes that complete the drawing. Origami is a Japanese tech-
nique of folding paper, an appropriate allusion for Rockburne's work with its
impeccable and refined sensibility. Her drawing has a presence that is self-
contained and meditative.

The second category of shape (as opposed to geometric forms) is *or-
ganic shape*, less regular than geometric shape and sometimes referred to as *bio-
morphic, amoeboid,* or *free form.* An example of organic shape can be seen in a
drawing by the sculptor Lee Bontecou (Figure 3.3). In her three-dimensional
work, Bontecou is known for her assemblages made of found materials such
as iron, welded steel, canvas, war surplus materials, zippers, rivets, even small
machines. Her sculptural reliefs contain references to images of violence and
destruction along with organic overtones, allusions to the processes of growth
and transformation. Image, scale, and structure combine to give her work its
essential, powerful character. The tension in her sculpture is achieved in her
drawings as well. *Amerika,* a pencil-and-charcoal drawing, is based on a series
of repeated ovoid forms that weave across and through an eerie space. Larger

3.3. LEE BONTECOU. *Amerika.* 1966. Pencil and charcoal, 19³/₄ × 27¹/₈″ (50 × 69 cm). Albert J. Pilavin Collection, Museum of Art, Rhode Island School of Design.

shapes loom behind the small fender-like horizontal forms in the foreground. Small, repeating, long ovals resemble openings that undergo a change in the background where they transform to what looks like a row of teeth. It is as if we are looking into the mouth of some space insect. Cavities, voids, sockets are suggested through the adept use of concave and convex shapes. The atmospheric space encasing the images seems to pulsate, lending an aerodynamic effect to the amorphous shapes with their valve-like forms suggesting the workings of an animated machine.

Usually we find a combination of geometric and organic shapes in an artist's work. In *Interior with Profiles* (Figure 3.4), Romare Bearden combines geometric and amoeboid shapes in a well-integrated composition. The figures in Bearden's collage are built of organic shapes, while the background is predominantly geometric—squares and rectangles. Texture is an important element in Bearden's work. Shapes are created both by textural patterns and by flat and modeled values in the hands (and in the still-life objects in the background). The collage is organized along horizontal and vertical axes, which both flatten and stabilize the composition. The figures remind us of an Egyptian frieze. There is a timeless quality in Bearden's work that comes from his faultless sense of balance and rhythm. Unity is achieved by repetition of shape and value. Spatially, the work is very complex; it is difficult to locate exactly each figure in relationship to the other. This ambiguity of placement is further reinforced by the illogical scale between the parts.

As you have seen, shapes can be made by value, line, texture, or color. They may even be *suggested* or *implied*. In the drawing *Egyptian Ballet—Horns and Hands* (Figure 3.5), Leonard Baskin suggests or implies by minimal use of line the shape of the man-goat figure. The negative white space is conceptually filled by the mythic creature's body. Although the shape of the figure is not explicitly shown, we imagine it to be there. Baskin develops three focal points named in the title, horns and hands. Somewhere between head and hand the

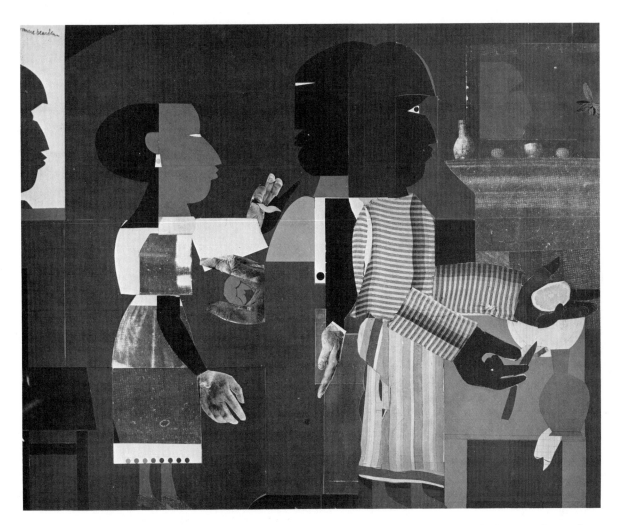

goat has undergone a transformation, and this transformation is left for the viewer to construct. The richly rendered centers of interest are in bold contrast to the white void that spans the space between them. Placement of the developed areas is crucial: The head is centralized; below the head a dark value shape leads our eyes to the hands, which are asymmetrically placed. The hand in the center points to the one on the right; a black shape under the thumb directs the movement back into the picture plane, away from the edge.

Perception is such that we fill in an omitted segment of a shape and perceive that shape as completed, or closed (Figure 3.6). In doing so, we tend to perceive the simplest structure that will complete the shape rather than a more complex one (Figure 3.7). We also group smaller shapes into their larger organizations and see the parts as they make up the whole (Figure 3.8).

The heavy, open circular form made by a dragged-out brush in the work on cardboard by Robert Motherwell conveys the artist's interest in stylistic gesture (Figure 3.9). Paint and accompanying splatters have been applied by quick turns of the brush. The eye is compelled to complete the circle in spite of an emphatic blunted end to the circular flourish of the brush mark. This abrupt ending to the flow of the shape provides tension in the drawing. The

3.4. ROMARE BEARDEN. *Interior with Profiles.* 1969. Collage, 3′3³/₄″ × 4′1⁷/₈″ (1.01 × 1.27 m). First National Bank of Chicago.

3.5. LEONARD BASKIN. *Egyptian Ballet—Horns and Hands.* 1971. Ink and wash, 40 × 27½" (101 × 70 cm). Courtesy of the artist.

constricted opening leads the eye into an interesting enclosed, calm white shape. Motherwell is well known for his mastery of black and white forms and for the intensity they convey. Many contemporary artists purposefully contradict accepted rules of composition and of perception; like Motherwell they challenge the viewer visually to complete the circle.

Shapes of similar size, color, value, texture, or form attract each other; it is by this means the artist organizes the picture plane and directs the viewer through the composition. Like attracts like. Normally, small shapes tend to recede and large shapes to advance; however, in the Bontecou drawing (see Figure 3.3), because of the overlap, the large shapes seem to be predominantly background shapes. The uniformly shaped ovals can be interpreted as holes or openings into the surrounding shape, rather than as positive forms floating in the background.

POSITIVE AND NEGATIVE SPACE

On the *picture plane*—the surface on which you are drawing—there is another distinction between shapes, that between positive and negative. *Positive shape* refers to the shape of the object drawn. In Robert Longo's drawing (Figure 3.10), the dark, isolated, positive shape of the jacket is the subject of the work. This somewhat menacing form is at first glance difficult to identify; it overpowers the figure below. There is nothing in the empty background (negative space) to give further information. The man is unidentifiable; his coat seems unforgettable.

Negative space describes the space surrounding the positive forms. Negative space is relative to positive shapes. In Paul Wieghardt's work (Figure 3.11) two women are seated in front of a wall. The floor forms a ground for the white figure of the chairs; the chairs, wall, and floor form a ground for the figures of the two women. Thus, the floor and wall are negative to the chairs, and the chairs in turn are negative to the two women.

3.6. Incomplete shapes are perceived as completed or closed.

3.7. The four dots are perceived as forming a square rather than a more complex shape.

3.8. Smaller shapes are perceived as part of their larger organization.

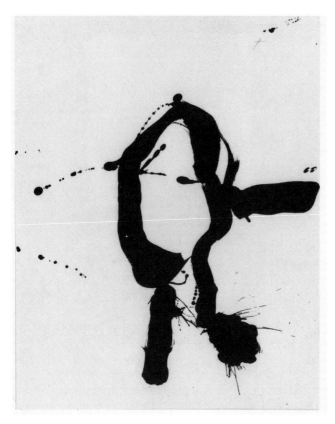

3.9. ROBERT MOTHERWELL. *Untitled (Black Gesture)*. 1982. Acrylic on rag board, 29 × 23″ (74 × 58 cm). Collection of the Modern Art Museum of Fort Worth, Museum Purchase; gift of the artist. © 1997 Dedalus Foundation, Inc./ Licensed by VAGA, New York, NY.

In real life we are conditioned to search out positive shapes, but this habit must be altered in making art. On the picture plane all shapes, both positive and negative, are equally important. Combined, they give a composition unity. Paul Wieghardt's integration of positive and negative shapes is so complete that it is nearly impossible to classify each shape as either positive or negative. The progression of space in the Wieghardt painting does not follow a completely logical recession seen in real life; for example, the chairs and floor in the right foreground meld to form a light shape that wraps around the women and functions as both foreground and background to the pair. Shapes that we logically know are more distant (note the placement of the woman on the right) are, in fact, perceptually on the same plane. Notice the relationship between the laps and legs of the two women. Wieghardt uses shapes of similar size, value, and form to attract each other and by this means creates a tight, interlocking composition.

In Dmitri Wright's stencil print (Figure 3.12), we see a changing emphasis from the positive images to the negative space surrounding them. The print has the look of a photographic negative. Reverse values and spatial dislocation of the objects contribute to a feeling of emptiness. Wright has used a blueprint as the base for the stencils. The geometric shapes and words behind the figures and implements create a second level of space, which further enhances and complicates interpretation of the print.

In the Donald Sultan work (Figure 3.13), positive and negative shapes switch with each other. Viewing the image one way, we can see the black shape as positive; viewing it another way, we see the black shape as back-

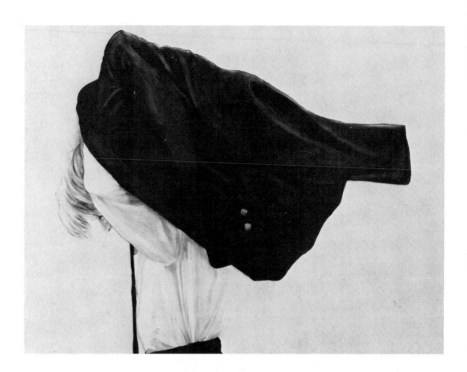

3.10. ROBERT LONGO. *Untitled.* 1978. Charcoal on paper, 30 × 40″ (.76 × 1.02 m). Collection Robert Halff. Metro Pictures.

ground to the white forms. This positive/negative interchange is signatory of Sultan's style. The rich, matte-black medium has a strong physical presence, and the powdery residue enlivens the white spaces. Sultan purposefully chooses images that can be interpreted as either abstract or concrete, such as the tulip with its head turned inward to the leaves, creating a composite shape with the vase that is more than the sum of its parts.

The terms *positive/negative* and *figure/ground* are interchangeable. Other terms are *foreground/background*, *figure/field*, and *solid/void*. Negative space is also called *empty space* or *interspace*.

PROBLEM 3.1
Composite Shape Problem

Draw a silhouette of two combined objects so that they create a composite shape. Have the objects overlap in one or more areas so that enclosed positive and negative shapes occur. We have an example of this merging of forms in the Sultan drawing of the tulips; the flower shape combines with the leaf and vase shapes to create a unified, single, composite shape (see Figure 3.13).

A more complex handling of composite shape can be found in Mary Dryburgh's *Large Crow* (Figure 3.14). The bird is clearly defined; however, the remaining shapes are not immediately recognizable as objects from the real world. Is the bird perched on a branch? On a window? Or are the shapes invented analogous forms that relate compositionally to the crow? One can detect references to the crow's beak, head, wing, and tail in the surrounding positive and negative shapes. The negative white spaces are activated by smudges and powdery deposits from the charcoal. The crow is backlit, but otherwise the various positive and negative shapes occupy different levels of

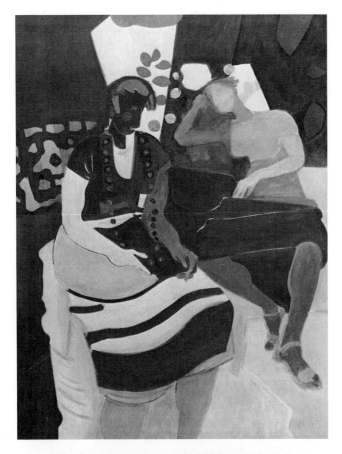

3.11. PAUL WIEGHARDT. *The Green Beads*. 1951. Oil on canvas, 39³/₈ × 20″ (101 × 77 cm). Location unknown.

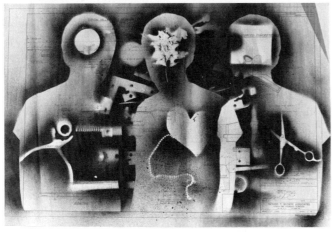

3.12. DMITRI WRIGHT. *Untitled*. 1970. Stencil print, 24 × 36¹/₈″ (61 × 92 cm). The Brooklyn Museum, gift of the artist.

space. (One need only note the spatial ambiguity of the shapes in the lower half of the drawing.) The treatment of the bird and its accompanying shapes carry mythic overtones; it is not only the bold dark forms that assert themselves, the treatment of the medium itself carries a message.

Now that we have puzzled over what the background shapes might be, let us hear the answer directly from the artist herself: "A papier-mâché decoy sitting in my studio window amid assorted treasures. I like to start my drawings with an observed reality and explore other possibilities from that point."

3.13. DONALD SULTAN. *Tulips and Vase June 2, 1986.* Oil, plaster, and tar on tile over Masonite, 8′1¼″ × 8′1⅝″ (2.47 × 2.48 m). Collection Mr. and Mrs. Roger I. Davidson, Toronto.

PROBLEM 3.2
Interchangeable Positive and Negative Shapes

Make an arrangement of several objects or use figures in an environment. In this drawing, emphasize the negative spaces between the objects or figures by making them equal in importance to the positive shapes.

In a second drawing place emphasis on negative space. This time try to make the positive and negative shapes switch off with one another; that is, see if you can make the positive forms seem empty and the negative shapes positive. In other words, try to make the positive shapes recede and the negative shapes advance.

Robert Birmelin, in his wittily titled drawing, *The City Crowd, The Ear* (Figure 3.15), places great emphasis on negative space. The centralized figure is a faceless, empty white shape. Dark values, lines, and textures define the interstices and spaces between the figures. The foreground figure is massive and is swiftly moving out of the picture plane to the right. The implied movement is from upper left to lower right. Negative shapes play the major role in defining not only space, but the positive figures as well. The empty white figures are set in relief against their adjoining dark shapes. The line direction that symbolizes hair, the repeated lines that indicate the thighs of the walkers, and the marks that delineate the large, encircling, indefinable shape

3.14. MARY DRYBURGH. *Large Crow.* 1993. Charcoal on paper, 24 × 19″ (61 × 48 cm). Collection of the artist.

on the left side of the picture plane—all lead the viewer into the center of the drawing and into the bustle of the crowd.

PROBLEM 3.3
Geometric Positive and Negative Shapes

Make a quick, continuous line drawing of a still life. You may wish to refer to the description of this technique in Chapter 2. Redraw on top of the drawing. Regardless of the actual shapes in the still life, reduce both positive and negative shapes to rectangles and squares. Repeat the problem, this time using ovals and circles. You will, of course, have to force the geometric shapes to fit the actual still life forms.

Look carefully at the subject. Which shapes are actually there? Which shapes are implied? Which types of shapes predominate? In asking these questions you are giving yourself some options for the direction the drawing is to take. You may note that circular forms predominate, and you may or may not choose to emphasize a circular motif in the drawing. In making this quick analysis, you are bringing to consciousness information that will be helpful as you extend the drawing.

Repeat the initial procedure, using landscape as a subject. Draw only organic forms in both positive and negative shapes. One way to ensure that

3.15. ROBERT BIRMELIN. *The City Crowd, The Ear.* 1978. Conté crayon on paper, 22 × 29³/₄″ (56 × 76 cm). The Arkansas Arts Center Foundation Purchase, 1984.

negative spaces form enclosed shapes is to make the composition go off the page on all four sides.

PROBLEM 3.4
Invented Negative Shapes

Choose any subject—landscape, still life, or figure. In your drawing invent some negative shapes that relate to the positive shapes of your subject.

Ada Liu Sadler structures her drawing of a lawn chair around the ready-made patterns found in the chair's webbing (Figure 3.16). Formally, the geometric shapes move around the picture plane to create a spatially intriguing design with a simple subject matter, a truncated view of a lawn chair. Cast shadows dominate the composition; they form an undulating grid that anchors the chair in its special place, in its unique light. A series of implied triangles formed by the chair's tubular construction offers a secondary shape theme. The sameness in the direction of the pastel strokes flattens the remaining background negative shapes. Form and variation are the keys to this integrated, decorative work. It is the shapes that take the lead in structuring the composition both visually and spatially.

PROBLEM 3.5
Collaged Negative Spaces

Begin by using torn paper to represent the negative spaces in a still life. Then impose a simple line drawing of the still life, allowing line to cross over the torn paper shapes. This procedure will help integrate the positive and negative areas. Use enclosed shapes in both positive and negative spaces.

3.16. ADA LIU SADLER. *Taliesin West #2.*
1992. Pastel, 18 × 18″ (46 × 46 cm).
Joseph Chowning Gallery, San Francisco.

Imagine the Sadler drawing to be a collage with each shape cut out and reassembled and with the lines that form the chair and shadows imposed onto the cutout paper base.

A cropped view of a group of chairs or a chair and table would make a good subject for this problem.

PROBLEM 3.6
Enclosed Invented Positive and Negative Shapes

For this drawing you are to invent a subject. It may be taken from your memory of a real object or event, or it may be an invented form or abstraction, but it should be a mental construct. Look back at the discussion of conceptualized drawings in Chapter 1 to refamiliarize yourself with their nature.

Once you have thought of a subject, draw it by using enclosed shapes in both positive and negative space. Define the shapes by outline, by texture, or by flat value. Fill the entire page with enclosed shapes. There should be no leftover space.

The Christine Federighi drawing could have been made in response to this problem (Figure 3.17). A rather simple and static composition using a limited number of shapes is greatly enhanced by the addition of the dot-and-line texture which weaves a pattern of subtle secondary shapes. The lines are reversed from black to white in the enclosing frame, which creates a

3.17. CHRISTINE FEDERIGHI. *Two House Rider.* 1985. Pastel and graphite on paper, 30 × 44″ (76 × 112 cm). The Arkansas Arts Center Foundation Collection: The Stephens Inc. City Trust Grant, 1986.

3.18. IRVING TEPPER. *Third Cup of Coffee.* 1983. Charcoal on paper, 43³/₄ × 51¹/₂″ (111.1 × 130.8 cm). Arkansas Arts Center Foundation; purchase, 1984.

stagelike effect. A centralized rhomboid spatially penetrates the large U-shape under which the elongated figure floats. Only the encased figure escapes the darting movement of the broken-line patterning. Federighi has combined line, texture, and flat value patterns to create a simple group of shapes whose relationships result in a spatially innovative work.

THE SHAPE OF THE PICTURE PLANE

The shape of the picture plane has an effect on the type of composition chosen. Irving Tepper centralizes his image in a squarish format (Figure 3.18); the placement of the cup is slightly off center—the target area of the coffee seems perfectly located. A centralized image can present the artist with a

3.19. NEIL JENNEY. *Window* #6. 1971–1976. Oil on panel, 1'3³/₄" × 4'9¹/₂" (1.01 × 1.46 m). Thomas Ammann, Switzerland.

problem of how to handle the four corners, but Tepper has resolved the drawing by using a variety of circular shapes and interesting groupings of abstract lines that reverberate outward from the saucer. The viewer looks directly down into the cup, and this unusual point of view has the effect of transforming it into an abstract interplay of spherical forms. It is interesting to note that Tepper is a sculptor who works in clay.

Neil Jenney's image in Figure 3.19 conforms to its eccentrically shaped frame. The tree branches are particularly suited to the chopped-off format; the angle of the limbs points to the lopsided structure, while the enclosed negative shapes—the intervals between limbs and edges of the frame—establish a secondary theme. We are reminded of the so-called "window into space," the spatially illusionistic goal for painting by Renaissance artists. Jenney has certainly updated the window; it is an unmistakable twentieth-century version.

SHAPE AS PLANE AND VOLUME

It has been difficult to speak of shape without occasionally referring to volume. *Volume* is the three-dimensional equivalent of two-dimensional shape. Shapes become volumetric when they are read as *planes*. In the graphic arts and in painting, volume is the illusion of three-dimensional space. Volume defines *mass*, which deals with the weight or density of an object.

The way shape becomes volume can be seen in an illustration of a cube. If you take a cube apart so that its six sides, or planes, lie flat, you have changed the cube from a three-dimensional form into a two-dimensional shape (Figure 3.20). This new cross-shape is made up of the six planes of the original box and is now a flat shape. If you reassemble the cube, the reconnected planes (the sides, top, and bottom) once again make volume. If you make a representation of the box seen from below eye level with one of its

3.20. Cross-shaped form made from an opened box.

3.21. Diagram of a cube.

3.22. Cube diagram with interior lines erased.

corners turned toward you, it will be composed of only three visible planes. Even if you draw only these three planes, the illusion of three-dimensionality remains (Figure 3.21). If you erase the interior lines, leaving the outer outline only, you have again changed volume into a flat shape (Figure 3.22).

The key word here is *plane*. By connecting the sides, or planes, of the cube, you make a *planar analysis* of the box. You make shape function as plane, as a component of volume.

Joel Shapiro's diptych, or two-part drawing (Figure 3.23), is a concrete example of how a shape can be perceived spatially in two very different ways. Shapiro is a minimalist sculptor whose work is concerned primarily with these perceptual differences. Polarities lie at the core of his work: presence/absence, discrete/nebulous, color/noncolor (the dark, flat shape on the right is in actuality a saturated red), dimension/flatness, certainty/uncertainty, ambiguity/decisiveness. The two corresponding large shapes are fixed in their posi-

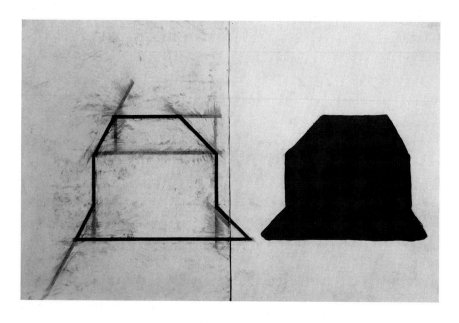

3.23. JOEL SHAPIRO. *Untitled,* *1979.* Double: Charcoal and gouache on paper, 23¹/₁₆ × 36¹/₂″ (58 × 93 cm). Paula Cooper Gallery.

3.24. CLARENCE CARTER. *Siena*. 1981. Acrylic on canvas, 6′6″ × 5′ (1.98 × 1.52 m). Courtesy Gimpel/Weitzenhoffer Gallery, New York.

tions, yet there can be a multiplicity of interpretations in reading them. Shapiro plays with the flatness of the picture plane and the flatness of the two-dimensional shape as opposed to the illusion of the form on the left that has been broken up into a group of planar shapes. Analyze this shape for the number of ways it could refer to an object in space. The four lines that extend outside the object's enclosed planes confound our perception of the figure as a box; the perspective in support of this interpretation is not accurate. Not only does the artist engage the viewer in perceptual games with these very reduced means, he also allows the viewer to be involved in the process; the handmade quality of his drawings with their smears and smudges is a major part of their appeal.

Using a more traditional presentation of shape as plane, Clarence Carter creates an illusion of volume by connecting the adjoining shapes (Figure 3.24). A monumental effect is achieved by seemingly simple means; the smaller,

connected shapes of the stairs lead to the middle ground occupied by the two smaller buildings set at an angle. Smaller, fainter steps climb to the larger, more frontally placed building in the background. Carter achieves an architectural unity by interlocking planes, by the progression of small to larger shapes, and by the distribution of lights and darks.

In the human figure, planes are, of course, much more complex and subtle than those of a geometric volume, but Henry Moore has used interlocking planes to create the effect of rounded volumes in his *Family Group* (Figure 3.25). The figures have been abstracted and penetrated by large, enclosed negative shapes. Moore has imposed on them an illusionistically three-dimensional grid. The sculptor makes extensive use of organic and hollowed-out forms in his three-dimensional work. Larger, heavier, more dimensional forms are indicated by dark line, while secondary, less important planes are drawn with a fainter line.

We have one more way to transform shape into volume: modeling. *Modeling* is the change from light to dark across a surface to make a shape look volumetric. By means of modeling Edward Ruscha converts what is normally conceived of as a flat image into a floating, dimensional shape (Figure 3.26). The word *Chop* appears to be a ribbon unwinding in space. Ruscha's intent of divorcing the word from its semantic function is further enhanced by such an unexpected presentation.

You can clearly see the modeling technique in Fernand Léger's pencil drawing (Figure 3.27). Figure 3.28 reduces the Léger composition to shape. By comparing the two you can see how modeling transforms shapes into volume. The shading from light to dark is more pronounced on the women's forms. A spatial contradiction is the result of the combination of flat, cutout shapes with illusionistically rounded forms. Léger has also used contradictory eye levels; for example, we see the women from one vantage point, the rug

3.26. EDWARD RUSCHA. *Chop*. 1967. Pencil on paper, $13^{1}/_{4} \times 21^{7}/_{8}''$ (34×56 cm). Collection of the Modern Art Museum of Fort Worth, gift of the Junior League of Fort Worth.

and floor from another—as if we were floating above the scene—and the tabletops from yet another. The composition is structured by means of repetition, repetition of volumes and shapes.

Another means the artist uses to create a sense of volume is overlapping shapes. In Diego Rivera's *Study of a Sleeping Woman* (Figure 3.29), the figure of the woman is constructed by a progression of forms, one overlapping the other from feet to the dark shape of the hair. The viewer's eye level is low; we look up to the figure. The full, organic shapes are given volume by limited use of modeling concentrated at those points of maximum weight. The compact, compressed form is well suited to the proportions of the paper. The simple volumes are the primary means by which a feeling of monumentality and timelessness is achieved.

3.27. FERNAND LÉGER. *Three Women*. 1920. Pencil, $14^{1}/_{2} \times 20''$ (37×51 cm). Rijksmuseum Kroller-Muller, Otterlo, Netherlands.

3.28. Shape analysis of Fernard Léger's *Three Women*.

3.29. DIEGO RIVERA. *Study of a Sleeping Woman.* 1921. Black crayon on off-white laid paper, 24½ × 18½″ (62.7 × 46.9 cm). Courtesy of the Fogg Art Museum, Harvard University Art Museums. Bequest of Meta and Paul J. Sachs.

The following problems will help you think about shape and volume in new ways. Remember to change the size and shape of your format to help further your compositional abilities.

PROBLEM 3.7
Shape as Plane and Volume

Using paper bags, a stack of boxes, or bricks as your subject, draw the edges of planes rather than the outside outline of the objects. Concentrate on the volumetric aspect of the objects, that is, on how shapes connect to create volume. In one drawing use line to define planes. You may wish to develop a focal point using shading in one small area of the drawing as in the example by Gérard Titus-Carmel (Figure 3.30). In a suite of drawings whose subject is variations on the idea of deterioration, the artist has imagined the corner of a box to be folded open—the arrows are the reason we use the verb "imagined." Modeling, light, and cast shadow create an illusionistic space in what is otherwise a simple diagrammatic reference to a box. The focal point is realistically developed, although the fixed, black, unmodulated, flat triangle presents a barrier to our seeing what is inside the box.

3.30. GÉRARD TITUS-CARMEL. *Drawing #7* from 20 *Variations sur l'idée de détérioration.* 1971. Pencil on paper, 19½ × 27⅝" (52 × 74.5 cm). Private collection, Paris.

Make a second drawing that is primarily tonal and more volumetric, where planar change is indicated by the use of white, black, and gray shapes as in the Carter work (see Figure 3.24).

PROBLEM 3.8
Planar Analysis

With your own face as subject, make a planar analysis in a series of drawings. Begin by drawing the larger planes or groups of planes; then draw the smaller units. Work from the general to the specific.

After you have become familiar with the planar structure of your face, construct a three-dimensional mask from cardboard or bristol board. The sculptured mask should be life size, made to fit your face. Keep a sketch pad handy to redraw and correct the planar relationships. This interplay between stating the form two-dimensionally and making a three-dimensional model will strengthen your understanding of the process involved in creating the illusion of volume.

Cut out the planes and use masking tape to attach them to one another. Making a three-dimensional analysis is an involved process. Look for the most complex network of planes. Note how the larger shapes can be broken down into smaller, more detailed groups of planes.

When you have completed this problem, you will have gained a real insight into how larger planes contain the smaller planes and how large planes join one another to create volume.

Paint the mask with white paint. You have now deemphasized the edges of the planes to create a more subtle relationship between them. Place the mask under different lighting conditions in order to note how different light emphasizes different planes.

PROBLEM 3.9
Rubbed Planar Drawing

Read through *all* the instructions for this problem carefully before beginning to draw. Spend at least an hour on this drawing.

Use a 6B pencil that is kept sharp at all times. To sharpen the pencil properly, hold the point down in contact with a hard, flat surface. Sharpen with a single-edge razor blade, using a downward motion. Revolve the pencil, sharpening evenly on all sides. Use a sandpaper pad to refine the point between sharpenings. Draw on white charcoal paper.

Use a model and warm up with several line-gesture drawings to acquaint yourself with the pose. Use a light line to establish proportions and organizational lines. Again, as in the head study, analyze the figure according to its planar structure. Begin drawing the largest planes. What are the figure's major masses? Upper torso, lower torso, upper legs, lower legs, head? Work from the general to the specific. Determine where the figure turns at a 90-degree angle from you and enclose that plane. Look for the major volumes of the body and draw the planes that make up these volumes. After you have drawn for three or four minutes, rub the drawing with a clean piece of newsprint. Replenish the newsprint squares often. Rub inward toward the figure. Two warnings: Do not rub the drawing with your fingers, because the oil from your hands will transfer to the paper and make splotchy marks. Do not rub the drawing with a chamois skin because it removes too much of the drawing. Redraw, not simply tracing the same planes, but correcting the groupings. Alternate between drawing and rubbing. Continue to group planes according to their larger organization.

This technique is different from the continuous movement of the gesture and overlapping line drawings. Here you are attempting to place each plane in its proper relation to every other plane. Try to imagine that the pencil is in contact with the model. Keep your eyes and pencil moving together. Do not let your eyes wander ahead of the marks.

When viewed closely, this drawing might resemble a jigsaw puzzle, each plane sharing common edges. When you stand back from the drawing, however, the planes begin to create volume, and the result will be a more illusionistically volumetric drawing than you have done before. The rubbing and redrawing give the planes a volume and depth.

This exercise is actually an exercise in seeing. Following the instructions will help you increase your ability to concentrate and to detect planes and groups of planes that are structurally related.

One of the most significant concepts to take shape in twentieth-century sculpture was that of construction. Prior to this century the three-dimensional mass of carved or sculpted forms was dominant. The Cubists with their involvement in the breakup of space pioneered the faceted surface both in sculpture and in the two-dimensional arts. (See Figures 1.11, II.9, and 10.17.) Picasso revolutionized sculpture with his constructions of paper, string, metal, wire, and wood. These constructed objects shifted the emphasis from sculpted or carved masses to a constructed and sculptural space and laid the groundwork for the use of collage in sculpture as well as in painting.

The Russian Constructivists (who adopted their name in 1921), with their revolutionary goals (both for society and for art), employed the new Cubist forms and principles in their work. The idea of structural laws dictating form and activating space became a central tenet of their movement.

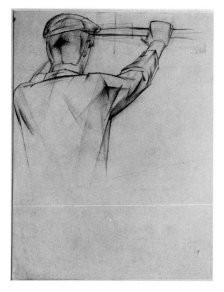
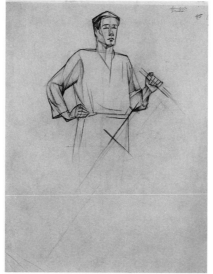
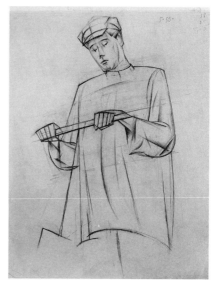

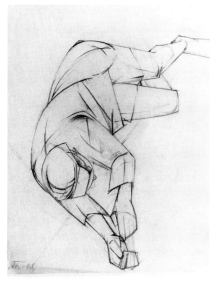
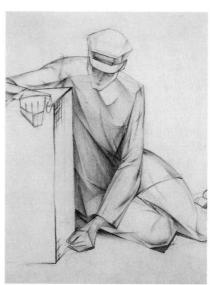
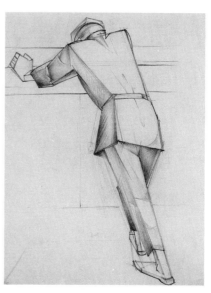

3.31. ALEXANDER BOGOMAZOV. *Figure Studies I–VI.* Pencil on paper. I: 1928, 13 × 10″ (33 × 25 cm). II: ca. 1926–28, 13½ × 11¼″ (34 × 28 cm). III: ca. 1926–28, 14¾ × 11½″ (37 × 29 cm). IV: ca. 1926–28, 13½ × 11½″ (34 × 29 cm). V: 1926, 16⅜ × 12⅜″ (42 × 31 cm). VI: 1926, 16⅜ × 12⅜″ (42 × 31 cm). The Arkansas Arts Center Foundation Collection.

Analyze the group of figure studies by the Russian artist Alexander Bogomazov (Figure 3.31) before beginning this problem. He has employed a technique similar to the one described above. The third and fourth drawings indicate the beginning stages, while the last two drawings of the seated and leaning man show how the planes are converted to volumes through modeling.

PROBLEM 3.10
Basic Volume

The preceding problems provided you with some experience in drawing a volumetric form. For this problem use a different subject for each drawing—landscape, still life, figure in an environment. Think in terms of basic volumes. Render the subject in a quick, light, overlapping line; then

impose volumes regardless of the actual forms in the still life. You will have to force volumes to fit the subject; for example, you might choose either a cylinder or a cube to represent the upper torso of a figure. Remember to register which volumes are actually there and which ones are implied. Look for repeating volumes to help unify your composition as in the Bogomazov studies. As in the planar analyses, you should go from the large to the small, from the general to the specific. Remember the two bridges between shape and volume: shapes stated as planes appear volumetric, and modeling over a shape creates volume.

PROBLEM 3.11
Modeling and Overlapping

Arrange several objects in deep space. Then draw these objects, exaggerating the space between them. Arrange large and small shapes on your paper, overlap shapes, and use different base lines for each object. In your drawing try to distinguish between foreground, middle ground, and background.

Think in terms of the different levels of negative space—horizontal space between the objects, vertical space above them, and diagonal space between them as they recede into the background. Imagine that between the first object and the last are rows of panes of glass. Due to the cloudy effect of the glass, the last object is more indistinct than the first. Its edges are blurred, its color and value less intense, its texture less defined. A haze creates a different kind of atmosphere between the first and last object. The illusion of depth through atmospheric effects such as those just described is called *aerial perspective.*

An extension of the preceding problem is to model negative space. Use a still life or figure in an environment and concentrate on the different layers of space that exist between you and the back of the still life or figure. Make the shapes change from light to dark; model both positive and negative space; different lights and darks will indicate varying levels. This modeling of negative space is a plastic rendering of the subject, an illusionistically three-dimensional description of objects in the space they occupy. Your drawing should show a feeling for the different levels of space. Note in Ronald Milhoan's pastel drawing (Figure 3.32) that values are not confined to a single object; they cross over both positive and negative forms. A rich surface texture has been achieved by varying the direction of the chalk and by erasure and rubbing. In your drawing use the eraser as a drawing tool; try to imagine that the eraser can actually model space; use it to "reach inside" the picture plane to the various levels of space.

SUMMARY
DIFFERENT KINDS OF SPACE

A shape is two-dimensional if it has an unchanged or unmodulated value, color, or texture over its entire surface. Uniformity in color, value, or texture will make an otherwise volumetric form appear flatter. A form outlined by an unvarying line creates a two-dimensional effect.

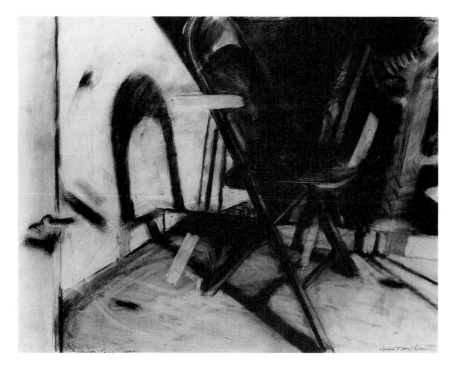

3.32. RONALD MILHOAN. *Windowcase.* 1975. Pastel, 24 × 30″ (61 × 76.2 cm). Collection of Pensacola Junior College, Pensacola, Florida.

Shapes functioning as planes, as the sides of a volume, give an illusion of three-dimensionality. Shapes can be given dimension by tilting them, truncating them, making them move diagonally into the picture plane.

When both flat, two-dimensional shapes and three-dimensional volumes are used in the same drawing, the result is ambiguous space. If a shape cannot be clearly located in relation to other shapes in the drawing, ambiguous space again results.

If a line delineating a shape varies in darkness or thickness, or if the line breaks, that is, if it is an implied line, the shape becomes less flat. Imprecise edges, blurred texture, and the use of modeling tend to make a shape appear volumetric. Modeling, the change from light to dark across a shape, transforms it into volume, creating the illusion of three-dimensionality.

SKETCHBOOK PROJECTS

PROJECT 1
Shaping the Composition to the Format

In your sketchbook draw five or more different formats to be used as picture planes—a long horizontal, a square, a narrow vertical, a circle, and an oval. Quickly make a composition in each unit, using the same subject in each of the formats. Change the composition according to the demands of the framing shape. You will have to adjust your composition from format to format, juggling the relationships between size, shape, and value. Each different outside shape demands a different arrangement of the internal forms. You may use recognizable subject matter or nonobjective images, or you may

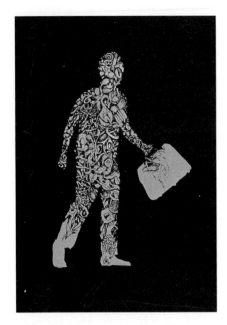

3.33. JONATHAN BOROFSKY. *Tattoo Man (Black)*. 1987. Silkscreen, 29 × 41″ (74.5 × 105 cm). Watari-Um Museum of Contemporary Art, Tokyo.

choose a subject from art history and alter its composition to fit each specific picture plane. Do not change subject matter from one drawing to the next. It is the arrangement of the formal elements inside the picture plane that must undergo change.

PROJECT 2
Experimenting with the Relationship between Positive and Negative Space

Fill several pages of your sketchbook with outlined silhouettes of objects that are interesting to you—figures of animals or people; natural forms, such as trees, plants, flowers; or machines or tools. The outlines should be immediately recognizable as subjects taken from the real world. After you have drawn twenty or so outlined images, choose a particular one to work with. Refine the edges, being as accurate as you can in the delineation of the silhouette. Enlarge the image to fit comfortably on a page of your sketchbook; in other words, pay careful attention to the relationship between positive and negative space. Cut out four or five copies of your chosen outlined image and paste them in your sketchbook, one to a page. Or you may make a stencil of the shape and trace from it onto each page.

After you have transferred the form to the sketchbook, make drawings in the interior of the form as in the Jonathan Borofsky drawing titled *Tattoo Man (Black)* (Figure 3.33). Each figure should be filled with different subject matter, again your choice. Some suggestions are: organic natural forms, machine parts, abstract patterning, writing or a found text. In each variation try for a different spatial effect. You may reverse the placement of the repeating filled-in images and leave the figure empty while filling in the background space; or you may ink in the background shape to establish a positive-negative spatial inversion as Borofsky did in his iconic man.

The tension in Borofsky's work is the result of the contrast in the two types of images. The walking man with the briefcase has become an archetypal figure for Borofsky. The conjunction of the natural forms with the urban man gives the viewer occasion to speculate what the relationship between the two could be.

The faintly, loosely scribbled numbers on the left side of the page are Borofsky's counting meditation, symbolic of control, order, and structure, which he has been writing since 1968. The numbers are mantras which focus his attention.

V A L U E

FUNCTIONS OF VALUE

Value has the most emotive and expressive potentiality of all the elements. Simply defined, *value* is the gradation from light to dark across a form; it is determined both by the lightness and darkness of the object and by its natural color—its *local color*—and by the degree of light that strikes it. This chapter is concerned not with color or hue, but with value, the range from white to black as seen in the scale in Figure 4.1. An object can be red or blue and still have the same value. What is important in determining value is the lightness or darkness of the color. This approach is an achromatic one.

It is difficult to learn to separate color from value, but it is an essential task in art. We have two good examples of this separation in everyday life—in black-and-white photography and in black-and-white television.

If you squint while looking at an object or at color television, the colors diminish, and you begin to see patterns of light and dark instead of color patterns. When the value is the same on both the object and its background, you easily lose the exact edge of the object; both object and negative space are united by the same value. Although value can be confined to a shape, it

4.1. Value scale, from 100 percent white to 100 percent black.

can also cross over a shape and empty space; it can begin and end independently of a shape.

These two different applications of value can be seen readily in Figures 4.2 and 4.3. Rick Bartow, a Native American Yurok, and Juan Alonso, a Cuban American, both of dual heritages, retain cultural, ethnic traditions in their art, using subjects valued for their spiritual and emotive significance. Bartow's wounded animal stands for the artist himself who uses Yurok myths and motifs for self-examination. An intensity of feeling is achieved by the vigorously scumbled, gestural application of values crossing over both positive and negative shapes. Even the static outline of legs and haunch does not inhibit the implied fleeting movement of the deer. This action is a result of Bartow's application of value. Contrast his technique with that of Alonso's treatment of the iconic human/deer/flower. Heavy outlining limits movement and confines the lightly modulated value within the shapes. The centralized image, although faceless, seems to be listening quietly to some spirit communication emitted from the encircling flower-phones. Both artists achieve expressive goals through value patterns befitting their mythic subjects.

In addition to its emotive or expressive appeal, value is a concern of many graphic artists whose subjects are themes of social injustice (Figure 4.4). What better means than the stark contrast between black and white to carry a message of protest! Carlos Cortez has had a long career working for the Chicano movement and its labor issues. The words of the title *La lucha continua (The Struggle Continues)* go off the picture plane, thus reinforcing the idea of continuation. The middle values of the photograph were dropped out, concentrating the light and dark. The subject was derived from a photograph of a Bolivian peasant demonstration. The line of workers and skulls is depicted in sharp relief, providing a dramatic and instantaneous reading of the reduced, stripped-down forms, a desired characteristic for poster art. Cortez, like many social commentators, has been influenced by the great Mexican artist José

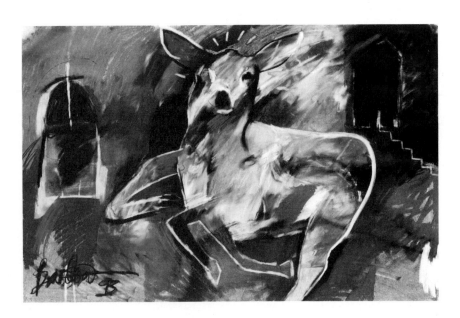

4.2. RICK BARTOW. *Deer Hunt II.* 1993. Pastel, charcoal, graphite on paper, 26 × 40″ (66 × 102 cm). Francine Seders Gallery Ltd., Seattle.

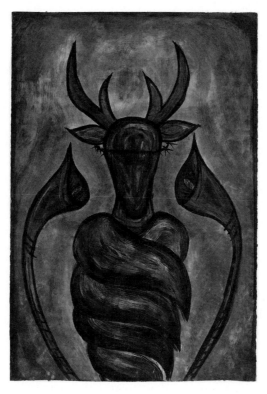

4.3. JUAN ALONSO. *Trophy*. 1994. Acrylic on paper, 44 × 30½" (112 × 77 cm). Francine Seders Gallery, Seattle.

Guadalupe Posada (1852–1913) whose animated skeletons course through Latin American art now, a hundred years after their initial appearance. Cortez frequently posts his graphic images directly on the street.

The technique of creating gradual value transitions without using line is called *sfumato*, a process used by the Renaissance artist Leonardo da Vinci. Jiri Georg Dokoupil bases his technique on the literal definition of *sfumato*, "in the manner of smoke," using candle soot as his sole medium in the work entitled *Bosnian Refugees Arriving in Germany* (Figure 4.5). Dokoupil, whose work

4.4. CARLOS CORTEZ. *La lucha continua (The Struggle Continues)*. 1986. Woodcut, printed in color, 17⅜ × 22⁹∕₁₆" (44.8 × 57.3 cm). Collection of the artist, Chicago.

4.5. JIRI GEORG DOKOUPIL. *Bosnian Refugees Arriving in Germany.* 1992. Candle soot on canvas, 50 × 40¼″ (127 × 102 cm). Tony Shafrazi Gallery.

deals with emigration, displays an amazing level of control using a demanding and unconventional medium. The value patterns built up from the residue of smoke from a burning candle create a highly realistic style that brings to mind old black-and-white newsreel documentary images. The work is compelling on a formal as well as a conceptual level.

Like Dokoupil's work the elaborate three-part composition *Big Girl Lie # 1* (Figure 4.6) attracts the viewer through its unorthodox materials. This massive piece (108 × 204 × 3″) is made with conté crayon on Formica and sandblasted steel. The centralized image traces its source to the long-honored tradition of seventeenth-century Dutch still life, or *pronkstilleven* as they were called—sumptuous or ostentatious still life. These luxurious arrangements were not simply to display the artist's skill, but to point up a moral theme. How different were the European patrons, famous for their prosperity and conspicuous consumption, from the art consumers of the twentieth century? Can we assume the Big Girl is Mother Nature herself? Then what is her first lie? Something about fecundity, decay, and mortality, no doubt. The abundance depicted in Karin Broker's monumental work is a result of virtuosic control over a wide value scale used to convey the stunning textures of the flowers, vase, leaves, nest, and eggs.

The central image and its accompanying close-up view of the bouquet on the right are visually and conceptually distanced from the panel on the left with its two lone, concentric target shapes. The left segment, defined by a simple overall value, contradicts the explosive richness of its companion panels. Their gaudiness, splendor, and lavishness seem to be canceled by the insistent blankness of the first segment. Is it the contradiction between the two styles and images that makes the center-stage drama a lie? Frequently,

4.6. KARIN BROKER. *Big Girl Lie #1*. 1992. Conté on Formica with sand-blasted steel, 9' × 17' × 3" (2.74 m × 5.18 m × 8 cm). Gerhard Wurzer Gallery, Houston.

the Dutch still lifes were called *vanitas*, still lifes which underscore not only the transitory nature of the prolific blooms but of life itself.

Broker's descriptive skill holds its own with the early Dutch artists. Her keen observation, accuracy, and expressiveness in depiction of the natural forms along with the intrigue of the message itself keep the viewer's attention firmly fixed.

As we have seen, artists can base their work on actual appearances, or they can create their own value patterns, their own kind of order, illustrated in the three drawings of rabbits in the accompanying figures (Figures 4.7, 4.8, and 4.9).

Wayne Thiebaud's sleeping rabbit (Figure 4.7) is centralized in an otherwise empty space. It is tied to the ground by a dark semicircular shadow at its tail; it is strangely isolated, its forms generalized. Value is gently modulated from white to gray. Repeating, undulating shapes ripple across the surface. The rabbit seems to be sitting in a pool of light; its cast shadow is the darkest, most clearly defined shape in the composition. The value patterns are theatrically exaggerated by this intense light. As if to point out how crucial value is to the composition, the shadow cast by the ear reads as a value scale. Whether Thiebaud actually set up artificial lighting or invented it in the drawing, his manipulation of lights and darks is an intense and personal one.

Beth van Hoesen has chosen a middle value range for her print (Figure 4.8). The gray background decreases sharp value contrasts. The transition from white to black is very subtle; the rabbit's curved forms grow faintly darker as they recede into space. Because of eye contact with the rabbit, we feel identification with the subject.

4.7. WAYNE THIEBAUD. *Rabbit* (from *Seven Still Lives and a Rabbit* 1971). Lithography in color, 22¼ × 30″ (57 × 76 cm). The Brooklyn Museum, National Endowment for the Arts and Bristol Meyers Fund.

A totally different approach, by style, technique, and subject matter, is taken by Lydia Martinez in her invented scene inside the rabbit hutch (Figure 4.9). Two dark, looming, cringing, and gesticulating rabbits with human hands dominate the foreground space. Their dark forms merge with one another so that it is difficult to tell where each separate body begins and ends. What we assume to be two more anthropomorphized rabbits appear in the

4.8. BETH VAN HOESEN. *Sally.* 1979. Etching and drypoint printed *à la poupée*, 11⁹⁄₁₆ × 13³⁄₄″ (29 × 35 cm). San Francisco Museum of Art, Ruth and Moses Lasky Fund Purchase.

4.9. LYDIA MARTINEZ. *Negotiations.* 1986.
Pastel on paper, 21 × 19″ (53 × 48 cm).

background, heads and upper torsos cut off by the top of the picture plane.
Some dramatic event is in progress. The rabbit on the right seems to be con-
spiring with, or at least enlisting help from, the viewer. A sense of impending
disaster is conveyed by the darkness of the figures. An extreme raking light
washes out the table and creates cast shadows behind the standing figure and
the table legs.

The kind of observation and value decisions made in Thiebaud's and
van Hoesen's works have not been employed here. In this imagined scene
with nonhuman actors, the darkness of the forms carries a weight and seri-
ousness that conflicts with whatever humor one might find in the setting.
Again, it is the use of value that lends a conceptual weight to our interpre-
tation of this drawing.

Value describes objects, the light striking them, their weight, structure,
and spatial arrangement. Value can also be expressively descriptive. So value
has two functions: It is objectively as well as subjectively descriptive. Susan
Hauptman's drawing (Figure 4.10) is a study in representational clarity. The
composition is built with a wide range of values, all visually accurate, from
the wrinkled, lightweight scarf to the glass, shell-shaped vase. Values cross
over positive shapes and empty space in the upper third of the drawing; the
white tabletop disappears, reappears, and disappears again in the background
space. The texture, or tactile quality, of the drawing is a result of a virtuosic
handling of values. While Hauptman's drawing is unquestionably representa-
tional—illusionistic, both spatially and texturally—it is highly subjective; an
atmosphere of mystery pervades the work.

In the ink drawing by the Mexican artist, José Louis Cuevas (Figure
4.11), the printmaker Désandré is shown working on a self-portrait. The artist

4.10. SUSAN HAUPTMAN. *Still Life.* 1985. Charcoal and pastel on paper, 31½ × 43¾" (80 × 111 cm). Private collection. Allan Stone Gallery.

is shown in the company of three partial figures. They appear to exist on a different plane, in a separate realm, from the intent printmaker. Handwritten notes are loosely scribbled in the space surrounding them. Are the figures studies for Désandré himself, or are they beings from the spirit world which bring messages to the attentive draftsman? The concentrated blacks and the wispy whites suggest an idea of a heavily loaded content. An inwardly directed psychology lies at the very heart of Cuevas's work. Self-portraits (and,

4.11. JOSÉ LUIS CUEVAS. *The Printmaker Désandré Working on a Self-Portrait.* 1965. Ink and watercolor on paper, 18¼ × 22¾" (46.2 × 57.8 cm). Solomon R. Guggenheim Museum, New York.

4.12. MARY BAUERMEISTER. *Drawing No. 16, Three Pergaments.* 1964. Ink and collage, 19½ × 23½" (50 × 60 cm). Galeria Bonino.

in this case, a portrait of a self-portrait) comprise the major portion of Cuevas's output. An introspective, surreal quality gives tension to the work and is underscored by his symbolic and expressionistic use of value.

WAYS OF CREATING VALUE

In the graphic arts there are two basic ways to define a form—by line or by placement of two values next to each other. Most drawings are a combination of line and value as we have seen in the previous illustrations.

Mary Bauermeister in *Drawing No. 16* (Figure 4.12) has created value shapes by density, or closeness, of lines and by pressure exerted on the drawing tool. The busy, complex design is activated by short, squiggly lines that congregate as if by some magnetic force. The darker, heavier, less electrically charged lines stabilize and quiet the otherwise fractured surface.

A drawing may be exclusively tonal, as in Robert Kogge's compact still life (Figure 4.13) in which the objects' actual or local values are carefully observed and translated onto the picture plane. A light source (from left front and slightly above the still life) creates minimal shadows, and, while suggesting the curvature of the rounded containers, the ultimate effect of the even lighting is to flatten the objects in their tense proximity on the picture plane. Kogge sets up an interesting spatial paradox in the work: First, a uniform texture created by graphite on the canvas tends to flatten the otherwise illusionistically three-dimensional objects; second, although the forms are modeled from light to dark to depict rounded volumes, the space from

4.13. ROBERT KOGGE. *Untitled.* 1989.
Graphite on canvas, 24 × 36″ (60.9 ×
91.4 cm). O.K. Harris Works of Art.

4.14. GUILLERMO MEZA. *Giantess.*
1941. Pen and ink, 25⅝ × 19⅞″ (65 ×
50 cm). The Museum of Modern Art,
New York; gift of Edgar Kaufman, Jr.

4.15. GIORGIO MORANDI. *Nature Morte au Gros Traits.* 1931. Etching, 9⅝ × 12¼" (25 × 34 cm). Harriet Griffin Gallery. © Giorgio Morandi/Licensed by VAGA, New York, NY.

foreground to background is extremely compressed. Note that the baseboard in the lower right of the picture plane seems to exist on the same level as the small objects on the lower left. Kogge's tightly knit composition is held together by a meticulous handling of values; this spatial tension results in a contemporary look.

Other examples of all-tonal compositions can be found in Figures 3.24 and 4.19. Both Carter and James Casebere make use of strict, stripped-down, unmodulated value with no textural embellishment; shape and value relay the intent of light and volume.

Tonal quality can also be made by smudging, by rubbing and erasing, or by washes made with wet media. In Robert Rauschenberg's work (see Figure 6.29), we see a distinctively twentieth-century technique of creating value, the use of transferred images from magazines or newspapers. Large areas of value created by grouped lines unify disparately scaled images and tie the various segments into a cohesive whole.

Tonal variation can also be effectively achieved by stippling. Guillermo Meza uses this technique in his pen-and-ink drawing *Giantess* (Figure 4.14), in which the figure with its exaggerated forms dwarfs the small island in the background. A powerful plasticity is the result of careful modeling from light to dark. Eye level—the figure is seen from an ant's-eye view—is a major contributing factor in establishing scale.

Cross hatching is another means of creating value. In his still life (Figure 4.15), Giorgio Morandi constructs an ordered arrangement using cross hatching. Background and foreground are uniformly crosshatched, thus flattening the space. The bottles are defined by groups of angled lines, which indicate planar change; the still life contours are strengthened, and thus flattened, by outline. Morandi's value patterns create an otherworldly effect; the objects seem strangely isolated and lonely.

ARBITRARY USE OF VALUE

Artists sometimes ignore the natural laws of value, such as the way light falls across a form, and use value arbitrarily—to create a focal point, to establish

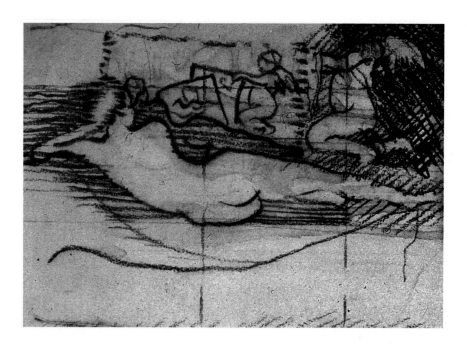

4.16. JUAN DOWNEY. *Venus* (detail). 1979. Acrylic, colored pencil, pencil on paper, 22 × 30″ (56 × 76 cm).

balance between parts, to call attention to a particular shape, or otherwise to organize the composition. These uses of value are based both on the artist's intuitive responses and the need to comply with the demands of the design. In other words, *arbitrarily stated values* are light and dark patterns that differ from local values as in the drawing by Juan Downey (Figure 4.16). The grouped lines creating arbitrary value patterns could be allusions to electronic impulses that create linear patterns on television screens—an appropriate conclusion since Downey is a video artist. In an updating of the art-historical Venus, the Rokeby Venus by the seventeenth-century Spanish master Diego Velázquez, Downey arranges four images of the goddess in a stacked space with spatial movement from lower left to upper right. These shapes cross over both figures and negative space. Some positive forms are relatively blank, as in the background group of figures, while others are integrated with their adjacent shadows.

Lines are densely grouped to create darker, weightier shapes, while others are more diffuse, resulting in lighter value shapes. Lines maintain their direction within a given shape, thus flattening the space. Spatially, the drawing is very complex; it is the interweaving of the grouped lines creating the value patterns that both integrates the drawing and confounds a logical spatial analysis.

A second example of the arbitrary use of value to organize the picture plane can be seen in the dizzy spatial composition by Judy Pfaff (Figure 4.17). In this abstract work complex value patterns build on one another to create deep, winding pictorial spaces like an activated abstract landscape. This is not such a far-flung assumption since we have been given a clue to interpret the subject as a landscape by its title *Untitled (Quartet for Quintana Roo)*, a region in Mexico's Yucatan peninsula.

A galaxy of exploding textured value shapes results in a highly active and mobile composition. The dot-and-line patterning resembles textile frag-

4.17. JUDY PFAFF. *Untitled (Quartet for Quintana Roo)*, 1980. Mixed media on tracing paper, 3′9¾″ × 6′5″ (1.16 × 1.96 m). Courtesy of André Emmerich Gallery.

ments whose diagonal shapes and zigzagging segments weave in and out of space like patterns created in a universe of interconnected stars. This exciting and provocative work is a challenge to analyze with its intricate, intertwined, and interrelated shapes and values. Pfaff's drawing can be interpreted as a utopian affirmation of cosmic harmony.

In *Portrait of a Man* (Figure 4.18) Rico Lebrun focuses attention on the subject's face by use of value. The gestural suggestion of the body with its massive bulging shapes is an intriguing foil to the treatment of the head. Darker, heavier lines, which direct the eye to the head, also carry the message of gravity and weight.

PROBLEM 4.1
Using Value Arbitrarily

Choose a still life or model as your subject, from which you are to make two drawings.

In the first drawing fill the page using background shapes. (Remember, continuous overlapping lines will create some repeated shapes.) Using black, white, and two shades of gray, arbitrarily distribute values within the defined shapes. Continue using values to enclose shapes, and keep the values flat, unmodulated. Lead the viewer's eyes through the picture plane by the location of dark shapes. Add grays, establishing a secondary pattern. Base your

decisions according to compositional demands rather than on the actual appearance of the subject.

In the second drawing, rather than using only flat shapes and values, model some of the shapes to give them a more volumetric appearance. Again you can direct the eyes of the viewer through the picture plane by the distribution of these modeled areas. You should have a major focal point and minor focal areas. A combination of flat shapes and modeled volumes in the same drawing results in ambiguous space.

DESCRIPTIVE USES OF VALUE

Value can be used to describe objects in physical terms of structure, weight, light, and space.

Value Used to Describe Structure

Value can describe the structure, or planar makeup, of an object. Light reveals structure, but values can be distributed according to an analysis of an object's planes; that is, value describing structure need not depend on the natural laws of light. In James Casebere's photograph (Figure 4.19), the planar structure is pronounced. Light does, in fact, make a differentiation between adjoining planes. There is, however, more than one light source, one from the upper right and another from the lower right.

PROBLEM 4.2
Using Value to Describe Structure

In this drawing you are to reduce the figure to two values—black and white—and to two basic planes—front and side. Carefully examine the figure to determine where head, arms, legs, and upper and lower torso face you and exactly where these forms turn away from you at a 90-degree angle. In other words, imagine the figure to be composed of only two planes, front and side. Draw a line separating the planes, placing a flat value within the planes that recede, leaving the rest of the figure white. Here you are using value to describe both the structure of the figure and its recession into space.

The Alfred Leslie drawing of the seated model (Figure 4.20) employs the beginning stages described in this problem. An added effect is the sense of a sharp, raking light that illuminates the figure and emphasizes its planar structure.

PROBLEM 4.3
Using Value to Describe Planes

Use a skull or head as subject and make a drawing that emphasizes the planar aspects. Do you remember the drawings on planar analysis in Chapter 3? In this drawing you are to group lines within the planes to create value. A change of line direction indicates a change of plane. Make your marks change directions just as the planes change. Make the strokes run vertically for those that are parallel to you and diagonally for those planes that turn

4.18. RICO LEBRUN. *Portrait of a Man.*
1939. Ink and chalk. Private collection.

into space. This change in direction will emphasize the juncture of planes
and will be more illusionistically dimensional than the drawing in the pre-
ceding problem.

The British artist Lucian Freud, descendant of Sigmund Freud, famed
founder of psychoanalysis, has concentrated on the human figure through-
out his long career. His psychologically tense work is often disquieting. It
has been claimed that his work is more a "still life of skin" than a portrait of
a person. This claim seems justified by his drawing *Large Head* (Figure 4.21).
Freud's direct, penetrating observation is based on an informed structural
analysis of interconnecting planes, and it is this visual understanding that
gives power to his work.

4.19. JAMES CASEBERE. *Boats.* 1980. Black and white silverprint, 16 × 20″ (41 × 51 cm). Courtesy Michael Klein Gallery.

4.20. ALFRED LESLIE. *Untitled.* 1978. Graphite on paper, 40 × 30″ (102 × 76 cm). The Arkansas Arts Center Foundation Collection; the Barrett Hamilton Acquisition Fund, 1982.

4.21. LUCIAN FREUD. *Large Head*. 1993. Etching, 32½ × 26⅛″ (sheet), 27⁵/₁₆ × 21⁵/₁₆″ (plate), (69 × 54 cm). Edition of 40. Matthew Marks Gallery.

Freud has employed curvilinear lines to create the various planes; the result is a far more volumetric figure than would result from a strictly angular statement of lines.

Value Used to Describe Weight

The weight, or density, of an object can be defined by value. We sense the pressure of gravity in all objects in real life. The artist frequently enforces this sense by placing darker values at points of greatest pressure or weight, or at places where the greatest tension occurs.

In Luis Jimenez's *Cruzando el Rio Bravo (Border Crossing)* (Figure 4.22), a work that deals with the cultural archetypes of the American Southwest, we see a drawing that is the basis for a public sculpture commissioned for a Los Angeles park. The two figures merge into one monumental, heroic form. The planes of the woman's knees replace the man's strong shoulders. His strong, heavy legs wade through the reeds that rise up from the bottom of the picture plane. Jimenez, like many sculptors, seems to have an innate sense of weight. His drawings are loaded with the conventions artists use to convey a sense of volume and mass, such as the planar breakdown of the forms, cross-contours to emphasize the figures' dimensionality, and the use of value to carry the idea of pressure and tension.

Philip Pearlstein, in his *Female Model on Ladder* (Figure 4.23), gives volume to the shapes by depicting the effects of light and shadow, which in turn

4.22. LUIS JIMENEZ. *Cruzando el Rio Bravo (Border Crossing).* 1986. Lithograph, printed in color, 38¾ × 28⅝″ (98.4 × 72.7 cm). Horwitch LewAllen Gallery, Santa Fe.

adds to the sense of weight and gravity. Key areas in which a heavy, darker-value line creates the illusion of weight are where the hand presses into the leg, where the thigh spreads on the ladder step, and in the folds of the stomach and the sag of the breast. There is one area where value could be used to create weight and gravity: The foot of the ladder between the model's legs seems to float. The back foot of the ladder is tied to the floor by the use of value connecting the ladder to its cast shadow.

Now is a good time to introduce an important point: Sometimes one can draw things exactly as they appear, but if the light, arrangement of objects, or point of view are not properly composed, the drawing will look wrong. Sometimes the artist has to change things in the drawing for it to appear visually correct. This license to rearrange and alter is an important lesson for the beginning student to learn. A typical problem area for the artist can be where a background edge intersects a foreground edge, such as at the corner of an object. In his drawing Pearlstein maintains the clarity and separation of the figure, ladder, and baseboard by controlling the intersection of foreground and background shapes. Pearlstein's interest in the structure of the human figure is conceptually fortified by the ladder, with its complex pattern of cast shadows. Figure and ladder are analogous forms; the pose of the model reiterates the triangularity of the ladder shapes. The ladder becomes a visual metaphor for the framework of the figure. The expressive quality of the work is conveyed primarily by means of value—a cool, detached, analytical ap-

4.23. PHILIP PEARLSTEIN. *Female Model on Ladder.* 1976. Sepia wash on paper, 29½ × 41" (75 × 104 cm). Robert Miller Gallery.

proach to a figure in an environment. The headless figure reinforces the impersonal theme of model in a studio.

PROBLEM 4.4
Using Value to Describe Weight

Make a first drawing beginning in the imagined center of the figure. Revolve your drawing tool to make a heavy, weighty mass of tangled line, moving outward from the central core. Exaggerate the model's weight; double the mass. The outside edge of the figure should be fuzzy and ill-defined, while the center should be darker (see Figure 2.27).

Make a second drawing, again use value to describe weight and mass. Begin exactly as in the first drawing, filling the form from the inside out. As you reach the outer edge of the figure, lighten your marks; then, using a sharper, defined line, make contact with the horizontal contours of the figure. Imagine that you are coating the figure with a thin webbing or that you are wrapping it in line, as you would a mummy. As the body's surface changes, so does the line change.

4.24. GÉRARD TITUS-CARMEL. *17 Exemples d'Alteration d'une Sphere. 12eme Alteration.* 1971. 19½ × 28″ (52 × 74.7 cm). Private collection.

A sculptor who uses this technique to promote a sense of weight and mass in his drawings is Henry Moore (see Figure 5.20). The drawing entitled *Row of Sleepers* is from a large series of air-raid shelter drawings done during World War II.

In a third drawing the technique will be fingerprint; using black acrylic you are to make a stippled drawing by applying the paint with your thumb. Lightly establish the figure on the page, keeping the initial thumbprints small and widely spaced. After you have lightly laid out the figure in its proper scale, proportion and placement, begin applying darker, larger prints. Imagine that your paper has depth and that you are applying slabs of clay to an armature. This technique is related to a sculptor's building up a mass of clay. Use greater pressure in those areas where you perceive the greatest weight and gravity, creating a buildup of value. Lighten the pressure and use less paint in the areas where weight and gravity do not play a role, such as at the top of the shoulder or the top of the arm. You will be more successful in your depiction of weight if you imagine that you are actually constructing a three-dimensional figure.

Going back to Chapter 1, look at the large-scale image of the human face by Chuck Close (see Figure 1.19). The visual force of the drawing stands in contrast to the intimacy of medium. Close maps the surface variations of his subject using a version of the pointillistic technique so closely identified with the Post-Impressionist Georges Seurat.

Value Used to Describe Light

Light falling on an object creates patterns that obey certain rules. If light falls from one direction onto the object, the value patterns created can reveal the structure of the object, its volumetric and its planar aspects; for example, a sphere under a single light source will have an even change in value over its

4.25. Light on rounded and angular forms.

surface. In the graphic arts, modeling—the gradual transition from light to dark to create spatial illusion—is called *chiaroscuro*. This technique can be seen in Gérard Titus-Carmel's alteration of a sphere (Figure 4.24).

Cylinders, cones, and organic volumes change gradually from light to dark over their surfaces, while cubes, pyramids, and other angular forms change abruptly from light to dark on their surfaces; that is, their planes are emphasized by light (Figure 4.25).

Generally, light as it falls over a form can be reduced to six categories: highlight, light, shadow, core of shadow, reflected light, and cast shadow (Figure 4.26). Within a single form or volume we may see parts of it as light against dark and other areas as dark against light. Some areas may seem to disappear into the background; that is, if a light-valued object is set against a light background, the edge of the object will disappear. Values can cross over both objects and negative space, causing the edge of the object to seem to disappear.

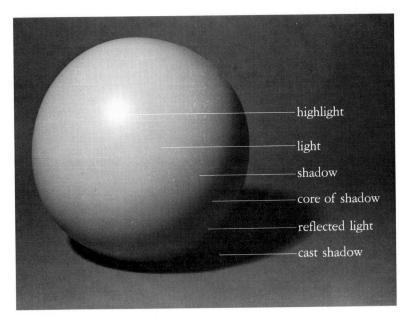

— highlight

— light

— shadow

— core of shadow

— reflected light

— cast shadow

4.26. Six categories of light as it falls over a form.

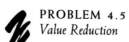

4.27. ALFRED LESLIE. *Alfred Leslie.* 1974. Lithograph, 40 × 30″ (102 × 76 cm). Published by Landfall Press, Inc., Chicago.

Multiple light sources can result in ambiguous space because the form revealed by one light may be canceled by another.

Manipulation of light sources can produce striking effects which result in a very different mood from that produced by natural light. In a self-portrait (Figure 4.27), the artist employs a stark underlighting to create a sense of drama. A tense, apprehensive effect is gained by an unexpected reversal of values. The stylized hair and shirt contrast with the visual accuracy of the facial features; the hair seems to be electrified by the intense raking light that illuminates the head. Note the spatial ambiguity between neck and chin where the light has washed out the shapes that normally differentiate the two.

PROBLEM 4.5
Value Reduction

Set up a still life of several objects with nonreflective surfaces. Study the subject carefully, and on a value scale from one to ten (see Figure 4.1), find its midpoint value. Squint your eyes to reduce color effects so that you see only patterns of light and dark. This drawing is to be a value reduction. You are to reduce all values in the subject to either black or white. Note both the actual values of objects and the light patterns on them, and classify these values as either black or white: Values from one to five will be white, from six to ten, black.

Draw the subject lightly in pencil; then use black acrylic or ink to make everything that is darker than the midpoint value a flat, unmodulated black.

4.28. RUPERT GARCIA. *Manet Fire.* 1987. Mixed media (chalk, oil paint, pastels) on canvas, 3'9¾" × 5'6" (116 × 168 cm.) Collection Oliver Stone, Santa Monica; courtesy of the artist, Rena Bransten Gallery, San Francisco, and Galerie Claude Samuel, Paris.

Erase the pencil lines, leaving the rest of the drawing white. Values will cross over objects and negative space; value will not necessarily be confined to an object. The finished drawing will be spatially flat, very dramatic, and somewhat abstract.

Make a second drawing, this time a two-part drawing; on one side use only two values to create a high-contrast study as in the diptych by Rupert Garcia (Figure 4.28). The subject can be drawn from memory; it can be invented; or it can come from a photographic source. Aim for expressive content as in *Manet Fire,* Garcia's homage to the nineteenth-century artist Edouard Manet.

In the second accompanying panel, expand your value range to four or five, and create an abstract, nonobjective surface that will give added expression to the other half of the drawing with its recognizable imagery.

Use a wet medium such as ink or acrylic, or use a medium that can be dissolved by wash, such as grease pencil and turpentine, or pastel and turpentine. A loose handling of the materials and a layering of values will result in a richer, more expressionistic surface.

PROBLEM 4.6
Four Divisions of Value

Carefully observe the light patterns on a still life. Coat your paper evenly with charcoal of four or five on the value scale (see Figure 4.1). If necessary go over the paper twice to create a smooth-textured drawing surface.

Choose four divisions of value—the gray of your paper, a darker gray, white, and black. The actual light patterns on the subject will govern your decisions. Try to divide accurately the values in the subject according to the light patterns on it. Indicate the blacks and dark grays with compressed charcoal, and erase the whites with a kneaded eraser. Now begin to model the values. Values should again cross over objects and negative space.

To refresh your memory concerning modeling and overlapping, refer to Problem 3.11 before beginning this exercise.

Milhoan's pastel drawing (see Figure 3.32) is an informative one to study for use of erasure and modeled values.

PROBLEM 4.7
Categories of Light

In this drawing you are to use a value range of six to depict the categories of light referred to in Figure 4.26. Set up lighting conditions using only one light source, so that you have a highlight, light, shadow, core of shadow, reflected light, and cast shadow. After carefully observing the actual light patterns on the still life, make four value scales of six values each, using these techniques: scribbling, stippling, cross hatching, and making parallel grouped lines. Density, or closeness of marks, and amount of pressure exerted on the tool are the means to value change. Now choose one of the value techniques and draw the still life with six values. Use no more than six values, and make the transitions gradual and smooth; try to match accurately the actual values in the still life in your value scale. In Giorgio Morandi's *Oval Still Life* (Figure 4.29), you can see how density, or closeness of marks, can be the means to value change. Since Morandi maintains the sameness of the direction of the marks within a shape creating a linear buildup, the resulting space is ambiguous. The flatness of the picture plane is reinforced by the sameness of the lines despite the objects overlapping and their occupying dif-

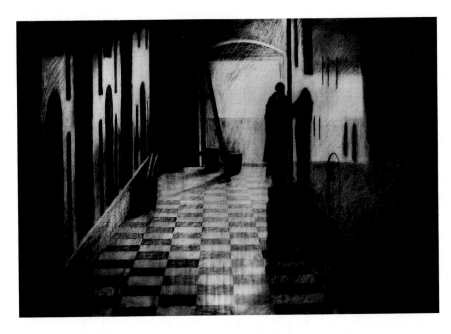

4.30. SHARRON ANTHOLT. *Tracing a Stranger Self.* 1988. Charcoal on paper, 39 × 56″ (99.1 × 142.2 cm). Courtesy of the artist.

ferent base lines. The Italian artist achieves a classical calm and presence by his sensitive balance of shapes and his unique capacity for rendering an enveloping atmosphere in which the timeless objects exist.

It is taxing to train the eye to see actual patterns of light and dark, but it is a rewarding exercise. Your ability to see will be enhanced, and your power of concentration will be multiplied in doing these problems.

PROBLEM 4.8
Tonal Drawings

Using a still life as your subject, make two all tonal drawings. In the first use a light value scale to organize your drawing; in the second expand the value scale to include more darks. In your drawing indicate the change of light across each object and allow values to cross over both objects and negative space. Occasionally the edges of objects should seem to disappear into their adjacent negative shapes or shadows.

Value Used to Describe Space

As in depicting light, artists may comply with nature to describe space as it actually appears, or they can promote the feeling of space by the use of value. Spatial depiction has many manifestations; there is no single way to indicate space. The handling of space is a result of the artist's view, tempered by culture and personality.

One approach to the depiction of space is to use a progression of values from dark to light or light to dark. In Sharron Antholt's charcoal drawing (Figure 4.30), we see a depiction of the hallways and cells of a Buddhist monastery, a physical means to a metaphysical purpose. Space and light are used symbolically as metaphors for a world in which being takes precedence over *action*. The highly atmospheric work is one of solemnity and sublimity.

The spiritual dimension Antholt invokes is a result of a masterful control of value. Perspective and value combine to create a deep sense of space.

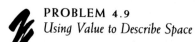

PROBLEM 4.9
Using Value to Describe Space

Focus on a spatial progression in a drawing that has three distinct levels of space: foreground, middle ground, background. Keep in mind that you are trying to describe a deep, illusionistic space. For your subject, arrange objects on a desk into three distinct levels of space. Think of them as monumental objects in a landscape setting. Exaggerate the scale of the various objects in order to create a vast sense of space. You might want to assume a low eye level rather than looking straight down onto the objects; this will help deepen the spatial field.

Manipulate the lighting to cast deep shadows; long shadows can lend an air of mystery. You might imagine the scene as taking place at night, so that the space behind the objects and beyond the desk will be dark and atmospheric. Keep in mind a progression of values either from light to dark as the objects extend into space, or from dark to light as they meet the horizon, the edge of the desk. Try to establish a mood through your use of space and through your selected value range. Aim for a gradual transition of values. Before you begin to draw, sit for several minutes looking at the objects, and in your mind's eye transform them to objects in a landscape. This meditative exercise will provide a good imaginative beginning for this assignment.

EXPRESSIVE USES OF VALUE

The most exciting aspect of value is its use as a forcefully expressive tool. You have read about the principles of value, the observation of natural appearances, and the way this observation can help you use value. Your attitude as an artist and your intellectual and emotional responses are the primary determinants of how you use value. Actual appearance can be subordinated to expressive interests. Value is a strong determinant in the depiction of emotions. An example is pathos. Striking contrasts of light and dark help to achieve the special *angst* of Howard Warshaw's *Red Man* (Figure 4.31). Fluid lines and layered washes envelop the somewhat transparent form. This expressive style contrasts with Ellen Soderquist's gently modeled figure (Figure 4.32). Here the white paper sets off the tonal gradations of natural light on the smooth skin of the model; the controlled modeling results in a classical detachment. The artist's sensitive eye and confident drawing technique encourage the viewer to inspect the forms closely. A limited high-value range is used for describing minute anatomical detail; especially important is the white space surrounding the figure. The outer edge of the torso from armpit to hip is implied; the white negative space crosses over into the positive form. By this subtle device, a conceptual contrast is established. Even though the negative space is empty, we interpret the space surrounding the hand to be a deeper space than the space adjacent to the hip. Soderquist's drawing is a good example of the issue of figure/ground relationship. One of the most important distinguishing characteristics of drawing is the way the

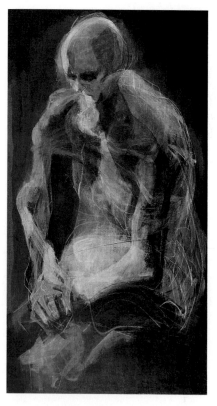

4.31. HOWARD WARSHAW. *Red Man.* 1967. Acrylic on paper, 5′5″ × 3′ (1.65 × .91 m). Courtesy Francis Warshaw, Carpinteria, California.

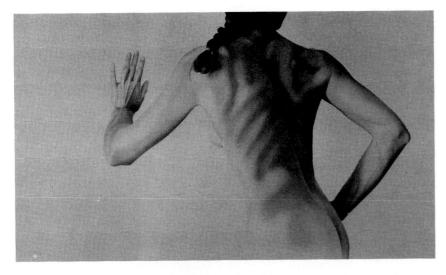

4.32. ELLEN SODERQUIST. *Fragment I: She Went This Way*. 1982. Pencil on paper, 31 × 53″ (78.7 × 134.6 cm). In the collection of Joel and Wendi Holiner, Dallas. Courtesy of the artist.

paper surface, or developed atmosphere of a drawing, becomes the space out of which the image emerges or, as is the case with the Soderquist drawing, dissolves.

Susan Harrington combines the two extremes of the value scale in her two-part drawing (Figure 4.33). The space in the upper section is ethereal; the temple/house/structure seems to be precariously balanced, as if on a cloud. On close inspection one detects a faint image of a large reclining figure dissolved into the whiteness of the paper. A tiny figure, schematically drawn and darker than the other images, is placed at the juncture of the divided picture plane and overlapping the reclining figure; it contrasts sharply with the lower half of the drawing, which is aggressively stated. Dark-valued lines create a dense mass, a sort of composite form—is there a kneeling figure on the left? Because of the two value systems in each of the two segments of the drawing, two contradictory kinds of space result—one light and airy, dreamlike, almost a trace of memory, the second one thick, heavy, and oppressive; it appears to advance menacingly outward toward the viewer. The juxtaposition of the two creates a tremendous tension in the work.

In the two examples just discussed we see the importance of value in creating pictorial space, and we see how that space can be used to expressive ends.

A final look at the way value can create mood is through the use of *value reversal*. This technique creates unusual spatial effects. In Claes Oldenburg's study (Figure 4.34), the chalk lines defining the vacuum cleaner are drawn on a dark ground. This gives the effect of a photographic negative, of space being mysteriously reversed. The commonplace object becomes ghostlike and supernatural. We are presented with an eerie vanishing act.

PROBLEM 4.10
Value Reversal

Using a subject of your choice, make a drawing in which the value patterns are reversed. Draw on either toned paper or on a neutrally colored paper (gray or tan). Some white medium such as conté, crayon, chalk, pastel, or white ink is a good choice. Think in terms of reversing values, using white

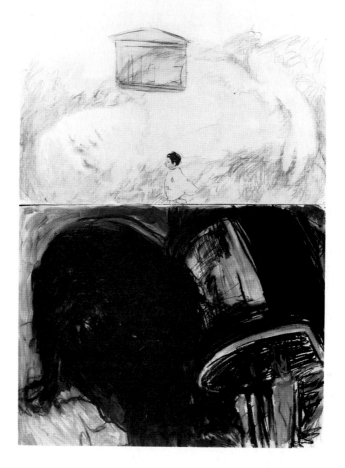

4.33. SUSAN HARRINGTON. *Passim.*
1989. Oil and encaustic on paper, 44 ×
30″ (111.8 × 76.2 cm). Courtesy of the
artist.

for black. You can achieve a range of whites by layering washes or by vary-
ing the amount of pressure placed on the drawing tool. Try for the effect of
a photographic negative, as in the Oldenburg drawing (see Figure 4.34).

PROBLEM 4.11
Value Used Subjectively

In this project you are to make a series of related drawings in which
you subordinate visual appearances to emotive content. Project a strong feel-
ing onto your subject using a value pattern that will underscore your attitude.
Choose a subject that is emotionally charged, toward which you have strong
feelings. You can create interlocking patterns of abstract shapes using value
to tie the forms together. Dark, heavy outlines can be employed to create an
emphatic statement. You may abrade the surface by erasure, smearing, or
smudging.

In his intimately scaled and sensitively drawn watercolor (Figure 4.35),
Michael Flanagan promotes a lyrical feeling using toned paper with bands of
washes (darker on ocean floor and sky, lighter in the center portion of the
drawing), over which he imposes a delicate line drawing of three images—
man, fish, and boat. The subtly drawn figures of man and fish seem at home

4.34. CLAES OLDENBURG. *Plan for Vacuum Cleaner, from Side.* 1964. Chalk and wash on gray paper, 40 × 26″ (102 × 66 cm). Private collections.

4.35. MICHAEL FLANAGAN. *Ocean Silence.* 1980. Watercolor and pencil on paper, 10⅞ × 8½″ (28 × 22 cm). The Arkansas Arts Center Foundation Collection; the Museum Purchase Plan of the NEA and the Barrett Hamilton Acquisition Fund, 1981.

4.36. ROBERT STRAIGHT. *Crossfire.* 1974. Pastel and mixed media, 27 × 40″ (68 × 102 cm). Artist's Collection.

in their gently washed background space. The ocean's silence is reinforced by the symbolic use of pale, watery washes. Both action and meditation seem to be contained in that silence—the twisting action of the fish and the quiet attitude of the man respectfully holding his hat while attending the fish's performance.

A subtle, conceptual, spatial change is effected by the slight separation of the two parts of the picture plane. We read the smaller upper segment to be above water while the larger lower section seems to be under water. The tiny sailboat that appears in the upper segment is a double spatial indicator: It represents a distant space, and it appears to be floating on the surface of the water against a high horizon line, thus suggesting that the larger segment is taking place on a lower level, closer to the viewer, on the ocean floor. We therefore seem to be witnessing an underwater, or better-said, metaphorical, interior event.

PROBLEM 4.12
Value Used to Create Abstract Patterns

In this project you are to use value to create abstract, nonobjective shapes. Use the same media and techniques in a series of related drawings. Read all of the instructions for this problem before beginning.

We have seen that drawings dealing with nonrecognizable subjects need not lack in expressive content. Formal development does not rule out a subjective approach.

Use a combination of grouped lines and flat and/or modeled value shapes as in Robert Straight's pastel drawing *Crossfire* (Figure 4.36). Here value shapes are distributed throughout the picture plane, concentrated at the edges and lower corners, and these geometric shapes, along with darker-valued wide lines, guide the viewer through the composition. Differing values of light and dark are created by areas of subtly hatched lines and by smudging. (Note areas of fingerprints that seem at home among the other values.)

Washes made by turpentine and pastel can produce a gradual value transition. A reminder: The viewer is led through the picture plane not only by the value patterns but by the attraction of like shapes. Use mixed media to create a rich surface quality.

Since this is to be a series of drawings, you will be working in the same style and medium while using a similar vocabulary of shapes, lines, textures, and values. Compositionally, you will be changing their placement, size, or scale from one drawing to the next. Before undertaking this set of drawings you should complete the Sketchbook Projects found at the end of this chapter. Also read Summary: Spatial Characteristics of Value, which immediately follows.

SUMMARY
SPATIAL CHARACTERISTICS OF VALUE

Of all the art elements, value has the greatest potential for spatial development. When value defines light, structure, weight, or space, it is being used three-dimensionally. A combination of these approaches may result in ambiguous space.

If more than one light source is used, each source may cancel volumetric qualities revealed by another. As a result, the drawing may have a sense of ambiguous space. A combination of flat value and modeled value also produces ambiguous space.

Flat patterns of light and dark confined within a given shape make the space seem shallow. Uniform lines within a shape keep the shape flat. In the same way, a uniformly textured surface pattern has a tendency to flatten.

On the other hand, volumes with gradual transitions from light to dark are seen as three-dimensional. When value defines the edges of planes and these planes behave according to the rules of perspective, the resulting space is illusionistic. Movement from the foreground in a stepped progression of value planes produces a three-dimensional space. Irregular lines used to build lights and darks make a drawing more dimensional than do uniform patterns of line.

SKETCHBOOK PROJECTS

Now is a good time to begin using the sketchbook for *thumbnail sketches*, preparatory drawings in which you jot down ideas and options for final drawings. This practice is an economical one: It saves you time, materials, effort, and, additionally, it serves as a memory bank for ideas that come at odd times when you are out of the studio. Often these inspirational jolts are the most valid ones, so having a record of them can be a great help.

PROJECT 1
Using Thumbnail Sketches

As in Sketchbook Project 1 in Chapter 3, you should draw several differently proportioned formats or picture planes for your compositional

4.37. PIET MONDRIAN. *Composition.* ca. 1925. Pencil on paper, 8¾ × 11⅝″ (22 × 29.5 cm). Stephens Inc., Little Rock.

ideas. Quickly note both visual and verbal ideas; for example, if you do not have colored media handy, you might write some descriptive words concerning the color, or set of color or value relationships that will revive your memory later. Visually indicate the placement of various elements; try several compositional arrangements. When you have settled on one or two that particularly appeal to you, develop them further.

At this stage you are not interested in details; it is the broader, more general issues that concern you. (This is not to suggest that details cannot be isolated and developed in your sketchbook: The sketchbook is expansive enough to hold all sorts of ideas, big and small, important and petty. All could be helpful at some later date.) Do not, however, expend all your creative and imaginative energies developing the drawing in the sketchbook. Learn when to stop and move on to the primary drawing, but don't bypass those vital initial stages of compositional juggling and visual thinking.

A look at some thumbnail sketches by Piet Mondrian will be instructive in seeing how visual ideas develop. Mondrian, an early Modernist (1872–1944), was absorbed with the reduction of the image to its barest essentials (Figure 4.37). He aligned the basic elements of flat areas of pure color and geometric forms along a strict horizontal and vertical axis (see Figure 1.35). For Mondrian this venture into reductive forms was not simply a Modernist design exercise; it was rather a mystical search for the Absolute. He regarded abstract art as prophecy of an ideal social order.

In the quick sketch shown here, the rigidly straight lines of his paintings are rendered in freehand squiggles to indicate broad, flat color shapes. Mondrian continued to search throughout his career for that perfect composition in which no single element asserts itself over the others, a visual manifestation of his hope for a utopian, egalitarian social order in which no group dominates.

PROJECT 2
Applying Thumbnail Sketches to Actual Subject Matter

Working on site and using landscape as subject, make a series of thumbnail sketches. Concentrate on reducing the composition to simple value shapes. Use no more than three or four values.

Squint and assess the actual landscape subject. Quickly note the larger shapes and most prominent value patterns.

After you have made four or five quick thumbnail sketches, make another series of sketchbook drawings in which you juggle the elements and size and shape of format.

Repeat this project using still life material and with groups of figures.

CHAPTER 5

LINE

Line drawings are the most elemental and purest form of drawing. Line is the element most associated with the graphic arts. It is valued both for its simple reductive power and for its expansive potentiality for embellishment. Of all the elements it is the most adaptable.

Drawing is open-ended and experimental, an ideal discipline for formative thinking and for idea generation, and line is most often the means to this uncovering of new ideas and motifs. Line can be put to analytical use; it is a good way to convert abstract thinking into visual form. No better means can be used for translating the world of three dimensions into one of two dimensions. And finally, line can be put to the most playful use—everyone enjoys doodling.

Sigmar Polke, in his felt-tip and ballpoint pen *Telephone Drawing* (Figure 5.1), has taken the doodle to an ultimate extreme by promoting that activity (with its tacky subject matter) to the condition of art. By attaching various sheets of paper filled with scribbles, messages, numbers, and kitschy subject matter (a favored target of Polke), and adopting a drawing style which is pointedly "dumb," Polke offers the viewer an insight into a culture's banality. Drawing with shapes and images that emerge unconsciously is called *automatic drawing*, a technique developed by the Surrealists in the early part of the twentieth century.

137

5.1. SIGMAR POLKE. *Telephone Drawing.* 1975. Felt-tip and biro on paper, 27½ × 39½" (70 × 100 cm). Collection Kunstmuseum Berne; gift of Toni Gerber.

Line can be an economical indicator of space; it is a key element in establishing the relationship between the surface of the paper and the emerging or dissolving images on it.

Philip Guston uses line to communicate ideas and feelings without reference to recognizable imagery in his ink drawing (Figure 5.2). He investigates space using pure line. The kinetic marks have a somewhat disquieting physical presence; they are in an uneasy equilibrium with each other. The force and directness with which they are stated make them appear to be crowding against one another, pushing and pulling at the same time. We can sense the physical movement that went into the making of the lines, at times tentative, at other times assertive, feeling around the space, moving both laterally and in depth from back to front.

You have had considerable experience already in using line in problems in the preceding chapters. You have used gestural line, structural line, organizational line, analytical measuring line, directional line, outline, scribbled, tangled, and wrapping lines, continuous overlapping lines, crosshatched lines, and lines grouped to make value. This chapter deals with line quality, with the ways line can be used both objectively and subjectively as a carrier of meaning.

DETERMINANTS OF LINE QUALITY

A first step in becoming sensitive to line is to recognize the inherent qualities of various linear drawing tools. While materials sometimes can be made to work in ways contrary to their nature, recognizing the advantages and limitations of a medium is an important first step in learning to draw. From everyday experience we are acquainted with some linear tools that move effortlessly to create line: pencil, felt-tip marker, ballpoint pen, and pen and ink. And we have used some media that produce a grainy, abrasive line: charcoal,

5.2. PHILIP GUSTON. *Untitled.* 1960. Ink on paper, 18 × 24″ (46 × 61 cm). Stephens Inc., Little Rock.

chalk, and conté crayon. China markers and lithographic pencils contain grease and can easily be smudged or dissolved. (See Guide A on materials for further discussion of drawing media.)

The surface on which a line is drawn is another strong determinant of the quality of that line. Michael Gross's large earthenware container with its applied decorative linear patterning (Figure 5.3) is an example of how surface affects line quality. The character of an incised line is different from that

5.3. MICHAEL GROSS. *Be Smart, Buy Art.* 1986. Stoneware with slip and molded decoration, 30 × 13½″ diameter (76 × 34 cm). The Arkansas Arts Center Foundation Collection: The Decorative Arts Museum Fund, 1986.

5.4. RICHARD SMITH. *Late Mister.* 1977. Acrylic on canvas with metal rods and string, 55″ diameter (1.4 m). Feigen Inc., New York.

of a painted one. Gross's naively drawn and modeled images contrast with the sophisticated and well-made pot. The piece is highly tactile; some lines are indented, others raised; the energetically drawn surface is in keeping with the zany subject matter.

Lines can be created in experimental ways, as in Richard Smith's *tondo,* or round, composition (Figure 5.4). Smith is an artist whose work crosses over the traditional categories of painting, drawing, and sculpture. He is interested in the spatial positioning of pictorial elements; particularly important are his faceted, shaped picture planes with their joined individual units. Sometimes, as in this work, he employs tying; in other work folds and cuts are used. Smith sees "shaping as a way of drawing"; the linear elements are strings, cuts, and folds. It is interesting to note that Smith uses the analogy of tent- and kite-making in his fabrication of art—both tents and kites have affinity with space.

The surface that receives the mark affects line quality just as does the tool that makes it, so it is important to learn to assess both implement and surface. It is difficult, for example, to make a clean, crisp line with pen and ink on newsprint because of the paper's absorbency. On the other hand, good use can be made of ink on wet paper when it is in keeping with the artist's intent, as in Paul Klee's whimsical drawing of a fishing scene (Figure 5.5). Here the dampened paper has caused the ink lines to bleed, and a rather scratchy, whimsical, intimate line quality is the result. The watery medium

5.5. PAUL KLEE. *They're Biting.* 1920. Pen and ink and watercolor on paper, 12¼ × 9¼" (31 × 23.5 cm). Tate Gallery.

supports the water theme. Klee, a teacher at the Bauhaus for a time, wrote a short text entitled *Taking a Line for a Walk,* and he did just that in his prolific art production. He is well known for his distinctive line quality and for the incorporation of line into his paintings.

In studying Klee's work one finds ample proof that the strongest determinant of line quality is the sensitivity of the artist. An artist's linear style is as personal as handwriting; just as we are able to identify a person's handwriting, familiarity with the artist's style makes the work identifiable. Picasso's subjects, along with his several drawing styles, make his work easy to recognize.

Other major determinants of drawing styles and line quality are the times and societies in which we live. This is most apparent in the works of artists who deal with social commentary, such as George Grosz, a savage satirist of the social conditions in Germany during the war years (Figure 5.6). His powerful visual indictments make use of exaggerated lines to convey exaggerated commentary. Grosz's linear style is the carrier of his passionate convictions.

There are no heroes in Grosz's work. His caustic accusations are conveyed by his crabbed line. The dominant "willful possessors" fill the composition, crowding out the common people. Disparity in size (note the difference in scale between the crippled veteran and the bankers in the foreground) and disparity in line quality (in the depiction of the "bad guys" and "good guys") are extreme. The child is insubstantial, the table edge cuts through its foot, rendering its form transparent. The regimentation of society is shown in the geometric, severely ordered cityscape. Even the background figures are

5.6. GEORGE GROSZ. *Exploiters of the People* from the series for *The Robbers* by Friedrich von Schiller. 1922. Photolithograph. 26⅜ × 18⅜″ (48 × 38 cm) (sheet); 19⅛ × 14¾″ (67.3 × 47 cm) (image). Print Collection, Miriam and Ira O. Wallach Division of Art, Prints and Photographs, The New York Public Library, Astor, Lennox and Tilden Foundations. © 1997 Estate of George Grosz/Licensed by VAGA, New York, NY.

statically placed along a horizontal/vertical axis. The idea of a world gone askew is reinforced by the angularity of the three figures at the table. Grosz's subjects do not invoke sympathy; indeed, he presents them for condemnation.

The technology of a given period exerts influence on contemporaneous drawing style and line quality. Many artists have recognized the relationship between art and technology as a major issue in their work. Pablo Picasso and the Cubists, the Italian Futurists Umberto Boccioni, Giacomo Balla, and Gino Severini, the Soviet avant-garde Vladimir Tatlin, Naum Gabo, and Pavel Filonov, and the American artists Robert Rauschenberg and John Cage are only a few twentieth-century innovators whose work used technology as a springboard.

Members of the Soviet avant-garde early in the century were products of modern scientific thinking; they were particularly influenced by new discoveries in biology and in microscopic and X-ray technology.

The Italian Futurists were dedicated to putting into practice the ideas promulgated in their *Technical Manifesto*. In 1909, the sculptor Medardo Rosso proclaimed, "The movements of a figure must not stop with the lines of contour . . . but the protrusions and lines of the work should impel it into space, spreading out to infinity the way an electric wave emitted by a well-constructed machine flies out to rejoin the eternal force of the universe." Ideas new to physics were quickly claimed by the Futurists. Light and speed took precedence over solid, static material form.

Boccioni developed a means for expressing the group's "new absolute velocity" in his innovative style which can be seen in *Study I for Dynamism of*

5.7. UMBERTO BOCCIONI. *Study I for Dynamism of a Cyclist.* 1913. Ink wash and pencil. 8¹⁄₁₆ × 12″ (21 × 31 cm). Yale University Art Gallery; gift of Collection Société Anonyme.

a Cyclist (Figure 5.7). The abstracted figure merges with the bicycle and becomes one with the machine itself. The line quality conveys the notion of speed and space which so fascinated the Futurists. Their mechanistic worldview is in sharp contrast to the more traditional naturalistic view of the nineteenth century.

Just as scientific discoveries early in the century affected art styles, in today's world the computer explosion certainly has had an equal effect on art, especially drawing (see Figures 1.6 and 10.16). On a daily, even hourly basis, we are bombarded with computer-generated graphic images, so it is no surprise that artists have exploited this new technology. Victor Newsome's gridded drawing of a head (Figure 5.8) is an example of such influence. Unmistakably a contemporary drawing, the lines resemble those generated by a computer; the grid lines themselves are another reference to a mechanically generated surface. The line quality derives from technological influence.

LINE IN OTHER ART DISCIPLINES

One other contemporary art phenomenon determining line quality that should be mentioned is the relationship drawing shares with the other disciplines of art—painting, printmaking, sculpture, and photography. Drawing, especially the linear element, extends to other disciplines and other media. We have already looked at two examples of what an important role line plays in a weaver's and a ceramicist's work (see Figures 5.3 and 5.4). It is perhaps commonplace to say how the distinctions among the various art disciplines have been blurred. The very marks that define drawing are now incorporated into their work by sculptors and photographers.

In Deborah Butterfield's sculpture (Figure 5.9), the welded steel elements are presented in linear form, much like the art of drawing itself. Using horses as her sole subject, Butterfield works with sticks, mud, scrap metals, and

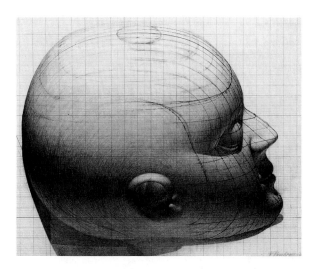

5.8. VICTOR NEWSOME. *Untitled.* 1982. Pencil and ink on paper, 13½ × 17¼" (34.3 × 43.8 cm). Arkansas Arts Center Foundation Purchase, 1983.

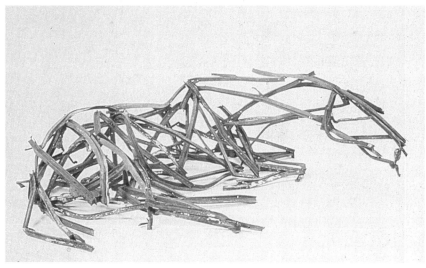

5.9. DEBORAH BUTTERFIELD. *Mibo.* 1994. Welded steel, 24 × 86 × 60" (61 × 218 × 152 cm). Los Angeles Museum of Art (partial and promised gift of Ann and Aaron Nisenson), Gallery Paule Anglim.

bronze. The open strutwork in *Mibo* provides a brittle, angular, linear diagram; the viewer is compelled to fill in the horse's outer shape. One can imagine, unlike a drawing where the view remains consistent, that this three-dimensional linear rendition of the animal would be very different from different viewpoints. When one thinks of sculpture, one generally thinks of mass and solidity; Butterfield, in her linear strategies, confounds the expectation.

A final example of the parallel relationship between two art disciplines can be found in a combination photo-drawing by Ian McKeever (Figure 5.10). His work unites two different techniques in a body of work whose subject is the processes of the natural world. McKeever says that these two disciplines are like landscape itself in that they are able both "to expose and obscure, reveal and conceal . . . they are like the agents of land erosion breaking down and rebuilding surfaces." He notes that photography is closed while drawing is open; it is these two opposite types of representation that coalesce in his work. What better means than line to present a world in flux!

Artists from Paleolithic times to the present have left a rich storehouse of various types of line. In contemporary art a reinvigorated use of line has

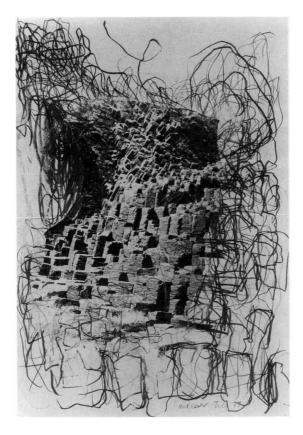

5.10. IAN MCKEEVER. *Staffa-Untitled.*
1985. Pencil and photograph on paper,
30 × 22″ (76.2 × 55.9 cm). Collection of
the artist.

been introduced. Let us now turn to some uses of line peculiar to art in the
last quarter of the twentieth century.

LINE IN RECENT DECADES

Minimalist artists such as Sol LeWitt focus on reductive means. Their work
is a "deflation" of art activity. Art is stripped down with a concentration on
one or two of the elements that go into its making. LeWitt is particularly im-
portant to our discussion of line because his works are pared down to this
prime element. His work has no literary focus; it is reductive, intellectual, and
analytical in character. He, like other Process artists, establishes a process, a
procedure, laying down rules for the execution of the art piece. He concep-
tualizes the organization of the work then follows his own preset directions.
We might call his finished pieces responses to simple commands. Artists such
as LeWitt see this conceptualized approach as a viable organizational factor
equal to, if not superior to, traditional visual, pictorial means of composing
a work of art. In Process Art the viewer is able to recreate intellectually the
process or action that went into the making of the work. LeWitt's title, *Wall
Drawing Part Two with Ten Thousand Lines 12″ Long* (Figure 5.11), sums up the en-
tire process. Actually, anyone could carry out the instructions; it is not re-
quired that the artist actually execute the work. The work is finished when
the instructions have been carried out. Yet the work, like LeWitt's, may have
a visual presence that is elegant in its clarity.

5.11. SOL LEWITT. *Wall Drawing Part Two with Ten Thousand Lines 12″ Long* (detail). 1971. Graphite on wall, entire work 9′4″ × 46′8″ (2.84 × 14.22 m). John Weber Gallery.

Artists who occupy the extreme opposite end of the scale from the Minimalists come from the Neo-Naïve, Bad Painting, and New Imagist styles. Their work is often characterized by crude figuration and expressionistic handling—they reject accepted norms of the "right" way to paint or draw. Philip Guston's drawings exemplify one approach; his images are drawn with an exact crudeness, a calculated dumbness, somewhat grotesque, but honest (Figure 5.12). It is, in fact, their ugliness that elicits our response. The objects themselves are accoutrements of his studio, personal symbols of the artist's struggles, and, as odd as it may seem, they are in dialogue with the art of the past over which Guston has such a command.

Guston's reintroduction of this new figuration was extremely influential over the latter part of the twentieth century. His line quality is in perfect keeping with his subject matter, a sort of groping, an uncertain search for personal meaning in his life.

Line is an indispensable element whether used abstractly, as in the Modernist work by Richard Diebenkorn (see Color Plate 11), or to depict recognizable subject matter, as in the Post-Modernist piece by Al Souza (Figure 5.13). Diebenkorn uses a taut line to divide the picture plane asymmetrically. This linear pattern holds the field in tension; both lines and shapes seem to push and pull inward and outward at the same time. Diebenkorn's imagery developed from landscape, moved to abstraction, and then to nonobjective forms.

A technique that has found much favor with Post-Modernist artists is that of overlaid images. In Souza's work *Arc de Triomphe* (Figure 5.13) we see three separate overlays: the golf players, the rocking chair, and a series of tree limbs. It is impossible to assign a definite location in space for all three layers, although the golf scene forms a field for the other images. The

5.12. PHILIP GUSTON. *Untitled.* 1980. Ink on paper, 18¾ × 26⅜″ (46.4 × 67 cm). McKee Gallery; collection of Mr. and Mrs. Harry W. Anderson.

images are not integrated by color, by style, or by scale. This overlaying of images runs counter to normal ways of representing objects and the space they occupy. It is a distinctive innovation of the Post-Modernists.

In the last two decades of the century, line seems to have been given an even more important role in artists' development of space. We have seen

5.13. AL SOUZA. *Arc de Triomphe.* 1986. Oil on canvas, 22½ × 41″ (57.2 × 104.1 cm). Courtesy of the artist.

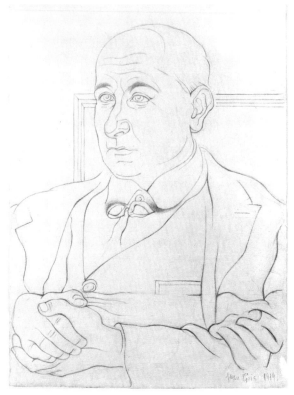

5.14. WILLIAM T. WILEY. *Mr. Unatural Eyes the Ape Run Ledge.* 1975. Colored pencil and wax on paper, 36 × 28¾″ (91 × 73 cm). Collection Robert and Nancy Mollers, Houston.

5.15. JUAN GRIS (JOSE VICTORIANO GONZALEZ). *Portrait of Max Jacob.* 1919. Pencil, 14⅜ × 10½″ (36.5 × 26.7 cm). The Museum of Modern Art, New York; gift of James Thrall Soby.

how adaptable line is in conveying ideas and how suited line is for generating intellectual and visual thinking. Now let us begin our investigation of the many types of line available to the artist.

TYPES OF LINE

We have looked at only a few of the many functions of line. In our study of line we will categorize some line types and learn to use as well as recognize them in other artists' work. A reminder: Seldom does an artist confine the use of line to one particular type. This statement is attested to by William T. Wiley's humorous drawing (Figure 5.14). Wiley, with his tongue-in-cheek drawing, even points out the role of line for an artist with a sign in the upper left of the drawing: "Suite out a line, sweet out a line" (Sweet Adeline). Wiley's works are filled with both visual and verbal puns. His dual roles as artist/magician and artist/dunce are favorite ones.

Contour Line

Chapter 2 discussed basic approaches to drawing. As you may recall, in contrast to the quick, immediate gestural approach, which sees forms in their wholeness, is the slower, more intense contour approach. Contour involves an inspection of the parts as they make up the whole. Contour, unlike outline,

5.16. JUAN GRIS. *Personnage Assis.* 1920. Pencil on paper, 13½ × 10⅝″ (34.3 × 27 cm). Arkansas Arts Center Foundation Collection, The Tabriz Fund, 1987.

is spatially descriptive. It is plastic, emphasizing the three-dimensionality of a form.

Juan Gris's *Portrait of Max Jacob* (Figure 5.15) is a masterly use of contour; every line is fluently drawn. Slow and accurate observation is the key. The composition is subtly unified by a sidewise figure-eight shape; the clasped hands find their echoes in the bow tie and in the eyes. The form builds from the hands to the head. The geometric framework of a background shape interrupts further upward movement. The lightly stated, sensitive curve of the head directs us back to the ears, where yet another set of curving lines leads us to the tie; the V of the vest points to the hands. We are again at our starting point.

Not only is the composition contained; we feel that the sitter himself is self-contained. Contour line is here used to describe change of plane, change of texture (between shirt, vest, coat, for example), change of value (note the ridge line of the nose), change of color (between eye and pupil). This pure contour has been drawn with sensitivity and precision. Gris has used a contour of varying width. Heavier, darker lines create accents (usually where the line changes direction the mark is darker); lighter lines describe the less dominant interior forms.

Not all contour drawings are drawn from life, however. An interesting pairing with the portrait of Max Jacob (see Figure 5.15) is another Gris drawing, the abstracted, mental construct *Personnage Assis* (Figure 5.16). In the first drawing Gris used intermittent dark lines; in the second one, the darker lines

are not accents; in fact, they play the dominant role in the composition, and, spatially, they set up a series of interchanging foreground, middle ground, background planes. It would be impossible to assess a definite location for nearly any shape in the drawing. It reminds us once again of that ever-present issue in the drawing: figure/ground relationships.

Five variations of contour line will be discussed: slow, exaggerated, quick, cross-contour, and contour with tone. The same general instructions given in Chapter 2 for blind contour are applicable for all types of contour.

REVIEW: STEPS IN CONTOUR DRAWING

1. Use a sharp-pointed implement (such as a 2B pencil or pen and ink).
2. Keep your eyes on the subject you are drawing.
3. Imagine that the point of your drawing tool is in actual contact with the subject.
4. Do not let your eyes move more quickly than you can draw.
5. Keep your implement in constant contact with the paper until you come to the end of a form.
6. Keep your eye and hand coordinated.
7. You may begin at the outside edge of your subject, but when you see that line turn inward, follow it to its end.
8. Draw only where there is an actual, structural plane shift or where there is a change in value, texture, or color.
9. Do not enter the interior form and draw nonexistent planes or make meaningless lines.
10. Do not worry about distorted or inaccurate proportions; they will improve after a number of sessions dedicated to contour.
11. Use a single, incisive line.
12. Do not retrace already stated lines, and do not erase for correction.
13. Keep in mind line variation in weight, width, and contrast.
14. Keep the drawings open and connected to the ground.
15. Draw a little bit of everything before you draw everything of anything.

PROBLEM 5.1
Slow Contour

Using a plant or figure as subject, begin on the outside edge of the form. Where the line joins with another line or where the line turns inward, follow, imagining that you are actually touching the object being drawn. Exactly coordinate eye and hand. Do not look at your paper. You may only glance briefly for realignment when you have come to the end of a form. Do not trace over already stated lines. Draw slowly; search for details. Try to convey spatial quality through variation in pressure and in width of line. Make several drawings, spending as much as an hour on a single drawing. With practice your drawings will become more accurate in proportion and detail.

5.17. DAVID LEVINE. *Clement Greenberg.*
Ink on thin board. Lescher & Lescher, Ltd.

If you find a particularly worrisome area, skip to the bottom or top of the paper, and isolate an extended study of the problem area.

Line width and variation have been mentioned throughout the book. In a second drawing, experiment with different found implements, creating contour line of various widths by turning the implement as you draw and by changing pressure on the implement. Keep in mind the spatial differentiation that comes from the use of thick and thin, dark and light lines. Note that a line of varying width is generally more subjective than a line of maintained, or unvarying, width. Make two slow-contour drawings, one in which you keep the line the same all along its length, and another in which you vary the line. The manner in which an artist varies the line is very personal; the line quality will change from artist to artist.

PROBLEM 5.2
Exaggerated Contour

In the blind contour exercises in Chapter 2 you were warned to avoid intentional distortion; however, exaggerated contour line takes advantage of these distortions, intentionally promoting them. It is the preferred technique of caricaturists whose drawings make pungent or even poignant commentary on our cultural heroes. There is a long line of distinguished caricaturists, beginning in the modern period with Honoré Daumier.

David Levine, the adroit cartoonist for *The New York Review of Books,* is an accomplished draftsman whose drawings depict the major cultural and political figures of our time. In Figure 5.17, Clement Greenberg, often hailed as the most influential art critic in American history, is depicted in the costume

5.18. MILTON AVERY. *Untitled* (Male Figure) from *Eleven Provincetown Sketches.* n.d. Pencil on paper, 8½ × 11″ (22 × 28 cm). Collection of the Modern Art Museum of Fort Worth; gift of Sally Michel Avery.

of a pope. Not only is Greenberg shown as the ultimate arbiter of art and culture, but Levine slyly points to Greenberg's near religious fanaticism on the subject of modern art; in fact "Greenbergian formalism" and "Greenbergian Modernism" were bywords in the critical writing on Abstract Expressionism of the 1950s and Color-Field Painting of the 1960s.

In Levine's caricatures, the scale of the head dominates the picture plane; the remainder of the body is drawn in a highly reduced scale. Certain salient features of the subject's physiognomy are also exaggerated. Levine captures the very essence of his targets' physical shape as well as their cultural roles.

In this exaggerated contour exercise we will reverse Levine's procedure by enlarging the lower half of the model's body and reducing the scale in the upper half of the figure.

Your subject in this problem is a model standing or seated on a high stool. Lightly dampen your paper before you begin to draw. Use pen and ink. Begin by drawing the feet in the model. Use a contour line. Draw until you have reached the middle of the page (you should be at knee level on the figure). Now you must radically reduce the scale of the figure in order to fit it in the remaining space. The resulting drawing will look like an ant's-eye view. There should be a monumental feeling to the figure. Milton Avery has employed this technique in his *Untitled* (Male Figure) (Figure 5.18), using an extreme shift in scale from foot to head.

Note the different kind of line quality that is a result of the dampened paper. You will have a darker line along those forms where you exerted more

5.19. JOSEPH BEUYS. *Trace I.* 1974.

pressure or where you have lingered, waiting to draw. This line of varying width is one you should intentionally employ from time to time.

PROBLEM 5.3
Quick Contour

The quick contour line technique is a variation of basic contour drawing. It requires less time than the more sustained contour drawing, and you may look at your drawing more frequently than in a slow contour. The inspection of forms, however, is just as intense. Quick contour drawing might be considered a shorthand version of slow contour drawing. A single, incisive line is still the goal; however, the movement of the line is faster, less determined. In quick contour drawing you are trying to catch the essence of the subject.

In the Joseph Beuys drawing (Figure 5.19), the speed with which the animal was drawn is apparent. You can see where each line begins and ends. No more than a few seconds were required to make a drawing that is complete in essential information. Beuys's quick contour drawing is a conflation of prehistoric and contemporary images; time collapses between the two. Not only are we aware of the speed with which the drawing was made, we are conscious of an animal in motion. The head and horns are more challenging areas to draw. Note the lines of varying width and how they serve as spatial indicators that would be absent in a contour line of maintained width. We can imagine that the darker splotches and heavier lines are a result of the artist's hesitating a split second in that area to assess shape and direction.

Make several quick contour drawings, in your sketchbook and in your drawing pad. Experiment with scale, size, and different media. Keep in mind the importance of a single, informative line. Make multiple drawings of the same subject; combine several quick studies on a single page; make several

single-page drawings. Alternate time: 15 seconds, 30 seconds, 45 seconds, 1 and 2 minutes are adequate lengths of time to make a quick contour drawing.

Your subject matter can be anything. Animals are good subjects for beginning quick contours. Simplify their shapes and try to capture the essence of their poses.

PROBLEM 5.4
Cross-Contour

Cross-contour lines describe an object's horizontal contours, or cross-contours, rather than its vertical edges. They emphasize an object's turn into space. You are familiar with contour maps which describe the earth's land surface. Henry Moore's air-raid shelter drawings are excellent examples of this technique.

Moore was a British sculptor whose drawings had an autonomous yet parallel relationship to his sculpture. In both disciplines he explored the ideas of weight and mass; his subjects seem to emerge from the earth. Moore concentrates on the sculptural aspects of a form in his drawings; his lines feel around the forms encasing them as if they were cocoons. His figures, both sculpted and drawn, have a roundness and solidity that make them resemble mountains.

Moore's *Row of Sleepers* (Figure 5.20) demonstrates the cross-contour line technique. Cross-contours are particularly effective for learning to see the complex spatial changes that occur across a form.

Make a cross-contour drawing using a model as subject. Imagine the line to be a thread that wraps the body horizontally, encasing its mass. Detailed studies of arms, legs, front and back torso using cross-contour are recommended. Combine several studies on a page, changing view from front to back to side. Refer to the Newsome drawing (see Figure 5.8) to see how reductive cross and vertical contours can be teamed to build a three-dimensional illusion.

Cross-contour drawings of draped fabric will enhance your skills. Keeping your implement continuously in contact with the surface of your paper, carefully observe the drapery's folds and try to indicate its undulating shape. By grouping the cross-contour lines either far apart or close together, you can control the value changes across the form. You might lighten the lines for the forms that rise and use darker, grouped contours for the recessed folds of the fabric.

PROBLEM 5.5
Contour with Tone

After you have had some practice with contour drawing, you can add value or tone. Be selective in your placement of value. Don Bachardy's poignant drawing of his dying friend Christopher Isherwood (Figure 5.21) is a good example of contour with tone. In fact, this drawing is a compilation of the various types of contour we have been discussing in the preceding exercises. Bachardy has used quick contour to indicate the body's mass, slow and exaggerated contour to depict the sorrowful face, cross-contour to convey Isherwood's wrinkled brow, and a limited value scale to heighten the facial features. The artist leads the viewer through the drawing with an

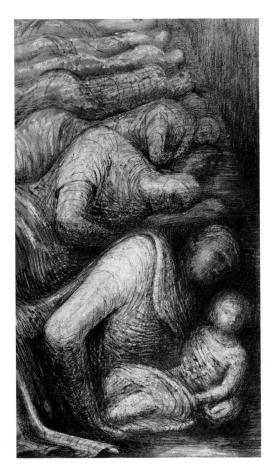

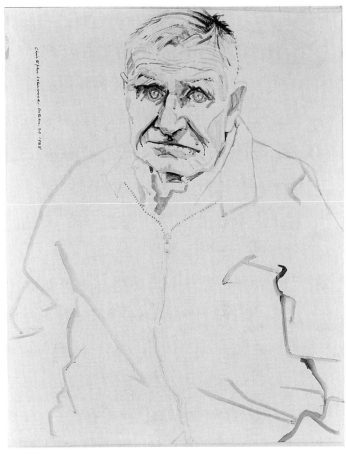

5.20. HENRY MOORE. *Row of Sleepers.*
1941. Pencil, wax crayon, watercolor
wash, pen and black ink, 21¼ × 12⅝″
(55 × 32 cm). Collection British Council,
London.

5.21. DON BACHARDY. *Christopher
Isherwood, October 20, 1985.* Black acrylic
wash on ragboard, 40 × 32″ (101 ×
81 cm). Collection of the artist.

economical use of value; three or four values are ample to convey a world of information and sympathy. This powerfully simple graphic document, quickly stated, emphasizes how fleeting life is.

Mechanical Line

Mechanical line is an objective, nonpersonal line that maintains the same width along its full length. An example would be an architect's ground plan in which various lines indicated different materials or levels of space.

Steve Gianakos, who studied industrial design, uses a number of drafting techniques in his work (Figure 5.22). The carefully plotted arcs and angles are structurally meaningless; however, they do seem to make some tongue-in-cheek remark on architectural drawings. The gorillas have satirical, autobiographical significance for Gianakos. Note the mechanical application of line; each individual line is unvarying, deliberate, and controlled.

PROBLEM 5.6
Using Mechanical Line

Draw multiple views of an object—top, bottom, sides—using mechanical line. You may keep the views separate, or you may overlap and superimpose them. Keeping in mind that mechanical line remains the same

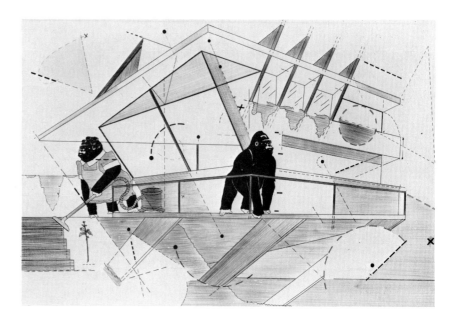

5.22. STEVE GIANAKOS. *Gorillas #10.*
1983. Ink and colored pencil on paper,
3′4″ × 5′ (1.02 × 1.52 m). Barbara Toll
Fine Arts, New York.

throughout its length, use a drawing tool that will produce this kind of mark,
such as pencil, felt-tip marker, ballpoint pen, or lettering pen.

Structural Line

Structural lines indicate plane direction and reveal planar structure. Structural
lines build volume and create a three-dimensional effect. Although a draw-
ing can be made using only structural lines, these lines are usually found in
combination with either organizational line or contour line. Structural lines
can be grouped and are then perceived as value.

Structural line can also be put to more abstract use as in Marcel
Duchamp's pencil-and-wash drawing (Figure 5.23). Here an idea of simul-
taneity and sequential motion is conveyed by the use of structural and dia-
grammatic line. Change, the recurring theme of this highly esteemed artist,
is given graphic form.

PROBLEM 5.7
Using Structural Line

Make several hand studies using structural lines to indicate the changes
of planes, to create values, and to build volume. You can use parallel lines,
cross hatching, or grouped contour lines as in the drawings by Leslie and
Freud (see Figures 4.20 and 4.21). Structural lines can be grouped and will
then be perceived as value; they can be either angular or curved. In Freud's
drawing a three-dimensional effect is enhanced by the buildup of interlock-
ing rounded planes. In Leslie's figure the overall spatial effect is ambiguous
due to a flattened texture created by repeated lines stated in the same direc-
tion within a given plane. An outline tacks the figures in place and further
limits a completely three-dimensional interpretation. Within both drawings,
however, we observe a planar structure. A faceted breakup of planes can con-
tribute to a Cubistic effect.

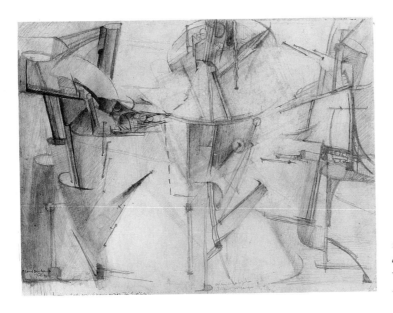

5.23. MARCEL DUCHAMP. *La Mariée Mise a Nu Par Ses Celibataires.* 1912. Pencil and wash, 9⅜ × 12⅝″ (23.8 × 32.1 cm). Musée National d'Art Moderne, Paris.

Lyrical Line

Lyrical drawings have an intimate, subjective character and reflect a sensitivity of expression. We connect a certain exuberance with lyrical drawings. Lyric verse is akin to song and its forms include sonnets, elegies, hymns, and odes. The earliest ones were written to be accompanied by the lyre, from which the word *lyric* is derived. In art, lyrical lines are ornate, intertwined lines that flow gracefully across the page like arabesques.

Contour line and decorative line are frequently combined to create a lyrical mood. Lyrical drawings reinforce a mood of lightness and gaiety. Repeating curvilinear lines establish rhythmic patterns fitting for a relaxed theme.

Generally, the more deliberately controlled a line, the more objective it is. The more spontaneously a line is stated, the more subjective it is. Lyrical line falls under the subjective category and is characterized by sensitivity of expression.

Artists who are known for using lyrical, decorative line are Pierre Bonnard, Raoul Dufy, Edouard Vuillard, and that graphic master, Henri Matisse.

Lyrical line and the drawings of Matisse are synonymous. In Matisse's distinctive pen-and-ink drawing (Figure 5.24) the line flows effortlessly across the page. The white ground of the paper is activated by the forms that weave across the surface. Matisse's line is the manifestation of his wish to make art that is as "comfortable as an armchair." He effects a relaxed mood, while at the same time relaying a compendium of spatial information. In fact, references to space reverberate throughout the composition. We see a model, her back reflected in a mirror in the background, a door to another space, another room, a window to an outside space, and in the lower-right-hand corner a shorthand description of the scene just described, an even more abstract handling of space than in the dominant composition—and a notation of the artist's hand holding a pen, a reference to another space. What a rich source of spatial ideas this single, seemingly simple, highly lyrical drawing contains!

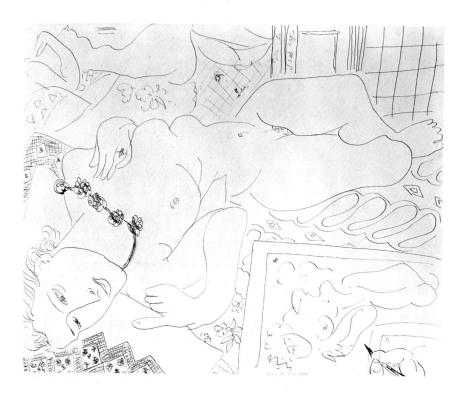

5.24. HENRI MATISSE. *Nude in the Studio.* 1935. Pen and ink, 17¾ × 22⅛" (46 × 57 cm). Location unknown.

![scratch mark] PROBLEM 5.8
Using Lyrical Line

Choose a room interior as subject of a lyrical drawing. Create decorative linear patterns, using a free-flowing implement: either brush and ink, or pen and ink. Try drawing in time to music. The goal is spontaneity. Take a playful, relaxed attitude.

Constricted, Aggressive Line

A constricted line makes use of angular, crabbed, assertive marks. Such marks are aggressively stated. They may be ugly and scratchy, carriers of a bitter expression; they can convey the feeling of tension (see Figure 5.6).

![scratch mark] PROBLEM 5.9
Using Constricted, Aggressive Line

An incised line is a good choice for this problem, as cutting or scraping can be aggressive acts. Note the abraded surface and rugged line quality in Jean Dubuffet's drawing (Figure 5.25). The images are scratched into the surface, a technique called *grattage*. Dubuffet's line quality is at one with his primitive intent.

For this drawing, you may use black scratchboard (a clay-coated, prepared paper), or you may coat a piece of bristol board with a layer of gesso over which you then apply a coat of black ink. The drawing implements can be a collection of found objects or discarded drawing tools, such as old pens, palette knives, or mat knives. Razor blades can also be used as scrapers; any sharp implement will serve.

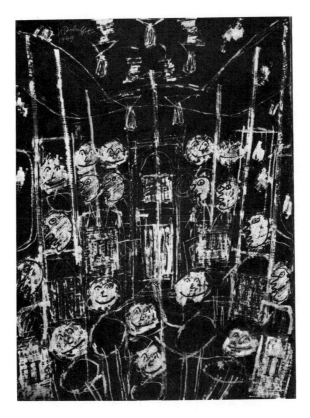

Draw a scene that depicts a situation toward which you feel great antipathy. Use constricted, aggressive lines to convey a strong, negative feeling. Aim for a drawing style and a line quality that will underscore a bitter message.

Handwriting: Cursive and Calligraphic Line

In the Orient artists are trained in calligraphic drawing by first practicing the strokes used in making the highly complex characters used in their writing. Subtleties of surface, value, and line quality are promoted. The marks can range from rigorously severe to vigorously expressive as in the massive drawing (4′9″ × 8′) by the Japanese artist Yuichi Inoue (Figure 5.26).

Ink and brush is the traditional medium of calligraphy where instrument, media, surface, and technique all play crucial roles. The technique is related to gesture; the variations of the line encompass the full range from bold to delicate, from thick to thin. And while calligraphy has traditionally been classified as sweepingly graceful, Inoue's emotional work, a text whose marks seem splintered and shattered, has been tagged as "renegade." The writing describes the artist's memory of the firebombing of Tokyo in 1945.

Mark Tobey, an American artist, was greatly influenced by Eastern calligraphy and adapted the technique to his linear intertwinings (Figure 5.27). He called these overall textural patterns "white writing." An unusual spatial ambiguity is found in his work due to the shift of scale in the layers of writing and also the change in medium in the central section and frame or border. An interesting question arises: Is the lighter section on top of or behind

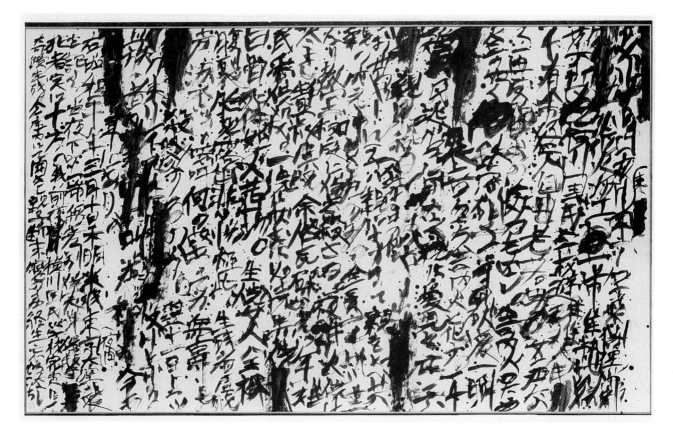

5.26. YUICHI INOUE. *Ah! Yokokawa National School.* 1978. Ink on paper, 4'9" × 8' (1.45 × 2.44 m). UNAC Tokyo.

the black border? Tobey's writings are "a diary of a human hand," a provocative revelation.

PROBLEM 5.10
Using Handwriting or Calligraphic Line

Practice writing with ink and a bamboo-handled Japanese brush. Hold the pen near the end, away from the brush, and at a 90-degree angle to the paper. (Your paper should be on a horizontal surface.) Change scale, making the transitions of the marks gradual and graceful. Apply different amounts of pressure to create flowing motions. Turn the brush between your fingers as your write. Experiment with the way you hold the brush and with the amount of ink loaded onto the brush.

After you have practiced and have the medium under some control, make a composition using written words, layering them, obscuring their legibility, only occasionally allowing them to be read. Choose a text that is appealing to you—a poem, a passage from a novel, or your own, original writing.

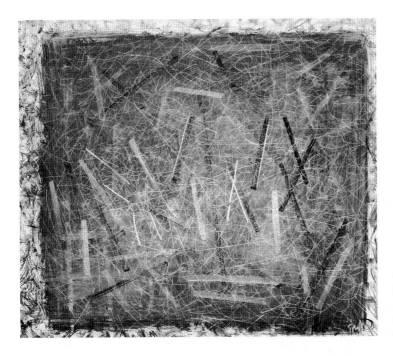

5.27. MARK TOBEY. *Remote Field.* Tempera, pencil and ink on cardboard, 28½ × 30⅛" (71.4 × 76.5 cm). Collection, The Museum of Modern Art, New York; gift of Mr. and Mrs. Jan de Graaff.

To differentiate the layers, you may want to use black, white, and sepia ink on a light gray or buff colored paper. Or you may tone your paper with a light valued wash before beginning to write. (Note the layered effect in the center of Tobey's drawing.)

Implied Line

An implied line is one that stops and picks up again. It can be a broken contour; the viewer conceptually fills in the breaks. We discussed implied shape in Chapter 3. Refer again to the Baskin drawing (see Figure 3.5) to freshen your memory.

In David Hockney's print (Figure 5.28), the artist makes use of a fragmented, or implied, line. This approach is more concentrated in the lower half of the drawing where hand, dress, and chair dissolve into a series of accent marks. The individual shapes are not clearly defined. Hockney makes use of a weighted broken contour.

Implied line results in an interchange between positive and negative shapes. It brings the negative space into the implied positive shapes, creating spatial ambiguity. This lost-and-found line requires a viewer's participation since line and shape must be filled in mentally.

PROBLEM 5.11
Using Implied Line

Choose a still life as subject for an implied-line drawing. Alternate drawing between the left and right side of the still life; leave the opposite

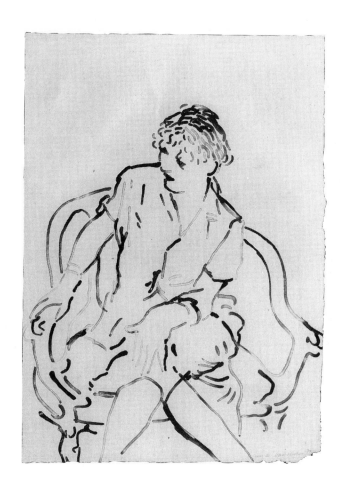

5.28. DAVID HOCKNEY. *Celia Inquiring.* 1979. Lithograph, 40 × 29″ (101.6 × 73.7 cm). Ed: 78.

side empty. Create implied shapes. Be conscious of the pressure on your drawing tool, lightening the pressure as the line begins to break. The lines should change from light to dark along their length. Use a minimal amount of line to suggest or imply shape.

Blurred Line

Blurred lines are smudged, erased, or destroyed in some way, either by rubbing or by erasure. They are frequently grouped to form a sliding edge; they are not as precisely stated as implied lines. Blurred and smudged lines are much favored by present-day artists because they create an indefinite edge, thereby resulting in an ambiguous space.

David Hockney, in the study of a friend (Figure 5.29), uses blurred and erased lines to build the figure. Lines are grouped in a single direction to create a buildup of plane and volume, binding the figure to its space. There is an unfinished quality to the drawing, due to the disruption of the contours. The strokes seem to emerge from the surrounding space; they both anchor and attack the seated figure at the same time. Hockney's technique of using blurred line is especially appropriate when we note the title, *Henry in Candlelight.* The flickering and shimmering quality of the light is translated into the drawing by means of the blurred line, and the fading out of the drawing in

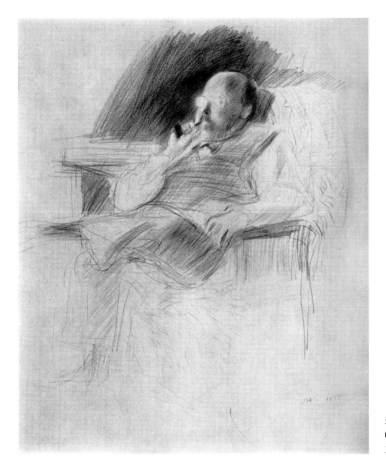

5.29. DAVID HOCKNEY. *Henry in Candlelight*. 1975. Crayon, 17 × 14″ (43 × 35.5 cm). Private collection, France.

the bottom of the composition imitates the fading power of the candlelight.

We have mentioned several artists who have a distinctive line quality, a signature by which we recognize the artist. The Abstract Expressionist Willem de Kooning is one such artist. Blurred, erased, repeated gestural marks signify his work (Figure 5.30). He creates a spatial ambiguity through a textural surface of built-up and erased line in both his drawings and paintings. His style gives us a strong clue as to why the Abstract Expressionists were called Action Painters. De Kooning's technique is extremely subjective; the attraction and ambiguity of women are a continuing theme in his art.

Our discussion of erased and blurred line would not be complete without mention of what is arguably the most discussed drawing of the century, Robert Rauschenberg's 1953 *Erased de Kooning Drawing*. Rauschenberg was interested in disintegration, in obliterating the artist's hand and artistic presence from his own work, so he devised a project that would be a perfect vehicle for implementing his theories: Rauschenberg requested that de Kooning give him one of his drawings, one that de Kooning would not like to part with; the other stipulation was that it should be a drawing that would be difficult to erase. De Kooning gave the request long and serious consideration before complying. After the drawing was exchanged, Rauschenberg spent two months trying to eliminate all traces of de Kooning's marks by carefully erasing the entire drawing. The remaining texture or surface was persistent in

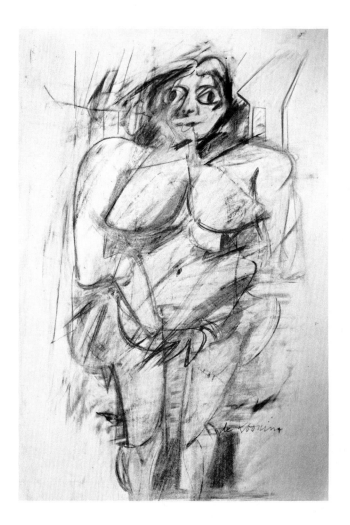

5.30. WILLEM DE KOONING. *Woman.*
1952. Pastel and pencil, 21 × 14″ (52 × 36 cm). Private collection, Boston.

retaining both memories of de Kooning's original gestural marks and shades of his composition.

PROBLEM 5.12
Using Blurred Line

With a soft pencil and a white plastic eraser make a drawing in which you use blurred, smudged, and erased line. Use the eraser as a drawing tool, making sweeping motions that go counter to the pencil marks. Erase and blur the already established lines. Alternately redraw and erase until the drawing is finished.

A toned ground is a good surface for a blurred-line drawing. Develop clusters of line (using both erasure and lines created by charcoal or conté crayon) where the forms converge. By this means the positive and negative shapes will merge; the positive shapes will dissolve into the ground of the toned paper. Allow some of the connections to be implied. You might compose your drawing so that a light, positive shape adjoins a light, negative shape; a dark, positive shape adjoins a dark, negative shape. This will ensure an ambiguity of edge. This problem is related to our discussion of implied line and shape.

5.31. RED GROOMS. *Rodeo Arena* (detail). 1975–76. Colored felt-tip pens on 17 sheets of paper, 47 × 80⅜″ (1.19 × 2.03 m). Collection of the Modern Art Museum of Fort Worth; Museum Purchase and Commission with funds from the National Endowment for the Arts and the Benjamin J. Tillar Memorial Trust.

Whimsical Line

A playful, whimsical line quality is appropriate for a naïve, childlike subject. This subjective line is both intuitive and directly stated. The whimsical line may change its width arbitrarily. Whimsy is more a feeling than a technique, but we find numerous examples of line used lightheartedly. Exaggeration and unexpected juxtapositions play a major part in creating a whimsical mood. Paul Klee is the master of whimsical line (see Figure 5.5). While his drawings are appealingly naïve, they incorporate sophisticated, formally organized devices. In a distinctive style he combines geometric abstraction with fantasy in many of his works.

A current artist whose work is rooted in the humorous vein is Red Grooms. His boisterous sculpture, prints, and drawings reflect his trickster art personality. In the drawing done in conjunction with the installation of *Ruckus Rodeo* (Figure 5.31), which Grooms refers to as a "sculpto-pictorama," we see how effective an appropriate line quality can be in conveying a whimsical mood. Quick contours, simple outlines, reduced symbolic forms such as the repeating shapes of the hats to indicate the crowd, the sketchy circular arena with its gates, flags, and cast of entertainers, all add up to a droll account of a wild western ruckus. Not only is the drawing fun to look at, it must have been fun to make; a full-hearted entering into the game is the first requirement of working with whimsical line.

PROBLEM 5.13
Using Whimsical Line

Choose a subject toward which you can adopt a humorous attitude. Use a line that reinforces a playful mood. Aim for caricature-like distortions,

using a line that is quickly stated. You might use pen and ink and felt-tip markers. By turning the drawing tool between your fingers as you draw you can create a line quality that is unpredictable and playful. Have fun.

SUMMARY

SPATIAL CHARACTERISTICS OF LINE

Although each problem in this chapter has generally been confined to the use of one kind of line, most artists do not limit their line so severely. You should experiment, employing several linear techniques in the same drawing.

Subjective lines are generally more dimensional than objective lines. This is because a subjective line changes width, changes from light to dark, and is more suggestive of space than a flat line of maintained width. Outlining makes shapes appear flat; contour line is more dimensional than outline.

A contour line of varying width and pressure is more dimensional than one of uniform weight. A discontinuous, or broken, line is more spatial than an unvarying one.

When line is stated primarily horizontally and vertically, that is, when it remains parallel to the picture plane, a shallow space results. If, however, lines penetrate the picture plane diagonally, a three-dimensional space is produced. Generally, a buildup of lines is more volumetric than a single line.

If lines are grouped in a single direction to create value, the resulting space is flatter than if the lines are not stated uniformly. Lines that create a repeating pattern of texture make a flatter space than those stated less predictably.

Again a reminder: You must analyze all the lines in a drawing in order to determine the entire spatial effect. Look at the line's spatial characteristics. Is it dark, light, thick, thin? Analyze the line quality in terms of contrast, weight, thickness, and movement, and determine what information concerning edge the line defines.

Finally, line is the most direct means for establishing style. It is, as we have said, as personal as handwriting. And like handwriting it should be practiced, analyzed, and refined throughout your drawing career.

SKETCHBOOK PROJECTS

All of the problems in this chapter are appropriate for working in your sketchbook; in fact, daily contour drawings are strongly recommended. They are ideal for sketchbook since they can be done with any subject matter and in the shortest time periods. Keep your sketchbook handy and fill it with the various types of contour drawings.

The more lines you draw, the more sensitive you will become to different line qualities. Being involved in simple mark-making will improve your sensitivity to line. Line used abstractly as well as concretely to describe an object in the real world requires practice on a regular basis. You will begin to find possibilities for new line applications the more you draw.

Now, let us look at some contemporary applications of line.

PROJECT 1
Conceptual Drawing

Sol LeWitt has claimed that it is the idea that makes the art. In his work instructions are explicitly stated before the drawing begins. The person making the marks simply follows the requisites laid down by the person who conceived of the idea, so the drawing will vary according to who actually completed or "performed" the instructions.

Here are instructions for two wall drawings made by LeWitt.

> Within a six-foot square 500 vertical black lines, 500 horizontal yellow lines, 500 diagonal (left to right) blue lines, and 500 diagonal (right to left) red lines are drawn at random
> Ten thousand straight lines at random.

In this exercise write instructions for a drawing to be completed at a later date. The instructions should involve line and repetition; you might use permutations where a certain type of line is run through several variations, such as right to left, left to right, top to bottom, bottom to top. Write each set of rules at the top of a page in your sketchbook; leave three or four blank pages after each set. After you have composed by this highly rational approach, go back and follow your directions. Make three or four drawings for each conceptual drawing idea. Do not, however, make the drawings one immediately following the other. Rather, allow a lapse of several hours, or even overnight, so that your eye and hand are not conditioned by the type of marks made in the previous drawing. The appeal of these resulting drawings will be their order and coherence. You may be surprised at how much difference there can be from drawing to drawing even though you are employing the same set of rules.

You might enjoy working with a friend on this project. Trade instructions, thereby making the separation between concept and drawing even more removed.

PROJECT 2
The Cadavre Exquis *(The Exquisite Corpse)*

The *cadavre exquis* was a drawing technique devised by the Surrealists in which a group of artists work on the same drawing, each unaware of what the others have drawn. In the same drawing there will be different styles, different ideas, and mixed images. The result can be surprisingly coherent, funny, and strange at the same time.

The person who begins is to cover the beginning segment of the drawing by taping a piece of blank paper over the initial image. A line or two can be left visible so that the second person can attach the second part to the first part. Continue the process of drawing and concealing until the third person has finished. Unmask the drawing and unravel the visual message.

This project is in complete contrast to the conceptual drawing in the first exercise where you knew in advance what the elements of the drawing would be. You might want to set a few rules in advance, although this is not necessary. You could, for example, restrict what kind of imagery is to be used: parts of the body, animals, still life objects, no nonobjective shapes, all

nonobjective forms, and so on. You might limit what kind of media is to be used; this will make for a more visually coherent drawing. And, since this exercise is designed to make you more comfortable in working with line, you should make several exquisite corpse drawings that employ line only.

T E X T U R E

THE ROLE OF TEXTURE IN CONTEMPORARY ART

O<small>F ALL THE ART ELEMENTS, TEXTURE HAS</small> undergone the most radical changes in the twentieth century. Two examples will furnish insight into the extremes to which texture has been taken in contemporary art—the first by the conceptual artist Richard Long (Figure 6.1) and the second by the performance artist Janine Antoni (Figure 6.2). Both artists employ quirky materials and innovative methods. Long, extending the landscape tradition established in the last century, evokes a romantic response to landscape even in enclosed gallery spaces. On long walks he creates temporary sculptures of mud, rock, and dirt. In gallery settings using materials taken from specific locations, he evokes memories of past treks and the ephemeral art produced on them; both time and place are important components in his work. In a recent body of work Long uses the silt of famous rivers as a medium for large drawings; in the example shown here the rivulets of actual mud flowed over Japanese rice paper bring to mind the ebb and flow of the Mississippi itself.

Antoni approaches her work with a somewhat perverse sense of humor. In performance art using her own body as a tool, she calls attention to the

6.1. RICHARD LONG. *Untitled.* 1992. Mississippi mud on rice paper, 78 × 43" (198 × 109 cm). Modern Art Museum of Fort Worth; gift of the Director's Council.

parallels between what women suffer for beauty's sake and the methods used in art making. This body involvement is a feminist stance used for serious purposes by many contemporary women artists. In *Loving Care* Antoni uses her hair as a brush for making a drawing; the title refers to a commercial hair product with which the artist paints. The strokes create a texture that is another reference to the high Modernist art style, Abstract Expressionism (associated primarily with male artists), and with its painterly individualistic gestural marks. Many artists since the Abstract Expressionists have tried to establish a distance between the artist and the work; Antoni reestablishes the connection in a particularly feminist manner; she thinks in terms of dance; "mopping the floor is the opposite of ballet."

This piece comes in part from her connections with art from the past, particularly the French neo-Dadaist and performance artist, Yves Klein, who painted *with* models. (Klein used women as "paintbrushes," covering their bodies with paint and then having them transfer the paint to large floor surfaces through their body movements.) Antoni's work presents multiple interpretations using simple actions.

Another art-poking-fun-at-art parody is Roy Lichtenstein's *Little Big Painting* (Figure 6.3), in which the artist has isolated the Abstract Expressionist brush stroke and transformed it in his signature cartoon style. The humor comes from the conjunction of the two styles; the impersonal flat, commercial technique with its static and rigidly drawn texture has little in common with the texture of the sweeping, dripping, gestural, and autographic mark to which it refers. Lichtenstein's penchant for transforming art historical styles from Classic Art to Minimalism never fails to intrigue. While his textural devices, Benday dots, flat paint application, and lines of maintained width remain constant, the progression of styles from period to period furnishes him with an unending supply of subject matter. And it is their conversion to a disjunctive texture that serves as an in-joke to the informed.

6.2. JANINE ANTONI. *Loving Care.* 1992. Performance (detail). The artist soaked her hair in hair dye and mopped the floor with it. Anthony d'Offay Gallery, London.

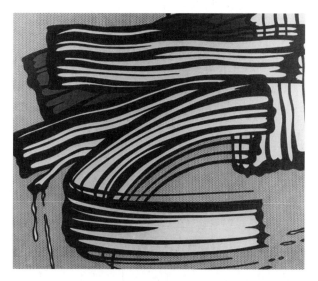

6.3. ROY LICHTENSTEIN. *Little Big Painting.* 1965. Oil and synthetic polymer on canvas, 68 × 80" (172.7 × 203.2 cm). Collection of Whitney Museum of American Art. Purchased with funds from the Friends of the Whitney Museum of American Art.

A quick summary of how texture has been used historically will emphasize how dramatic textural experimentation has been in this century. Until the mid-nineteenth century, texture was primarily tied to the transcription of local or actual textures of the subject depicted. In the Renaissance the ideal for painting was that it be a "window into space"; this meant that a smooth surface with imperceptible individual brush strokes was the goal so that the spatial illusion of the picture plane not be disturbed. The brushwork of Romantic artists of the last century became more flamboyant in order to relay emotional and expressive content; mood and settings overrode surface illusion. Even more radical textural transformations of the picture plane took place with the Impressionists and Post-Impressionists (see Figures 1.10, 1.11, and 1.12). Texture was released from its limited function of illusionistic veracity and was thereby a major tool in creating various kinds of pictorial space. The uniformity and texture of broken brush strokes were a major means of flattening forms and reasserting the two-dimensionality of the picture plane.

The twentieth century has seen a number of influential developments in artists' use of texture, beginning in the years before World War I, when the Cubists invented the technique of *collage*—the addition of any flat material to the surface of a work. These avant-garde artists also introduced the idea of adding sand and other substances to paint to create a more pronounced surface texture. Other innovations were followed by the development of the technique of *assemblage* (added dimensional material resulting in either high or low relief). More recently, technology has offered artists new options for texture, such as transferred and photocopied images. Formal and technical developments in collage and construction have been amplified by contemporary artists. Textural possibilities have been broadened, allowing for a wider range of expressive and material options.

In contemporary art texture is the primary element in establishing meaning and in organizing the work on a formal level. Anselm Kiefer, a German Neo-Expressionist, has broken all textural constraints in his art. He incorporates lead, straw, plants, iron, and other objects and materials that are either embedded in the paint or affixed to the surface. He burns, scorches, and melts

6.4. ANSELM KIEFER. *Shulamite (Sulamith).* 1983. Oil, emulsion, woodcut, shellac, acrylic and straw on canvas, 114¼″ × 145¾″ (290 × 370 cm). Saatchi Collection, London.

the materials to a disturbing effect. These tortured materials are his means of "practicing alchemy"—the secret, medieval "science" of transforming base material into gold. Kiefer's desired goal is that of spiritually transforming society. He resurrects German—even Nazi—themes, demanding that his viewers take a new look at history. He is deconstructing history and our interpretation of it. Art is a metaphor to this end. (Deconstruction is a critical stance that asks us to reevaluate our accepted and unquestioned values.) *Shulamite (Sulamith)* (Figure 6.4) is based on a biblical figure, a Jewish beauty, whom Kiefer conflates with Margarete, the Aryan heroine in Goethe's *Faust.* Both are innocents who are led to tragedy: Kiefer indicates Margarete by the straw for her hair. (In the legend Margarete lies on a bed of straw in prison. Her innocent love of Faust leads her to despair, and she kills her own baby.) Kiefer bases his painting on the crypt-like building, a Nazi design, proposed as a memorial to German soldiers. He has subverted the original intent of that commemoration by writing Shulamite's name in the upper left corner. The painting now becomes a memorial for the Jews who were murdered during the Nazi reign. We see in this powerful work how texture is the key to understanding the symbolism, how, as Kiefer says, these symbols "link our consciousness with the past," and how through them "we recollect our origins." Kiefer's texture is physically and psychically dense.

In the previous chapter on line we talked about how the technology of a given period affects line quality; the same can be said for texture. Think of the way the camera has modified how we look at things; often we cite the photographed image as the "real thing." The Impressionists, too, were influenced by that emerging technological tool, the camera; it is especially apparent in their use of cropped compositions. For many artists the camera is as essential as a sketchbook. In Photo-Realism the textures that are conveyed

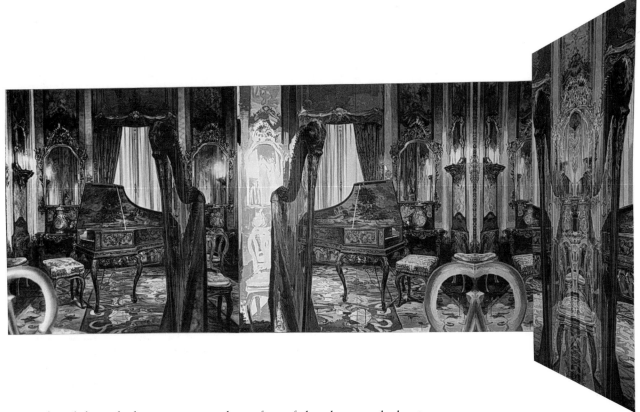

are mediated through the camera; it is the surface of the photograph that is relayed rather than the texture of the objects depicted.

One can hardly imagine Ben Schonzeit's four-paneled, monochromatic *The Music Room* (Figure 6.5) being created without the aid of a camera and projector. Textural preferences and how we perceive them—by style, period, sensibility, or history—are cultural constructs. The complex installation piece, unquestionably contemporary even with its Rococo subject matter, comes close to textural overkill. It is stark in terms of color (blue monochrome), yet sensuous with its lustrous surfaces and textures. By incorporating reflective mylar panels, Schonzeit has further compounded the textural activity.

A significant impulse of the late 1970s, one that particularly involved texture, was the emphasis on decorative patterning, as seen in the gouache drawing by Kim MacConnel (Figure 6.6). In MacConnel's work, subject matter, and texture coalesce; they are one and the same. The textural patterns define shape and their interplay defines a space particular to flat patterning. Using pattern and decoration for textural enrichment is not a twentieth-century innovation; the most ancient and honored art forms make use of these methods. The contemporary Pattern and Decoration artists established ties with much older decorative sources, such as oriental patterns, crafts, folk art, the early twentieth-century work of Matisse and the Fauves, and especially with women's work, such as quilting (see Figures II.7, 5.24, and 11.6).

Patterns convey conceptual and cultural associations; they are not simply decorative. Pattern motifs are references to systems, to various types of organic, scientific, and mathematical organizations; they are the core of crafts such as weaving and ceramics.

6.5. BEN SCHONZEIT. *The Music Room.* 1977–78. Diptych: left–acrylic on canvas, 8 × 8′ (2.44 × 2.44 m); right–oil on canvas, 8 × 8′ (2.44 × 2.44 m); mylar mirror: 8 × 4′ (2.44 × 1.22 m); double harp: oil on canvas, 8 × 4′ (2.44 × 1.22 m). Courtesy of the artist.

6.6. KIM MACCONNEL. *Miracle.* 1979. Acrylic on cotton with metallic paint, 7′9″ × 10′3″ (2.36 × 3.12 m). Holly Solomon Gallery.

Pattern and Decoration artists had a political motive in challenging art's prejudices of elitism, racism, sexism, and cultural and economic biases. The term *decorative* was a pejorative one in Modernist criticism. Pattern and Decoration artists sought to break the hierarchical separation between "high" and "low" art, and, additionally, they challenged Minimalism's tendency to reductive art. Their emphasis on texture, color, and complexity expanded ideas of what is "appropriate" imagery for art.

Another development in late-twentieth-century art, and one that deals specifically with actual texture, is the emergence of the *object* as a distinct genre. This novel development introduced a new kind of art formulation. Although these objects are three-dimensional, they are not strictly sculpture; they do not deal primarily with volume, mass, intervals, and voids.

Artists' one-of-a-kind books fall into this category, a crossover between drawing, painting, printmaking, photography, and sculpture. In these objects—cubes, boxes, trays, containers, books—real texture on real objects has displaced the illusionistic function of texture. Dottie Allen's book entitled *Hard Choices/All There Is* (Figure 6.7) is made of materials associated with neither books nor art, but out of more base materials that avoid connotations of art. Pages are formed of layered pieces of glass, acetate, and mirror, which are held together by soldered lead and encased in a glass container. These dimensional pages are then embedded in another glass case filled with dirt clods. Allen's theme, as she says, is "Ashes to ashes, dust to dust. . . ." Blurred, confusing words and images are photographed and drawn—incised—on the layered sheets, backed by crazed and pitted mirrors, and are legible only when held up to the light. Actual, real-life texture plays a leading role in all of Allen's work: the dirt clods, the leaded holders, the double, blurred images resembling photographic negatives, the mirrors. All function on a formal, design level, but more importantly, these textures are crucial to the work for

6.7. DOTTIE ALLEN. *Hard Choices/All There Is.* October, 1986. Glass, lead, dirt, photocopies on acetate, $4^{1}/_{16} \times 5^{1}/_{2}$ inches each. Museum of Fine Arts, Houston.

their symbolic role. At first look, the viewer sees confusing double images; it is only by holding the pages and looking through them, having them illuminated by real, literal light that we can decipher the message. The viewer is also illuminated, so to speak, and given a tactile reward in actually handling the work.

We have seen only a few examples of the heightened role of texture in contemporary art. Artists have taken a radical departure from the modernist trends of mid-century art. Let us now turn to the role of texture in the graphic arts. The emphasis in drawing is more on visual textural effect. The contrasts between rough and smooth, coarse and glossy, or soft and hard can be communicated without actually using glossy or rough media. Don Nice conveys the idea of various tactile surfaces in his Western predella (Figure 6.8) in which the images become icons, objects worthy of veneration. (A *predella* is a painting, or sculpture, or, in this case, a series of small drawings that forms the lower edge of an altarpiece.) While the texture of each object is rendered in exact detail, the objects are isolated, floating in an empty space. The dimensionality of their meticulously imitative textures is in antithesis to the white space surrounding them; the objects cast no shadows; no context is given in which to place them. Their interrelatedness is curbed by the frames that further isolate each object; an illogical scale prevails; the steer dominates by size, yet the gum wrappers are larger than the landscape itself. All the spatial devices one normally finds in a highly realistic work are missing. Texture is taken to an extreme in an otherwise reductive work.

The textural quality in the charcoal, pencil, and wax drawing by William T. Wiley (Figure 6.9) depends on the surface on which it is drawn, the inherent character of the media, and the artist's control of that medium. Wiley crafts an elaborate, overall surface texture with vigorous overlapping lines. His self-assured whimsy often makes us forget what a consummate draftsman he is.

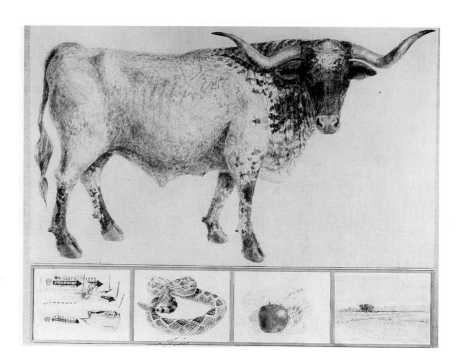

6.8. DON NICE. *Longhorn Steer, Western Series, American Predella #6.* 1975. Acrylic on canvas; 4 watercolors on paper, 7'7" × 10' (2.31 × 3.05 m). Given by the Delaware Art Museum, funds provided by a grant from the National Endowment for the Arts and other contributions.

In addition to reinforcing the content of a work, texture gives information about materials and media. In this role it surpasses the other elements. Some basic categories of texture, beginning with the traditional ones of actual, simulated, and invented, will lead us to a clearer understanding of this element.

TRADITIONAL CATEGORIES OF TEXTURE

Actual Texture

Texture in its most literal meaning refers strictly to the sense of touch. This is the category of actual texture. For the artist, however, the visual appearance of a work, its surface quality, is most important. While this type of texture may have only a subtle tactile quality, it has a visual quality that contributes to the textural character of the work. Chuck Close's paper pulp portrait (Figure 6.10) demonstrates how important both visual and tactile texture can be in a work of art. The print can be read on two levels—one referring to the face of a child, the second as a formal means of ordering the picture plane through the use of modules of paper pulp in a range of values. Close is not involved with the traditional means of seeing and rendering normally associated with portraiture; he is concerned as much with how an image is represented as with the subject itself. Although Close works from a photograph, the surface texture is a result of his stated intent of revealing the personal identity of his hand. The uniformity of the dabs of paper creates a textural pattern that tends to compress the space, yet the contemporary pointillistic technique results in a shimmering, flickering image that activates the surface like a handmade dot matrix.

6.9. WILLIAM T. WILEY. *G.A.D.* 1980. Charcoal, wax, pencil on paper. 35½ × 53½″ (90 × 136 cm). George Adams Gallery.

Actual texture refers to the surface of the work (smooth or rough paper, for example), the texture of the medium (such as waxlike crayons, which leave a buildup on the surface), and any materials, such as fabric or paper, added to the surface.

Susan Schwalb's drawing (Figure 6.11) is another example of the actual texture of the medium, one not easily identified without knowledge of the technique used. Texture is created by holding the paper above a candle flame and controlling the carbon deposits that collect on the paper. This technique is called *fumage*. A stencil blocks out the white areas. By shifting the stencil and by controlling the thickness of the carbon deposits, overlapping dark and light circles are created. We sense a deeper space in the center of the work, where the carbon deposits are thicker and where the circles seem to collide.

Texture, as we have seen, not only conveys information about the artist's medium but also gives information about subjective and expressive intent.

Finally, any real material added to the surface of the work is, of course, actual texture; but for our purposes we have created a new category for this additive material, which we will discuss later.

Simulated Texture

Simulated texture, as its name implies, is the imitation of a real texture. It has traditionally been used to represent actual appearance, and many contemporary artists continue to use texture in this way. Simulation can range from a suggested imitation to a highly believable trick-the-eye (*trompe-l'oeil*) duplication. In Leo Joseph Dee's drawing (Figure 6.12) we see a contemporary handling of the *trompe-l'oeil* technique where verisimilitude is the goal. The torn segment of an envelope is painstakingly and illusionistically rendered; an isolated detail of the crumpled paper emerges from the blank picture plane. By the title we are given directions to interpret the drawing as a metaphorical stand-in for a landscape. Careful control of the tool, silverpoint on gessoed board, and a concentrated observation result in a trick-the-eye texture.

6.10. CHUCK CLOSE. *Georgia.* 1984. Handmade paper, 4′8″ × 3′8″ (142 × 112 cm). Edition: 35, plus 8 artist's proofs. Printed by Joseph Wilfer. Published by Pace Editions.

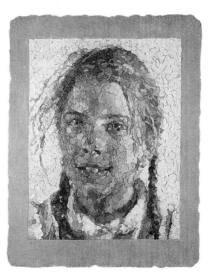

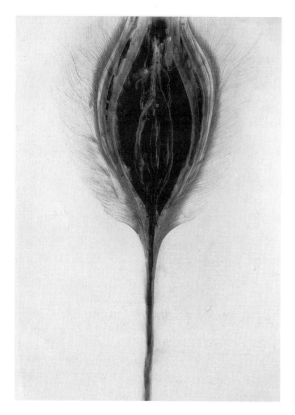

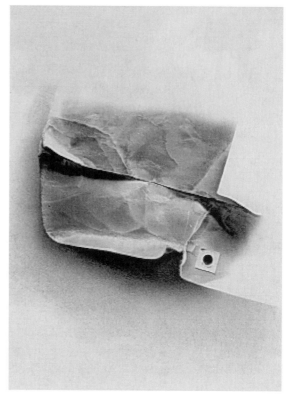

6.11. SUSAN SCHWALB. *Kabili V.* 1980.
Silverpoint, copperpoint, smoke and wax
on clay-coated Video Media paper,
36 × 24″ (91 × 61 cm). Norton Museum of
Art, West Palm Beach, Florida.

6.12. LEO JOSEPH DEE. *Paper Landscape.*
1972. Silverpoint on gesso-coated
museum board, 35¹/₈ × 26″ (88 × 66 cm).
Yale University Art Gallery. Purchased
with the Aid of Funds from the National
Endowment for the Arts and the Susan
Morse Hilles Matching Fund.

The achievement of an imitation of real textures usually results in the illusion of a three-dimensional image. This simulation, however, can result in a more abstract, two-dimensional space as in Georges Braque's still life (Figure 6.13), where the texture of the wood grain is imitated, not real.

Invented, Conventional, or Symbolic Texture

Invented, or decorative, textures do not imitate textures in real life; the artist invents the textural patterns. Invented textures can be nonrepresentational patterns as in David Hockney's sketch for the stage designs for *The Rake's Progress* (Figure 6.14). They also may be abstracted, conventionalized textures symbolizing actual textures; for instance, Hockney uses symbolic notations for hair, fabric, and crocodile skin.

Conventionalized texture prevails in Jennifer Bartlett's diptych *In the Garden #116* (Figure 6.15). Depicting the essential elements of a garden such as the statue, the pool, and a schematic notation of plants, Bartlett opposes two shifting perspectives, suggesting movement of the artist/viewer at two different times and in two separate spaces. The elements of the garden are reduced to a minimum and severely abstracted; symbolic, conventionalized textures unify the disparate views. Although only sketchily indicated, there is adequate textural information to interpret water, plants, and walkway.

James Rosenquist's work is a concise compendium of texture, a good choice to conclude our discussion of actual, simulated, and invented texture.

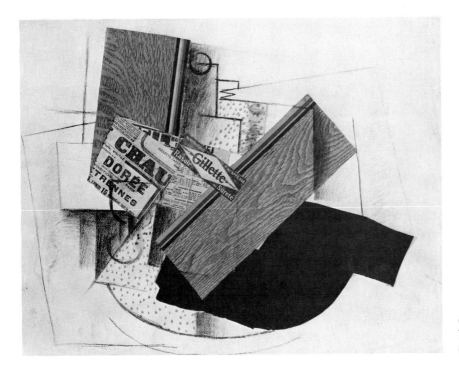

6.13. GEORGES BRAQUE. *Still Life on a Table.* 1913. Collage, 18½ × 24¾" (47 × 62 cm). Private collection.

In his lithograph *Iris Lake* (Figure 6.16) he combines all three kinds of texture—actual, simulated, and invented. Texture is, in fact, the subject of the work. The image on the left is an example of invented texture; the image in the center simulates crushed paper; and the third image makes use of actual

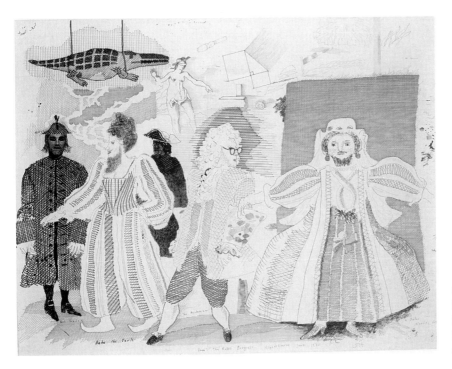

6.14. DAVID HOCKNEY. "An Assembly" from *The Rake's Progress.* 1975. Pen, colored inks, cut and pasted paper, 19¾ × 25⅝" (49.9 × 65.0 cm). The Museum of Modern Art, New York; gift of R. L. B. Tobin.

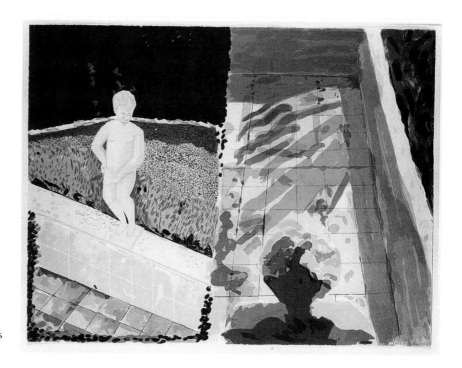

6.15. JENNIFER BARTLETT. *In the Garden #116.* 1982–83. 115 color silkscreen on Arches cover paper, 29¼ × 38¼" (74 × 97 cm). Edition: 100, plus 15 artist's proofs. Paula Cooper Gallery.

6.16. JAMES ROSENQUIST. *Iris Lake.* 1974. Lithograph, 3'1½" × 6'2" (93 × 188 cm). Marian Goodman Gallery. © 1997 James Rosenquist/Licensed by VAGA, New York, NY.

texture in the marks and rubbings. The pictorial space is ambiguous because the illusionistically three-dimensional elements are placed in a flat, white field. Are the shapes on top of the plane or are they holes in its surface? The black vertical lines reinforce this ambiguity.

Of course, texture is a critical element whether used referentially or independently of the subject depicted. Like the scale of artistic choices with realism at one end and nonobjective art at the other, there are gradations in the use of texture, too. Texture, although it can be used to record the ob-

served phenomenon of external reality, always relays information concerning media.

Frank Stella's planar surfaces with their graphic involvement are a major component in his work whether it be sculpture, painting, or works on paper. In the suite of etchings entitled *Swan Engraving Series* (Figure 6.17), textural variations combine with printed tablecloth patterns and labels to create a purely nonobjective work, dramatic with its deep illusionistic space. Stella says it is the space "around and behind things" that he aims for in his abstractions; textural variations are a means to this end.

This series of prints is a collage of sorts; Stella retrieved the offcuts or scraps of metal used in earlier constructions, fitting the pieces together, leaving no interstitial spaces. Although the engravings are black and white, there is a textural lushness that one usually associates with color. The broad, looping incised lines are etched into the metal to create a dense yet subtle surface of texture, shape, line, and value.

6.17. FRANK STELLA. "Swan Engraving III" from *Swan Engraving Series*. 1982. Etching, relief print, 5'6" × 4'3½" (1.66 × 1.31 m). Edition: 30. Tyler Graphics Ltd.

PROBLEM 6.1
Using Actual Texture

In this problem you are to focus on the texture of the drawing medium itself, its inherent qualities. Use mixed media such as chalks, pastels, and/or charcoal in conjunction with a glossy, water-based house paint. Begin with a gestural network of lines using various media; then overlay some sections with paint. Redraw, repaint until you have achieved an interesting surface and a satisfactory composition. Do not develop a focal point; the final product will be a continuous field, a vibrating plane that activates both positive and negative space.

PROBLEM 6.2
Using Simulated Texture

Choose as your subject a textured, two-dimensional surface, such as a weathered piece of wood, a textured piece of wallpaper, a piece of fabric, or a carpet sample (see Figure 8.24). Photocopy several of these textures, and make studies of both the actual texture and the photocopy in your sketchbook. After making a number of sketches, make a finished drawing in which you incorporate several kinds of simulated texture.

PROBLEM 6.3
Using Invented Texture

For this drawing you are to invent a mythological creature. Once you have decided on a subject, draw your conceptualized character by using enclosed shapes in both positive and negative spaces. Fill the entire page with enclosed shapes that you define by invented textural pattern and/or outline. Use pen and ink or black-and-white acrylic on fabric. The absorbent quality of the cloth will provide a softer and much different texture from paper. Experiment with several kinds of fabric; a tighter weave will allow you more control. Some suggestions are: muslin, duck, sailcloth, or canvas.

You may change the scale of the textural pattern within a shape in order to indicate a spatial progression or you may choose to use an ambiguous

6.18. MICHAEL ABYI. *The Twins Who Killed Their Father Because of His Properties.* Ink on fabric, 33 × 22″ (84 × 56 cm). Collection Claudia Betti.

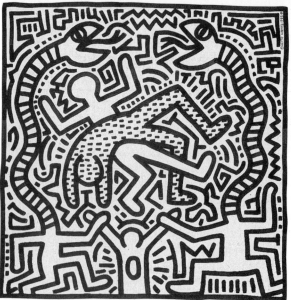

6.19. KEITH HARING. *Untitled* (for Malcolm McClaren Project December 1982). Black ink on paper, 23 × 23″ (58 × 58 cm). Courtesy of the artist's estate.

space as in Figure 6.18 by the African artist Michael Abyi. This lively ink drawing on fabric deals with a mythic subject, *The Twins Who Killed Their Father Because of His Properties.* Every inch of space is activated with bulging biomorphic shapes defined by decorative line-and-dot patterning; textural variations fill the composition, crowding out empty space. The compact design is made up of invented textures and fantastic shapes that reveal the artist's fertile imagination.

A second example, an ink drawing by Keith Haring (Figure 6.19), could also have been made in response to this problem. Here the line-and-dot texturing creates a flatter space than the Abyi work. The lines of maintained width are more geometrically organized, and in spite of the limited space and nearly symmetrical arrangement, the surface is charged with activity. We are reminded more of sounds than of space. Haring has effectively used repetition and rhythm to evoke jazz variations and riffs. The schematic figures seem to be performing some powerful ritual to a silent beat.

PROBLEM 6.4
Using Conventionalized or Symbolic Texture

Represent various surfaces in an imaginary scene by means of conventionalized or symbolic texture. You may choose to draw an imaginary landscape, or you might try drawing your room from memory. Aim for a symbolic interpretation of textures.

In David Hockney's *A Lawn Being Sprinkled* (Figure 6.20) symbolic or conventionalized texture dominates the composition. Repeating rows of diminishing-sized marks indicate grass; inverted triangles of spray paint represent

6.20. DAVID HOCKNEY. *A Lawn Being Sprinkled.* 1967. Acrylic on canvas, 60 × 60″ (152.4 × 152.4 cm). Collection of the artist.

sprayed water; alternating stripes of random value suggest a fence; rectilinear shapes predictably describe the roof tiles. Hockney's commitment to conventionalized texture has remained a constant throughout his career. Like many artists, Leonardo da Vinci the most famous among them, Hockney has been obsessed with the graphic description of water. Subjects such as pools, fountains, and showers continue to engage him and elicit inventive responses to the numerous ways moving water can be depicted on a flat surface.

TWENTIETH-CENTURY TEXTURES

Additive Materials to Create Texture

We mentioned earlier in this chapter the innovations of the Cubists in their introduction of collage and other additive materials to their art (see Figures 1.11, 6.13, and 10.17). We should not underestimate the decisive role this invention played in the development of later art of the century. Philosophically, these additive nonart materials expanded our ideas of what art can be. Additive materials are interesting because they retain a sense of their previous identity while functioning compositionally within the work.

We can divide such additive materials into two classifications: *collage* and *assemblage*. Collage is the addition of any flat material, such as paper or

6.21. KURT SCHWITTERS. *Merzzeichung 75 (Merz Drawing 75)*. 1920. Collage, gouache, red and black printer's ink, graphite on wood-pulp papers (newsprint, cardboard), and fabric, 5³/₄″ × 3¹⁵/₁₆″ (14.6 × 10 cm). Peggy Guggenheim Collection, Venice. The Solomon R. Guggenheim Foundation, New York.

fabric, to the surface of a work. Assemblage is the use of dimensional material attached by any means—glue, nails, wire, or rope, for example.

In the visual arts a major development by the Dadaists was *montage*—the combining of photographs, posters, and a variety of typefaces in startling new juxtapositions. The aim was to jolt the viewer; shock was the motive. These raffish anti-art artists began their campaign in 1918. They attacked the status quo, both in art and in politics. Artistic chaos paralleled political chaos. The Dadaists needed a disjunctive art form to hold up as a mirror to a world out of control. Montage became their primary means.

One of the best known artists to emerge from this movement was Kurt Schwitters. His collages are made up of tickets, newspapers, cigarette wrappers, rubbish from the street (Figure 6.21). An important element in Dada is randomness of chance as a compositional principle. The informality and looseness of Dada compositions along with a use of perishable materials had a lasting effect on later art in the century. Schwitters's engagement in everyday life resurfaced in the 1960s with the Pop artists' choice of banal, everyday subject matter. His famous announcement, "I am a painter and I nail my paintings together," could be the motto for late-twentieth-century art.

Several definitions of terms will be useful here in talking about texture. *Papier collé* is a term for pasting paper to the picture plane; *photomontage*, as its name implies, uses only photographs; *collage*, like *montage*, is any flat material put together to create a composition. Works using *papier collé*, collage, montage, and photomontage usually remain flat, although they can be built up in relief.

These techniques are alive and well in contemporary art, and nowhere are they more evident than in Barbara Kruger's work with its pointed exposé of establishment values (Figure 6.22). Kruger, like Kiefer, uses a visual method of deconstruction in demanding the viewer's reassessment of accepted ideas. A terse statement overlays a photographic image, and at the junction between the two lines a biting admission. Near the puppet's mouth is a line of tiny print that says, "We mouth your words." The message is clear, and the billboard size is not an easy one to ignore. Kruger's work begins with photographs and typography and is then mechanically reproduced; so the resulting image, while resembling a montage, is actually a single, unlayered plane. Kruger uses images appropriated from media to underscore her sociopolitical message. *Appropriation* may be used as a means of deconstruction; the appropriated image is given the task of revealing or exposing a hidden or underlying bias.

One final update on collage before we move on to our discussion of assemblage—Jacques de la Villéglé's work (Figure 6.23) is an offshoot of collage. He calls his work *décollage* (unpasting); he pulls down and reveals hidden, layered posters from Parisian walls, executing his art without scissors or paste. This idea had already been suggested as a possibility by Dada artists. Villéglé stresses the impersonal character of his work; he describes himself as an "anonymous lacerator."

Assemblage, called by one critic "home-grown California modern art," was firmly in place in the 1960s. Assemblage has held a continuing attraction, not only for the Pop Artists, but for artists of the Post-Modern period as well.

Jim Dine, who first emerged as a Pop Artist, uses assemblage in his work, frequently attaching art implements and tools to the surface. These implements refer to artmaking; they make a Modernist comment, a self-reference

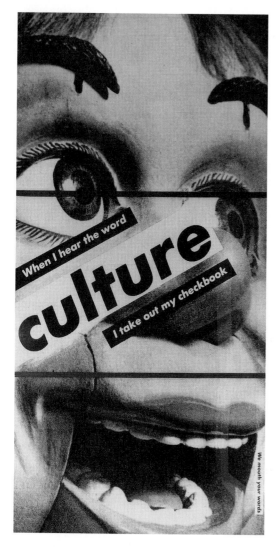

6.22. BARBARA KRUGER. *Untitled (When I Hear the Word Culture I Take Out My Checkbook)*. 1985. Photograph, 11½ × 5′ (3.51 × 1.52 m). Mary Boone Gallery.

6.23. JACQUES DE LA VILLÉGLÉ. *Metro Saint-Germain*. 1964. Torn posters, 19 × 13½″ (48.3 × 34.3 cm). Zabriskie Gallery.

to the nature of art. Everyday objects are infused with personal meaning in Dine's work, especially in his thematic series whose subject is a bathrobe. The bathrobe becomes a stand-in for the artist's self-portrait. In Figure 6.24 a drawing of the robe is shown in combination with three-dimensional cement objects.

Depending on the dimensional items added to the surface, an assemblage can range from a low relief to a freestanding, three-dimensional composition. It can combine both two- and three-dimensional elements in the same work. In the introductory remarks to this chapter we discussed the object as a special genre in twentieth-century art. The object as a work of art had two major influences: Cubist collage and Dada, which opened art to include heretofore nonart objects. Perhaps the artist best known for his objects and for his assemblages is Joseph Cornell. His intimately scaled, beautifully crafted, poetic works are shadow-box glimpses into a private, intense world. In Figure 6.25 the dimensionality of the twigs combines with a flat scale model

of a building, enriched by drawn architectural ornament to produce an intricate and delicate "setting for a fairy tale," as its title informs us. Cornell contrasts the actual texture of the twigs with the simulated texture of the architectural embellishment. The discrepancy in scale and texture between the real and drawn gives the work its surreal quality.

A logical development of assemblage is the blurring of categories between two- and three-dimensional art. In earlier times the separation of sculpture, painting, and drawing was readily determined. Today the demarcation is less precise. Installations, such as the chaotic environment created by the Soviet artist Ilya Kabakov in *The Man Who Flew Into Space From His Apartment* (Figure 6.26), use both two- and three-dimensional objects, drawing, painting, and photography with both real and pictorial textures. The diorama of a grim communal Moscow apartment is accompanied by an extravagantly fantastic narrative written by the artist. In this fictive account the lonely inhabitant of the room realizes his dream of a flight into space by catapulting himself through the attic with his vault. The ceiling is ripped away by the explosion, leaving the squalid room in shambles. Kabakov absurdly concludes that in all probability the project was successfully realized. Even this turbulent and illogical piece does not measure up to the dramatic chaos experienced by the Soviet states in recent years.

In collage, montage, photomontage, assemblage, and installations, bizarre and unlikely combinations press the viewer to interpret, to find meaning in the disparate pieces. The breakdown of conventional categories and predetermined rules for art has helped close the gap between art and life, a steadfast goal of the artists of our era.

6.24. JIM DINE. *Charcoal Self-Portrait in a Cement Garden.* 1964. Charcoal and oil on canvas with 5 cement objects, 8'11¼" × 3'9⅝" × 2'3" (2.75 × 1.17 × .69 m). Allen Memorial Art Museum, Oberlin College, Oberlin, Ohio. Ruth C. Roush Fund for Contemporary Art, 1965.

6.25. JOSEPH CORNELL. *Setting for a Fairy Tale.* 1942–1946. Box construction, 11⅜" × 14½" × 4" (29 × 37 × 10 cm). Peggy Guggenheim Collection, Venice.

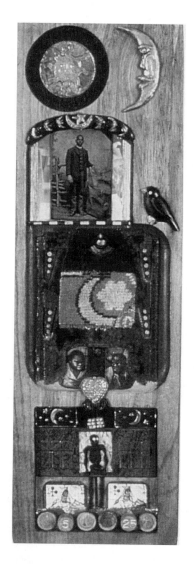

6.26. ILYA KABAKOV. *The Man Who Flew Into Space From His Apartment.* 1981–88. From *Ten Characters.* 1988. Installation, six poster panels with collage, furniture, clothing, catapult, household objects, wooden plank, scroll-type painting, two pages of Soviet paper, Diorama; room 8′ × 7.11″ × 12″ (2.44 × 2.41 × 3.73 m). Ronald Feldman Fine Arts Inc.

6.27. BETYE SAAR. *Is Jim Crow Really Dead?* 1972. Mixed media assemblage, 17 × 5½ × 1″ (43.2 × 13.3 × 2.54 cm). Collection of the artist.

PROBLEM 6.5
Using Papier Collé

For this problem, reassemble old drawings to create a new work. For example, you might tear up old figure drawings and rearrange the pieces to make a landscape. Pay attention to the shapes of the torn paper and to the marks drawn on them. Paste the torn paper on a piece of heavy supporting paper and redraw, integrating the *papier collé* into the work.

PROBLEM 6.6
Using Collage

Make a composition with photocopies using an arrangement of real objects directly on the copier. Make several different compositions, altering placements of the objects until you have a good selection. Choose one of these to develop into a final drawing. Take care in choosing the objects; try for a wide range of textural variety. You may (or may not) draw on the sur-

face, using such media as colored pencils, grease markers, pencil, or ink. Add textural elements; you could embellish the surface with ribbons, buttons, fabric, and drawing. The result could be an odd amalgamation of seemingly realistically rendered textures in illogical relationships. If you include objects of different scale, the disorientation will be even greater.

PROBLEM 6.7
Using Assemblage

Make an assemblage that takes into account some aspect of history. You might find photographs, illustrations, and three-dimensional objects that relate to a particular historical event to use in making a bas-relief or shadow box. Reacquaint yourself with Joseph Cornell's boxes (see Color Plate 3 and Figure 6.25). The assemblage could be freestanding, as in the art history raid by the contemporary artist Larry Rivers. (For a satirical rendition of Manet's *Olympia*, see Figure 10.8.)

The black artist Betye Saar expands our understanding of American culture from a black female point of view. In her assemblages the African-American spiritual tradition is extended through accumulations of both fabricated and found objects (Figure 6.27). Saar's bas-relief, using a stacked composition, undergoes a transcendent change from bottom to top; the repeating moon, the very symbol of change and darkness, is transformed from a flat schematic semicircle to a full-blown, dominant, and dimensional man in the moon with his companion sun ringed in black. The work is both intensely personal and touchingly universal at the same time.

Transferred Texture

Related to both actual texture and simulated texture is the transfer of a texture from one surface to another, a technique called *frottage*, developed by the Surrealists in the 1920s. This transfer can be made by taking a rubbing from an actual textured surface or by transferring a texture from a printed surface onto the drawing. Transferred textures cannot clearly be categorized as actual texture or simulated texture because they possess elements of both; they belong to a crossover category.

In the rubbing *The Great American Dream: Freehold* (Figure 6.28), Robert Indiana centralizes a large heraldic image for Americans. In Indiana's work, the rubbing movement diagonally from right to left creates an overall texture that flattens the space. Small areas of lighter value activate the space and break the otherwise insistent textural surface. The image is made static by its central placement and by the enclosed shapes, especially the closed circle. Such complete balance in the positioning of the image permits no movement. The stars above the image are likewise symmetrically placed, as is the rectangular shape of the word *freehold*. Heraldry is a branch of knowledge that deals with family pedigrees and describes proper armorial insignia. Indiana's rubbing makes a droll comment on democracy by creating a heraldic emblem for Americans.

Transfer from a printed surface is a popular contemporary technique. The image to be transferred is coated with a solvent and then laid face down onto the drawing surface and rubbed with an implement such as a wooden spoon, brush handle, or pencil. The directional marks made by the transfer

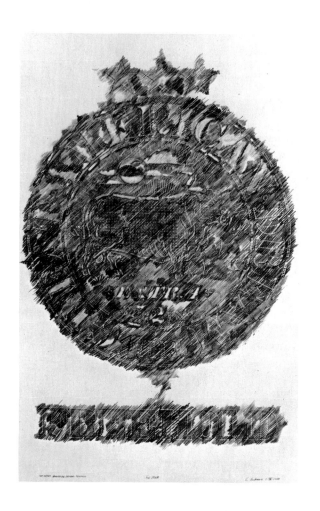

6.28. ROBERT INDIANA. *The Great American Dream: Freehold.* 1966. Conté crayon stencil rubbing, 40 × 26″ (102 × 66 cm). Courtesy of the artist.

implement provide additional textural interest in a drawing. Robert Rauschenberg developed the technique of transfer from a printed surface in the 1950s as a means of reintroducing representational imagery different from other realist techniques. Rauschenberg used secondary sources taken from the mass media in his transferred imagery in drawings and prints. In *Canto XXI, Circle Eight, Bolgia 5, The Grafter* (Figure 6.29), based on Dante's *Inferno*, Rauschenberg combines rubbed transfer with gouache, collage, graphite, red pencil, and wash. The marks made by the implement in transferring the images provide textural unity for the composition. The overall sameness of line direction has the effect of flattening out the images. At the same time the streaked lines build on one another to make an agitated surface, creating a nervous movement throughout the work. Dante's *Inferno* is given a modern interpretation; war, quite literally, is hell. Texture along with image are the carriers of meaning.

Another technique claimed by artists is the photocopy. It is an accessible and speedy solution to providing multiple images so prized by contemporary artists. Photocopied images are a rich source for collage. The readily available process depends on the texture inherent in the medium of the copy and the texture of the object being photocopied. Photocopies lend themselves easily to the process of transfer from one surface to another.

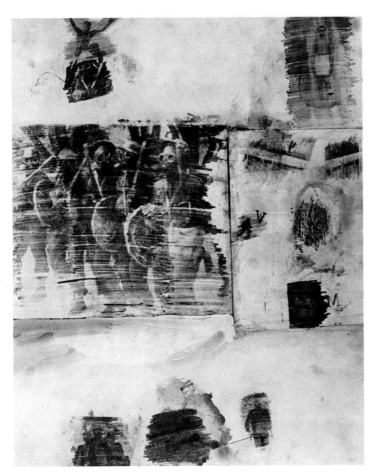

6.29. ROBERT RAUSCHENBERG. Illustration for *Dante's Inferno: Canto XXI, Circle Eight, Bolgia 5, The Grafter.* 1959–1960. Red and graphite pencil, gouache, cut-and-pasted paper, wash, and transfer, $14^3/_8 \times 11^1/_2''$ (37×29.3 cm). Collection, The Museum of Modern Art, New York. Given anonymously. © 1997 Robert Rauschenberg/Licensed by VAGA, New York, NY.

PROBLEM 6.8
Using Rubbing

Using a graphite stick, a litho stick, or a china marker, make rubbings of several textured surfaces, combining them into one image or into one composition. By changing pressure on the drawing implement and by controlling the line direction, you can create a range of values. In addition to creating interesting textures, aim for some spatial tension in the work. Line direction and change in value will help establish a sense of space. The resulting space will, of course, be ambiguous since the rubbing technique creates a uniform texture within a shape.

Oriental papers are good for rubbed drawings. They are strong and can withstand the friction without tearing, and they are texturally interesting. Consult the Guide to Materials for a list of papers.

PROBLEM 6.9
Transfer from a Printed Surface

In this project you may use images from magazines or newspapers, or photocopies of images. If you choose photocopies, duplicate several images

6.30. SIGMAR POLKE. *Frau Herbst und ihre zwei Töchter (Mrs. Autumn and Her Two Daughters).* 1991. Artificial resin and acrylic on synthetic fabric, 9′10″ × 16′ 4³/₄″ × 1⁵/₈″ (3 × 5 m × 4 cm). Collection Walker Art Center, Minneapolis; gift of Ann and Barrie Birks, Joan and Gary Capen, Judy and Kenneth Dayton, Joanne and Philip Von Blon, Penny and Mike Winton, with additional funds from the T. B. Walker Acquisition Fund, 1991.

to be used in one composition. You may wish to copy the same image several times, either enlarging or reducing the scale on the copy machine. Use a machine that produces a good value contrast.

Make a drawing using transferred images. Alcohol can be used for transferring photocopies, turpentine or Nazdar for magazine images. Lightly brush the solvents on the back side of the image to be transferred, and let it set a minute so that the ink will soften before beginning to rub. Lay the image face down on the picture plane and rub with a wooden spoon, brush handle, or pencil. Work in a well-ventilated space.

After having decided on placement, distribute the transferred images throughout the picture plane; integrate the composition by using gouache, graphite and turpentine, watercolor, or ink wash. You may choose to draw over certain areas in order to unify the work so that the images emerge from and dissolve into the background space.

Familiarize yourself with Rauschenberg's prints and drawings where this technique is used extensively.

A good quality rag paper is ideal for this problem. Consult the paper list in the Guide to Materials.

While Sigmar Polke has not used transfer in his wall-sized painting, it might be informative to analyze his work before beginning this project. In *Mrs. Autumn and Her Two Daughters* (Figure 6.30) Polke has imitated and vastly enlarged images taken from nineteenth-century wood engravings; the theme is an allegory in which Mrs. Autumn, the seasonal Mother, cuts up pieces of paper which her daughters strew over an abstract landscape in imitation of a snowstorm. On the formal side the deft control and scale of the mimetic copy in conjunction with the experimental abstraction in the remaining space set up a deliberate dissonance of textures, styles, images, scale, and media. The compression of time and sensibility between the images and styles is a suitable foil for Polke's attack on the coherence of Modernism and the cult of the personality of the artist.

SUMMARY
SPATIAL CHARACTERISTICS OF TEXTURE

Generally, uniform use of textural pattern and invented texture results in a relatively shallow space. A repeated motif or texture that remains consistent throughout a drawing tends to flatten it.

The use of simulated and invented texture in the same drawing results in arbitrary space, as does a combination of simulated texture and flat shapes.

Simulated texture is illusionistically more dimensional than invented texture. If sharpness of textural detail is maintained throughout the drawing, space will be flatter. Diminishing sharpness of textural detail results in a three-dimensional space. Objects in the foreground that have clearer textural definitions than those in the background usually indicate an illusionistic space.

In summation, simulated texture is generally more three-dimensional than invented texture. Repeated patterns or textural motifs result in a flatter space. Spatial ambiguity can result from a use of simulated and invented texture in the same work.

SKETCHBOOK PROJECTS

PROJECT 1
Identifying Textural Techniques Used in Depicting Water

This assignment goes beyond the actual sketchbook. Go to the library and look at some work by artists who use images of water in their work. In this text you will find images using water by Roy Lichtenstein, Ben Schonzeit, Jennifer Bartlett, and David Hockney. Their styles range from hyperrealism to the comic book techniques of Lichtenstein. In addition to others you will find, be sure to look at the notebooks of Leonardo da Vinci with their scientific and visual investigations of the properties of water.

In your sketchbook take verbal and visual notes of how the various artists have approached the problem of depicting this fluid and symbolically loaded element. Classify the textures according to the various categories discussed in this chapter. Note the scale of textural variety from photorealistic to illusionistic to symbolic to abstract. Describe the kinds of marks, styles, and media used to achieve various textural effects.

PROJECT 2
Transcribing Textural Techniques

Make a list of different kinds of water images—for example, swimming pools, waterfalls, natural pools, lakes, oceans, droplets, water running from spigots, bathtubs, showers, sprinklers, birdbaths, boiling water, ice water in a glass, steam, fog, rain, splashing water, standing water, turbulent water, and so on—the list should be as comprehensive as possible.

Write verbal descriptions of the characteristics and properties of each item on your list.

Choose a minimum of seven kinds of water to transcribe into drawn textures in your sketchbook. The size of each textural notation should be at least 4 × 4″ (10.16 × 10.16 cm), or it can fill a full page. Experiment with different kinds of media and with different kinds of marks. Scale is an interesting aspect of this project. In some of your transcriptions try for an illusionistic rendering; in others synthesize the information in a nonconventional approach. Make a minimum of five drawings for each category.

Variations on this problem can be done with an endless number of textural challenges: urban textures, manufactured surfaces; natural, organic textures, such as animals, plants, or minerals; secondhand textures drawn from found printed surfaces, such as photographs or illustrations. You might want to devote a special notebook to textures for reference in later work.

Both transcribing visual textures and inventing ways to symbolize texture will sharpen your perceptual and conceptual skills. Finding the appropriate textural notation for the message in the work is a lifelong challenge for the involved artist.

CHAPTER 7

COLOR

FUNCTIONS OF COLOR

COLOR, MORE THAN ANY OTHER ELE-
ment, has a direct and immediate effect on us, on the emotional, intellectual,
psychological, even the physical level. It evokes associations and memories;
it can provoke the full gamut of physical responses such as anger, excitement,
sadness, peacefulness, and joy. Our language is full of references, analogies,
metaphors, descriptions, and allusions to color. Cy Twombly calls attention
to the emotive, expressive, symbolic, and associative powers of color in his
work that resembles a discarded page from an intimate diary (Color Plate 9).
In mute, stuttering handwriting he scribbles the heart-wrenching message, "In
his despair he drew the colors from his own heart"; and that color from the
heart is red, quite a contrast to the dark and somber mood of the seemingly
illiterate written fragment. This work would carry a different meaning and
emotive content if it were made in another color. The scale of the hand-
writing enlarged to the nearly five-foot-high format makes us confront the
drawing and its message as something more than a discarded sheet of paper.

Twombly's scrawled writing evokes a visceral response, and being aware of that, he chose the most powerfully loaded symbolic color of all to carry the impact of the message, red.

In daily language we use color in our descriptions of objects in the real world. In addition, we use color to describe such phenomena as a musical instrument's timbre or distinctive sound quality by referring to its tone color; chromaticism in music refers to the use of sharp or flat notes in chords and harmonic progressions or in the chromatic scale. In literature color is used to describe an ornate style, or one that has particularly vivid descriptiveness. "Colorful characters," "colorless situations," "things take on a different color," "alibis are colored," "anger colored her decision"—expressions such as these give vitality to our language and underscore how deep-seated our human response to color is. In our everyday conversations adjectives relating to color are legion: gaudy, bright, intense, fresh, deep, gay, brilliant, lustrous, florid, flashy, glaring, soft, subdued, tender, dull, lifeless, leaden, muddy, pale, sallow, faded, lackluster—we could go on for pages. Color lies at the very core of our sensual, visual, and conceptual experiences.

Children intuitively seem to understand not only the aesthetic function of color but its symbolic significance as well (see Color Plate 1). Exciting and unexpected color combinations are also found in the work of self-trained artists, so-called outsider art. In their work, color runs the gamut from naïve to intuitive to sophisticated. Their color choices are subjectively selected and seem perfectly in tune with their frequently quirky subject matter.

Culture is a determinant of how color is viewed; for example, the color of royalty in Eastern cultures is green while in European cultures it is purple; black is symbolic of death in European cultures, while in many African cultures white signifies death. There are as many ways of looking at the world as there are people in it. Space and time are experienced differently by different cultures, so it is no surprise that color should not be exempted from cultural interpretation. One of the positive benefits of art is that it may lead to acceptance of differences in people and cultures when other efforts fail. Viewing art from other cultures and trying to understand its bases are ways to expand our humanity.

Attitudes toward color are culturally revealing. Juan Sánchez, an American-born artist of black and Puerto Rican descent, creates work that reflects his ethnically diverse background (Color Plate 10). His work combines religious, mythical, and cultural symbolism with a strong social consciousness. He uses both *barrio* and Anglo sources for ideas and images. Sánchez describes his efforts as "reconstructions" ("Rican/structions") forging a relationship between his homeland and his Brooklyn neighborhood. His sensuous palette is emotionally charged; we can feel the island's climate in his color choices. The colors from the tropical landscape unify Sánchez's work, and they provide a symbolic underpinning of his visual ideas. He uses large-scale, altarlike formats on which he combines photos, newspaper clippings, and religious artifacts with handwritten texts inscribed over and around the images. The textural surface of the paintings reminds one of urban walls with graffiti and torn posters. Sánchez combines abstract shapes with religious icons and photography of real people, fragments from everyday life. Layered, hot colors, actively applied, connect the disparate segments both conceptually and formally.

At certain periods of time people have expressed decided color preferences; for example, in the 1960s Americans generally preferred clear, intense colors associated with advertising and television. In the 1980s Victorian color schemes for houses were making a popular return, a break from the preference for all-white houses that prevailed for many years. In the 1990s, more subtle and complex color combinations have found favor; layering of colors on interior walls is a revival from historical periods. Even geography plays a part in color preference; certain colors seem to be right for specific climates, such as pastel colors in California and tropical towns or the rich range of grays in New York City.

COLOR MEDIA

The importance of materials in the use of color cannot be overestimated since the work is as much a product of what it is made of as how or why it is made. Involvement, practice, and experimentation with color media will give you new respect for the integral nature of each medium. Pastels are dry and chalky; watercolors are transparent; gouaches are opaque; acrylic and oil can be used as thin and fluid washes or they can be applied in a thicker, flatter, more opaque state; pen and ink drawings can be scratchy; ink and brush drawings can be fluid, stippled, rubbed, or dabbed; oil crayons leave a waxy buildup. This is not to say that materials cannot be handled in ways contrary to their basic nature, but that their inherent characteristics should first be understood.

Certain media are preferred over others in any single work; it is, as we have seen, the fusion of materials and idea that makes for a successful drawing. In some contemporary work, the medium can literally be the message.

Color evokes often visceral, instinctual, or intuitive responses. We respond not only to the color but to the medium itself. In art the very signs of spontaneity are directional marks that signify the speed of execution. And they signify the singularity of a particular, unique moment; they are a mirror of time, a conjunction of action and material.

Richard Diebenkorn's gouache (Color Plate 11) is from *Untitled* (*The Ocean Park Series*); the black lines form a scaffold which holds the suspended, disembodied wash in check. The picture plane is divided into asymmetrical shapes with thick and thin loosely applied brush washes that contrast with the taut underpinning of the linear elements. Color is subtle—a rich range of blues, browns, and grays dominate while a thin red line peeks through in the upper right-hand corner. It has been suggested that the California coastline, the location of the artist's studio, is the source of the abstract imagery in this series. Diebenkorn has chosen a color range that suggests the light and tonalities found in a coastal landscape.

Before you begin the color problems, carefully examine the color plates in the Part II Introduction to space and in this chapter. Note what medium is used in each work, how it is applied, and what effects are achieved with the various color media. Remember that your experiments with color application should be based on the knowledge and experience you have already gained from working with various wet and dry media.

Here are some suggestions to follow when working with color.

GUIDELINES FOR WORKING WITH COLOR

1. Avoid filling a shape with a single color unless you desire a spatially flat effect.
2. Experiment with layering colors, combining multiple colors to build a rich surface.
3. Think not only in terms of color but value as well.
4. Combine media—incorporate charcoal, pencil, conté crayon, china markers, oil crayons, and ink with any or all of the color media.

Because color is such an eye-catching and dominant element, do not forget what you have already learned about the role of shape, value, line, and texture. Color can be used to develop a focal point in an otherwise achromatic drawing; it can be used to direct the eye of the viewer through the composition; and it can be an effective tool for creating spatial tensions in a drawing. Give consideration to your own personal response to color and try to broaden your color tastes.

PROBLEM 7.1
Using Color Media

Choose an old drawing to recycle as a base for this problem. On top of the drawing use a number of colors of oil pastel to build a surface. Try overlapping the colors, drawing directly over the already established image. Try to create an interestingly colored and textured surface. Notice that even though you may have used only five or six colors, your palette seems to be more extensive; this is because of the color mixing, one color modifying another. Take advantage of these color changes.

Use a wash such as turpentine, gesso, or ink in several places to create focal points or to unify the drawing. You might want the underdrawing to reappear in certain places; in this case, redraw the image, incorporating some of the medium used in the original background drawing in combination with the color. Continue to layer images and color until you have achieved a satisfactory effect.

COLOR TERMINOLOGY

Our discussion of color begins with some definitions and terms. Color has three attributes: hue, value, and intensity.

Hue is the name given to a color, such as violet or green.

Value is the lightness or darkness of a color. Pink is a light red; maroon, a dark red. As noted in the chapter on value, a change of values can be achieved by adding white, black, or gray. A color can also be heightened, darkened, or modified by mixing or overlaying two or more hues. Color media can be built up, layered, and modified. Paper can be toned with an overall colored value on which marks of various hues and values can be overlaid

to build a richly dense colored surface. Intense colors can be modified to darker values by such overlays. Dulling and modulation of a color can be achieved by applying color on top of color. Unexpected "no-name" colors can result from this technique.

Intensity refers to the saturation, strength, or purity of a color. The colors in Wayne Thiebaud's *Candy Ball Machine* (Color Plate 12) are so intense that they could have been derived from color television. It is as if the hues had been turned up to a high level of brilliance.

The *Munsell Color Wheel* (Color Plate 13) is a circular arrangement of twelve hues, although one can imagine an expanded gradation of color. These twelve colors are categorized as primary, secondary, and tertiary. The *primaries* (red, blue, and yellow) cannot be obtained by mixing other hues, but one can produce all the other hues by mixing the primaries. *Secondaries* (green, orange, and violet) are made by mixing their adjacent primaries; for example, yellow mixed with blue makes green. *Tertiaries* are a mixture of primary and secondary hues; yellow-green is the mixture of the primary yellow and the secondary green.

Local color and *optical color* are two terms artists use in describing color. Local color is the known or generally recognized hue of an object regardless of the amount or quality of light on it, for example, the red of an apple, the green of a leaf. The local color of an object will be modified by the quality of light falling on it. Bright sunlight, moonlight, or fluorescent illumination can change a color. If, for example, we imagine an intense red object under moonlight, the intense red, the local color of the object, might change to a deep red-violet, and we would call this its optical, or perceived, color. The distinction between local and optical color is that one is known (conceptual) and the other is seen (perceptual).

PROBLEM 7.2
Using Local and Optical Color

In this problem you are to duplicate as closely as you can the perceived color of an object. In verbal descriptions of the color of an object, it is usually enough to name a single hue, as in "a red apple." But an artist must describe the apple more accurately, using more than one hue.

The subject of this drawing will be, in fact, a red apple. Tape off a segment on the surface of the apple—a rectangle 2 by 3 inches (5 × 8 cm). Using pastels, make a drawing of this selected area, enlarging the section to 18 by 24 inches (46 × 61 cm). Use a buff-colored paper: Manila paper is a good choice. The drawing will be a continuous-field composition, focusing on color and textural variations.

Examine the portion of the apple to be drawn very carefully, analyzing exactly which colors are there. You may see an underlying coat of green, yellow, maroon, or brown. Tone your paper accordingly and build the surface of your drawing using layers, streaks, dabs, and dots of pastels. The longer you draw and look, the more complex the colored surface will appear. Sustain this drawing over several drawing sessions. If you extend the drawing time to several days, you will find the apple itself has undergone organic changes and will have changed colors as a result. Adjust your drawing accordingly.

COLOR SCHEMES

Color schemes require a special vocabulary. Although there are other kinds of color schemes, we will discuss only monochromatic, analogous, complementary, and primary color schemes. A *monochromatic color scheme* makes use of only one color with its various values and intensities (see Color Plate 11).

An *analogous color scheme* is composed of related hues—colors adjacent to one another on the color wheel, as for example, blue, blue-green, green, yellow-green. Analogous color schemes share a color; in the example just given, the shared color is blue. A stripped-down analogous color scheme is used by Bruce Nauman in his *Drawing for Seated Storage Capsule for Henry Moore* (Color Plate 14). Nauman is a conceptual artist whose drawings are to be interpreted as blueprints or projected plans for objects to be constructed, or for installations. In this case the centralized image with its evocation of a seated mummy carries a good-humored barb at the artist Henry Moore, acclaimed for his hieratic sculpture and for his drawings with their cross-contour lines that wrap their subjects "like a mummy casing" (see Figures 3.25 and 5.20). If one ignores the title, which directs the interpretation of the drawing, this work by Nauman is strangely mysterious and archetypal, even elegant in its reductive color and shape vocabulary. The analogous colors are subtly modulated; their richness lies in the application of the media, pastel and acrylic.

Complementary color schemes are based on one or more sets of complements. Complementary colors are contrasting colors, which lie opposite each other on the color wheel. Blue and orange, red and green, yellow-green and red-violet are complements. Complementary colors in large areas tend to intensify each other. Small dots or strokes of complementary hues placed adjacently neutralize or cancel each other. The viewer blends these small areas of color optically and views them as a grayed or neutralized tone.

Not only does a color scheme organize a work by directing the eye of the viewer (like attracts like), but a color scheme is also the carrier of meaning in a work. The California artist William T. Wiley uses a primary color scheme in *Your Own Blush and Flood* (Color Plate 15). Not only do we find a primary color scheme and a primary triad (yellow, red, and blue), we find triads abounding in the work. Triangular forms are everywhere: three-pronged, forked limbs, a triangular tabletop; on one of the three central blocks are three symbols, one of them a triangle. There are three cut logs behind the bucket. Are we to surmise, then, that the triadic color scheme has symbolic meaning? Much of Wiley's work relies on paradox, on something being two things at once. Wiley learned from Zen Buddhism that opposites are reconciled when seen as a part of a continuous chain. (Are not the fans and spirals a visual metaphor for this chain? And since the palette has an analogous shape to the fans, can Wiley be giving us a clue as to the important role of art in the continuity of life?) Wiley's work is full of contradiction, complexity, humor, and metaphor. So engaging is it that we don't escape easily; he traps us into attempting to interpret the allegory.

Wiley directs us through his allegorical maze by both shape and color; the reds call our attention from one object to the next, while the complicated blue value patterns unify the jumbled composition. The crystalline colors are in keeping with the fragmented, broken quality of the images. The brittle, jagged edges echo the fragmentation inside the picture plane. Is Wiley say-

ing this is just a part, a fragment, of the greater picture, metaphorically speaking? He presents clues for interpretation grounded in the triangular forms; he offers reconciliation through the triad.

We have by no means exhausted the number of color schemes available to the artist. The chosen color scheme contributes to the overall mood and meaning in a work. Not only are these color schemes related to aesthetics and to the psychology of color, but they must suit the demands of the artist's own personal vision.

PROBLEM 7.3
Using a Monochromatic Color Scheme

From a magazine or newspaper, choose a black-and-white photograph with at least five distinct values. Enlarge the photograph to a drawing with no dimension smaller than 12 inches. Convert the photograph to a monochromatic drawing, duplicating the original values; for example, you might choose an all-blue or an all-red monochromatic color scheme. Take note of the value variations within a given shape and try to match them in your chosen color.

Some photocopy machines can duplicate images in red, blue, or yellow ink. It might be interesting, after you have completed your drawing, to photocopy the original black-and-white photograph using one of the primary colors; then compare the two versions.

PROBLEM 7.4
Using a Complementary Color Scheme

For this project use as your subject a still life by a window; combine an interior view with an exterior view. You may draw from life, or you may invent the scene. This was a favorite subject of Picasso and Matisse. Before you begin your drawing, go to the library and look at some books on these two artists; be sure to note their use of color and how it contributes to the spatial effect in each work.

Use a complementary color scheme, a color scheme of opposites, with no fewer than three values of each complement. You can mix the opposites to change intensity and use white to change value. You should use color arbitrarily; that is, do not use color to imitate local color and value.

Arrange your composition so that in some areas the complements intensify each other; for example, the view through the window might frame an intense color scheme. In other parts of the drawing, by using dabs of color, try to make the complements neutralize each other. (Analyze a full-color reproduction of Georges Seurat's *Sunday Afternoon on the Island of the Grande Jatte* for an understanding of how this works.)

Using adjacent dabs of color complementaries might be an appropriate approach for describing fabric, drapes, or wallpaper in the interior space. Experiment with various intensities and values and their relationships with their opposites.

By changes in value and intensity, you can make a color appear to advance or recede, expand or contract. Can you reverse the expected function of color? For instance, can you make a red shape appear to recede rather than

come forward as you would expect? Matisse is a particularly good artist to study in this regard.

WARM AND COOL COLORS

Colors can be classified as warm or cool. Warm colors, such as red, orange, or yellow, tend to be exciting, emphatic, and affirmative. In addition to these psychological effects, optically they seem to advance and expand. We can readily see some of these effects in the Sánchez work (see Color Plate 10). His warm (better said, hot) colors promote an active, excited response in the viewer. Even the greens and blues are warm tones. The work is organized by the broad expanse of the background colors. Try to imagine the effect of this work if the background spaces were white, black, or a cool blue; symbolic and psychological meaning would undergo a radical change.

Cool colors—blue, green, or violet—are psychologically calming, soothing, or depressive, and unemphatic; optically, they appear to recede and contract. These characteristics are relative, however, since intensity and value also affect the spatial action of warm and cool colors. Intensely colored shapes appear larger than duller ones of the same size. Light-valued shapes seem to advance and expand, while dark-valued ones seems to recede and contract.

PROBLEM 7.5
Using Warm and Cool Colors

In this problem you are to use two sources of light, one warm and one cool. Seat the model in front of a window from which natural, cool light enters. On the side of the model opposite the window, place a lamp that casts a warm light. Alternate the light sources; draw using the natural light for three minutes; then close the window shade and draw using the warm artificial light for three minutes. Continue this process until the drawing is completed.

Use colored pencils or pastels and no fewer than three warm colors and three cool colors. There will be areas in the figure where the warm and cool shapes overlap; here you will have a buildup of all six colors. Work quickly, using short strokes, overlapping color where appropriate. Focus on drawing the light as it falls across the form. You are to draw the light, in the negative space and on the figure. Do not isolate the figure; draw both negative and positive forms. Try to imagine the light as a colored film that falls between you and the model. Do not use black for shadows; build all the value changes by mixing the warm and/or cool colors.

Note how the short strokes unify the drawing and limit the space. By concentrating on the quality of light, you will find that you can achieve atmospheric effects.

HOW COLOR FUNCTIONS SPATIALLY

The spatial relationships of the art elements and the ways each element can be used to produce pictorial space are a continuing theme in this text. Color,

like shape, value, line, and texture, has the potential to create relatively flat space, illusionistically three-dimensional space, or ambiguous space.

When unmodulated flat shapes of color are used, when colors are confined to a shape, a flatter space results. But when colors are modeled from light to dark, a more volumetrically illusionistic space results.

Colors contribute to a three-dimensional illusion of space not only when they are modeled from light to dark but when brighter colors are used in the foreground and less intense ones in the background.

When flat color shapes and modeled color volumes are used in the same composition, an ambiguous space results. Further, when bright colors occur in the background of an otherwise three-dimensional shape, an ambiguous space results. In Michael Heizer's colorful work on paper (Color Plate 16), we see a complicated progression into space. The stacked boxes seem to occupy a logical perspectival space, with their edges forming flat color planes. The space surrounding them is an atmospheric one, somewhat diffused. There seems to be a transparent plane, like a piece of glass, that intervenes between the slabs and the viewer. On this imagined glass wall are scribbles, drips, and notations. The vivid red and yellow marks advance toward the viewer; the blue and turquoise marks occupy a second level, while the gray and black marks appear to be located on yet other levels. The diffused orange, green, and pink airy film made with spray paint looks as if it is suspended and hanging in space; sometimes it seems to come forward; at other times it moves back. Heizer has carried the spatial behavior of color to its limit; in fact, it is the very essence of this complex drawing. Color is both the means and the subject.

When color crosses over shapes, a flattening can take place, making space ambiguous. You can see this effect in Heizer's work in the areas where the blue crosses over the edges of the cubes and melds with shadows and negative space in the background forms. Sprayed color areas, colored marks, and drips all occupy an ambiguous space; they are not confined to a shape. In spite of the abstract nature of this work we sense a spontaneous physical immediacy and presence. A mood, an odd sense of place such as found in some fantastic mind travel, is the result of Heizer's unabashed use of color.

SOME EARLY INFLUENCES ON CONTEMPORARY ATTITUDES TOWARD COLOR

Because our current attitudes toward color have been shaped by earlier artists, a quick survey of some innovations in their treatment of color during the past hundred years is in order.

We might begin with what has been called the "revolution of the color patch," the revolutionary way the Impressionists applied color. With Impressionism in the late nineteenth century, artists began depending on more purely visual sensations. Their concern was the way light in its multiple aspects changes forms, and their approach was scientific in many respects. Recording the stimulation of the optic nerve by light, they began working outdoors directly from nature, using a new palette of brighter pigments and purer colors, applying them in broken patches. Dark shadows were eliminated, local

color was ignored, and local values or tones were abstracted to create atmospheric effects.

The Impressionists were innovators in color application, applying it in perceptible strokes unlike the smooth, brushed surface that characterized most earlier works. The outlines of objects were blurred in order to make them merge with their backgrounds. Volumes were diminished in favor of describing the effect of light over a form. These quick, broken strokes, suggesting the flicker of light, resulted in a sameness or uniformity in the overall texture that flattened the image and created a compressed space. Such strokes had the added bonus of allowing the artists to work more directly to keep pace with the changing light. The Impressionists saw that color is relative; when light changes, color changes.

The Post-Impressionists continued their predecessors' investigations into color. They used complementary colors in large areas to intensify each other and in small dabs to neutralize each other. They interpreted shadow as modified color, not simply as black or gray; and they made use of optically blended color. The viewer blends colors visually; a dab of red adjacent to a dab of green will be blended by the eye to appear gray. These complementary hues in small contrasting areas also made for greater luminosity and greatly enlivened the surfaces of the paintings.

Early in the twentieth century a group of painters called the *Fauves* (Wild Beasts), who were familiar with the color advances of the Impressionists and Post-Impressionists, renounced the pretense of recreating reality and began a subjective and symbolic investigation of color. They sought a heightened reality more exaggerated than actual appearances. The Fauves used flat, pure, unbroken color to further limit traditional perspective, depth, and volume.

Wassily Kandinsky, a contemporary of the Fauves, carried the freeing of color a giant step forward into abstraction. In placing emphasis on composition and color, he left representation of objects behind. His goal was to infuse shapes that had no reference to recognizable objects with a symbolic and metaphysical intensity, and he saw that the most direct means of achieving that goal was through the use of color. His memoirs open with the sentence, "In the beginning was color."

The Abstract Expressionists continued Kandinsky's freedom of paint application, but it was Hans Hofmann who was the teacher and theoretician for the advancement of modernist ideas concerning color and space. Fundamental perceptions led Hofmann to his rules concerning the flatness of the picture plane and the necessity for preserving its two-dimensionality. Foremost among his teachings were those dealing with color tensions to create spatial dynamics, his famous "push-and-pull" concept. Hofmann's art rules of pictorial grammar dealt with the distinction between positive and negative space, the autonomy of the picture plane, and the visual interaction of warm and cool colors to create pictorial spatial illusion.

Hofmann's theories concerning colors' perceptual retreating and advancing in pictorial space laid the groundwork for many of the color experiments in art later in the century. They had special influence on Color-Field artists and on modernist attitudes toward color in general.

Expressionists throughout this century—the German Expressionists before World War I, the Abstract Expressionists in the 1940s and 1950s, and the Neo-Expressionists in the 1980s—have all used color to underline their

PLATE 9. CY TWOMBLY. *Untitled.* 1985. Oil, oil/wax crayon, and water-based paint on board, 64⅟₁₆ × 46⅝₁₆″ (162.7 × 125.9 cm). Cy Twombly Gallery, Houston. Gift of the artist.

PLATE 10. JUAN SÁNCHEZ. *Bleeding Reality: Así Estamos.* 1988. Mixed media on canvas, 44 × 108½″ (1.12 × 2.76 m). Courtesy Exit Art, New York.

PLATE 11. RICHARD DIEBENKORN.
Untitled (The Ocean Park Series). 1972.
Gouache on paper, 27¾ × 18¼". (69 ×
46 cm). Arkansas Arts Center Foundation,
Permanent Collection.

PLATE 12. WAYNE THIEBAUD. *Candy Ball
Machine.* 1977. Gouache and pastel on
paper, 24 × 18" (61 × 46 cm). Collection
John Berggruen, San Francisco.

a. Hue

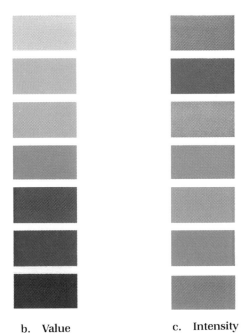

b. Value c. Intensity

PLATE 13. The major elements of color: hue (as expressed in the Munsell Color Wheel), value, and intensity.

PLATE 14. BRUCE NAUMAN. *Drawing for Seated Storage Capsule for Henry Moore.* 1966. Pastel and acrylic on paper, 42 × 35¾″ (106.7 × 90.8 cm). Private collection.

PLATE 15. WILLIAM T. WILEY. *Your Own Blush and Flood.* 1982. Watercolor on paper, 22 × 30″ (55 × 75 cm). Collection Byron and Eileen Cohen, Shawnee Mission, Kansas.

PLATE 16. MICHAEL HEIZER. *45°, 90°, 180° Geometric Extraction Study #1.* 1983. Silkscreen, watercolor, crayon, ink on paper, 50 × 50″ (125 × 125 cm). Private collection. Courtesy M. Knoedler & Co., Inc., New York.

own emotional responses. Strong contrasting colors applied in thick slashing strokes give urgency to a charged content.

The Color-Field artists in the 1960s saw that they could communicate essentially through color alone. Reducing their formal means, limiting shape, line, value, and texture, they depended on color to carry the weight of the work both in form and in content. Certainly the Color-Field painters can be said to be dealing with the physiological effects of color noted at the beginning of this chapter. The scale of these artists' works is so large that even our peripheral vision is encompassed. Envisioning the difference between a spot of red on a wall and an entire wall of red will enable you to understand better the concept of enveloping color. We are absorbed by the expanse of color and by the field of color in the painting; experience and vision are one.

The strategy of the Pop Artists in the 1960s and 1970s was to use technology and common objects in a man-made environment as sources of technique and imagery. They used advertising techniques and established a new palette based on color television and advertising layouts. Colors were intensified, often garish.

The Photo-Realists use film colors to establish their color. Taking their color schemes directly from the photograph, they present the viewer with an alternate means of establishing reality or verification. Image, color, and technique are derived from photography.

In contemporary art, color maintains its decisive role. All the earlier uses of color are exploited—the representative, emotive, psychological, and symbolic impact—for their subjective and objective functions.

The overriding lesson that contemporary artists have learned is that color is relative. Through a lifetime of experimentation Josef Albers investigated the relativity of color. In his theoretical writing and in his work he offered ample proof that color is not absolute but interacts with and is affected by its surroundings. Since colors are always seen in a context, in a relationship with other colors, artists must make use of this knowledge of color relationships.

PROBLEM 7.6
Studying Influences on Contemporary Color Attitudes

Go to the library and find two or three examples of the historical styles that have formed our attitudes toward color (Impressionism, Post-Impressionism, Fauvism, German Expressionism, Abstract Expressionism, Color-Field, Pop Art, Photo-Realism, and Neo-Expressionism). Look at one book on Kandinsky and one on Albers.

Pay special attention to color relationships and to color application. Reread this section while looking at the art work from the period. You need not limit your search to drawings because the artist uses color in much the same way whether the work is a painting, a drawing, or a print.

PROBLEM 7.7
Using Symbolic Color

Making a drawing in which you use color symbolically. Invent an imaginary scene or event as your subject. Use color to enhance the subject

both visually and symbolically. Consider not only the universal symbolic significance of your chosen palette, but think of personal associations the colors have for you. Try to weld message and color; aim for a formal and conceptual integration of color.

You might look at some work by Paul Gauguin and Vincent van Gogh, both of whom used color in new and unexpected combinations. Gauguin's *Yellow Christ* is a good example of the use of symbolic color. Van Gogh is well known for his impetuous use of color. His color choices are emotionally based and symbolically powerful.

A contemporary artist who uses dynamic symbolic color is the Italian artist, Francesco Clemente.

PROBLEM 7.8
Using Color-Field Composition

On a large format, one that is twice as wide as it is tall, divide the picture plane in half. On one side of your paper make a drawing using a recognizable subject (you may use local color or arbitrary color); on the other side use a continuous field of color. Aim for the same feeling on both sides. On one side you can convey your message by using images and color; on the second side you are limited to color as the carrier of the meaning.

Using a medium of your choice, give careful consideration to the exact color you need, not only to the hue but to its proper value and intensity. You may layer the color in washes, you may build the color in overlapping strokes, or you may use a saturated single color. Try to achieve the effect you want by this continuous field of color. Think of the color in psychological and symbolic terms; determine what you think the physiological effects might be.

Look at some work by the Color-Field painters such as Mark Rothko or Barnett Newman. Make a list of adjectives describing the moods or feelings the works elicit.

SUMMARY
SPATIAL CHARACTERISTICS OF COLOR

In the twentieth century we find art works that give the illusion of three-dimensional space, works that are relatively two-dimensional, and works that are spatially ambiguous. Color is one major determinant of spatial illusion.

When flat patterns of hue are used, when colors are confined to a shape, the shapes remain relatively parallel on the surface of the picture plane. On the other hand, when colors are modeled from light to dark, a more volumetric space results; and when bright colors are used in the foreground and less intense values are used in the background, color contributes to a three-dimensional illusion of space.

As a general rule, warm colors come forward and cool colors recede. This rule, however, is relative since the intensity and value of a hue may affect the spatial action of warm and cool colors.

When flat color shapes and modeled color volumes are used in the same composition, an ambiguous space results. When bright colors occur in the

background of an otherwise three-dimensional work, the background will seem to come forward, flattening the picture plane to some extent. Also when colors cross over shapes, a flattening takes place, making space ambiguous.

SKETCHBOOK PROJECTS

PROJECT 1
Using Color for Quick Landscape Sketches

Pochade is a French term for a rapidly made sketch, a shorthand notation. The Impressionists were famous for working outdoors on site; their *plein-air* practices are clearly apparent in their work. For this exercise you are to make a series of landscape sketches, or pochades, using various color media.

Choose a convenient site, one you can visit easily and frequently over the period of a week or so. Visit the setting at various times of the day (or night), and, if possible, under different weather conditions. You are to make a series of quick, abbreviated sketches using color to convey both the quality of light and the feel of the place. In the initial drawings let the optical color determine your palette. As you familiarize yourself with the actual setting and its compositional relationships, expand your color choices.

Use only dry media for one session, wet media for another, and combinations of wet and dry at other times. In spite of being quickly drawn, colors can be layered. You might make several drawings simultaneously, especially if you are working with wet media; then go back over them as they dry. This series can develop into some very interesting color relationships, changing values, hues, intensities from one wash to the next.

It is important to stay with the same subject in order to free yourself for color experimentation within self-set limits. At the end of the time designated for this project, you might want to choose one of the more successful sketches, or you might combine elements from a number of sketches in a larger, finished drawing which you complete in the studio. By this time your familiarity with the scene and your memory of it will enhance the preparatory sketches.

Acrylic or oil paint, colored inks, watercolor, and gouache are wet media that can be used for this project. Oil-based crayons, colored chalks, pastel sticks, pastel pencils, and colored pencils are suggested dry media. Water-soluble colored pencils are a good choice. Oil-based crayons are soluble in turpentine. Do not strictly limit the media to color media; the combination of pencil, conté, charcoal, and black ink with the color media can be very effective. Color can be used for the development of a focal point, or it can be used more extensively throughout the drawing. Think of it in descriptive, structural, and expressive terms.

PROJECT 2
Using Color to Convey Emotive Content

Bring your pochades back to the studio and make a second-stage series of color sketches from them.

Using color to carry the message of emotional intensity, make at least three different sketches. Each sketch should use color to convey a specific emotion such as joy, anger, or fear.

C O N V E N T I O N S F O R
C R E A T I N G S P A T I A L
I L L U S I O N

I<small>N TRANSLATING THREE-DIMENSIONAL</small> visual data from the real world onto the constraints of a two-dimensional surface, the artist must make a number of choices as to how to express the experiences and ideas of the phenomenal world. Some of these choices are made intuitively and others consciously. Some are personally determined while others are culturally influenced. Optical appearance is frequently insufficient for the artist who wants to express more about an object than a strict visual description taken from one particular viewpoint.

Any single expression of our multiple experiences in the world will, of course, be limited and partial. Advantages gained in one spatial system must be weighed against possibilities lost by not choosing another system. In Chapters 3 through 7 we saw how the spatial relationships of the art elements can be used to create pictorial space, how that space may be relatively flat, illusionistically three-dimensional, or ambiguous, depending on how the various elements of shape, value, line, texture, and color are used. We have looked at a broad spectrum of spatial approaches in the illustrations in this text; images that seem to jut out toward the viewer; other objects that appear to

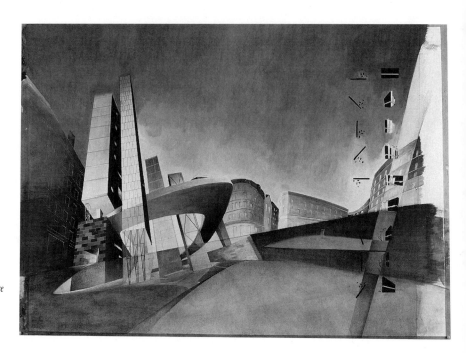

8.1. ZAHA HADID. *Worm's eye view of ramp and towers, competition entry from Trafalgar Square Grand Buildings Project, London.* 1985. Acrylic on paper, 25¾" × 18⅝" (65.4 × 47.4 cm). Private collection.

recede into space; and objects and figures that seem to occupy a jumbled, fragmented, illogical space.

Space is an essential ingredient in all the visual arts. In the performance arts, drama, and dance, the performers are contained by a designated space activated and transformed by the performers. In sculpture the viewer moves around the work to see it in its entirety; in painting and the graphic arts where space is pictorial, we are presented with an illusion of space. While architecture provides the spatial environment for our daily lives, architectural drawings present an illusion of space, as can be seen in the competition entry drawing by Zaha Hadid for Trafalgar Square Grand Buildings Project (Figure 8.1). In drawings for her innovative designs, Hadid looks back to Suprematist art as a basis for her drawing and then extends those ideas beyond contemporary architectural conventions. Implicit in her drawings are her ideas that social and technological changes demand visionary new uses of spaces. She employs radically new methods of architectural representation presenting a building from conflicting angles, from above and below simultaneously. Her visual language results in a narrative process. An explosively energetic setting is created by using distorted perspective, shifting eye levels, changing planes, and implied dynamic movement.

Drawings lend themselves particularly well to the development of architectural ideas, principles, theories, and techniques, but it is not just for their technical applicability they are valued; their aesthetic appeal can be equally strong.

Our ideas about space have changed radically in the twentieth century as scientific exploration of space has exceeded the most active speculations of the previous century. New knowledge and discoveries in an expanding universe, along with new ideas in physics, such as quantum mechanics and chaos

theory, have resulted in an ambiguous notion of space; so it is no surprise that the ways in which artists depict space also have changed.

This is not to say that an artist always predetermines the kind of space used in a work. Space can be intuitive, not accidental. This intuitive response comes not only from a cultural base but from a private, personal one as well. Other considerations, such as subject and intent, also enter into the decision.

You, as an artist, must have an understanding of space in order to analyze both your own work and the work of other artists. This understanding gives you wider choices in meaning and technique; knowing which techniques give the effect of two-dimensional, three-dimensional, or ambiguous space keeps you from making unintentional contradictions in your work. Knowledge of how the elements function will help you carry out your intention.

In this chapter we will look at perspective, that convention of representing three-dimensional objects as they appear to recede into space onto a two-dimensional surface. The word *perspective* comes from the Latin, which means "to see through or into." In traditional art, perspective relationships that exist in the real world are transcribed onto the confines of the two-dimensional picture plane. In looking at a work of art that employs traditional perspective, we as viewers can project ourselves through our imaginations into that imitation, or simulacrum, of real space.

A theory developed in the Renaissance, linear perspective is a quasi-mathematical system based on the observations that parallel lines seem to converge as they move into space, that all lines going in the same direction into space appear to converge or meet at a single point on the horizon. This discovery of perspective provided art with a forceful and exciting impetus at a time when many former ideas and ways of interpreting the world were being replaced with new observations and theories.

According to this convention, objects appear larger or smaller in relation to their distance from the viewer. This recession into space can be relayed by the artist according to certain rules. Some knowledge of perspective is invaluable to the artist, but it also has limitations. Perspective should be used as an aid in seeing, not as a formula to be substituted for visual acuity.

Keep in mind that linear perspective is only one of many systems of representation and is not always the most appropriate choice for a particular idea. In different time periods different systems have been dominant. In non-Western art, in children's art, in the art of the Middle Ages, and in the art of the twentieth century, the dominant system of representation has not been linear perspective, but has made use of a combination of multiple viewpoints.

EYE LEVEL AND BASE LINE

One important matter that the artist must consider in the treatment of space is the use of eye levels. An *eye level* is an imaginary horizontal line that is parallel to the viewer's eyes. When we look straight ahead, this line coincides with the horizon. If we tilt our heads, if we move our angle of sight to a

8.2. ANN PARKER. *Sturgeon Stake Out.*
1991. Linocut, 30 × 50″ (76 × 127 cm).
Courtesy of the artist.

8.3. ANN PARKER. *The Prize* from
"Northern Sports Series." 1991. Linocut,
30 × 50″ (76 × 127 cm). Courtesy of the
artist.

higher or lower position, this eye-level line will also change on the picture plane, thereby making the horizon line seem higher or lower.

Two extremes of eye level, the ant's-eye view and the bird's-eye view, are amplified in the exuberant works by Ann Parker from her "Northern Sports Series" (Figures 8.2 and 8.3). The first print is from an ant's-eye view, or better said, from a sturgeon's view. The sturgeon in this linocut are lures, or decoys, ornately carved and decorated to attract the real sturgeons. From beneath the ice we look to the surface where the frigid fisherman is patiently staked out, trident in hand. We perceive the fish and sportsman as occupying two different levels of space, and two different states of mind: the decoys seem more animated than their owner.

Parker's second print, titled *The Prize*, makes use of an overhead viewpoint; forms diminish in size as the space recedes from top to bottom of the picture plane. The ice fisherman proudly displays his catch while the lures seem to share in his achievement; the "Prize" itself seems somewhat skeptical. A conceptually deeper space is indicated by the dark hole in the ice occupied by the sturgeon who witness the boast; this inset does not make use of the bird's-eye perspective; it is indicated by a more normal head-on perspective, a penetration of space from front to back. A third, and very clever,

8.4. MIKE PARR. *The Inertia of Night (Self Portrait as a Slat).* 1983. Charcoal and Giroult on paper, 8′11⅞″ × 6′ (2.74 × 1.83 m). Collection of Roslyn and Tony Oxley, Sydney, Australia.

kind of space is used in the sketchy background; Parker has distorted the space to wrap around the fisherman and his catch. This circular notation of Lake Winnebago and its surrounding woods holds the key to a visual pun. In photography the lens that compresses a 360-degree view onto a rectilinear format is called a "fish-eye lens." So it is the fish who has the last laugh; there is no doubt the prizewinner is posing for a documentary photograph, but who is behind the camera?

Artists since the Renaissance have been occupied with the problem of how to recreate a distorted image as it might be found in the real world, as in a convex mirror, for example. In the twentieth century this distortion takes on new connotations. In *The Inertia of Night (Self Portrait as a Slat)* by the Australian artist Mike Parr (Figure 8.4), the oblique figure on the left reminds us of the distortion that occurs when a slide is projected at an angle, when the parallax is not true. We feel we are not parallel to the drawing, and if we could shift our viewing angle, the distortion would disappear. Parr makes reference to space and flatness in his use of the word *slat* in the title of the work. The massive scale of the drawing (9 × 6′) relates more to a projected slide or film image than to the human figure. It is the unsettling eye level or point of view that manipulates the viewer's sense of space, making this work both disturbing and intriguing.

8.5. JUDY YOUNGBLOOD. *Foreign Correspondents #1.* 1979. Etching with aquatint and drypoint, 11³/₄ × 14³/₄" (30 × 37 cm). Courtesy of the artist.

We have seen several examples of highly subjective manipulations of perspective; perspective is much more than a spatially descriptive tool for these artists; it is a major means of conveying conceptual, psychological, and emotive ideas.

Another important consideration is *base line,* the imaginary line on which an object sits. Base line and eye level are closely related. If all the objects in a given picture share the same base line, that is, if the base line remains parallel to the picture plane, space will be limited. If objects sit on different base lines, and if these lines penetrate the picture on a diagonal, the resulting space will be deeper.

In Judy Youngblood's suite of etchings *Foreign Correspondents,* horizon lines, eye levels, and base lines play a crucial role. The horizon is placed

8.6. JUDY YOUNGBLOOD. *Foreign Correspondents #2.* 1979. Etching with aquatint and drypoint, 11³/₄ × 14³/₄" (30 × 37 cm). Courtesy of the artist.

8.7. JUDY YOUNGBLOOD. *Foreign Correspondents #3.* 1979. Etching with aquatint and drypoint, 11³/₄ × 14³/₄″ (30 × 37 cm). Courtesy of the artist.

progressively lower in each print. In Figure 8.5 bundles of twigs are distributed in a random fashion. In Figure 8.6 the horizon line is slightly lower; the objects are situated on either side of a double curve leading into a deep space. Here the location of the viewer is somewhat ambiguous; the nearest object seems to be simultaneously seen from above and below. This figure of wrapped hair intrudes on the viewer's space; it is cut off by the lower left corner.

In Figure 8.7 the horizon line has been lowered considerably, and the stuffed sacks are less ominously placed; space is somewhat limited. In Figure 8.8 the bags have sprouted legs. (Twigs from Figure 8.5 seem to have combined with bags from Figure 8.6 to produce striding anthropomorphic figures.) These figures occupy different base lines on a low horizon. The figures seem

8.8. JUDY YOUNGBLOOD. *Foreign Correspondents #4.* 1979. Etching with aquatint and drypoint, 11³/₄ × 14³/₄″ (30 × 37 cm). Courtesy of the artist.

8.9. CHRISTOPHER BROWN. *Untitled (Potemkin Study)*. 1994. Pastel on paper, 43$\frac{1}{2}$ × 40$\frac{1}{2}$″ (110.5 × 102.9 cm). Courtesy of the artist.

to be standing on the rim of the horizon. Cast shadows connect the objects in a series of diagonal lines that penetrate the picture plane.

The images in the four prints are made from objects that are intimately associated with both the artist and her environment. Tableaux are arranged from which drawings and occasionally photographs are made. Spatial manipulation—variations in eye level and base lines—is of utmost importance in Youngblood's work.

In Christopher Brown's work (Figure 8.9), the horizon line is completely out of the picture plane; the result is a very shallow depth of field. (Note the camera reference again.) The smeared, unfocused figures seem to be in the very act of disappearing, even of sliding off the picture plane itself. This loss or slipping from memory is in keeping with Brown's message. Memory, past events, and historical associations underlie his imagery. The work is deceptively simple and deeply provocative, both figurative and abstract at the same time; point of view is crucial to its development.

Keep in mind that eye level is only one determinant of pictorial space. The space an artist uses is relative; it is not possible to determine the spatial quality of a work by eye level alone. In fact, the same eye level can result in a shallow or deep space depending on other determinants in the work, such as scale, proportion, texture, value, and color.

Using Eye Level and Base Lines

Before beginning this problem, complete Sketchbook Project 1 found at the end of this chapter.

Make a diptych, a two-part drawing, using the invented forms and ideas taken from the preparatory work in your sketchbook. Refer to Youngblood's suite of etchings (see Figures 8.5–8.8) to see how simply the negative space is handled. You may use different invented forms from one panel of the drawing to the next or you may keep the forms consistent. (In Youngblood's work she uses the same image within each individual work, but changes images from print to print.) You may or may not change horizon line from one drawing to the next; however, the two drawings should work as a pair. You might have one side take place in daylight, the other at night. You might use a distant view of a group of images combined with a close-up, magnified view of the same images.

Give real consideration to how the two sides of the drawing relate to one another. Keep the negative space simple; focus on the relationship of the objects within that space. The diptych can be either horizontal or vertical, depending on the demands of the subject.

AERIAL PERSPECTIVE

There are two distinct types of perspective, linear and aerial. *Aerial perspective* is the means by which the artist creates a sense of space through depicting the effects of atmospheric conditions. Various atmospheric conditions affect our perception of shape, color, texture, value, and size at different distances; compare your memory of a bright, sunny summer day and a cold, drizzly winter night. For centuries artists have used aerial perspective to enhance the sense of depth, and it is still used by many artists today. All realist artists are well versed in this perspective system.

Depicting atmospheric conditions can convey a sense of depth. Aerial perspective is one means by which the artist creates spatial illusion. In aerial perspective objects in the foreground are larger and their details are sharp, while those in the background are diminished and less distinct. As the objects recede into space their color and value become less intense and their textures less defined. (Note these effects in the *Foreign Correspondents* suite [see Figures 8.5–8.8].)

Cyril David has employed aerial perspective in his pencil drawing *Island* (Figure 8.10). A soft, hazy light bathes the scene while an isolated, centralized image of a floating island abruptly stops the otherwise continuous field of water. The horizon line is high in the picture plane; it lies slightly above the island's base. The natural landscape offers two opposing forms, earth and water. The light seems diffused; we can nearly picture the water particles in the air softening the distant landscape.

Aerial perspective demands that as the distance increases textural definition decreases. This effect can clearly be seen in the water patterns that change in textural clarity and in diminishing value. The waves near the bottom of the drawing appear to be moving, while those in the distance are less

8.10. CYRIL DAVID. *Island.* 1981. Graphite on paper, 18 × 12½″ (46 × 32 cm). Courtesy of the artist.

distinct and less texturally active. Likewise, the trees along the front edge of the island have more concise form than those farther away which lose their definition as they recede into space.

A sense of calm and an at-oneness with nature pervades the drawing whose effects are achieved through the artist's control over aerial perspective. David's ability to convey a washed, fresh plane of pristine light lends an evocative feeling to the realistic rendering.

PROBLEM 8.2
Using Aerial Perspective

Make a landscape drawing on site. Try to depict a particular atmosphere, a specific time of day or night and season of the year. What atmospheric clues can aid you in establishing a mood? Your main subject might be the sky, in which case you could use a low horizon line, as in the David drawing. Or you might focus on a field of grass with a high horizon line, in which case, pay particular attention to the size, value, and scale of your marks: Make them smaller and closer together as they near the horizon line.

Some other devices by which you can control space and create a sense of atmosphere are diagonals penetrating the picture plane, overlapping forms,

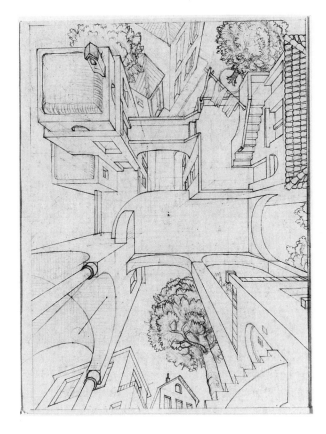

8.11. M. C. ESCHER. Study for the lithograph *High and Low.* 1947. Pencil, 5′8¾″ × 4′2½″ (2.71 × 1.99 m).

diminution of size as the forms recede, gradual value changes, blurring in focus from front to back, and changes in texture from foreground to background.

Select a medium that can be combined with a wash in order to achieve a blurred focus.

LINEAR PERSPECTIVE

M. C. Escher, the master of perspectival games, has maintained an extreme bird's-eye view in the upper half of his drawing aptly named *High and Low* (Figure 8.11). And, in keeping with his unwavering involvement with spatial ambiguity, in the lower half of the drawing he has abruptly changed eye level to an equally extreme ant's-eye view. Within each segment the eye level is strictly maintained. Escher employs contour line along with a rigidly controlled one-point perspective to set up an exaggerated spatial contradiction.

Perspective assumes a fixed point of view, so it is important that you remain relatively stationary in order to make a consistent drawing.

In order to use perspective it is necessary first to establish a horizon line. Imagine a pane of glass directly in front of you. This glass is perpendicular to your sight line. If you look up, the horizon line is below the direction of your sight; if you look down, the horizon line is above your sight line. The pane of glass is always perpendicular to your line of vision.

This pane of glass represents the picture plane; you are transferring the visual information seen through this imagined glass onto your drawing surface.

Your viewing position is of utmost importance in perspective. Two relationships are crucial: one, your distance from the subject being drawn, and two, your angle in relationship to the subject. Are you directly in the middle front and parallel to the subject, or are you at an angle to it?

The horizon line should always be located even if it falls outside the picture plane. Its position will describe the viewer's position—whether the viewer is looking up, down, or straight ahead.

Perspective hinges on the fact that lines that in reality are parallel and moving away from us appear to meet at some point on the horizon. That meeting place is called the *vanishing point,* or the point of convergence. Parallel lines of objects above the horizon line will converge downward; those of objects below the horizon will converge upward. Lines perpendicular and parallel to the picture plane do not converge unless the viewer is looking up or down, tilting the picture plane.

In Escher's drawing, the vanishing point is in the exact center of the picture plane; all parallel lines both above and below converge at the mark. (Compare the two views of the tree, stairs, and passageway connecting the buildings on either side of the composition and trace their converging lines.)

Once the horizon line has been determined, finding the vanishing point is relatively easy. Simply point with your finger, tracing the direction of the receding lines until you reach the horizon line. The vanishing point is located at the juncture of the traced line and the horizon line. True *one-point perspective* will have a single vanishing point in the middle of the picture plane. One-point perspective is useful chiefly in situations in which subjects are parallel or perpendicular to the picture plane, as in the Escher drawing.

If you are standing in front of a building parallel to the picture plane and you move to the right or left so that the building is seen at an angle, you will have changed to a *two-point perspective.* There are now two sets of parallel lines, each having a different vanishing point. There may be multiple vanishing points in two-point perspective; any number of objects set at an angle to the picture plane can be drawn, and each object or set of parallel lines will establish its own vanishing point. All planes which are parallel share the same vanishing point.

Objects in *three-point perspective* have no side perpendicular to the picture plane, so there will be three sets of receding parallel lines, which will converge to three vanishing points, two sets on a horizon line and one set on a vertical line.

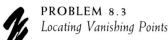

PROBLEM 8.3
Locating Vanishing Points

Cut six strips of stiff paper ¼ by 11 inches (.6 × 28 cm). Use them to determine where the vanishing points fall on the horizon. Locate vanishing points and horizons in each illustration in this chapter by laying the strips along the converging lines. Note that horizon and convergence points frequently fall outside the picture plane. Note whether or not the artist has taken liberties with a strict perspective in each drawing.

One-Point Perspective

A humorous introduction to the discussion of one-point perspective is the sketch by David Macaulay entitled *Locating the Vanishing Point* (Figure 8.12), taken from his book *Great Moments in Architecture*. It certainly was a great moment in art when Renaissance artists discovered this new means of describing the visual world. One-point perspective is the device in which parallel lines (lines parallel in actuality) located diagonally to the picture plane converge at a single point on the horizon (Figure 8.13). This convergence point is called the vanishing point. The humor in Macaulay's drawing stems from the fact that the railroad tracks converge before they reach the horizon. This contradiction sets up a complicated response in the viewer who tries to explain (both logically and visually) this paradox.

In addition to a point of convergence, other devices—overlapping, reduction in the size of objects as they recede, and blurring of detail in the distance—contribute to the sense of spatial recession.

An example of one-point perspective with a fixed, straight-on eye level is the gouache drawing *Reminiscing about Jackie Robinson* by the African-American artist Willie Birch (Figure 8.14). A trained artist himself, Birch reflects in his work on black history with its African roots by employing techniques used by southern black untrained artists. An odd, yet rigid perspective is often found in their work. Technically Figure 8.14 is an example of one-point perspective, yet certain elements, such as the tilted floor and the extreme diagonal movement of the walls into space, are exaggerated. The box fan and the sign on the right do not share the same vanishing point as the rest of the picture; the chairs seem to levitate from the floor. Birch chronicles not only the tragedies but the vitality of poor urban neighborhoods; his goal, he says, is to make the viewer see "the forgotten America that suffers from premeditated as well as unintentional neglect." By fixing our eyes with a fixed single-point perspective on his views of America, Birch succeeds in his efforts.

PROBLEM 8.4
Using One-Point Perspective

In this problem and those following, it is important to position yourself so that your angle of vision encompasses both the height and width of your subject.

Station yourself directly in the center of a house, a building, or a room; your angle of vision will be the center of the drawing. If you place the picture plane too close to your line of vision, the objects in the foreground will be so large that they will crowd out the objects in the distance. First, lightly establish the horizon line, even if it is off the paper. Establish the height of the verticals nearest you. Draw them, and then trace the parallel lines to their vanishing point on the horizon line.

Use contour line. Create a center of interest in the center of the drawing. The depth of space is flexible; you may either create an illusionistically deep space or one that is relatively flat. Remember to maintain a fixed point of view. It may be helpful to close one eye to rid yourself of the problem of binocular vision in tracing vanishing points.

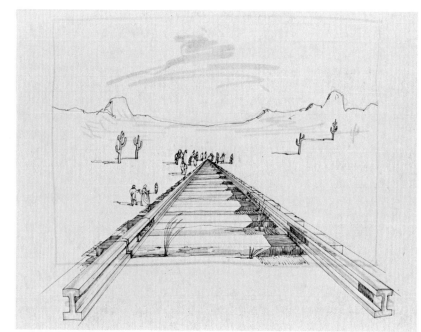

8.12. DAVID MACAULAY. Final preliminary sketch for Plate XV, *Locating the Vanishing Point* (Macaulay's intentionally misplaced horizon line), from *Great Moments in Architecture.* 1978. Ink and felt marker.

8.13. DAVID MACAULAY. Diagram— One-point perspective superimposed on David Macaulay's final preliminary sketch for Plate XV, *Locating the Vanishing Point* (Macaulay's intentionally misplaced horizon line).

true horizon line

vanishing point

Macaulay's point

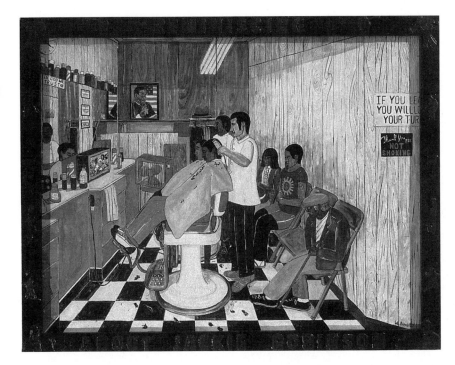

8.14. WILLIE BIRCH. *Reminiscing about Jackie Robinson*. 1987. Gouache on paper with relief frame, 4'6" × 3'6" (1.37 × 1.07 m). Courtesy Exit Art/The First World and Luise Ross Gallery.

Two-Point Perspective

A picture that uses two-point perspective has two vanishing points on the horizon, rather than the single point of convergence in one-point perspective. Two-point perspective comes into use when objects are oblique to the picture plane, that is, when they are turned at an angle to the picture plane. This is clear when we look at Edward Ruscha's *Double Standard (Collaboration with Mason Williams)* (Figure 8.15). The verticals all remain parallel to the vertical edges of the picture plane, but the two sides of the service station lead to two vanishing points, one to the right and the second to the left (Figure 8.16). The vanishing point on the right is at the exact lower right corner; the one on the left falls outside the picture plane. The horizon line coincides exactly with the bottom edge of the picture plane. (For two-point perspective, any number of objects may be oblique to the picture plane, and each object will establish its own set of vanishing points on the horizon line.) Conceptually, the form is well suited to the meaning in Ruscha's work. What better way to present a double standard than an X shape! Further, there is a play on words: "double standard" is equated with "moral dilemma," and certainly Ruscha indicates we have had a standard response to the question. The looming form of the building takes on mythic proportions as has our profligate use of nature (oil). The base line is at the exact bottom edge of the print. The scale of the building and the extreme upward view emphasize the ant's-eye view and diminish the scale of the implied viewer.

It would be informative to make a visual comparison between Ruscha's linear perspective and David's aerial perspective (see Figure 8.10). What extremely different sensibilities and ideas are conveyed in these two works! You can readily see how important the choice of spatial systems can be to both the perceptual and conceptual development of an idea.

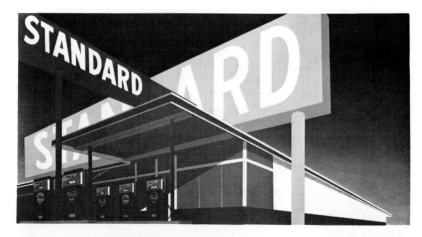

8.15. EDWARD RUSCHA. *Double Standard*
(Collaboration with Mason Williams). 1969.
Color silkscreen printed on mold-made
paper, 25³/₄ × 40¹/₈″ (65 × 102 cm). Edition
of 40.

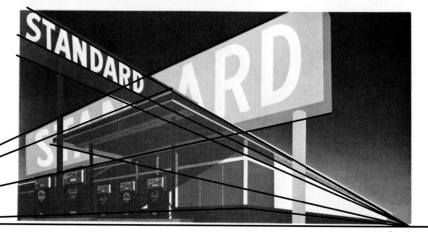

vanishing point 1 horizon line vanishing point 2

8.16. Diagram—Two-point perspective
superimposed on Edward Ruscha's *Double*
Standard.

 PROBLEM 8.5
Using Two-Point Perspective

Choosing the same subject matter as in the preceding problem, change
your position either to the right or to the left, so that you will be at an an-
gle to the subject. (Remember that in two-point perspective, the subject must
be seen obliquely.) Before using perspective in this problem, execute a quick
freehand sketch, depending on your perceptual ability. Then make a draw-
ing in which you use one-point perspective. Compare the two drawings for
accuracy and for expressive content.

Now draw the same view using two-point perspective. Again register
the horizon line by checking your angle of vision. Estimate the height of the
vertical nearest you, and draw it. This first step is crucial; it establishes the
scale of the drawing, and all proportions stem from this measurement. Next
trace the vanishing points. Remember that you may have several sets of van-

ishing points (all facing on one horizon line) if you are drawing a number of objects that are set at an angle to the picture plane.

A preliminary aid to drawing in perspective is to use a china marker on a piece of clear Plexiglas. The grease marks can be wiped clean after your study is finished.

Hold the glass at a fixed distance from your eyes; close one eye and trace the scene, concentrating on the objects in perspective. Establish the horizon line and lightly extend the diagonals to their vanishing points on the horizon. Place the clear glass on a piece of white paper and compare your drawing with the traced one. This device will help clarify the angles and points of convergence. Using a transparent picture plane will help you solve some problems in seeing. Do not, however, use this as a crutch to prevent you from developing your own visual acuity.

Three-Point Perspective

In addition to lines receding to two points on the horizon, if you are looking up (at a building, for example), parallel lines that are perpendicular to the ground appear to converge to a third, a vertical, vanishing point. In Hugh Ferriss's dramatic study for a skyscraper (Figure 8.17), we can easily trace this third, vertical vanishing point. Each tower has its set of stacked parallel, horizontal lines receding downward to two points on the horizon line, while the vertical lines of each tower converge at a single point above the central tower (Figure 8.18). The speed with which the lines converge produces a sense of vertigo on the part of the viewer, not unlike the effect the tourist experiences in New York City looking upward at the vertical architectural thrusts. Ferriss counters this pyramidal effect with rays of beacon lights, which converge downward. The cleanly modeled forms change in value, from light at the base to a flat, dense black at the top, further emphasizing the building's verticality.

PROBLEM 8.6
Using Three-Point Perspective

Assume an ant's-eye view and arrange several objects on a ladder. Position yourself at an angle to the ladder so that your view is looking upward. Again, trace with your finger the vanishing points that will fall on the horizon line, and then trace a third vanishing point, the vertical one. Remember to keep in mind all three vanishing points even though they may fall outside the picture plane. The forms will be larger at the bottom of the ladder (and at the bottom of the picture plane). When you reach midpoint on your paper, check the scale and draw in the remainder of the ladder and objects. Employ some aerial perspective to further enhance the feeling of space.

MULTIPLE PERSPECTIVE

The extremely disorienting effect that can be achieved by changing eye level and perspective in the same painting is illustrated by Giorgio de Chirico's eerily disturbing *The Mystery and Melancholy of a Street* (Figure 8.19). In addition to the unreal lighting, sharp value contrasts, and extreme scale shifts,

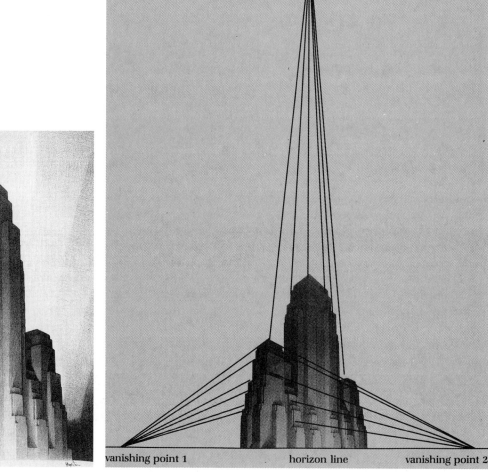

8.17. HUGH FERRISS. *Study for the Maximum Mass Permitted by the 1916 New York Zoning Law, Stage 4.* c. 1925. Carbon pencil, brush and black ink, stumped and varnished on illustration board, 26³/₁₆ × 20″ (66.5 × 50.8 cm). Cooper-Hewitt Museum, Smithsonian Institution; gift of Mrs. Hugh Ferriss.

8.18. Diagram—Three-point perspective superimposed on Hugh Ferriss's *Study for the Maximum Mass Permitted by the 1916 New York Zoning Law, Stage 4.*

which contribute to the surreal, otherworldly atmosphere, the most jarring effect is produced by de Chirico's forcing the viewer to change eye levels from one part of the painting to another. One eye level is used for the cart, another for the building in the foreground, another for the building on the left, and yet another for its openings. (The top windows and the top of the arched arcade should vanish to the same point as the other parallel lines in the building, but they do not.) In the diagram in Figure 8.20, you see four sets of vanishing points, which do not fall on the horizon line. The diagonals converge at dizzying rates within the picture plane. A troubling strangeness upsets what could be a classical objectivity.

PROBLEM 8.7
Using Multiple Perspective

Make a drawing in which you use changing, or multiple, eye levels within the same drawing. The resulting space will be ambiguous. You might

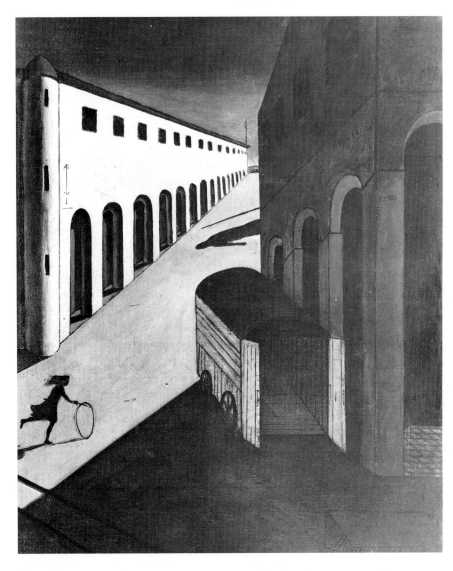

8.19. GIORGIO DE CHIRICO. *The Mystery and Melancholy of a Street.* 1914. Oil on canvas, $34^{3}/_{8} \times 28^{1}/_{2}''$ (87 × 72 cm). Private collection. © 1997 Foundation Giorgio de Chirico/Licensed by VAGA, New York, NY.

draw the interior of a room, using one eye level and perspective for a view through the window, another for a tabletop, and still another for objects on the table.

Or you might choose to draw a cityscape or an urban freeway, changing eye level and perspective from one section of the drawing to another, from building to building. The roadways might vanish on an extreme diagonal into space; billboards could be out of scale and have multiple vanishing points. Keep in mind the disorienting effects of a multiple perspective with its highly ambiguous space. Use extremes of perspectival space to mirror the disorientation of city life.

STACKED PERSPECTIVE

An ancient Egyptian mural (Figure 8.21) and a twentieth-century comic strip-style painting of Öyvind Fahlström (Figure 8.22) illustrate how parallel base

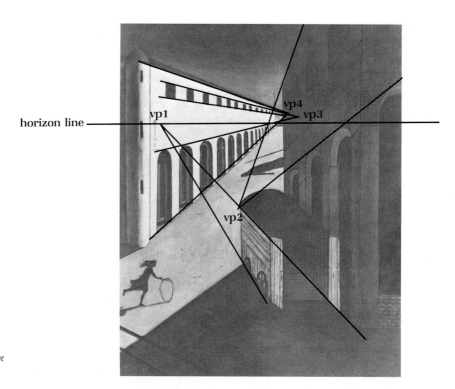

8.20. Diagram—Multiple perspective superimposed on Giorgio de Chirico's *The Mystery and Melancholy of a Street*.

lines create space that is predominantly two-dimensional. These parallel base lines within the same picture plane give the effect of stacked panels or frames and encourage the viewer to read the page from top to bottom or from bottom to top in a sequential order. The parallel base lines call attention to the two-dimensionality of the picture plane.

8.21. Egyptian. Funerary Papyrus of the Princess Entiu-ny, Daughter of King Paynudjem. Detail: *The Judgement: Weighing of the Heart*, XXI Dynasty, c. 1025 B.C. Paint on papyrus. Metropolitan Museum of Art, Museum Excavations, 1928–29, and Rogers Fund, 1930.

8.22. ÖYVIND FAHLSTRÖM. *Performing Krazy Kat III.* 1965. Variable painting, tempera on canvas and vinyl with movable magnetic elements, 4′6³/₈″ × 3′5⁵/₈″ (1.38 × .93 m). Collection Robert Rauschenberg, New York.

Both works use a number of common devices to maintain a relatively shallow space. Modeling is limited; value remains flat within a given shape. Repeated shapes organize the two compositions. There is a limited use of diagonals; shapes remain parallel to the picture plane on a horizontal/vertical axis. Outlines and invented textures in both works are made up of lines and dots.

The emphasis in the Egyptian drawing on papyrus is on positive shapes, which fill the grid but create little depth. The size and placement of figures are arbitrary; they fit a religious and social hierarchy rather than a visual reality. The Egyptian panel also uses a twisted perspective to show the salient features of profile and front torso; the head is in profile, the eyes are front view. It is impossible actually to assume the stance of the standing figures.

Size and placement of images in the Fahlström piece are also arbitrarily determined. The contemporary work makes more use of negative space, indicated by horizon lines that vary slightly from frame to frame. There are also pronounced shifts in eye level.

In Figure 8.23 we see a modified stacked perspective from an ant's-eye view in a drawing of San Francisco's topography by Wayne Thiebaud. An uphill view is combined with an extreme compression of space from bottom to top. Thiebaud's work differs from the Fahlström piece in that his images are taken from the real world. So developed is his observation and memory that he produces the images after visiting a particular site. His work is a

8.23. WAYNE THIEBAUD. *Down 18th Street (Corner Apartments).* 1980. Oil and charcoal on canvas, 48 × 35⁷/₈″ (121.8 × 91.2 cm). Hirshhorn Museum and Sculpture Garden, Smithsonian Institution. Museum purchase with funds donated by Edward R. Downe, Jr., 1980.

8.24. DAVID MACAULAY. *Fragments from the World of Architecture,* from *Great Moments in Architecture.* 1978.

refinement of perspective, color, shape, and composition. The compressed space accentuates the vertical. Thiebaud is interested in visual extremism, and certainly San Francisco's extreme contours are ideal subjects for him. It is interesting to note that while he has chosen a subject which demands a perspectival solution, he protects the surface integrity or autonomy of the picture plane so that we never feel we are looking through that much-cited window-into-space of traditional art. Color is exaggerated in Thiebaud's work and is not descriptive of actual or local color; light is ambiguous; both morning and evening light are used, so that, as Thiebaud says, "the day is stretched out." This stretched-out space seems to be further extended by the long freeway that dissects the picture plane. The snakelike movement of the adjoining roads weaves through the composition leading the viewer's eyes upward. The viewer "enters" the picture plane from the bottom; unlike many other works where the reading is from left to right or from top to bottom (an encoded Western bias), in this work the reading is bottom to top.

PROBLEM 8.8
Using Stacked Perspective

Set up a still life made up of several common objects. Place some of the objects on a table in front of a window; arrange the remainder on a windowsill. Use multiple parallel base lines. Draw two or three objects on each base line. Make use of repeated shapes, repeating values, invented texture, and outlining to create a relatively shallow space. Some of the objects may be parallel to the picture plane, others set at an angle to it. Scale and proportion may or may not change from panel to panel. Macaulay's *Fragments from the World of Architecture* (Figure 8.24) could be a suitable solution to this problem. For subject matter he has chosen common building materials—acoustical tiles, Formica, fake brick, Styrofoam, and Astro-turf—all "archaeological finds" from the twentieth century. They are stacked on various base lines in a two-point perspective drawing. Texture is meticulously handled. The volumetric depiction of the objects is in contrast with their strictly limited space.

FORESHORTENING

Perspective is concerned with representing the change in size of objects as they recede in space. *Foreshortening* is the representation of an object that has been extended forward in space by contracting its forms. Foreshortening produces an illusion of the object's projecting forward into space. The two techniques are related, but they are not the same thing. Foreshortening deals with overlapping. Beginning with the form nearest the viewer, shapes are compiled from large to small, one overlapping the next, in a succession of steps. In George Rohner's twentieth-century version (Figure 8.25) of Andrea Mantegna's fifteenth-century Christ, we are presented with an example of extreme foreshortening. The forms are compiled one behind the other from foot to head. The leg on the left is more severely foreshortened than the one on the right presented in a side view. The leg on the left is compressed, each unit maintaining its own discrete shape; there is no flowing of one form into the other as we see in the other leg.

8.25. GEORGE ROHNER. *Drowned Man.* 1939. Oil on canvas, 23³/₄ × 31⁵/₈″ (60 × 80 cm). Courtesy Galerie Framond, Paris.

Foreshortening does not apply to the figure exclusively; any form that you see head-on can be foreshortened. In foreshortening, spatial relationships are compressed, rather than extended. Foreshortening heightens or exaggerates the feeling of spatial projection in a form, its rapid movement into space.

PROBLEM 8.9
Using Foreshortening

Observing a model, combine four or five views of arms or legs in a single drawing. In at least one view employ foreshortening; that is, begin with the form nearest you, enclose that form, then proceed to the adjacent form, enclosing it. Be careful to draw what you see, not what you know or imagine the form to be. For example, in drawing the leg, break down the parts that compose the form: foot, ankle, calf, knee, thigh, hip connection. This is unlike a profile drawing where you are presented with a side view and each form flows into the next. Foreshortening describes the form's projection into space. In foreshortening a feeling of distance is achieved by a succession of enclosed, overlapping forms. Make careful sightings when making horizontal and vertical measures.

SUMMARY

SPATIAL ILLUSION

The type of space an artist uses is relative; it is seldom possible to classify a work as strictly two- or three-dimensional. As a drawing student you may be

required to create a flat or an illusionistic or ambiguous space in a given problem, but as an artist your treatment of space is a matter of personal choice. Mastery of the spatial relationships of the elements will give you freedom in that choice. Your treatment of space should be compatible with the ideas, subject, and feeling in your work. Along with shape, value, line, texture, and color, proficiency with spatial manipulation can help you make an effective personal artistic statement.

SKETCHBOOK PROJECTS

The sketchbook projects at the end of each of the preceding chapters can be done at any time during your study of each element; the following two Projects, however, should be done after you have read the introductory material to Chapter 8, and in preparation for Problem 8.1.

PROJECT 1
Invented Spatially Illusionistic Forms

A reminder before beginning: While your approach in keeping a sketchbook is serious, playful invention should not be minimized. A look at the visual improvisations by Picasso, an artist known for his clever variations, will be informative. Picasso was rigorous in keeping sketchbooks, volumes of them. Figure 8.26 shows 22 lighthearted variations. Some of the anthropomorphic forms are derived from still life material, from man-made objects, others from organic shapes, vegetables, and bones; many are geometric. The invented class of creatures all share a basic anatomy (hence the title of the drawings) in that they have heads, necks, upper and lower torsos, and limbs—arms and legs. Put together in wildly wacky ways, they offer insight into Picasso's never-failing inventiveness.

In your sketchbook invent several pages of organic, bonelike forms; they need not necessarily be anthropomorphic. Try to imagine what they would look like from various angles as they turn in space. Concentrate on making them volumetric. Indicate front and sides either by planar connections or by volumetric modeling. Imagine a single light source casting shadows to enhance the three-dimensionality of the forms.

PROJECT 2
Employing Different Horizon Lines

In the next several pages of your sketchbook make quick drawings in which you arrange three or four of your invented shapes in an imagined space. Employ different horizon lines. (In Picasso's collection he has a horizon line of maintained height.) In the first drawing arrange the forms on a low horizon line; remember that if all the forms share the same base line, that is, if they are lined up along a single line parallel to the picture plane, space will be limited. A diagonal or angular distribution of the forms penetrating the picture plane will result in a more three-dimensional spatial illusion.

In the second group of sketchbook drawings raise the horizon line, locating it somewhere in the middle third of the picture plane. Be aware that

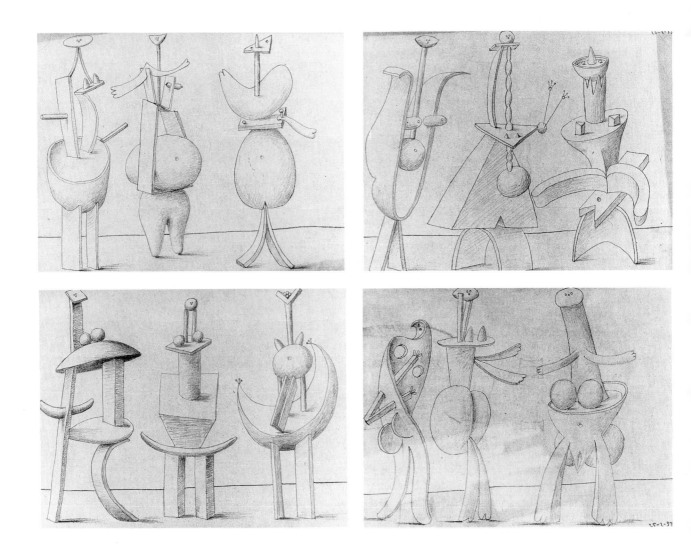

you are manipulating the viewer's stance. Are the forms being viewed from above or from below? Indicate the light source to help you achieve the spatial effect you desire.

In the final group of drawings use a high horizon line located in the top third of the picture plane. You must decide whether the point of view is from above or below. Here overlapping forms and a radical shift in size and scale of the objects distributed throughout the composition will help you achieve a greater spatial effect.

Keep the drawings fresh and immediate. Do not try for a polished, completed look. Do not overwork your ideas. This group of preparatory sketches will provide material to be used in Problem 8.1, so you can save the finishing touches for that problem.

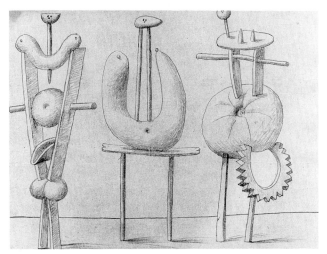

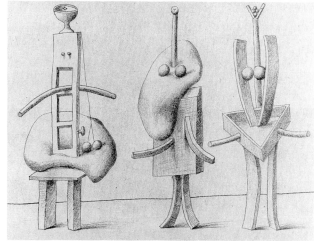

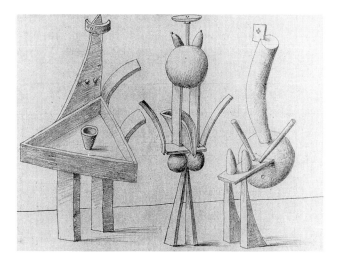

8.26. PABLO PICASSO. *An Anatomy.* 1933.
Pencil on paper. Musée Picasso, Paris.

PART III

A
CONTEMPORARY
VIEW

CHAPTER 9

THE PICTURE PLANE

CHALLENGES TO TRADITIONAL COMPOSITIONAL APPROACHES

As we rethink our physical, intellectual, and emotional orientation in the world, the implications for art are that we must revise our ways of handling form. Changes in art parallel changes in culture. John Baldessari, a teacher and major influence on conceptually based photography, directs us to *A Different Kind of Order* in his retelling of a story about the well-known jazz pianist Thelonius Monk (Figure 9.1). Five photographs of various disasters found in press files are matted crooked in their frames; the images are hung straight, leaving the frames askew. In the sixth frame is the narrative:

> There's a story about Thelonius Monk going around his apartment tilting all the pictures hanging on the wall. It was his idea of teaching his wife a different kind of order. When she saw the pictures askew on the wall she would straighten them. And when Monk saw them straightened on the wall, he would tilt them. Until one day his wife left them hanging on the wall tilted.

239

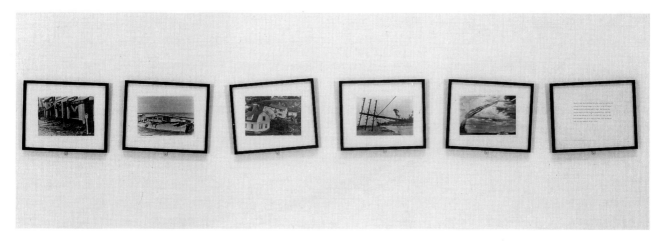

9.1. JOHN BALDESSARI. *A Different Kind of Order (The Thelonius Monk Story)*. 1972–1973. Five gelatin silver photographs and one typewritten sheet, individually framed; each image: 6⁹⁄₁₆ × 9¹³⁄₁₆″ (16.7 × 24.9 cm); each frame: 11⅝ × 14¹⁄₁₆″ (29.5 × 37.3 cm). The Museum of Fine Arts, Houston; purchased with partial funding provided by the National Endowment for the Arts.

There is more to this anecdote than meets the eye, so to speak. Baldessari points to our adherence to a "right" convention in art without giving consideration to why we are committed to it. The artist shows us both visually and verbally that there is more than one kind of order in the world. Even in this one art work we find at least two different kinds of meanings, the semantic one and the visual-aesthetic one. (*Semantics* is a branch of linguistics that deals with the study of meaning and the relationships between signs and symbols and what they represent.) Visually the mounted photographs ask a question that can only be answered in a qualified way: Is it the photographs or the frames that are crooked?

We can learn a lesson from Baldessari's cautionary tale, one not only in life but in art as well. Art derives its vitality from new ideas and feelings; it challenges previously accepted conventions, styles, techniques, and definitions. So the "rules of composition" are not fixed; they need to be understood to be transcended, to be used or discarded as the visual idea requires. We have seen how important it is in some artists' work to remove the hand of the maker; in other artists' work it is that very personal, individual mark that is valued. In some works a carefully balanced, unified composition is desired; in others chance, even chaos, is the governing concept.

There are many issues in contemporary life and art that have challenged the traditional view of composition. One example will suffice for now: Think of how the advent of cinematography with its sequential frames has changed static single frame art. Multiple formats, such as the divided picture plane and especially the grid, have become the very identifying characteristics of contemporary art. Sequence and serial development lie at the heart of Minimalism, a major contemporary development. Impermanence, change, and transition in the culture are mirrored in the art of our times. The critic Robert C. Morgan points out that "art is a system which parallels another system: culture."

Just as the grid is associated with twentieth-century art, the scroll is the format most connected with Oriental art. In an involved takeoff Laura Whipple appropriates both the scroll and the calligraphic brushstroke of Chinese art in *Homage to Tung Ch'i-ch'ang* (Figure 9.2). The media are the clue to the elaborate joke: flypaper, insects, paper, and silk. Whipple manipulates insect parts on flypaper to imitate visually the sensitive brushstroke so prized in

Chinese landscape painting. The picture plane itself is charged not only with art but with historical and cultural references as well.

In recent years artists have been subverting and otherwise transforming the conventions and aesthetics of earlier times, for example, the substitution of randomness for geometric order. This is not to say that one must not be familiar with former principles of compositional organization, but it is imperative to realize that these principles of design are not locked into place. They may be turned topsy-turvy; they may even be negated.

We confront crowded, disjunctive environments in the real world, so it is not surprising to find this kind of disorder in art as well. Art today encompasses the full gamut of personal expression; we find straightforward work alongside involuted work, the political alongside the comical, direct art statements alongside oblique ones. In other words, art, like life itself, is multidimensional in its pursuit of significance. And in art the means to this diversity go beyond the conventional compositional rules.

CONTEMPORARY APPROACHES TO THE PICTURE PLANE

Part II dealt with the ways the art elements can be used to create spatial illusion and with some of the ways pictorial space can be controlled through eye level and perspective. As you have seen, treatment of space is a major concern of the artist. This chapter focuses on another contemporary concern, the picture plane and how to handle the problems it presents. Artists have always been aware of the demands of the picture plane—its size, shape, flatness, edges, and square corners. However, many innovations in form in twentieth-century art have specifically and explicitly centered around the demands and limitations of the actual physical support or surface on which an artist works.

In James Rosenquist's *Military Intelligence* (Figure 9.3), the picture plane is even blasted away revealing the stretcher itself. This exposure (which supports a comment on the subject of secrecy and disclosure) undermines the illusion of the superscaled, hyperrealistic eyeglasses that float in a theatrical space of swirling flames. The title directs us to make connections between surveillance and vision suggested by the glasses.

The picture plane makes certain formal demands on the artist; certain compositional concerns must be dealt with in working on a flat, two-dimensional surface. *Form,* the interrelationship of all the elements, is the way artists say what they mean. In art, form and meaning are inseparable; form is the carrier of the meaning. It is the design or structure of the work, the mode in

9.2. LAURA WHIPPLE. *Homage to Tung Ch'i-ch'ang.* 1993. Flypaper, insects, spiders paper, silk, 7 × 35 × 1¾" (17.8 × 88.9 × 4.4 cm). Collection Eileen and Peter Norton. Courtesy Richard Heller Gallery, Los Angeles.

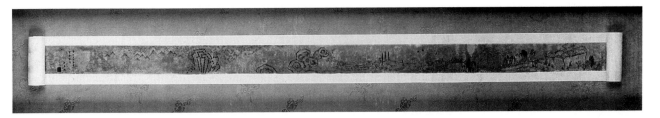

9.3. JAMES ROSENQUIST. *Military Intelligence*. 1994. Oil on canvas with charcoaled wood, 78½ × 118″ (199.4 × 299.7 cm)(2 panels 59″ wide). Leo Castelli Gallery. © 1997 James Rosenquist/Licensed by VAGA, New York, NY.

which the work exists. It is an order created by the artist. In this chapter we will look at some of the specific ways artists handle the picture plane and discuss the ways the picture plane has affected the form of contemporary art.

Dominance of the Edge

Perhaps the most obvious challenge to the rigidity of the perimeters of the traditional picture plane has been the breakup of its regular shape. Artists of the 1960s led the way for new forms and expressive means; the shaped canvas was one such innovation. Frank Stella gained wide recognition for his relief constructions. His early work was related to Minimalism; he employed symmetry and repetition of line. Over the years Stella has pushed his work increasingly toward a more projective three-dimensionality (see Figures II.15 and 6.17). His work has moved from logical, serialized investigation of flatness to a flamboyant, dramatic, expressionistic involvement that he himself proclaims has affinities with Baroque art.

Mel Bochner's large-scale charcoal drawing (Figure 9.4) makes a break with tradition in its cruciform shape. Bochner juggles shape and proportion in an elaboration of basic geometric configurations. Order, possibility, and change are the concepts behind his work. Movement is enhanced by the tilted format which reiterates the planes of the cubes. It is as if one of the three-dimensional cubes has been converted to the two-dimensional support. The background is made up of monochromatic rectangles of warm ochres dissolving into subtle grays. Various sized cubes emerge (or fall?) from the juncture or axis formed by the four background planes. The tumbling cubes seem to derive their energy from the off-centered coordinates of the background rectangles.

Figure 9.5 demonstrates the dominance of the outside edge of the picture plane. In this watercolor Yvonne Jacquette uses the airplane window as a border for the view outside the window. This window serves a triple function: It frames another image, it reiterates the size and shape of the picture

9.4, Above. MEL BOCHNER. *Via Vanvitelli.* 1987. Charcoal on paper, 64 × 64″ (162.6 × 162.6 cm). Private collection.

9.5, At right. YVONNE JACQUETTE. *Airplane Window.* 1973. Watercolor, 12⅛ × 9″ (53.6 × 22.9 cm). Collection of Mr. and Mrs. John F. Walsh, Jr., New York. Courtesy Brooke Alexander, New York.

plane, and it is a contemporary window into a contemporary space. Here the traditional Renaissance use of the picture plane as a "window into space" has been given a radically new twentieth-century look. In this instance the two images, window and outside view, serve a contradictory function. The window border has a beginning and an end—we know where it stops and where it starts—whereas the image outside the window depicts a continuous space, quite literally a limitless one. This highly complicated and sophisticated statement is delivered in a rather simple and straightforward way; both form and image are carriers of a complex message. Jacquette has created a visual/verbal pun in the play on the word "plane" with its double meaning: picture plane and airplane.

PROBLEM 9.1
Shaped Picture Planes

Go to the library and look at some catalogues of art shows and some books that deal with contemporary art. Focus on those contemporary artists who use nontraditional shaped formats in their work. Look at the work done in the 1960s when this movement was in its early stages of development. We have already mentioned Frank Stella; other artists of the same time are Tom Wesselmann (who cut the picture plane to conform to the shape of the actual object being painted, such as a hand holding a cigarette), Ellsworth Kelly,

Kenneth Noland, and Richard Smith. Note the evolution of the motif or image in Stella's work from the 1960s to the present.

Elizabeth Murray is only one of the many current artists working with shaped picture planes. Neil Jenney is associated with dominant, sometimes irregularly shaped frames that alter the look of the traditional format. Robert Morris's work makes use of eccentrically shaped frames that are an integral part of his work. Miriam Schapiro uses fan- and kimono-shaped canvases, appropriate to her work as a Pattern and Decoration Artist.

The shaped canvas is not only about edge but concerns itself with establishing the plane as an object, giving it a physicality that is different from the dematerialization sought after in illusionistic work.

In your visual research pay close attention to the motif or image and how it relates to the shape of the support. You will discover a broad range of subject matter being used on these structures, from nonobjective to recognizable. Try to determine how subject, content, and support are welded in each work.

This project will not only acquaint you with the important issue of the dominance of the picture plane but will also offer you a wider spectrum of work (and in color) than we are able to present in this book.

PROBLEM 9.2
Confirming the Flatness of the Picture Plane

Make a drawing that asserts the limits and flatness of the picture plane. You might choose a common, everyday object as subject for the drawing. Present the object frontally and enclose it with a patterned border. Use a conceptual approach. Combine solid value shapes, outlining, or invented texture within confined shapes, along with reverse perspective to emphasize the flatness of the picture plane. Jim Nutt is a good artist to study before begin-

9.6. JACKSON POLLOCK. *Composition* (white, black, blue, and red on white). 1948. Casein on paper mounted on masonite, 22¼ × 30½" (57 × 77 cm). Courtesy of New Orleans Museum of Art, bequest of Victor K. Kiam.

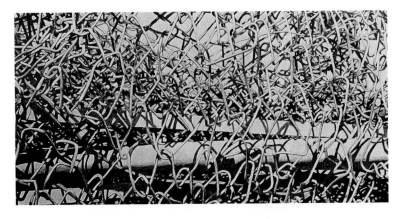

ning your drawing (see Figure II.5). Another artist who uses flat shapes but whose subject is taken from real life is Alex Katz (see Figure 9.12).

Continuous-Field Compositions

One innovation contemporary artists have made in dealing with the edge of the picture plane is to negate its limitations by making a continuous-field composition; that is, if we imagined the picture plane to be extended in any direction, the image would also extend, unchanged—the field, or picture plane, would continue as it is. Visualize a subject that makes use of this type of composition, for example, a continuous field of water, or grass, or a wooden floor. Images need not necessarily be taken from the real world; a continuous-field effect can be achieved easily with nonobjective forms as well. Jackson Pollock's work (Figure 9.6) is less a composition than a process; the action of the artist while painting has been documented. Movement and time have been incorporated to result in a richly energized surface; the limits of the final piece seem somewhat arbitrarily chosen. (Note that the paint drips go off the paper on all four sides.) Again, we can imagine the field to be continuous.

If a recognizable subject is used, as in Stuart Caswell's *Chain Link Disaster* (Figure 9.7), it must be one the viewer can imagine continues beyond the limits of the picture plane. In comparing the two works by Caswell and Pollock, it is as if Pollock's drips have metamorphosed into the tangled wire of Caswell's drawing. Both works are tense with implied motion; the lines are stretched across the surface. And in both works overlapping darks and lights bind the forms to each other in a complexly layered surface.

PROBLEM 9.3
Continuous-Field Compositions

Make two drawings that deny the limits of the picture plane, one using a recognizable, illusionistic image and the second using nonobjective imagery. Create an overall textured surface so that no segment of the drawing has precedence over another. There should be no dominant center of interest. Try to create the illusion that the image extends beyond the confines of

9.8. CLAES OLDENBURG. *Floating Three-Way Plug.* 1976. Etching and aquatint, 42 × 32¼″ (107 × 82 cm). Published by Marian Goodman Gallery, New York.

the picture plane. The use of line, value, and texture is consistent throughout the drawing. The shapes fill the picture plane with no priority of focus. We can easily imagine that the image extends beyond the edges of the paper.

Arrangement of Images on the Picture Plane

The importance of the relationship between positive and negative space has been emphasized throughout the book. In dealing with the demands of the picture plane, this relationship is again crucial. Positioning of positive and negative shapes is of utmost importance. By placement the artist may assert or deny the limitations of the picture plane.

Placement of an image calls attention to the shape and size of the plane on which it is placed. (Too small a shape can be dwarfed by a vast amount of negative space, and too large a shape can seem crowded on a small picture plane.)

Center, top, bottom, and sides are of equal importance until the image is placed; then priority is given to a specific area. Centralizing an image results in maximum balance and symmetry, and if that centralized image is stated frontally, the horizontal and vertical format of the picture plane will be further reinforced.

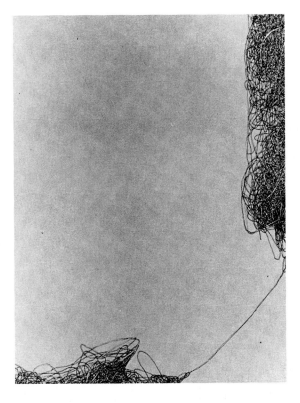

In his print (Figure 9.8) Claes Oldenburg centralizes a three-way plug.
The image is made static by its placement; the stasis is further enhanced by
the use of the enclosed shapes, especially the closed circles. Such complete
balance in the positioning of the image permits no movement. Oldenburg,
in typical, whimsical contradiction, makes the plug seem to levitate or float
by bisecting the shape with a line. So now we interpret the image as sus-
pended between sky and water, as being submerged midway between air and
water. Several hints are dropped for this reading of the image—the triangu-
lar ship sail and the cursive writing in the water, "floating plug in sunset."
Scribbles radiate from the sun in the upper half. These marks activate an oth-
erwise static space.

In some contemporary work, the center is left empty. A void seems to
crowd the images to the edge. This is especially true in Susan Hauptman's
drawing (Figure 9.9), which can be read on two levels—either as a tangled
web of threads or as an abstract, tangled mass of line. The placement calls
attention to the bottom and side of the paper and tests our sense of gravity.
Does the thread fall to the bottom, or is it being pulled forcibly by the bot-
tom mass?

In Robert Lostutter's *Emerald Bird at Sunset* (Figure 9.10), the picture plane
is divided diagonally, an unusual compositional device. Spatially, the work is
confounding. The bird-man is statically placed in the upper left corner, his
beak-nose paralleling the divided plane. The area below him depicts a deep
space of clouds and sky, while the empty, white triangle seems conceptually
charged. We can begin to decipher Lostutter's work in reading his poetry, in

9.10. ROBERT LOSTUTTER. *Emerald Bird at Sunset.* 1985. Watercolor on paper, 8 × 9¾" (20.3 × 24.8 cm). Courtesy of the artist, Chicago, Illinois.

which images of "an imperfect edge," flight, paradise, and seasonal references to wintertime appear. In this work the function of the divided plane is to convey the meaning of the work.

Another technique for asserting the picture plane is to crowd the picture surface with a great number of images. This device eliminates a priority of focus. Seemingly unrelated images of contradictory size, proportion, and orientation announce that the picture plane is not a place for a logical illusion of reality; rather, it is a plane that can be arranged any way the artist chooses, as in the colored pencil drawing by Frank Bigbear, Jr. (Figure 9.11). Bigbear is a self-taught artist who incorporates symbolic images from his Chippewa traditions with images from art and popular culture. He graphically warns us of the pain and dangers of poverty, discrimination, disease, and loss of hope, not only in his native culture but in the broader society. The fantastic subject matter, jumbled imagery, and odd juxtapositions are the compositional means to a powerful statement on the condition of our times. From the center of the seemingly hallucinatory scene emerges an arm holding a mirror: Is the artist asking us to reflect on this world we have made? Complex times make for complex art. Some messages require the artist to disregard accepted norms of taste and form and to intentionally break rules. Bigbear's message of the interrelatedness of all things has found suitable expression in his interconnected forms.

Frequently artists use a single positive image to crowd out the negative space, as does Alex Katz in his lithograph *Homage to Frank O'Hara: William Dumas* (Figure 9.12), which presents the point-blank stare of a youthful, empty face. The figure is cropped on all four sides by the edges of the picture plane. Katz denies the limits of the paper in this close-up, blown-up view. We are

9.11. FRANK BIGBEAR, JR. *Red Boy* (diptych). 1989. Prismacolor pencil on paper, 60½ × 44″ (1.52 × 1.12 m). Private collection.

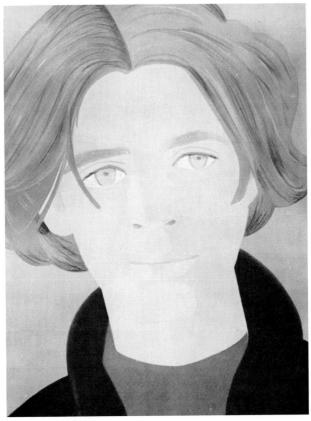

9.12. ALEX KATZ. *Homage to Frank O'Hara: William Dumas*. 1972. Lithograph, 33¼ × 25½″ (84 × 65 cm). Edition of 90. Courtesy Brooke Alexander Editions, New York. © 1997 Alex Katz/Licensed by VAGA, New York, NY/Marlborough Gallery, New York.

forced to come to terms with the unblinking eyes in the empty shape of the face. While Katz's figures are extreme simplifications of the human form, they are, nonetheless, real portraits. Katz's paintings are at once a picture of a class and of a single individual.

A compositional approach that has found favor with a number of contemporary artists is the use of overlayed or superimposed images. Hung Liu layers distinct but symbolically related images in her installation entitled *Trauma* (Figure 9.13). Liu, a native Chinese artist, makes work that is politically charged. In one wall of the installation she superimposes a drawing of a traditional Chinese woman, her feet bound, with images of the Statue of Liberty and the Goddess of Liberty (the figure of *Liberty Leading the People* created by the nineteenth-century painter Eugène Delacroix). The two liberty symbols were used by the Beijing students in their uprising in 1989 in Tiananmen Square. The three juxtaposed figures are in uneasy balance with the two small male figures in the foreground; they are a metaphor for a culture that is tradition bound and in the throes of trauma; hence the title of the work. In Liu's work the rigidly balanced, central figure dominates the wall. By hi-

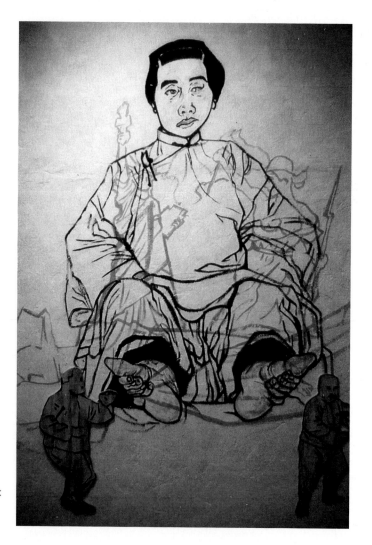

9.13. HUNG LIU. *Trauma* (detail). 1989. Mixed media installation at Sushi Gallery, San Diego, California. Detail approx. 80 × 64″ (2.03 × 1.63 m). Courtesy the artist and Steinbaum Krauss Gallery, New York.

erarchical scale and placement Liu helps us realize that tradition is not easy to unseat. In Postmodernist work, such as Liu's, formalist concerns are in the service of content. How different the meaning would be if all the figures were separate and of equal size. It is the cultural context that provides the means of interpreting the work.

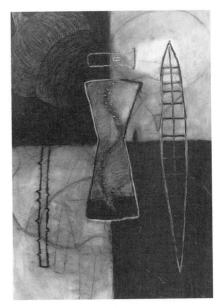

PROBLEM 9.4
Placing Images on the Picture Plane

Make two drawings in which placement is the prime concern. In the first drawing use a nonobjective centralized image. Present the image frontally. You can use several simple geometric motifs. The centralized form can be activated by small related shapes located on top of and behind the main image. You might think in terms of weaving. You can even add threads, beads, or bits of collage to enhance the surface.

In the second drawing, using the same set of related motifs, emphasize the edges or corners of the picture plane. Position the image so that corners and/or sides are activated. You will obviously work with a change in scale between the parts. You might reverse color and value from the first drawing. Even though your focus is on composition and placement, do not neglect the elements of shape, line, texture, value, and color. Try to create spatial tensions between the various images and the negative space.

The adherence to one particular format is not a rule to be rigidly observed. In Figure 9.14 Mary Porter's *Between Darkness and Light* combines a centralized motif with attention to the edges. The alternating grid supports the opposition of dark and light. The abstract images recede and advance in a shallow background space.

9.14. MARY PORTER. *Between Darkness and Light (No. 5)*. 1992. Charcoal on paper, 41 × 29″ (104 × 73.6 cm). Frederick Spratt Gallery, San Jose.

PROBLEM 9.5
Filling the Picture Plane

In this problem you are to use a single image that completely fills the picture plane. You may enlarge a detail of a form, or you may crowd out the negative space by filling the picture plane with the image. Confront the viewer with a composition that is cropped top, bottom, and sides by the edges of the paper.

DIVISION OF THE PICTURE PLANE

Another formal means contemporary artists have used to meet the demands of the picture plane is the grid, which divides the picture plane into units or segments. In addition to reiterating the flatness of the picture plane, its horizontal and vertical shape, the units introduce the element of sequence, which in turn brings up the idea of time. More traditional art is viewed synchronically; that is, the composition is seen all at once in its entirety. Grid compositions, on the other hand, are viewed both synchronically and linearly. We, of course, see the entire work at a first glance, but when we take a more sustained look, the composition demands to be read sequentially, segment by segment.

Pat Steir's drawn-on canvas (Figure 9.15) has been gridded by intersecting lines in the upper two-thirds and by horizontal lines in the lower third. The grid alternately advances and recedes in different segments of the painting. Pronounced rectangular shapes are distributed throughout the composition, again calling attention to the horizontal/vertical axis. The irregular line that divides the two major segments can be read either as the horizon or as a fluctuating graph line. The loosely stated marks and drips cancel out the otherwise rigid format. Certainly, the idea of sequence and of time is reinforced by the title *Three Green Days*. Our reading of the work is both synchronic and sequential.

Lynda Benglis uses an underlying, implied, irregular grid in her mixed media collage (Figure 9.16). The grid seems bent out of shape; it is loosely divided into a four-part structure. The units vary in size and shape within each off-square segment. The interplay of positive and negative organic shapes with their overlap creates a complex spatial tension. This unpredictable type of grid is ambiguous, both affirming and defying the flatness of the underlying support. We feel that if each segment of the work were reassembled in a strictly horizontal and vertical format the newly constructed composition would be larger than the original one.

The grid can be stated in a sequential pattern to suggest a stopped-frame, or cinematic, structure. While grids can be read in a number of ways—horizontally, diagonally, or vertically—in cinematic structure each frame logically follows the other. There is a definite sense of time lapse and movement.

These stopped-frame compositions use a regular geometric frame (like the segment of a piece of film) as in Steir's flower painting (Figure 9.17). This three-part composition is conditioned by modern technology, by close-up photography. The viewer is forced to adjust to the rapid change in scale from the first, rather distantly conceived object to the disproportionately large scale of the same flower in the third section. The traditional boundaries between realism and abstraction are also called into question in this single paint-

9.15. PAT STEIR. *Three Green Days.* 1972. Oil, crayon, pencil, and ink on canvas, 6 × 9′ (1.83 × 2.74 m). Collection Mrs. Anthony J. A. Bryan. Robert Miller Gallery.

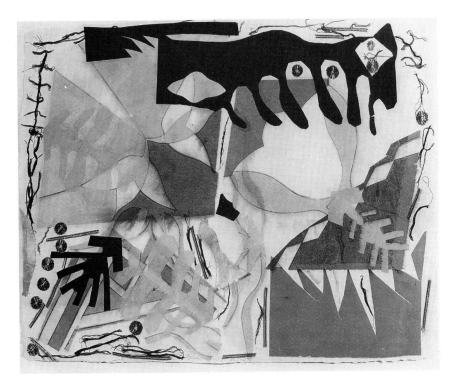

9.16. LYNDA BENGLIS. *Patang Fossil Papers, Drawing No. 6.* 1979. Cloth, foil collage, thread, tissue on handmade paper, 26 × 34″ (66 × 86.4 cm). Lent by Douglas Baxter. Paula Cooper Gallery.
© Lynda Benglis/Licensed by VAGA, New York, NY.

ing. The final segment seems more closely related to the Pollock in Figure 9.6 than to the painting of the small vase on the left. This relation is especially apparent when you realize that each segment in the Steir painting measures 5 feet (1.53 m) square.

Jody Mussoff uses a segmented picture plane, related to a stopped-frame composition—gridded at the top, with one large segment at the bottom—for her drawing *Atlas* (Figure 9.18). Mussoff uses the theme of passage, states of growth and change in her work. Conceptually, then, the divided picture plane is appropriate for the content. Close-ups of the girl's face seen from different angles fill the four top units. The eyes are intently focused in each segment, while the figure of the kneeling girl is tentative in her pose and in her glance. We cannot help but think of gravity and weight with the name *Atlas*; it leads us to question what this young female Atlas is supporting. We assume that vision is another major theme—the eyes are certainly the dominant feature of the top planes. We can reasonably assume that the subject of this powerful work deals with the role of the artist, with growth, vision, support, performance, vulnerability. While the subject may deal with vulnerability and the pose may portray a tentative position, Mussoff's line quality is strong and assured; it builds a powerful structure on which to hang a world of meaning.

In cinematic grids, visual reinforcement of the picture plane comes from the contained images. Conceptual denial is suggested by the idea of continuation, by the idea that with a longer lapse of time come more stopped-frame images.

While most stopped-frame compositions use a regular geometric division, a linear, sequential arrangement can be achieved by omitting the lines

9.17. PAT STEIR. *Chrysanthemum.* 1981. Oil on canvas, 3 panels, each 5 × 5′ (1.52 × 1.52 m). Collection Gloria and Leonard Luria. Robert Miller Gallery.

9.18. JODY MUSSOFF. *Atlas.* 1986. Colored pencil on paper, 48½ × 60″ (123.2 × 152.4 cm). Collection of Mr. and Mrs. Irving Tofsky.

that divide the units. A long, narrow format can be ideal for a work that requires a sequential, linear reading, or for a subject in which time is central to the meaning. Since movement and dislocation are repeating themes in contemporary art, the divided picture plane is a favored compositional device. It is a format that lends itself to narrative sequences, another thematic concern in today's art.

Throughout the text we have mentioned such strategies as deconstruction, appropriation of images from preexisting sources, exposés of accepted norms. At the root of all these concerns is the problem of context. Meaning or interpretation must have a context in which to develop. The divided pic-

ture plane is a conceptually loaded formal device to aid the artist in establishing context—even discontinuity between images—that has the underlying purpose of expanding or questioning our cultural and personal attitudes.

Robert Longo, an artist who focuses on the theme of tension in urban life, uses a multiple format, a triptych, in many of his works. His series of *Men in the Cities* are life-sized drawings of young professionals "frozen" in ambiguous poses (Figure 9.19). They seem to be victims of unseen forces, pushing, pulling, distorting them. Longo isolates the figures in an empty void—a formal means to a conceptual end—and he further distances the figures from one another by framing each unit separately, although he intends the three pieces to be viewed as a unit. Longo takes his subject matter from mass media—derived symbols of power and of "the good life," a theme of another of his series whose intent it is to expose media-propagated symbols.

Loosely related to the divided picture plane is the composition with an inset. In older, more traditional work, the artist always felt free to draw a detail or to rearrange the composition in some area of the drawing. In contemporary work, this latitude has been claimed as a favored compositional device. An inset creates an opposition between itself and the primary subject and sets up a feeling of discontinuity between the two images. In Leonel Góngora's lithograph (Figure 9.20), the artist has used several insets; in fact, all three figures plus the dark rectangle at the top of the page are set off by encircling marks. The centralized, transformed head of Samson dominates the loose composition. Góngora's beheading of Holofernes (by the encasement of the head in a white frame) parallels the actual decapitation by Judith. Góngorá draws an analogy between the two biblical tales, the shearing of Samson's hair by Delilah and the beheading of Holofernes by Judith. In his palimpsest-like, layered drawing, Góngorá pays tribute to a favorite Renaissance art theme, Judith's victory over Holofernes.

PROBLEM 9.6
Composing with a Grid

Make three drawings in which you use a grid. In the first drawing, establish a grid with each unit the same size. In the second drawing, lightly establish the grid; then use value, texture, and/or line to negate the regular divisions. Try to achieve an overall effect as opposed to a sequential reading

9.19. ROBERT LONGO. *Men Trapped in Ice* (triptych). 1979. Charcoal and graphite on board, each panel 60 × 40″ (152.4 × 101.6 cm). Courtesy Metro Pictures and the artist.

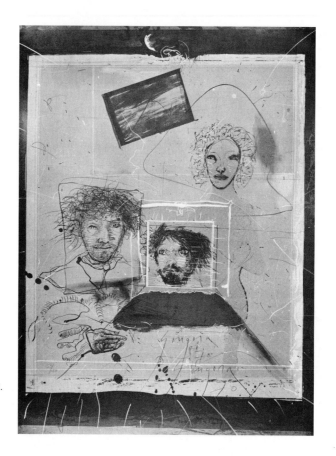

9.20. LEONEL GÓNGORÁ. *Transformation of Samson and Delilah into Judith and Holofernes.* 1970. Lithograph, 29½ × 22″ (75 × 56 cm). Courtesy the artist and Udinotti Gallery, Scottsdale, Arizona.

of the drawing. In the third drawing, use a grid of irregular units. You might use a concentric grid, or a grid in only one area, as in the Mussoff drawing (see Figure 9.18), or you might simply imply a grid structure.

 PROBLEM 9.7
Dividing the Picture Plane

Using a picture plane that is exactly twice as wide as it is high, divide the format into two equal segments. Make a drawing with an image in one half totally unrelated to the image in the other half. This is not as easy to do as it sounds, since we attempt to relate any two images seen simultaneously. For the first image you might choose a visual cliché, an image that is well known to everyone in American culture, such as the Statue of Liberty. Try to pair with the first image another subject that is totally unrelated by form, media, technique, scale, or meaning. The result should be a very disjunctive composition, one that is unsettling to the viewer.

PROBLEM 9.8
Using Inset Images

Make a drawing that employs an inset. The inserted image may or may not be related to the larger drawing.

The image in the inset could be a blow-up or a detail of the outside image; the drawing inside the inset could be stylistically different from the

main image; the inset could be drawn with different media from the outer drawing; or the inset image could be abstract and the outer image recognizable. You might think of a time shift between the two segments.

PROBLEM 9.9
Using Linear Sequence

In this problem you are to repeat an image in a linear or cinematic sequence. The drawing may progress from left to right across the page or move in a vertical direction from top to bottom. Keep in mind the idea of a time lapse. This may be achieved by having the image undergo slight changes from frame to frame. Try to create a sense of expectation as you progress along the picture plane.

Another option for subject is a narrative sequence; for example, you might take an imaginary character through a catastrophic day. A cartoon style would be appropriate. Think in exaggerated, symbolic terms. How can you succinctly convey your visual ideas?

SUMMARY
PERSONAL SOLUTIONS/DIFFERENT KINDS OF ORDER

We have looked at and discussed a number of ways contemporary artists have dealt with the demands of the picture plane. The list is by no means comprehensive, for each time artists are confronted with the clean, unblemished surface of the picture plane, new problems arise. Out of the artist's personal and subjective experience come the solutions to these problems. For many artists the response to the demands of the picture plane is on a highly conscious level; in others the response is more intuitive.

In your own work, whatever approach you take, the solutions or resolutions should not be turned into formulas, for there are no pat answers to any problem in art. Involvement in your own work and familiarity with the concerns and styles of other artists will help you solve your own problems in a personal and exciting way.

SKETCHBOOK PROJECTS

Over the period of a week make a collection of drawings, filling a single page of your sketchbook with multiple drawings before you move on to the next page.

PROJECT 1
Crowding the Picture Plane

This is to be a composition in which you crowd the surface with a great number of images. They can be totally unrelated, recognizable, abstract, and nonobjective. Include some writing, notes to yourself, scraps of information, quotations that appeal to you. Avoid a symmetrical or balanced distribution of images, especially in the beginning. Overlap and overlay images;

turn your paper from time to time so the orientation of the drawing is not always the same. Try not to think in terms of top, bottom, or sides.

After you have crowded the page with drawings, impose some minimal order by use of value or by connecting lines and shapes. Avoid the development of a focal point. Make several of these composite compositions in your sketchbook. When you fill one page proceed to the next. Remember the large *Telephone Drawing* by Sigmar Polke (Figure 5.1)? You might think of these drawings as visual diaries; the imagery and thoughts contained in them could be taken from your hour-to-hour experiences, a record of your day's activities, daydreams, and thoughts.

PROJECT 2
Attention to the Edge

Choose one page of the drawings done in the preceding exercise and use some white-out gesso, white acrylic, or white tissue or tracing paper to cover the center part of the page, leaving the images showing around the edges. The paper or white paint could be applied so that faint images from the original drawing show through; this will activate the surface. Try to integrate the two segments, paying particular attention to the compositional device of emphasis on edge.

PROJECT 3
Divided Picture Plane

Using masking tape, mask off some divisions of equal size in your sketchbook. You may create a grid of four, six, or nine segments; or you may use a linear, sequential division of three or more units. Leave the masking tape intact and proceed as in Project 1, filling the page with drawings done over several days or at least several drawing sessions. Do not confine the drawings to the delineated segments; draw over the full page, over the masking tape and paper. At the point an interesting texture develops, remove the masking tape to reveal the underlying white negative lines of the grid. Enhance the drawing with minimal additions if needed.

T H E M A T I C
D E V E L O P M E N T

DEVELOPING A BODY OF RELATED WORK

THEMATIC DRAWINGS ARE A SUSTAINED series of drawings that have an image or idea in common. Concern with process has made thematic work particularly evident today. The trend by galleries and museums of showing an artist's thematically related work along with working drawings gives the viewer more insight into how ideas and formal relationships develop. In a cohesive body of work by a particular artist, the conceptual and personal involvement that goes into the process of producing the work is revealed in ways that are not so apparent in a single piece. Image, idea, content, and form are juggled and transformed in a series to reveal a theme and variation similar to that in music.

A study of thematic development will inform you of the variety of ways artists use particular concepts so that you can better understand your own individual options.

There are a number of reasons to develop a series of drawings based on a single theme. The most basic reason is that art involves the mind as well

as a coordination between eyes and hand. Art sometimes begins with an exercise in thinking and moves to an exercise in doing. Just as frequently, the order is reversed, but the processes of thinking, observing, and executing a work are always in tandem. The emphasis in thematic series—and the emphasis throughout the problems in this chapter—is on process rather than product.

Any drawing problem has many possible solutions. Thematic drawings, since they are an open-ended body of work, provide a way to express more ideas or variations on an idea than it is possible to address in a single drawing. Nothing can better illustrate the number of possible compositional and stylistic variations on a given subject than a set of connected drawings. Since you will be using only one subject or idea throughout the series, you are free to attend more fully to matters of content and composition.

A thematic series allows you to go into your own work more deeply, with more involvement and greater concentration. Further, you work more independently, setting your own pace.

Finally, the process of working on a series develops a commitment to your ideas and thereby a professional approach. And, like a professional, you will begin more and more to notice the thematic patterns in other artists' work.

A first step toward developing thematic drawings is to look at the way other artists have handled a theme in their works. This chapter discusses three general categories: *shared themes*, the same images or subjects used by different artists over a period of time; *individual themes*, chosen by individual artists; and *group themes*, developed within a movement or style such as Cubism or Impressionism.

SHARED THEMES

A thematic thread that weaves through art is the relationship between word and image. Historically, there are innumerable examples of the interdependency of image and text. In the ancient world, as religions were formulated and codes of law developed, writing was invented, sacred books produced, scientific inquiries expanded, calculations devised to help regulate relationships between humans and between gods, rulers, and their subjects. Images and words recorded these basic developments. The drawn or painted image, of course, preceded the written word, but as soon as writing developed, image and word were solidly united, each serving to amplify the other.

Art history is packed with the theme of word and image. A document treasured for being the first written codification of laws is the black basalt *Stele of Hammurabi* from around 1700 B.C. on which the Babylonian King Hammurabi is depicted receiving the, until then, unwritten laws from the god Shamash; the code of laws is incised in the stone below the two hieratic figures.

A more familiar example of text and image is found in objects from ancient Egyptian dynasties; for thousands of years it was common practice to depict images accompanied by hieroglyphics in sculpture, wall painting, inventories, sacred scrolls, and codices made of papyrus.

10.1. THOMAS LANIGAN-SCHMIDT. *A Child's Byzantium in New Jersey. 1974–75.* 1982. Magic marker, cosmetics, disco tape, Saran wrap, and aluminum foil on plaster crucifix on cardboard, two panels, 22 × 18″ (55.8 × 45.7 cm) and 18 × 9 (45.7 × 22.8). Holly Solomon Gallery.

A practice closer to our experience is the illustrated book, the richest examples of which come from medieval times when the practice of copying sacred books and pictures reached its apex. Rulers and church authorities lent their patronage to establish libraries for the preservation of these texts.

In a contemporary homage to this practice, in *A Child's Byzantium in New Jersey 1974–75* (Figure 10.1), Thomas Lanigan-Schmidt appropriates the style of an illuminated manuscript—the style, but not the rich materials used by medieval copyists. Lanigan-Schmidt says he uses "poor and inexpensive materials . . . aluminum foils, plastic wraps, cellophane tape, staples, and felt-tip markers" to emphasize the clash in values among different social groups. While the earlier manuscripts were made for the privileged few, Lanigan-Schmidt's work reverses this exclusionary practice. His work is absolutely democratic; it resembles outsider art making use as it does of everyday materials and found commonplace images. Lanigan-Schmidt's style is midway between the iconographic style used in the Middle Ages and a cartoon style popular in the twentieth century. The juxtaposition between the old story given a contemporary twist and the centralized iconic image makes for a conceptual telescoping back and forth between old and new.

In early Islamic cultures sumptuous effects were achieved in plaster, metal, ivory, wood, textiles, and paper by interlacing organic motifs with calligraphy. Orthodox religious restrictions constraining the depiction of the human figure were more than compensated for by the development of intricate pattern and decoration. Word and image are so entwined, they are difficult to separate; together they make up the formal vocabulary of Islamic art in architecture, art, and crafts.

Oriental achievements in art are extended expressions of word and text. In the Orient the study of calligraphy provides the foundation for the training of an artist. The inscribed landscape scroll whose sections were to be

viewed in limited segments at a time was a unique Chinese development. (See Figure 8.22 for a contemporary takeoff on this ancient theme.) Poetic descriptions, narrative accounts, and maxims were the literary forms used in scroll painting. Poetic imagery accompanying eloquent descriptive writing is a characteristic of Oriental drawing and painting.

These are only a few of many examples of the long-standing tradition of word and image combined. You can no doubt think of dozens more instances throughout history of the use of image and word. Across time and cultures this theme has held its fascination for the artist.

In the twentieth century the relationship between word and image has grown in complexity. Cubists, Dadaists, Surrealists, Pop Artists, Conceptual Artists, and Narrative Artists have employed various strategies that make use of word and image. Of course, the reciprocal relationship between art and the mass media has fostered even more complicated connections between the two. At the core of advertising is the way words can alter the way we perceive an image, and, reciprocally, the way images can change the meaning of words.

The contemporary issue is not illustrative art where picture and text both function to the same ends, but how certain combinations and juxtapositions produce resonances between the verbal and the visual that are lacking in each separately. The power inherent in words and images makes it imperative that we be both visually and verbally literate so as not to be duped or swayed by propaganda—political, social, or otherwise.

The most basic connection between the traditional pairing of words and images is found in the role the title plays in a work of art. You can turn through the pages of any art book to discover how titles relate to their accompanying images. Titles of portraits, mythological subjects, and history paintings give us reference points for understanding the works; in the Romantic and Impressionist periods titles directed the viewer to emotive, expressive interpretations.

The interpretive role of words merely serving as titles to direct the viewer's focus changed radically in the twentieth century when actual words or fragments of words claimed equal status as the depicted image and words were incorporated into the actual body of the work of art. We see examples of this development in the Cubist work of Braque (see Figure 6.13) and in Schwitters's Dadaist collages (see Figure 6.21). In an update of the Dadaist reclamation of urban ephemera, the contemporary French artist Villéglé strips through layers of posters to reveal hidden words (see Figure 6.23).

Pop Artists derived their strategies from the mass media, using secondary sources for their commonplace subjects. Their incorporation of word and text is as common in Pop Art as it is in advertising. Warhol's *Campbell's Soup Can* might be cited as the icon of the 1960s. Trademarked products and names occur regularly in Pop Art; Coca-Cola bottles are as common in art of the 1960s as wine bottles were in Cubist art. An indebtedness to the comics for methods of representation and narrative sequence is owed by Pop Artists, Lichtenstein most notably (see Figure 1.30). Lichtenstein's detached, impassive style is an ironic foil to the dramatic and exaggerated subject matter cartoons often use.

In the 1970s and 1980s, the relationship between word and image underwent explosive changes. Conceptual artists led the way in asserting the primacy of words and written documents as stand-ins for the actual art ob-

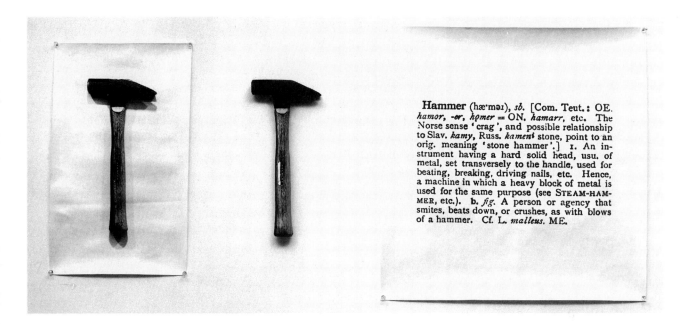

jects. Joseph Kosuth's title (used for more than one work) *Art as Idea as Idea* accompanied an enlargement of the dictionary definition of the word "idea." Kosuth says the basis of conceptual work is "an understanding of the linguistic nature of all art propositions." In Figure 10.2 he presents us with three ways of perceiving/conceiving an object: The actual object is paired with an image, a photograph of the object, and with the written, verbal definition of the object. Like Kosuth, many contemporary artists ask us to interpret and relate to the image in new conceptual terms, and this task is carried out by combining word and image. Neither the isolated text nor the isolated image provides the ultimate meaning; it is the combination (or disjunction) of the two that generates new and different meanings.

The goal of many contemporary artists is to disrupt the single meaning assigned to an image by strategies involving words and images. The results are often humorous as in Figure 10.3. The scene is both enigmatic and ambiguous. A bedroom is rendered in a "dumb" style with bed and tables floating in a highly unsettled manner. Tiny shoes on either side of the bed suggest human characters. The crudely written accompanying title or text "It was all play" is highly suggestive. Context and frame of reference are missing or at least ambiguous; we are presented with theatrical curtains which underscore the word *play* in the title. The inconclusive drama is suggested by an implied narrative. The viewer is forced to fill in the blanks. Absent figures seem to be involved in a psychologically loaded event. We are privileged to look at the scene but the stated drama eludes us. Spatial ambiguity abounds in the quirky perspective of the scene and the frontalized trio of vases with their spiky flowers.

We have seen examples of work in which facture is emphasized, where the particular handmade quality gives the viewer a clue as to who the maker of the art is. Look again at Twombly's work (see Color Plate 9) as an example of this phenomenon. Note how his linear configurations stem from hand-

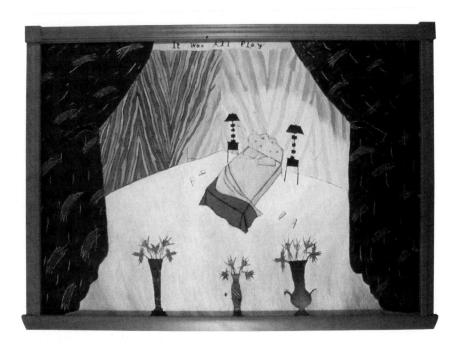

10.3. HOLLIS SIGLER. *It Was All Play.* 1980. Oil on canvas, 42 × 60″ (106.7 × 150 cm). Private collection. Courtesy of the artist.

writing, not from the artistic gesture. Twombly's intentionally clumsy writing style creates a tension between the written word and the often poetic response it elicits. The written word as image is the theme of Twombly's work; Twombly sometimes scrawls names from classical culture (like "Virgil" or "Dionysus") across the surface of his work; these words seem to be fragments of the past barely alive in our consciousness. The effect is an ironic one of poetic spareness. The word *mute* keeps cropping up in describing Twombly's work.

Other artists such as Ed Ruscha use the word itself as image. In Figure 3.26 the word *chop* has been turned into an illusionistically three-dimensional object with light and shadow giving it dimension; the word seems to be constructed from a streamer of paper folding and turning in perspectival space. We are left to puzzle the significance of this particular word. Why did the artist choose such an odd word? Is there a socially or privately encoded meaning? After intense concentration on the shape, we finally begin to lose the sense of its meaning, and see it as an object in the real world.

A second example by Ruscha will extend our understanding of his work. This time word and image work together to create a visual and verbal *double entendre* (Figure 10.4). The words are taped onto the paper and the image of the sailing ship is airbrushed over the surface. The tape is removed, leaving the words negative to the ghostly image that is now situated behind them. The statement "Brave Men Run in My Family" can be taken on at least two levels: The men either run away, an activity not associated with bravery, or a distinguishing characteristic of the men in the family is that they are brave. The ship supports both interpretations, but it is an absolute impossibility to hold both interpretations in mind simultaneously. The ideas are mutually contradictory. A third level that is operative in the work is the commentary on the romantic attitude with its ideas of heroism and bravery. The ghostly Ship of Romanticism seems to be slowly sinking in the waves. The idea of a life at sea (again a double meaning crops up: living onboard ship or living lost,

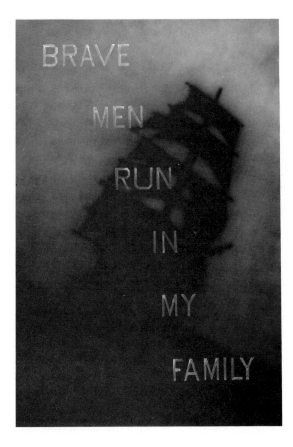

10.4. EDWARD RUSCHA. *Brave Men Run in My Family.* 1988. Dry pigment on paper, 60 × 40″ (152.4 × 102.2 cm). Collection Richard Salmon, London.

at sea, without meaning and direction) could be understood at a deeper level. Nearly any words one might choose to discuss this work point to sea metaphors and allusions, and from there to more personal, psychological "undercurrents." It is exactly this kind of game playing Ruscha uses in his work, and the efficacy of his seemingly simple approach is underscored when we as viewers join in the game.

Some artists work in a more clearly defined narrative mode. Dotty Attie insinuates encoded messages beneath the surfaces of old masters' paintings. Her goal is to expose and unveil secrets found in them through a recombining of segments of the painting with invented, fictional stories (Figure 10.5). By focusing on details that are secondary in the actual work (such as hands, feet, and glances), she subverts the original meaning and implies through her texts that the old masters themselves are involved in secret schemes and cover-ups. She generally works in small, 6″-square units arranged sequentially, either horizontally or sometimes in grids. She painstakingly and convincingly copies not only the image but the original artist's facture.

Combining details from two different paintings by the nineteenth-century American artist Thomas Eakins, Attie insinuates a disreputable story. Unlike Sigler who strips her images of a context or frame of reference, Attie creates new and multiple contexts for her repossessed images. We are aware of the historical context from which the images are taken; the artist creates a disjunction by removing them from that frame of reference and offers us another view, another set of propositions for interpreting them.

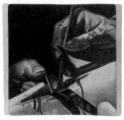
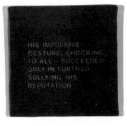

10.5. DOTTY ATTIE. *Barred from the Studio.* 1987. Oil on canvas, 11 × 34″ (27.9 × 83 cm) overall. P.P.O.W., New York.

The initial frame in *Barred from the Studio* the text reads: "Barred from the studio while male models were posing, female art students were placed in a corridor where a small window provided a distant view of the sitter's back." This is a fact of the actual practice of art schools of the time, but the following two narrative fragments leave viewers to draw their own conclusions concerning exactly what Eakins did that was so shocking in trying to rectify the situation. The second and fourth squares are bloody details taken from Eakins's *The Gross Clinic;* these combined with the famous image of Eakins's sculler leave us in a quandary. The sculler's central position and his intent gaze offer some clues to the underlying message. Looking, gazing, seeing, close inspection, close-up views, being barred from looking—these activities are either explicitly or implicitly stated in verbal and visual images throughout the six-part narrative. Can we then surmise that voyeurism itself is the subject of the work? Voyeurism operates on several levels in the images: The painted sculler returns the viewer's gaze (or is he observing the bloody proceedings going on in front of him?); the viewer is implicated by looking at the gory close-up details and by trying to fit together a plausible explanation for Eakins's "shocking" and "impulsive gesture" that "succeeded only in further sullying his career"; both artists, Eakins and Attie, are involved in "voyeuristic" activity, that of making art. We are all implicated, viewers and artists alike. With reduced images and minimal text, Attie plants notions that keep us involved long after the actual encounter with her work.

Let us conclude our discussion on the shared theme of word and image by looking at the work of a self-taught artist. It should not be surprising that so many outsider artists use words in their art. In their work language is another medium to get their message across; in spite of the fact that writing does not necessarily clarify, it does make for a lively surface and textural interest. Nowhere is this more evident than in the work by the Swiss artist Adolf Wölfli. Committed to a mental asylum as a schizophrenic, he turned to intense, compulsive, and obsessive art making, creating a massive and original body of work, including 45 text-and-image–filled books. In Figure 10.6 ornate musical staves create an architectonic structure. Words and images crowd the negative nooks and crannies. Wölfli reinvented himself as the hero of imaginary exploits, transforming himself into St. Adolf II, a sort of artist-god who recreated the world. Jean Cocteau gave the best testimony to visionary artists like Wölfli in his observation that their work frightens us because it is "the highest expression of the spirit of nonconformity." It is this

10.6. ADOLF WÖLFLI. *General View of the Island.* 1911. Pencil and colored pencil, 39.29 × 28.03″ (99.8 × 71.2 cm).

spirit of nonconformity that characterizes most interesting art. In our look at image-and-word themes we have seen that modes differ from artist to artist, but the cross-circuitry between the two disparate ways of relating to the world provides a spark for both viewer and maker alike. Our visual and verbal abilities are called into action to interpret and relate, and to provide our own personal imprint and responses.

A second major shared thematic thread that runs through contemporary art is appropriation of preexisting images. The art of the 1980s was characterized as being an art about "pictures" with appropriation as the dominant mode. The quotations come not only from art history but from the mass media as well. Appropriated images promote associations with style and with subject matter. These quotations pose questions concerning our pictorial language. Josef Levi's major theme is the combination of two figures from separate art historical periods. In Figure 10.7 we see two heads, one appropriated from Henri Matisse, the second from Leonardo da Vinci. This new context certainly alters our preconceptions about both artists' work; a new meaning is produced in seeing the images in the same picture plane. New meanings derive from style, from subject matter, from cultural attitudes of two very different periods.

Larry Rivers and Mel Ramos are only two among many who have taken subjects from earlier art and given them new meaning. In *I Like Olympia in Black Face* (Figure 10.8), Rivers transforms Edouard Manet's famous nineteenth-century painting into a mixed-media construction. The cartoon quality of the figures, the absurdity of the construction, and the general kitsch approach to

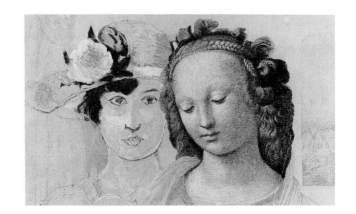

10.7. JOSEF LEVI. *Still Life with Matisse &
Leonardo.* 1984. Acrylic and graphite on
canvas, 38½ × 62½″ (97.8 × 158.8 cm).
O. K. Harris Works of Art.

a revered painting from history do not undercut the strong human comment
on class and servitude that Rivers is making. One additional in-joke refers to
the fact that Manet was criticized sharply for the flattened spatial effect of
his painting. The extreme lights and darks, along with limited modeling across
the reclining figure, resulted in a very limited space—especially for the art
of the time. It was Manet's spatial innovations that had such a strong influ-
ence on later art; Rivers's raid has more than a double meaning in its conver-
sion of Manet's flattened pictorial space to a literal three-dimensional object.

Ramos's satirical handling of the same painting transposes Manet's cour-
tesan into a 1970s centerfold (Figure 10.9). Different techniques, styles, and
materials have worked jolting transformations.

Some shared themes appeal to a wide public. Their general human con-
cerns have a universal attraction. The traditional mother-and-child subject
can be found throughout the history of art, in all cultures, at all times. We

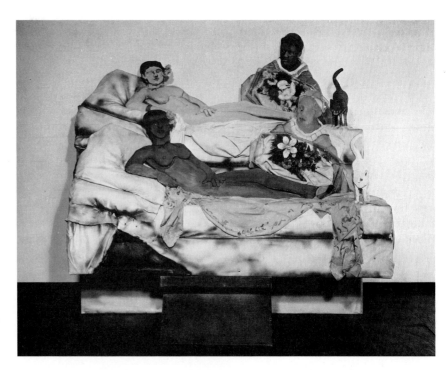

10.8. LARRY RIVERS. *I Like Olympia in
Black Face.* 1970. Mixed media construc-
tion, 71⅝ × 76⅜ × 39⅜″ (1.82 × 1.94 ×
1 m). Musée National d'Art Moderne,
Centre Georges Pompidou, Paris. © 1997
Larry Rivers/Licensed by VAGA, New
York, NY.

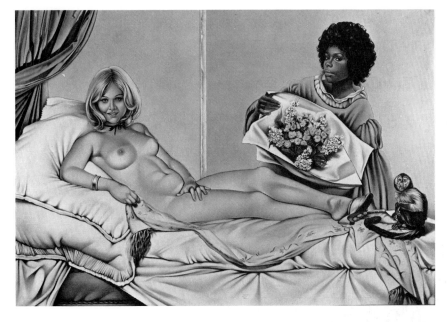

10.9. MEL RAMOS. *Manet's Olympia.* 1973. Oil on canvas, 4′ × 5′10″ (1.22 × 1.78 m). Louis K. Meisel Gallery. © 1997 Mel Ramos/Licensed by VAGA, New York, NY.

have only to think of the variety of Christmas cards that come from many sources to be reminded of how widely this theme has been used by artists. Usually in these works a balanced, insulated, protected world is depicted. How sharp in contrast in both feeling and content is Alice Neel's *Carmen and Baby* (Figure 10.10)!

Neel's interest in women's experiences and motherhood furnished her with a continuing theme. The unconventional view of a mother with her ill infant is a moving portrait. Neel's view is above eye level, so that the mother's loving face looms as the focal point of the composition. The child's strange posture with its frail, bent legs is echoed in the mother's enfolding hand. Neel makes a psychologically gripping statement in this work.

We end our discussion on shared themes with a work that sums up this topic: Frank Gardner's gridded image (Figure 10.11) has as its base a traditional mother-and-child subject. The artist has converted the image to a twentieth-century version by seemingly digitalizing the composition. What a surprise to discover that the work is, in fact, making use of a traditional technique—fabric squares, put together like a quilt! The resulting work is a clever compilation of the old and the new, of the recognizable and the abstract, of tradition and innovation.

PROBLEM 10.1
Word and Image

In this problem dealing with thematic development, you are to unify a series of drawings by media, technique, and idea, using words and images. You may arrange the series in a number of ways taking your cues from Chapter 9, paying special attention to the section called Division of the Picture Plane.

Tom Sale's *Self-Study Primer* (Figure 10.12) is an informative work to study before beginning this project. Formally, this series is unified by media,

10.10. ALICE NEEL. *Carmen and Baby.* 1972. Oil on canvas, 40 × 30" (102 × 76 cm). Private collection. Robert Miller Gallery.

technique, and image. Each segment is drawn on a blackboard, separately framed; each unit employs a limited number of images juxtaposed with a title that gives some clue as to how to interpret the drawing. In one drawing a fishing lure with an eyehook is combined with a centralized image of teeth; the single word written in a style akin to that in a handwriting manual reads "pacify." The second panel in the triptych includes a rocket, a fingertip bone, a pencil, and the words "distal phalanx." How are we to interpret such disparate images? Are they connected? What, if anything, do they have in common? Artists frequently develop a personal iconography that may be difficult to comprehend. The effort to discover, to unravel their meaning is a vital part of the art experience. Subtle connections emerge, testing our interpretative and deductive reasoning.

We can approach this triptych as if it were a game. Our first major clue in unraveling the meaning comes from the title, *Self-Study Primer;* we can assume that these drawings are lessons, a symbolic self-portrait. Two of the boards contain images that refer to seeing: the eyehook on the fishing lure (two visual/verbal puns). In the third drawing, a face is made of objects: rocket-eyes, bone-nose, pencil-mouth. What are the connotations of the objects? They seem to have double functions; in the fishing lure, there is a hook; the eye can be snagged. The rocket and pencil function as arrows, directing the viewer's line of vision; they, along with the teeth, are sharp; they could be a danger. The word "pacify" defuses the danger; one of the functions of art is to blunt the hooks of existence. The shoulder blade is also a visual/verbal pun (shoulder blade/knife blade). It appears with the words "boy enemies",

10.11. FRANK GARDNER. *Mother and Child*. 1987. Fabric on canvas, 76 × 64″ (1.93 × 1.63 m). O. K. Harris Works of Art.

10.12. TOM SALE. *Self-Study Primer*. 1990. Oil pastel on chalkboard with wood, each segment 18 × 24″ (46 × 61 cm), overall 24 × 54″ (61 × 137 cm). Collection of the artist.

reminding us of the games even big boys play with knives and rockets. The "distal phalanx" is the name of the first joint in the finger—also a pointer, a means of directing attention. Pointers direct you where to look, lures intrigue,

10.13. JASPER JOHNS. *Untitled.* 1983. Ink on plastic, 24¾ × 36¼″ (63 × 92.1 cm). Collection, The Museum of Modern Art, New York; gift of The Lauder Foundation. © 1997 Jasper Johns/Licensed by VAGA, New York, NY.

eyehooks grab or capture, rockets destroy, pencils create, teeth bite lures, and so on. We see the makings of a story in these seemingly incongruent images and words. Contradictions and oppositions seem to be contained within a single image; images and words play interchanging analogy games. We see how an artist can look at objects outside of art and reassemble them to make new meanings. Images fade in and out like half-remembered ideas. The erased images, Sale says, indicate that there are layers of images, built from back to front; others are ready to appear to create new sets of oppositions, contradictions, metaphors for making and looking at art, and, as the artist says, for creating the self. The artist, like his art, is in the process of becoming.

PROBLEM 10.2
Frames of Reference

For this problem you are to purchase five or six postcards with reproductions of paintings or drawings from art history—picture postcards.

Write captions of no more than three or four lines each. These do not necessarily need to be original. You can use found texts or found fragments of texts. They can be snippets from old letters, random sentences from any book on hand; you might even ask a friend or a child to write them. They need not relate to each other.

Combine the captions and pictures. Place the postcards face down on the table and let chance determine which text goes with which image. After you have spent some time with the combined words and pictures, alter the images in some way. You can draw over the surface; you can apply opaque paint; you can use collage; or you can cut the card into segments and rearrange the parts.

Choose one of your more successful efforts and turn it into a finished project. You can enlarge the card on a color copier or you might choose to duplicate it by hand. Incorporate the caption in some way into the compo-

sition, by overlay or some other means. A gridded format could be a good
choice. Look again at the work of Dottie Allen, John Baldessari, and Dotty
Attie in relation to this problem (see Figures 6.7, 9.1, and 10.5).

PROBLEM 10.3
Art History Series

Choose as your subject a work from art history. Make a series of draw-
ings with the work as a point of departure. You can approach your theme
through any of the methods discussed in this chapter. The original work can
be altered and transformed stylistically. You can make changes in the form,
or you can use a contemporary compositional format taken from Chapter 9.

In your drawings you can change the meaning of your chosen reference
by transforming it from its context into a scientific, secular, or religious con-
text. The use of grids or other twentieth-century devices, such as collage or
photomontage, can give your subject a contemporary look.

You might crop the original image and blow up a detail of the work. In
any case, keep the source of your subject apparent to the viewer. The re-
sulting series is to be an homage to your chosen artist.

INDIVIDUAL THEMES

An example of individual thematic development can readily be seen in the
works of Jasper Johns (Figures 10.13 and 10.14). Johns has used the cross-
hatch pattern since the early 1970s. The motif has been interpreted on a num-
ber of levels: 1) as abstractions, 2) as subtle compositional structures, 3) as
symbolic of something camouflaged or hidden, 4) as a reference to traditional

pictorial elements, 5) as a pictorial device appropriate for concerns with process and systems, 6) as an analogy for a covering such as the stretched canvas, and 7) as a motif for the artist's personal signature. In Johns's work in the early 1970s he used this motif in a nonobjective mode on panels of equal size, using different media on each subsection. In these works each subsection of crosshatch complied with a preset system; variations in color and scale contributed to a change in mood.

In the two examples shown here, the crosshatch motif has undergone a transformation. The apparently abstract patterning is more dimensional; its source is a detail of the demon of the plague in Matthias Grünewald's early sixteenth-century painting, which Johns has abstracted and reversed, or turned upside down. This citation has been the subject of much critical investigation. Without clues to help locate the hidden image, the average viewer could not detect the disguised reference, but this strategy lies at the very heart of Johns's work; doubleness of meaning and of appearance is a prime concern.

In a more recent phase of his career, Johns uses more recognizable imagery. In addition to the crosshatch motif, other recurring images are the clothes hamper, the faucet, the skull, the double flags (one with 48 stars; the other with 50—again, the question of doubleness), a vase, and a rather clumsily drawn head of a woman with a feather curling out of her hat. Johns has established a theme by using the same images and the same format (the diptych) throughout the 1980s. These images and format are the language Johns uses in his visual speculations on art, and they are the means he uses to tell us that things are not what they appear to be. The idea of multiple appearances and of art as the ground of his work has its visual equivalence in the divided picture plane. (In each of the drawings, the Grünewald crosshatch always appears on the left; it is the continuing ground of the entire cycle of work.) Not only is the picture plane divided into two major sections, each section is further subdivided into planes within planes. Johns has had a continuing interest in pictorial space from his early work to the present; segmentation is one manifestation of that involvement. He is interested in the part as opposed to the whole. The right picture plane functions as a wall on which two-dimensional objects are attached (note nails and shadows), while the objects that refer to dimensional shapes in the real world, basket, faucet and vase, are singularly flat.

Two images are especially worthy of note; they are both picture puzzles, paradoxes. The white vase can alternately be seen as a vase or as two facing profiles, male and female (again, doubleness of identity; the one on the left is Johns's profile). The drawn figure of the woman on the right is another composite, a borrowed 1915 cartoon, originally titled *My Wife and My Mother-in-Law*; she is either a young woman with her features turned away from the viewer, or she is an old crone depicted in profile view with a huge nose, her head lowered into her fur collar. Johns tests our perceptual quickness and requires us to form relationships and distinctions between the parts. References to mortality reverberate through these works—the skull, the two ages of woman, the Grünewald citation. And mood changes from drawing to drawing—from an atmosphere heavy and stormy to a lighter one with a summery feeling. These contrasts are crucial to Johns's concerns, to his continuing thematic dialogue on art and mortality. Johns's series of paintings, prints,

and drawings is entitled *Seasons*, that traditional metaphor for growth, change, death, and renewal.

We have discussed Johns's work at length, not only because it is so rich and full of meaning, but because it shows how an artist's theme and variation can extend over a lifetime of work. In Johns's art, we find a consistency of images or motif and a continuing involvement in formal concerns, especially that of pictorial space. His work has become much more personal in the latest phase of his career, in which he uses more figurative references and recognizable images. Throughout his work he has maintained an intense investigation into the ways in which pictorial space reflects and represents real space. Our extended discussion of Johns's work is intended to introduce you to the many options available to you when you embark on your own projects of theme and variation. Media, subject, images or motifs, formal decisions, technique, and style—all play a role in thematic development. The following problems will suggest points of departure for serial drawings.

PROBLEM 10.4
Individual Theme: A Series of Opposites/Transformation

We have seen how contemporary artists frequently create a feeling of disjunction by placing together two dissimilar objects. In this series you are to choose one object that will appear in each drawing. With that recurring image juxtapose another object that will either amplify or cancel the first object's meaning or function.

In Gael Crimmins's *Spout* (Figure 10.15), the source of the painting within the painting is Piero della Francesca's fifteenth-century portrait of the Duke of Urbino. The small portrait is combined with a small milk carton that in some strange way is analogous to the Duke's profile. By this surprising pairing we read multiple meanings into the work: the debt of modern artists to

10.15. GAEL CRIMMINS. *Spout* (after Piero della Francesca, *Duke of Urbino*). 1983. Oil on paper, 22 × 22½" (56 × 57 cm). Private collection, Los Angeles.

Renaissance art, the dominance of man over nature, the richness of the old contrasted with the depleted, ordinary carton full of references to a consumer world with our habits of use and discard.

A second way of developing your private theme of opposites is to have an object literally transform into another one. Crimmins has left the final stage of transformation to the viewer to perform. In preparation for choosing the objects to be transformed, it is helpful to sharpen your vision to see visually analogous forms. (The Duke's nose and the spout of the milk carton are visually analogous.)

You can graphically attribute human characteristics to an inanimate object; this is called *anthropomorphizing* the object. Or you can have two objects metamorphose into each other. Search for interesting pairings for several days before you begin on this thematic series.

PROBLEM 10.5
Transformation/Using Computer-Generated Images

This problem is, of course, optional. Because many art programs have computers available to their students, we are including a problem dealing with this contemporary medium.

The process of drawing with a computer is closely related to design. The distinction that we make between drawing and design is that in design there are a stated problem to solve and goals to be met. In this drawing you are to respond to what you see on the computer screen, allowing the image to govern what happens next: Do not let preconceptions interfere with the process.

Use a program that allows input from a video camera to capture the image; alter it, converting the image to lines, dots, or value shapes. Scanners are used for image input. You might find some interesting black-and-white images in a science textbook or in a book of illustrations. You can use some grid designs that come with the programs. Stretch, distort, enlarge, and/or crop on the computer. (You might include some words in your drawing. Various typefaces also come with computer programs. These, too, can be manipulated, altered, enlarged, etc.)

Print your computer-generated drawing on a laser printer, and then photocopy it—either enlarging or reducing the image to produce an appropriate scale.

Figure 10.16 shows pages from a book that was produced entirely on a computer. Danielle Fagan used only one image of a fish which she manipulated—stretching, compressing, enlarging, deleting, compiling, combining with some found texts all referring to fish. A grid has been altered to become a net, which is printed in red ink on clear acetate and is dispersed throughout the book, as if to catch the fish on the pages underneath. Blue paper is used for some of the pages, as an obvious reference to water.

The artist says the fish is a metaphor for the artist, who might "fall prey to fishermen or be trapped in the outer isles." She recommends a metaphorical summer as the time to go fishing, fishing for new ideas, images, questions, and answers.

One final comment before we move on to our next project: Computers can be good tools for artists, especially beginners, because they allow students to use and create more sophisticated images at an early stage in their

10.16. DANIELLE FAGAN. *Fish Book.* 1990. Computer-generated book, 8½ × 11″ (21.6 × 28 cm). Collection of the artist.

work. Frequently, beginning students want to produce more elaborate work than their hand skills permit. Using the computer will allow you to produce many variations quickly. You do not have to imagine what it would look like if, for example, you made it bigger, made it blue, moved it to the left, doubled it, or turned it sideways. The computer can turn your "what ifs" into concrete images. Computers are experimental tools; they can be freeing; they do not produce work that is "precious"; images can be discarded and retrieved easily. They do have a "sneaky" aesthetic and process all their own; it is important not to buy into it completely. In the hands of an artist with an established knowledge of art, they can be helpful aids, and the resulting drawings can be very creative. It will be very exciting to see what happens, the changes that occur, when young artists who have had this advantage mature.

PROBLEM 10.6
Developing a Motif

For this series you are to choose a single motif, a recurring thematic element, a repeated figure or design, that will be the dominant image in each drawing. Use nonobjective imagery rather than recognizable objects or figures. A repeating motif in Johns's work is the crosshatch; in Rauschenberg's it is the transferred image (see Figure 6.29).

Using a single motif, develop it through variations of the form. Change the scale of the motif; vary its placement; think in terms of its compositional and spatial arrangement. Your motif could be a decorative pattern that contracts and expands with a surface like a billowing piece of paper. Keep in mind the decisive role of the picture plane.

Use the same paper and media throughout the series. The images might change gradually from drawing to drawing, so that a decided difference is apparent between the first and last drawings in the series, but only a slight change when the drawings are seen in sequential order.

Drawings dealing with form need not lack in expressive content. Formal development does not rule out a subjective approach.

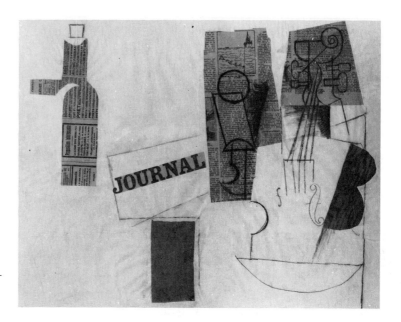

10.17. PABLO PICASSO. *Bottle, Glass and Violin.* 1912–1913. Paper collage and charcoal, 18½ × 24⅜" (47 × 62 cm). Moderna Museet, Stockholm.

GROUP THEMES

Members of the same schools and movements of art share common philosophical, formal, stylistic, and subject interests. Their common interests result in group themes. Georges Braque (see Figure 6.13) and Pablo Picasso (Figure 10.17), both Cubists, illustrate the similarity of shared concerns most readily. Their use of ambiguous space through multiple, overlapping, simultaneous views of a single object, along with a combination of flat and textured shapes, is an identifying stylistic trademark. Collage elements—newspapers, wallpaper, and playing cards—as well as images of guitars, wine bottles, and tables appear in the works of many Cubists.

Pop Artists have a preference for commonplace subjects. As the name suggests, these artists deal with popular images, taken from mass media, which are familiar to almost everyone in American culture. Not only do they choose commercial subjects such as the Coca-Cola bottle (Figures 10.18, 10.19), but they also use techniques of advertising design such as the repeated or jumbled image. The effect of the seemingly endless rows of bottles in Andy Warhol's painting is to emphasize the conformity and sameness of a commercially oriented world. For the Pop Artists both subject and technique make a comment on American life and culture.

PROBLEM 10.7
Style/Visual Research Project

Go to the library; look through several twentieth-century art surveys. Choose three twentieth-century styles. Some suggestions are: Analytical Cubism, Synthetic Cubism, Fauvism, German Expressionism, Surrealism, Constructivism, Abstract Expressionism, Pop Art, Minimal Art, Photo-Realism. Find the commonalities in the work of at least three artists within each style. Pay attention to preferred medium, to shared imagery, and especially to style.

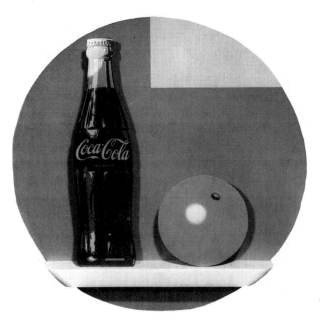

10.18. TOM WESSELMANN. *Still Life #50.*
1965. Assemblage on wood; diameter
39½″ (100 cm), depth 4″ (10 cm). Sidney
Janis Gallery. © 1997 Tom Wesselmann/
Licensed by VAGA, New York, NY.

(Style is the way something is done, as distinguished from its substance or
content, the distinctive features of a particular school or era.) What are the
distinctive characteristics of the periods you have chosen? Analyze the works

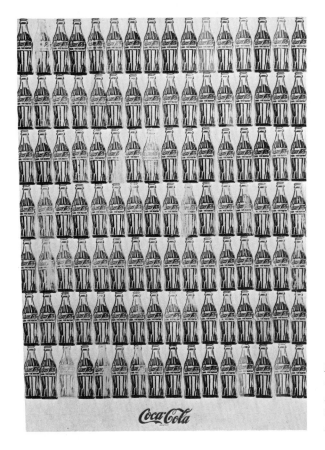

10.19. ANDY WARHOL. *Green Coca-Cola
Bottles.* 1962. Oil on canvas, 6′10″ × 4′9″
(2.08 × 1.45 m). Collection of Whitney
Museum of American Art. Purchase, with
funds from the Friends of the Whitney
Museum of American Art.

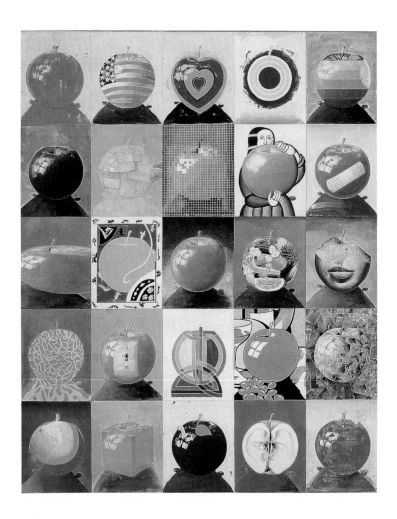

10.20. PAUL GIOVANOPOULOS. *Apple-Léger.* 1985. Mixed media on canvas, 60 × 40″ (152.4 × 101.6 cm). Louis K. Meisel Gallery.

according to how the elements of line, shape, value, texture, and color are used. What is the resulting space?

Paul Giovanopoulos provides us with a good art history exam in his apple conversion (Figure 10.20). How many artists or styles can you identify? We have discussed several of the artists whose works are parodied by Giovanopoulos. In your research on the shaped picture plane, you no doubt looked at Frank Stella's *Protractor Series*, but did it occur to you they were analogous to an apple?

SUMMARY

DEVELOPMENT OF A THEME

An artist's style is related to imagery. Sometimes an artist works with an idea in different media and in different styles, yet the theme is constant. In other artists' work the theme is the result of a stylistic consistency, and the imagery is changed from piece to piece. Whatever approach you take, let your own personal expression govern your choices.

Here is a list of some variables that will help you in structuring your thematic series:

1. subject matter, imagery, or motif
2. media or material
3. technique
4. style
5. compositional concerns, such as placement on the picture plane
6. use of space (determined by how you use line, shape, color, texture, and value)
7. scale

It is necessary to find a theme that is important to you. Each drawing in your series should suggest new ideas for succeeding drawings. An artist must observe, distinguish, and relate; these three steps are essential in developing thematic work. After having completed several of these problems, you will think of ways of developing your own personal approach.

SKETCHBOOK PROJECTS

Collecting ideas is a continuing process for the artist. Thematic series can evolve from simple sources.

PROJECT 1
Visual and Verbal Descriptions

Over a two-week period set yourself the task of drawing single, individual objects. You are to draw from life with the object in front of you, graphically describing the object as accurately as possible. After you have made the first drawing of the object, look at it again. You no doubt have a different perception of it now than before you drew the first study.

Next, you are to write about the object. Your writing should be as descriptive as possible. After writing an objective, accurate description, introduce into your writing metaphors and allusions. What is the object like? What does it remind you of? How does it make you feel? What associations with other objects, memories, or events does it evoke?

Your personal, unedited response is valuable in doing this project. If you want to make lists of words, or use sentence fragments, or try your hand at poetry, do not feel intimidated. You are trying to construct a personal, comprehensive, perceptual, and conceptual response to the object. The goal is to expand the way you look at and interpret the world. A fresh, open-ended, unexpected response is what you are after.

After drawing and writing about the object, make a second drawing of it. Compare the first and second drawings. How has the graphic concept changed? How did writing about the object inform and affect your second drawing?

PROJECT 2
Juxtaposition of Word and Image

Reverse the order of the preceding exercise. Begin with a written description, follow with a drawing, and conclude with a second written response.

Words can alter the way we perceive an image and, reciprocally, images can change the meaning of words. Juxtapositions of words and images can produce resonances between them that can jolt our perceptions. This exercise can be a reinvestment of meaning into the most common of objects.

Reduce your verbal description and responses to a single word. Pair that word with a drawn object. Word and image may or may not derive from the same object. Note the influence the single word has on the object. Try for multiple effects by changing the word but retaining the same drawn object.

C H A P T E R 1 1

A L O O K A T
A R T T O D A Y

*F*IN DE SIÈCLE IS A TERM THAT MEANS THE summation of phenomena associated with the end of a century, especially with its most extreme expressions. As we come to the end of one millennium and move into the next, we need to assess the world's concerns. What better discipline than art to shed light on new and old prophecies!

This final chapter is an overview of the art of our time, a crucial period not only for art but for human culture generally. Our world is immersed in images and information. It is imperative that we examine and interpret the systems that produce our images and ideas. How, why, and for whom images are made, how they are distributed, the context in which they are seen—all these issues demand critical assessment.

In a time of political, economic, and technological instability, it is no surprise that artists respond by employing images and strategies whose associations, references, techniques, styles, and meanings are in flux. We are living in a time when our basic institutions themselves are being reconsidered, altered, even dismantled. In a raucously humorous vein Nicole Eisenman presents us with a respected art institution, the Whitney Museum, in a state of dismantlement (Figure 11.1). This drawing is a companion piece to her hilarious mural painted at the Whitney of the museum blowing up around her as she paints on its only remaining wall.

THE WHITNEY BUY ANY OL' PAINTING SALE 1995

11.1. NICOLE EISENMAN. *Whitney Buy Any Ol' Painting Sale* (detail). 1995. Wall installation for Whitney Biennial at the Whitney Museum of American Art; mixed media, dimensions variable. Shoshana Wayne Gallery, Santa Monica, California, and Jack Tilton Gallery, New York.

Accepted hierarchical structures are being questioned by those who have been marginalized both in the art world and in the culture, especially ethnic and women artists. In the work of the end of the century no single stylistic, aesthetic, or political model lays solid claim over another.

WHY LOOK AT CONTEMPORARY ART?

Since today's world is multicultural and pluralistic, we must acknowledge other ways of seeing, speaking, and thinking, and a major means of accomplishing this high priority task is through art.

It is generally recognized that art forms are inscribed within the social context, so art is the most direct doorway to the *Zeitgeist* or spirit of our time. The visual route is the most immediate to comprehending our world. In art we are presented with the authentic diversities and complexities of the many different ways of viewing and relating to that world. Through art we learn that differences are not only good, they are vital and essential. By adopting another's perspective, we expand our own views and become more than a single-visioned entity. We recognize that all cultures are significant, all ways of thinking worthy, all languages important.

Frank Moore, appropriating Norman Rockwell's famous *Saturday Evening Post* cover, presents a multiracial family being offered a Thanksgiving dinner in his allegorical work entitled *Freedom to Share* (Figure 11.2). However, what Moore shows being shared is not the traditional meal but a platter of medication and syringes. Our metaphorical connections take on jolting new meanings in this painting with its message of inclusiveness.

11.2. FRANK MOORE. *Freedom to Share.* 1994. Oil and glass beads on canvas on wood with frame 5'9¼" × 4'7" (1.76 × 1.4 m overall). Private collection, New York. Sperone Westwater.

Contemporary art challenges preconceptions; it opens us to other views and ideas than those approved and promoted by the mainstream. Familiarity with today's art will enable you to relate your work to your own experiences and to the times in which you live. An acquaintance with current issues will increase your knowledge of art and provide a reservoir of techniques and points of view which will strengthen your own work.

Keep in mind while studying this chapter some ways in which meaning in an artwork is modified and conditioned: first, by the artist's intent, second, by the viewer's relationship to the art, and third, by the cultural context or setting of the work.

DEFINITIONS OF MODERNISM AND POST-MODERNISM

Our understanding of contemporary art is of necessity tied to our understanding of Modernism. For over a century Modernism has been the cultural standard that formed our conception of what art is. Newer ideas, attitudes, and art forms are being made now that do not conform to Modernist criteria. This broad cultural shift has been tagged *Post-Modern;* the term not only describes new directions in art, but changes in architecture, music, design— changes in the culture generally.

Twentieth-century art has been a march toward abstraction and reduction under the major direction of Modernism. Modernism has been characterized by dialectical shifts in style. Analytical Cubism, Fauvism, Futurism, Constructivism, Purism, Abstract Expressionism, and Minimalism are only a few in a line of "isms" progressing through the century. Each "ism" responded to a different philosophical theory of what art is. Modernism has been seen as a set of codified values about art and artmaking whose role is to investigate the essential nature of visual art. It deals with the processes by which art is made and with the nature of pictorial space. It stresses the primacy of form; it promotes truth to the intrinsic properties of the material from which it was made; and it asserts that art is a way of thinking and seeing that is opposed to the natural appearance of objects in the real world.

In Modernism, definitions held schools together—color for the Fauves, space for the Cubists, gestural vocabulary for the Abstract Expressionists. The definitions were exclusive. Modernism is involved in how an object is made, how it is perceived, and what defines art. It focuses on the formal properties of art.

In contrast, formalist issues in Post-Modern art take a secondary role to other concerns, such as why an art object is made, how it is experienced, and what the object means beyond its formal compositions. Post-Modernism focuses on the relationship between representation and content. In Post-Modernism categories are never clearly drawn; a multitude of purposes and categories exist side by side.

The two basic approaches, Modernism and Post-Modernism, are clearly evident in two periods of work by the same artist, Robert Morris (Figure 11.3 and Color Plate 7). A leading proponent in the two movements of Minimalism and Earthworks in the 1960s and 1970s, Morris was involved in material, seriality, and process—all formal concerns. In contrast, his recent work uses apocalyptic images dealing with the aftermath of nuclear destruction. A heavy Baroque-like frame encases a massive pastel drawing, with marks applied in slashing, violent strokes. The frame combines bas-relief images of skulls and dismembered body parts. Called a "mini-theater of fear and fascination," Morris's new work presents a horrific drama. It was inevitable that an investigation into subject matter would follow the "exhaustion of modernist forms," to quote the Minimalist-now-Post-Modernist artist.

11.3. ROBERT MORRIS. *Battered Cubes.* 1965–1988. Painted steel, 36 × 36 × 36" (91.4 × 91.4 × 91.4 cm) each. Leo Castelli Gallery.

Morris's work blew open the dictum by the Modernist critic Clement Greenberg that art should make no reference to any other order of experience, that it should confine itself strictly to the visual experience of art itself. Purely pictorial, nonillusionistic, essentially optical, and self-referential—these were the demands of Greenbergian Modernism.

Morris's work violates categories; that is, it can no longer be strictly categorized as pure painting or pure sculpture. This blurring of categories is perhaps the most distinguishing characteristic of today's art and of Post-Modernism generally.

PRECURSORS OF POST-MODERNISM

Let us now look at some styles within Modernism that led to the development of Post-Modernism.

Pop Art

In the 1960s the philosophical foundations of Modernism began to be undermined by Pop Artists with their debunking of the sanctity of art and the role of the "art hero," and the introduction of mundane subject matter. Think of Andy Warhol's now well-known Brillo boxes. Warhol's equation of art with mass-produced commodities emphasized how commercialized art had become just another commodity in a world full of commodities. Warhol's subject matter and method of working—having others execute his ideas—challenged the long-honored idea of originality.

Modernism prohibited connections to historical and social contexts. Here were Pop Artists thumbing their collective noses at such constrictions. The French critic Jean Baudrillard claims that media-derived images are even more real to us than reality itself. The extent to which commercial images have altered the way we look at the world cannot be exaggerated.

Minimalism/Conceptual Art/Earth Art

Modernism, or Formalism as it came to be called, reached its apex in Minimalism, which investigated such issues as sensory perception and process, the process of thought itself and its operation in how we perceive and order the world.

Form underwent a radical reduction in Minimalism (sometimes referred to as Reductivism), which in turn bred two further movements in the late 1960s and early 1970s: Conceptual Art and Earthworks, or Environmental Art. The latter involved work on a monumental scale using the earth itself as the medium (see Figure 1.7). Conceptual artists pushed Reductivist ideas to their extreme; these artists advocated the primacy of idea over form, finally eliminating the object altogether and driving a deep wedge in Formalist strongholds. Since idea is the essence in Conceptual Art, painting and sculpture were replaced by the unpossessable workings in the artist's mind. Art's longstanding complicity with commercialism, they believed, would be overcome by this strategy. Conceptualism helped liberate artists from critical and institutional restraints.

11.4. PHILIP GUSTON. *Untitled.* 1953. Ink on paper, 18 × 24″ (46 × 61 cm). Collection of the Paine Webber Group.

Photo-Realism

The Photo-Realists opened the door wide to representational imagery in the 1970s (see Figures 1.19 and II.12). While their approach to subject matter is detached and removed, imitating the way the camera sees, here the issue of major importance is that Photo-Realism dealt with a *mode* of representation—the manner in which the subject is represented, the way the camera sees. As you will learn later in this discussion, modes of representation lie at the very heart of Post-Modernist work.

EARLY DEVELOPMENT OF POST-MODERNISM

The critic Leo Steinberg used the term *Post-Modern* as far back as 1968 in reference to Robert Rauschenberg's work. In the early 1950s, Jasper Johns and Robert Rauschenberg began incorporating three-dimensional objects, words, collage, and photographs from mass media sources into their works. Steinberg labeled their approach a "shake-up which contaminates all purified categories."

Some artists, such as Rauschenberg and Jasper Johns, felt that Modernism's immersion in abstraction and reduction was in conflict with efforts to incorporate life and art, to bridge the gap between the two. People, their emotions, landscapes, and still lifes were excluded as subjects from Modernist art, and in the late 1970s and 1980s representations of human experiences returned to take center stage in the drama of art. Philip Guston was one of the first artists of major importance in redefining painting. His reputation was firmly established as an Abstract Expressionist; his early work dealt with the formal issues of color and atmospheric space (Figure 11.4). Then, in the late 1960s and early 1970s, his painting underwent a radical change. He began

11.5. PHILIP GUSTON. *Study for Edge of Town*. 1969. Charcoal on paper, 14 × 17" (35 × 43 cm).

making self-portraits featuring clumsily drawn, hooded klansmen with enormous hands and feet who were usually smoking, drinking, painting, or sleeping (Figure 11.5). Guston claimed that a painting is made in the mind, that it might be made of "things, thoughts, a memory, sensations which can have *nothing* to do directly with painting itself."

Along with a reintroduction of figuration, Guston incorporated complex iconography from many sources—personal, public, political, psychological, and art historical. Stylistically, Guston combines the rendering style of the 1930s Regionalists and Surrealists with other art historical sources, especially Italian Renaissance painting. Drawing was the primary means of developing the personal idiom that expressed his unique vision.

The work of Guston, along with that of other artists such as Robert Morris and a group called the New Imagists, were the pioneers of Post-Modernism in their exploration of new subject matter and their rejection of Modernist tenets. (We have included a number of them in this text: Jonathan Borofsky, Neil Jenney, Jim Nutt.)

These New Imagists, as they were called, along with other Post-Modern artists, regarded popular culture as a fruitful field for critical investigation, a mine of imagery, styles, and ideas. Comic book drawing styles and untrained, nonart techniques were claimed by the New Imagists to revitalize heretofore "unacceptable" ways of representation and to introduce new images into their work. This was in sharp contrast to the basic stance of Modernism which disallowed extraneous, personal, autobiographical, and social references.

In Post-Modernism there is a tendency to read all products of culture as "texts." This in turn leads to a reconsideration of the function of representation both in art and in the broader culture as well.

Influences of Feminist Art on Post-Modernism

One of the important influences forging change in contemporary art has been the women's movement. Feminist art is devoted to the idea of art as a direct

11.6. MIRIAM SCHAPIRO. *Homage.* 1975. Lithograph, printed in color, 20¼ × 20" (51.4 × 50.8 cm). Steinbaum Krauss Gallery.

experience of reality. Its stated goals are "raising consciousness, inviting dialogue, and transforming culture." Women have demanded new criteria for judging art. They challenge the limitation of a singular, dominant, "right" view of experience. The Guerrilla Girls are a group involved in exposing the "remedial category" to which women artists have been relegated. This anonymous group uses creative means to combat sexism in the art world—fighting not only artistic discrimination but other gender and racial problems as well. Dressed in gorilla suits, the members monitor exhibitions by major museums and call attention to the discrepancy in the numbers of men and women whose works are shown; for example, a widely distributed poster from 1986 asked how many women had solo exhibitions that year in each of the nation's most prominent museums. The answer: 0.

Out of women's work of the 1970s came new strategies; women were leaders in the evolving art forms of performance, video, and artists' books (see Figure 6.2). A newly accepted gender-centered vantage point opened art to new content, new techniques, and new materials. Autobiographical issues, particularly those related to women's sensibilities, have now been legitimized as vital subjects for art.

Miriam Schapiro and Judy Chicago were codirectors of the influential Feminist Art Program in Los Angeles, a program that promoted and sponsored artworks and performances by women. In her own work Schapiro draws both her imagery and materials from women's crafts—art which she calls "femmages." Her work summarizes the influences the women's movement has had on art in its use of personal iconography overlaid with political implications.

In *Homage* (Figure 11.6), Schapiro calls for a rewriting of art history to rightly include the place of women artists. The names of Sonia Delaunay and Georgia O'Keeffe, well-known European and American twentieth-century artists, are combined with the virtually unknown Canadian visionary artist Emily Carr.

11.7. BARBARA KRUGER. *Untitled (We Have Received Orders Not to Move)*. 1982. Photograph, 6' × 4' (1.83 × 1.22 m). Collection of Arthur and Carol Goldberg, New York.

Feminists are involved in a rigorous and ongoing questioning of hierarchical conditions and especially the analysis of how representations of women address power and position. Barbara Kruger uses visually reductive means to make powerful comments on our culture, especially the role of women in today's world. Her terse statements with their accompanying images have an impact beyond what we read at first glance. In Figure 11.7, the text "We have received orders not to move" overlays a pinned-down seated female figure. Can Kruger be suggesting the woman is pinned down, trapped inside the "male truth" of contemporary cultural discourse? The critic Michel Foucault argues that what is "true" is dependent on who controls the discourse. Kruger, in a seemingly simple work, highlights the two kinds of truth operative in our culture.

European Influence: The Development of Neo-Expressionism

A seminal figure in the erosion of strict categories of art was the German artist Joseph Beuys. He embraced Performance Art (called the most characteristic art of the 1970s) as a means of rehumanizing not only art but life. Performance Art encompasses language, physical activity, projected slides, three-dimensional objects—theater unbound by rules or traditions. Beuys's wartime experience (in World War II he had been shot down in the Crimea, and nomadic tribesmen had saved his life by wrapping him in grease and felt) provided impetus and techniques for his ritualized performances, the goal of which was transformation and healing (Figure 11.8).

11.8. JOSEPH BEUYS. *Eurasia* from *Siberian Symphony.* 1966. Mixed media performance.

Beuys had a tremendous influence on the developing new artists in Germany; in his teaching and in his art he revived myth as a powerful theme. German artists followed Beuys's lead in his humanizing efforts and in the revival of historical themes as redemptive necessities. Italian art paralleled these efforts.

German and Italian artists, the Neo-Expressionists as they were called, spearheaded a new movement in Europe and claimed international attention on two counts: their forceful use of paint and the return to the convention of representation. Enormous, heroic-scale, apocalyptic subject matter, bold, gestural brush work, vigorous, color-laden, energized works announced the arrival of something very different from the prevailing art, and continental artists were in the vanguard.

Anselm Kiefer, Georg Baselitz, Mario Merz, A. R. Penck, Francesco Clemente, Enzo Cucchi, and Helmut Middendorf are names you may be familiar with—we have discussed several of their works elsewhere in the book. And you are familiar with their American counterparts, Julian Schnabel and Robert Longo, among others. Anselm Kiefer has been called the quintessential Post-Modernist in his broad-ranging, wide-foraging use of appropriated images, in his conceptually loaded, nonart materials, and in his demanding agenda to reassess history and culture (see Figure 6.4).

The Neo-Expressionists revitalized painting and embraced images, subjects, and styles that had been banned by the Modernist code. By the late 1970s and early 1980s Post-Modernism took center stage in its search for a radical new content and in its renunciation of Modernism.

POST-MODERNISM: NEW SUBJECT MATTER, NEW STRATEGIES

The relationship between representation and content is in the forefront of Post-Modernist work. Figuration was reintroduced as a vehicle for conveying meaning, for making social and political commentary, as a vital way to invoke associations and make references to popular culture, history, and art itself. Post-Modernism is characterized by a reassessment of modern traditions of art and the role of art in society. Post-Modern artists see art as a means of interpreting nonart experiences, borrowing freely from the past and using art and nonart sources, popular imagery, and cultural artifacts.

Modernism had discredited certain themes as inappropriate for art, such as the role of the artist as social critic, literary themes, the relationship between art and language, image and concept, issues of political, social and cultural relevance, moral issues, the question of class and gender structure, the role of myth in a culture, and other psychological and philosophical investigations. In contrast, current artists have reclaimed these vital subjects in their art; they have shifted from a concern with style to a concern with issues, meaning, content, and context—with *how* we know what we know.

Content or meaning, then, has become the focus of current art. Robert Longo (see Figure 9.19) speaks for a number of contemporary artists when he says that he is "totally obsessed with the idea of human value. I feel like I'm contributing to my culture, posing certain questions about living and the pressures of living today."

Appropriation and Recontextualization

The art of the 1980s has been characterized as being art about pictures, with appropriation as the prevailing mode. Artists appropriate or "quote" pictures and styles from myriad sources. Art images are taken from the media—from television, newspapers, magazines; from films, posters, advertising, cartoons, illustrations; and from other works of art.

Artists remove images from their original context and recontextualize them. By this strategy the image sheds some of its original meaning and acquires new ones. Jane Hammond's images and styles are culled from both high and low cultures, from science and art, and from different historical periods. Images are overlaid and jumbled; separated from their original context, the differing modes of representation become more pronounced. Photographic images are combined with diverse images from unrelated historical periods. In Figure 11.9 the faded background of birds and butterflies evokes a poetic response to a lost, romantic time. Hammond's sources are far-reaching—manuals on knot tying, palmistry, phrenology, alchemy, furniture, and children's games, all are a part of her inventory. She regards her pictorial stock as similar to a deck of Tarot cards in which each new combination of images tells a different story.

Before beginning this particular series, Hammond asked the poet John Ashbery to write the titles for the yet-to-be-made work. The reversal of naming before the named comes into existence follows in line with her delegating decisions that are traditionally kept under the artist's control. In the

11.9. JANE HAMMOND. *Pumpkin Soup II.* 1994. Oil on canvas with collage, 6′ × 7′2″ (1.84 × 2.18 m). Luhring Augustine Gallery.

completed work references to different modes of illusionistic representations abound; phototransfers of the two collaborators, Hammond and Ashbery, are reflected in the mirrors of two vanity tables; a still life of fruit and flowers, a *vanitas*, an interplay of words and images, visual and verbal puns, spills over the furniture; a trained monkey balances two lamps (another wordplay on the monkey as a symbol of art's ability to "ape" nature). Geometric models allude to scientific modes of abstractly representing what we know of the world. The centaur atop a see-through box (yet another pun) is a reference to Ashbery's dual interests in the classical and the abstract. The poet–visual artist team has its precedents in a long line of artists who have collaborated over the years, most notably in publications of text and image.

A look at the picture-making process of the contemporary painter Mark Tansey will be informative in our discussion of appropriation and recontextualization.

Tansey constructed what he calls a "content wheel" consisting of three concentric rings; the first lists subjects, the second verbs, the third objects. When the wheel is spun, three different levels of content can be combined: the conceptual, the figurative, and the formal. The resulting combinations are then used as supplementary motivating narratives for his work. An example of a phrase that could appear is, "Cubists [subject from ring one] suppressing [verb from ring two] other history [object from ring three]."

After this exercise Tansey selects images from a voluminous collection of photos and texts compiled from magazines, newspapers, books, his own photographs, and drawings. The archive provides "low-brow iconography for high-brow issues." The selected images are then photocopied and synthesized into a collage. A graphite drawing follows the collage process and serves as a "veritable photographic source." Following the graphite drawing, Tansey

11.10. MARK TANSEY. *Literalists Discarding the Frame.* 1992. Toner on paper, image 8 × 7" (20 × 18 cm); frame 17¾ × 14½" (45 × 37 cm). Private collection, Boston. Curt Marcus Gallery.

makes a "toner drawing" by the subtractive process using erasers, brushes, and a variety of tools to remove the copier ink or toner and to produce a painterly-looking drawing.

At this step in the process Tansey informs us "the handmade and the reproduced are set in a sort of dialectical dance." Unlike the computer the copier allows the hand to imprint directly onto the surface and to manipulate the toner ink. The process itself raises questions concerning the relationship between the original and the reproduced, and in so doing has bearing on the content while providing an underlying theme.

In the drawing shown here (Figure 11.10), the structure of the frame is used as a metaphor of representation. In a suite called *Frameworks* from which this illustration is taken, Tansey explores framing as a metaphor of representational content, "art production as framing, frames as transformational edges and lines, frameworks as sites of representation, frames as substitutes for subject matter."

Finally, the drawing is translated to paint on canvas. Tansey's work is monochromatic, which, according to the artist, both clarifies and illuminates the subject. Texture (frequently used to carry opposing interpretations, such as rock formations built from words or texts) and value are the formal elements most pronounced in his work.

In keeping with contemporary goals, Tansey invites the viewer's involvement in an unraveling of complex meanings. The work is simultaneously metaphorical and allegorical.

The artist who has gone to the greatest lengths in appropriation is Sherrie Levine—in her photographs of photographs of other artists' work or her

11.11. BABA WAGUÉ DIAKITÉ. *Seni Cegni.* 1994. Mud cloth (Bogolanfini), 4'5" × 6'11" (1.35 × 2.11 m). Courtesy of the artist.

copies of art book reproductions. In this "original" format she questions the Modernist value of originality, along with its selective and exclusionary stance.

Myth and Allegory

Representation is not simply an imitation of objects; rather, it is a symbolic system that changes along with culture. Our representational tradition controls our perception of real life; it literally changes the way we perceive. Pictures or images can be signs, symbols, or archetypes; they are the means by which we create visual metaphors.

Myth and allegory are important themes especially for multicultural artists. We see the sacred and the secular cojoined in unexpected and exciting ways in contemporary works by artists from various cultures (see Color Plates 2 and 10).

The Mali artist Baba Wagué Diakité absorbs the tradition of storytelling in his art (Figure 11.11). In his native culture storytelling is both a form of instruction and entertainment; it is at the same time communal and ceremonial. In an effort to transplant ideas absorbed as a child in Mali to his adopted American culture, Diakité paints on African mudcloth remembered scenes of mythic reenactments. The vitality and playfulness of his forceful drawing style ensure an imaginative response; we feel freed from our cultural limitations in viewing his work.

Elsewhere in the text we have discussed the work of a number of artists involved in the relationship of myth and the individual, and with myth and society. Borofsky's work deals with dreamlike experiences (see Figures 3.33 and P.G.B1); Merz reworks traditional, classical mythic themes (see Figures 2.6 and 11.12); Clemente is interested in the coexistence of alternative realms of experience (see P.G.B6); and Kiefer is concerned with cultural myths and how they direct history (see Figure 6.4).

Mario Merz is interested in that state between the animal and human world animated by primal forces, a world beyond the physical world with its

11.12. MARIO MERZ. *Unreal City, Nineteen Hundred Eighty Nine (Citta Irreale, Millenovecentottantanove)*. 1989. Glass, mirrors, metal pipes, twigs, rubber, clay, clamps, 16′4⁷/₈″ × 32′8″ (5 × 10 m). Solomon R. Guggenheim Museum, New York; gift of the artist, 1989.

social/cultural problems (see Figure 2.6). Merz is particularly interested in the generative principles of the universe (Figure 11.12).

Many female artists are deeply involved in myth and allegory as subjects. In their search for a new, liberated identity, they have found myth to be an effective means of expanding our notions of the unknown and the illogical; myth has the power to transport us into imagined realms.

Archetypal, symbolic images present us with a natural energy, and they reveal to us our more base nature, which, Kiefer suggests, we must imaginatively overcome in order to be reconciled with each other and with the earth.

Images of the earth, garden, landscapes, animals, the earth goddess, masks, snakes, along with natural forms and materials fill the work of a great number of women artists. Not only are they interested in changing old attitudes toward women, they are involved in trying to change destructive attitudes toward the environment, in creating new restorative myths for the earth.

Humor and Irony

No artist has been more involved in the enterprise of showing us how popular culture and its modes of communication direct art's meaning than Andy Warhol—albeit with a light- and cold-hearted edge. Images from popular culture form Warhol's vocabulary. His pop icons are a tongue-in-cheek way of pointing to the role cultural symbols have in creating our reality. Humor and irony play a major role in Post-Modernism. An ironic approach is fitting for a project whose role it is to disclose and criticize. Irony allows an ambivalent stance: Criticism and humor are inextricably bound.

In a tangential vein is the work of the German artist Sigmar Polke (Figure 11.13). Although on the surface his work is humorous, on a more serious

11.13. SIGMAR POLKE. *Untitled.* 1988. Lacquer and distemper on fabric, 9′10″ × 7′3¾″ (3.0 × 2.23 m). Michael Werner Gallery.

level, it deals with modes of representation, the interplay between various modes of abstraction. Polke is a trickster—in some recent work he uses light-sensitive pigments, "time-released colors," whose unpredictable future appearance cannot be known.

Like Warhol and Polke, John Wesley appropriates imagery from popular culture for ironic ends. Best known for his takeoffs of Blondie and Dagwood Bumstead and Popeye, he provides strange, enigmatic, new roles for these clichéd characters. Wesley's compositions are simplified, crisp, tightly knit designs reminiscent of a highly edited Japanese woodcut or an Alex Katz portrait. The playful formality verges on the abstract. It is the juncture of the archetypal American comic characters, known for their mediocrity, and the sophisticated formal treatment of them that creates something beyond humor and irony. Figure 11.14 *Dagwood (Wave Dancer)* could be turned into a wallpaper design (a Warholian tactic) with its alternating and repeating rows of wave and figure. The wave, derived from the famous Japanese print by Hokusai, is as animated as Dagwood; it can be interpreted alternately as a singing, yawning, laughing, or threatening, gaping, open mouth. East meets West as both wave and dancer dance in tune with some unheard music.

Popular or Commercial Tactics

In Post-Modernist art the boundaries between art and commerce are frequently blurred. Jenny Holzer's signs were flashed above Times Square as a part of a project bringing art into public places (Figure 11.15). Her method of delivery is exactly the same as advertising techniques, but here the comparison ends. Holzer's *Truisms* call attention to commercial platitudes. "Your Oldest Fears Are the Worst Ones" and "Order Is Man's Vocation for Chaos

11.14. JOHN WESLEY. *Dagwood (Wave Dancer)*. 1991. Acrylic on canvas, 5' × 6' (1.52 × 1.83 m). Collection A. G. Rosen. Jessica Fredericks Gallery.

11.15. JENNY HOLZER. Selection from *Truisms*. 1982. Spectacolor board, Times Square, New York. Sponsored by the Public Art Fund. Courtesy of the artist and Barbara Gladstone Gallery.

11.16. SUE COE. *Wheel of Fortune: Today's Pig is Tomorrow's Bacon*. 1989. Watercolor, gouache, collage, graphite, acrylic ink, 4′10⅜″ × 4′7⅝″ (1.48 × 1.41 m). Collection of Thomas and Judy Brody; Galerie St. Etienne, New York.

Is Hell" are like no messages you will ever read on an ordinary billboard. It is interesting to note that in the art of Holzer and Joseph Kosuth (some of whose work is also on billboards), words replace images—they are the images (see Figure 10.2). Kosuth says that "artists work with meaning (not form) . . . by canceling, redirecting or re-organizing the forms of meaning that have gone before." Their work, along with that of Barbara Kruger (see Figure 6.22), has a political slant in addition to its appropriation and exposure of popular commercial techniques. Artists, advertisers, and politicians are interested in influencing public opinion.

Warhol and Polke incorporate mechanical reproduction as both media and message in their work. Roy Lichtenstein's stylistically coherent body of work derives from imitating commercial techniques (see Figures 1.30 and 6.3). Using photographs taken from mass media culture, the German artist Gerhard Richter focuses on the effects of printing processes by forefronting their blurring, misregistration, and accidental blots, along with the flatness of commercially screened surfaces. His work strides the fence between Photo-Realism and abstraction.

Social and Political Themes

Art with social and political themes uses a common, basic methodology that includes a call to action and a recognition or reading of the stance presented. Pictorial rhetoric ranges from the confrontational to the comic to the poignant. Political art has engendered debate between aesthetic purists and those who are politically motivated, but political art is broad enough to encompass a broad range and sensitivity of expression.

11.17. LEON GOLUB. *Worldwide* (detail). 1991. Photographic details of wall-size canvases reproduced in photo-emulsion on vinyl, 3′ × 3′ to 8′ × 6′ (.91 × .91 to 2.43 × 1.83 m). Installation view from worldwide exhibition, The Brooklyn Museum.

We have already noted women's challenges to the traditional insularity of art, especially art history. Not only women, but artists in general, urge us to look again at human values and to regard art from a broadened stance, to discover that art is more than simply an aesthetic discipline. Modernism has been accused of a divisive elitism: art for the few. Much of today's art, however, is bound up with social interaction that has a united goal; it represents an attempt to expose an indifferent culture and to replace it with a more human one. Not since the 1930s has there been such an involvement by artists in social and political issues.

Literary content was disallowed within the confines of Modernism, but in the 1980s and 1990s there has been a resurgence of a repoliticized art. In social and political work, the demands of communication bypass the need for a critic/interpreter; the goal is to convey and communicate ideas as directly as possible. This is certainly the case in the work of Sue Coe and Leon Golub (Figures 11.16 and 11.17). The work of Coe, an English artist, has its precedence in English satire and its stylistic roots in Dadaism, especially in the works of George Grosz (see Figure 5.6). Coe's theme in the series *Porkopolis/Animals & Industry* is the industrialization of death. In strong graphic images we are presented with a blistering indictment of our increasingly coarsened human sensibilities. Coe proclaims, "We are the pigs." She conducts extensive research, presenting written historical documentation collaged onto the drawings, invoking a tremendous pathos in her allegory or parable. Coe is best known for her disturbing and relentless protest against South African and American racism.

Political content is at the heart of Leon Golub's work, which exposes injustices and abuses of power (Figure 11.17). For political artists the issues outstrip aesthetic theories in importance. Golub's large formats make overt references to contemporary political events. Mercenaries, interrogations, riots, victims, violators, combatants are depicted in a claustrophobic space,

11.18. DAVID WOJNAROWICZ. *Fear of Evolution.* 1988–89. Mixed media on wood, 3'6" × 3' (1.07 × 9.14 m). P.P.O.W. Gallery.

walled in, all coldly engaged in their everyday activities. Golub's scraped paint and thin, raw, worked surfaces are carriers of meaning—a brutalized surface for a brutalized subject. In Golub's work the violence mirrors the nightly news reports.

A major impetus for the focus of ideological art since the 1980s has been the AIDS crisis. Political and social disenfranchisement is at the forefront of art dealing with this issue. Work by David Wojnarowicz has a critical intensity; it spans the private and public in its message of urgency. (Wojnarowicz died of AIDS in 1992; his work is being widely shown posthumously.) In Figure 11.18 the odd conflation of symbols of nature and culture (animal and money) points to an uneasy pairing. The photomontage carries a poignant and despairing message.

Performance and Body Art

Connected to social and political art is Performance and Body Art. In the early 1970s performance art took center stage with its three revolutionary tenets: (1) that the art object itself was dispensable; (2) that any event or act could qualify as art; and (3) that the viewer need not be a witness to the actual event—documentation was sufficient evidence of the happening.

Earlier in the century Marcel Duchamp set the stage for then-radical developments with the introduction of his ready-mades and his declaration that his playing a game of chess was a form of art. Pop artists in the 1960s regularly staged "happenings."

11.19. GILBERT AND GEORGE. *The Singing Sculpture ("Underneath the Arches")*. 1969. Mixed media performance at Sonnabend Gallery, October 1971.

The British team Gilbert and George categorize their art as "living sculpture"; their entire lives form the material of a lifelong performance. Their *Singing Sculpture* (Figure 11.19) presented in New York in 1971 was a major stimulus to performance art in the United States. In this performance Gilbert and George wear their "responsibility suits"; their faces and hands are bronzed; they repeat slowly and stiffly the lyrics to "Underneath the Arches." The performances last up to eight hours. Their performances are augmented by other collaborative art activity, such as making books, photographs, and drawings (see Figure II.13).

Our culture gravitates to the spectacular and the sensational, so it is no surprise that art devised a means to capitalize on this desire for theatricality. The best known performance artist to cross over into mainstream culture is Laurie Anderson. Her 1980 recording of "O Superman" made the hit record charts. Using a pastiche of images, inventive electronic manipulation, and a complex mix of sound, staging, light, and enigmatic texts, Anderson's performances (Figure 11.20) defy the traditional boundaries of art, theater, and music.

The most radical star in her "theater of operation" is the French performance/body artist whose assumed name is Orlan. A post-Duchampian, she considers her body to be her own ready-made. Her body-sculpting is both a metaphorical and literal endeavor. She has selected representations of famous women in art history and through plastic surgery reproduces their idealized features in her own body, such as the forehead of Leonardo's Mona Lisa, the mouth of Boucher's Europa, and the chin of Botticelli's Venus. Marginality and danger are necessary elements in her surgery-performances.

11.20. LAURIE ANDERSON. *Born, Never Asked.* 1983. From the United States, Parts I–IV, mixed media performance at Brooklyn Academy of Music.

11.21. CINDY SHERMAN. *Untitled Film Still* #3. 1977. Black and white photograph, 8 × 10″ (20.3 × 24.4 cm). Courtesy of Metro Pictures and the artist.

In somewhat less shocking ways artists like Janine Antoni (see Figure 6.2) and Hannah Wilke (who cast her body in chocolate) use the body as both process and subject matter and the female experience as content. The intimate relationship between a woman and her body is pronounced in many women's work. Just as the critique of the representation of the body has been brought into cultural politics, so the representation of women's bodies by women is a major subject in today's art.

In an age when the body is presented as an object for others (especially in the mass media) women using their own bodies as subject is an act of reclamation. Nowhere is this more evident than in the work of Cindy Sherman (Figure 11.21). Challenging a fixed identity, Sherman photographs herself in various outfits and settings. These are not self-portraits; she calls them "pictures of emotions personified." The sole actor in a wide range of personal narratives, Sherman's work is influenced by film and television; it explores a wide range of frequently stereotypical roles for women.

Multiculturalism and a New Inclusiveness

A new multicultural world is unfolding and critical respect by the art establishment is now being shown for work not based on Western or Eurocentric ideas and definitions. Works by multicultural artists and so-called outsider artists are set in new, international, and pluralistic contexts. The move toward inclusiveness has revitalized the dialogue on race, ethnicity, identity, gender, generational concerns, political debate, and aesthetic standards. In a new pluralism we are offered ideas and views other than those heretofore promoted by the mainstream.

Multicultural work serves as a reminder that we must be willing to revise and reconsider entrenched prejudices and look at the world in the light of present-day concerns. In a global culture political, economic, and sociological changes are taking place at a rapid pace; art parallels these changes.

Cultural dislocation and assimilation make up the theme of many artists who stand in two different cultures. The work by César A. Martínez is one such example. In *El Mestizo* (Figure 11.22) Martínez makes reference to a detail from a Mexican mural *Allegory of Mexico* by Francisco Eppen which shows a three-faced head—Aztec and Spanish faces on either side of a *mestizo*, a person of mixed cultures. In Martínez's iconography the jaguar refers to the New World and the bull symbolizes Europe. A self-portrait emerges between the two animals. What a perfect image to convey the idea of the person who stands in two different cultures! Many multicultural artists like Martínez seek to reinvigorate cultural clichés and stereotypes; their work points to an extensive range of issues, among them politics, popular culture, revised historical interpretations, and environmental concerns. The work of international artists has replaced our single-lens telescope with a colorful prism through which to look at the world.

So-called outsider art, art by self-trained artists, is making a strong impact on the art world. These artists offer us different realities from those shown by professionally trained artists. In their work there is a freshness, a psychological depth, and a personal urgency that sometimes borders on the obsessive. (See Figures II.17 and 10.6).

Howard Finster, an impassioned black minister and maker of visual sermons, is a contemporary self-taught artist. His work *Delta Painting* (Figure

11.22. CÉSAR A. MARTÍNEZ. *El Mestizo.* 1987. Charcoal and pastel on paper, 29 × 41″ (74 × 104 cm). Galería Sin Fronteras, Austin.

11.23) is full of admonitions that, if followed, would lead to a peaceable kingdom. His animated style reveals a world alive with energy, vitality, charm, and goodness.

From a correctional institution comes art by Raymond Materson (Figure 11.24). This seems an unlikely place for such exquisite small embroideries to be made. Each piece is a minute 2½ × 2¾″; it can take up to 50 hours to make the 1200 or more stitches per square inch. Materson's fibers are reclaimed twisted hair-fine fibers from unraveled socks and shoelaces. After drawing the image on paper, Materson makes a black shoelace border, then stitches the designs, which are derived from his personal experiences.

11.23. REVEREND HOWARD FINSTER. *Delta Painting.* 1983, Summerville, Georgia. Enamel on wood panel, frame molding, 25⅝ × 45⅛″ (65 × 115 cm). Collection of the Museum of American Folk Art, New York; gift of Elizabeth Ross Johnson.

11.24. RAYMOND MATERSON. *Joe DiMaggio.* 1993. 2¼ × 2¾" (5.7 × 7 cm). Collection of the artist.

Pictures have power over us; they make us desire—desire to know, to have, to be, to control, to own, to become. They attempt to tell us what the good life is, what our values are, what kind of people our society values. Art that uses these pictures and styles makes us confront and reassess our preconceptions about ourselves and the world; it makes us look at our assumptions and attitudes toward others. The concept of "the other" is crucial to a reading of Deconstruction, a prevalent critical mode of the 1980s. ("The other" involves the idea of difference, the dangerous notion that if persons are not like me, they are of less value.) Both conditions in the real world and in the art world have been such that a large number of ethnic artists are now being shown; they were previously ignored by critics, art publications, galleries, and museums. Art is richer by hearing the voices of these heretofore marginalized, silent artists. (Look at Color Plate 10, the work of Juan Sánchez, an investigation in cultural identity.)

Collaborative Art

We have already discussed works by collaborative artists, such as the Guerrilla Girls, Gilbert and George, Hammond and Ashbery. Generally, these artists shed their individual creative identity and merge talents and ideas. One larger group of activist artists, composed of Mexicans and Chicanos, has organized the Border Art Workshop/Taller de Arte Fronterizo (BAW/TAF). They are involved in performances, installations, and events that expose the political, social, and economic conditions of the border region between Mexico and the United States. They are interested in the clash between history and ideology, in the debate between individual and cultural positions. Figure 11.25 shows an installation view of David Avalos's *Border Fence as Möebius Strip.* Like

11.25. DAVID AVALOS. *Border Fence as Möebius Strip.* 1987. Mixed media installation at Centro Cultural de la Raza, 6′ × 15′6″ × 11′ (1.83 × 4.72 × 3.35 m), sculpture 15′5″ × 38′ (4.7 × 11.6 m)—mural.

the Möebius strip, the border turns back on itself; there is no end and no beginning. What an apt visual metaphor for a no-way-out situation!

A number of Russian émigrés now living in the United States work collaboratively; Savadov and Senchenko and Komar and Melamid are two such teams. In earlier work Komar and Melamid created a pastiche mocking Modernist and official Soviet, state-sponsored styles in their art. Their work mined dated styles for new meanings. Today their work has received wide media coverage. Komar claims "the most important thing in art isn't line or paint or

11.26. KOMAR & MELAMID. *America's Most Wanted.* 1994. Oil and acrylic on canvas, paperback book size. Ronald Feldman Fine Arts Inc.

brushwork but power. That's what art is about." Melamid, his collaborator, finishes Komar's line of thought, "Since we know what people want, we can even rule the people. All greater leaders and all great artists know the people." And to prove this claim the Moscow team organized an opinion poll to find just what kind of art the people want. The artists then painted *America's Most Wanted* (Figure 11.26). The resulting work reflects the people's choice of style and subject matter as opposed to the work chosen by a self-proclaimed elite of the art world—curators, collectors, and critics.

The most wanted painting is an autumn landscape with a vast blue sky, blue mountains, and blue lake with deer and George Washington standing on the shore. Some opinions revealed by their poll are: Landscapes with water and foliage are preferred over interiors; Americans do not like religious subjects; blue is their favorite color; and Americans do not believe that art should necessarily teach a lesson.

The team now has plans to poll other nationalities and paint by the true people's commands, art by consensus. Their ultimate goal, an ironic one, is to create "a painting of humanity," a summary of their worldwide polls.

Semiotics: Words and Images/Narrative Content

It is important to keep in mind that Post-Modernism is more an attitude than a style. Frank Stella said of Modern Art, "What you see is what you see." This is not the case in Post-Modern Art, where what you see is what is implied. What is not present is as important as what is present. The Post-Modern artist is primarily concerned with content, with signification, a sign or evidence of something beyond the image manifested, something in the world of ideas. *Semiotics* is a program whose goal it is to identify the conventions and strategies by which signifying practices, such as art and literature, produce their effects of meaning. No sign or image is ever pure; traces of other meanings are over- and underlaid in the viewer's mind. Semiotics focuses on communication and on how our values are encoded in our culture. The connections between language and art compound the problem of interpretation.

Vernon Fisher's complex installations, using drawing, photography, three-dimensional objects, and narrative texts, explore the role of signs and narrative structure and their relationship to semiotic investigation (Figure 11.27). The words and images in Fisher's work mutually question each other and subvert meanings. His work is metaphoric, suggesting multiple interpretations. The images cannot be read sequentially; associative meanings fill the gaps between two types of cognition: reading and seeing, words and pictures. Both approaches are culturally encoded. *Movements Among the Dead* deals with the blurred lines between reality and illusion. The text is a narrative relating a story about the Russian physiologist Pavlov and his well-known experiments on conditioned reflexes using dogs. Pavlov's dog has been conditioned to salivate at the sound of a bell (which previously announced the arrival of food). In Fisher's narrative the dog turns on his master. Fisher calls into question our human nature. In one section of the installation an appropriated photographic image of explorers in a strange environment suggests our search for hidden, undisclosed meanings. A parabolic mirror reflects and transforms an image on the adjacent wall, converting the white oval into a circle and restoring the black-and-white image into a Dalmatian. The Pluto quotation in the upper left has multiple associations—as a planet, as the cartoon character, as a

11.27. VERNON FISHER. Installation view, East wall, of the exhibition *Projects 20: Vernon Fisher.* January 20, 1990, through March 6, 1990. The Museum of Modern Art, New York.

11.28. ROBERT GOBER. Site-specific installation at Dia Center for the Arts, 548 West 22nd Street, NYC, Sept. 24, 1992–June 20, 1993.

classical mythic figure. Each viewer comes away with a different interpretation, conditioned by personal experience; much of what one sees in Fisher's work is what is implied. What is not there is as important as what is there.

The narrative impulse shows us our process of thought, how we perceive, and how we order the world, how we in turn are controlled and ordered by images.

For a more detailed discussion of the relationship between art and words, see Chapter 10.

Landscape

Simon Schama, in his book *Landscape and Memory,* investigates the role of the land in the human mind. He writes, "Landscapes are culture before they are nature, constructs of the imagination projected onto wood and water and rock." And, we might add, on canvas and paper. Contemporary landscapes seem to underscore Schama's claim. Today's landscapes are melancholic, frequently elegiac; loss rather than presence is most significant. The landscape is presented in its very act of disappearance.

Robert Gober engages the issue of nature and culture in an extremely ambitious and complexly metaphorical installation (Figure 11.28). A sylvan glade is painted on the gallery walls on which are hung three-dimensional sinks; stacks of newspapers and boxes of rat poison are positioned on the floor of the gallery. A black door and barred windows penetrate the illusionistically painted forest walls.

11.29. DON SUGGS. *Proprietary View (Mount Shasta)*. 1985. Oil and alkyd on panel, 21¾ × 39¾" (55.2 × 100.9 cm). L. A. Louver Gallery, Venice, California.

Our associative powers are confounded; the complexity and confusing dichotomies between nature and culture, between the sublime and the mundane jolt our sensibilities. The environment is not what it at first seems to be. The painted representation of nature points to the "other nature" which we turn into pulp and poison. The papers (imprinted by culture) are stacked and tied; they seem ready to be recycled. Nature, now also imprinted by culture, cannot be restored. In this installation, in this world, what is real? What is false? What is artificial? What is salvageable? A way out is suggested by the painted pathway leading into the woods. What, then, is the meaning of the barred windows and the blocked, blacked-out door? Is nature dead or alive? Are we in or out? The work is even more poignant for being located on the third floor of a building in lower Manhattan, far from the rustle of leaves and the sounds and smells of nature.

Leo Steinberg in his 1968 essay "Other Criteria" described the fundamental change in the practice of art as a shift in subject matter from nature to culture. Gober's work is a powerful underscoring of Steinberg's prophesy.

Increasing anxieties about the environment are reinforced by some contemporary artists; our removal from nature is so extreme that many contemporary landscape painters do not paint from nature at all. Don Suggs appropriates his images from photographs in books. These secondhand images (like postcards) stand between us and the real experience of nature in the same way as Suggs's bars intervene between the viewer and the painted image (Figure 11.29). The title *Proprietary View (Mount Shasta)* has a double edge: How can one "own" the earth except through images, which are feeble substitutions and reflections of the real thing? Our experience of landscape has been reduced to copies of copies. It is impossible not to see both images merged in Suggs's work. Both identities, illusion and abstraction, assert themselves.

11.30. TERRY WINTERS. *"b."* 1987. Graphite and gouache on paper, 11½ × 15⅛" (29.2 × 38.4 cm). Sonnabend Gallery.

Suggs forces us to pay heed to the landscape by rearranging the visual and emotional focus of the work.

Neil Jenney, unlike Suggs, addresses specific environmental problems in his work. He produces a ravaged slice of landscape in massive black frames (see Figure 3.19). The frames seem to be a metaphor for the closing in and shutting off of the natural world. The words on the frames in his work of the 1980s confront us more explicitly with the threat to the environment in their stark announcements, "Acid Rain," "Meltdown Morning," "Saw and Sawed."

How unlike the idyllic landscapes of the previous century with their sublime, heroic, romantic views of the wilderness! We had a physical sense of being able to enter into those illusions. The attitudes that formed those nineteenth-century paintings have disappeared as surely as the wilderness itself is disappearing. In the new landscapes, barriers, blocks, frames prohibit even our visual contact with nature.

Abstraction

The strategy of appropriation extends to the discovery of subject matter in abstract painting. Terry Winters's organic abstractions have their origin in textbooks, not as a literal source but as a point of departure. His visual investigations involve how DNA strands are constructed or the structure of vascular systems. Drawing plays a major role in Winters's exploration of form. His work deals with generative energy, primeval origins, primal forces, and stages of growth (Figure 11.30). The connections in Winters's work between the personal and the universal, between scientific research and the metaphorical, place him strongly in the Postmodernist camp. A number of artists are involved in organic abstraction—Suzanne Anker, Willy Heeks, and Rodney Ripps, for example. They employ a painterly and highly unmechanistic approach to a subject matter grounded in science.

Peter Halley uses humor to make wry, subtle social criticism in his work. Halley's abstracted images of cells and circuits are derived from diagrams in

11.31. PETER HALLEY. *Exploding Cell.* 1994. Set of 9 silkscreen prints. Edition Schellmann.

technical charts. In *Exploding Cell* (Figure 11.31), nine silkscreens present abstracted images of exploding cellular structures (such as nuclear cells, atmospheric cells, rain cloud cells, computer cells). Halley's commentary on complex social relationships is made with deceptively simple abstract forms that can be interpreted metaphorically, symbolically, and literally.

Earlier we talked about Polke's investigations into various modes of representation and about Richter's work, which crosses over into abstraction. New abstraction emphasizes the processes that go into the production of the work. Seemingly frozen paint drips, traces of the tools used to drag paint across the surface of the picture plane, cracked paint recording the drying process—these strategies go into making a reinvigorated version of abstraction producing images that refer to their construction, folding back on themselves in a continuous loop of process, subject matter, and meaning.

A look into the process that underlies the work of the abstract artist Jonathan Lasker (Figure 11.32) will give some insight into the concerns of new abstract art. Lasker was influenced by New Image painting in his choice of simple shapes, an intentionally clumsy drawing and painting style, and the use of flat grounds. Lasker has no interest in integrating figure and ground; in fact, he wants them clearly separated. He uses a limited inventory of meandering, overlapping, clunky lines. He rejects the Modernist concerns of placement and the notion that the marks are an extension of the sensitivity and subjectivity of the artist. Lasker painstakingly copies small studies. While traditionally painters have used drawing to work out ideas of form and content, Lasker enlarges the studies or small maquettes in which the problems have already been resolved. The media used in the small-scale prototypes are ballpoint, felt-tip pens, brushes, and palette knives. In the enlarged compositions different techniques must be employed to achieve the same effects as in the smaller versions. The problems involved in transferring one technique to another play a major role in Lasker's process.

11.32. JONATHAN LASKER. *Expressions of an Uncertain Universe.* 1994. Oil on linen, 30 × 40″ (76 × 102 cm). Private collection, Madrid, Spain. Sperone Westwater.

The basics of his formal vocabulary are limited line, limited shapes, and limited color; these elements undergo permutations from work to work with opposites providing visual interest and interaction—geometric versus the organic, flat painting against impasto, control opposed to looseness, positive shapes in contrast to empty negative ground, color contrasted with noncolor. The critic Raphael Rubinstein has aptly applied the term made famous by the poet Keats to Lasker's work, "negative capability."

The critic Robert Rosenblum accurately observed that "the battlelines between realism and abstraction have dissolved entirely."

At the heart of Post-Modern art is the impulse that all art—including the figurative and the representational—is abstract. All images, contemporary artists have discovered, are at least one remove (and frequently many more) from reality, from direct experience (an example: an offset print of a photograph of a mountain published in a book used as a subject for a painting over which have been imposed abstract stripes).

CONCLUSION

We have seen that the common purposes that used to bind schools together are no longer operative in today's art. It is difficult to understand contemporary art with its many subjects, strategies, attitudes, and approaches, but a commitment to making and looking at art is one of the most rewarding activities in which we can involve ourselves.

Literacy is the ability to decode words. Visual literacy is the ability to decode images—the capacity to discover in them meaning and knowledge about ourselves and about our world. What a humanistic enterprise art is!

Let us conclude with a quote from the environmentalist Frederick Turner: "[In this new age of information rather than hard goods] Possession is becoming very abstract. Our best possessions are empty space and time." Isn't this the perfect description of an ideal beginning for art making?—a clean, empty surface and time to make our marks!

PART IV

PRACTICAL
GUIDES

GUIDE A

MATERIALS

THE RELATIONSHIPS AMONG FORM, CON-
tent, subject matter, materials, and techniques are the very basis for art, so it
is essential that the beginning student develop a sensitivity to materials—to
their possibilities and limitations. The problems in this book call for an ar-
ray of drawing materials, some traditional, some nontraditional. The supplies
discussed in this chapter are all that are needed to complete the problems in
the book.

> **WARNING:** Since many materials used in the manufacture of art
> supplies are toxic, you should carefully read the labels and follow
> directions. Always work in a well-ventilated room.

PAPER

To list all the papers available to an artist would be impossible; the variety is
endless. The importance of the surface on which you draw should not be
minimized. The paper you choose, of course, affects the drawing.

Since the problems in the book require the use of a large amount of paper, and since the emphasis is on process rather than product, expensive papers are not recommended for the beginning student. Papers are limited to three or four types, all of them serviceable and inexpensive. Experimentation with papers, however, is encouraged—you may wish to treat yourself to better-quality paper occasionally.

Newsprint and *bond paper* are readily available, inexpensive, and practical. Both come in bulk form—in pads of 100 sheets. Newsprint comes either rough or smooth; the rough is more useful. Buying paper in bulk is much more economical than purchasing single sheets. Bond paper, a smooth, middle-weight paper, is satisfactory for most media. Newsprint is good for warm-up exercises. Charcoal and other dry media can be used on newsprint; it is, however, too absorbent for wet media.

Ideally, *charcoal paper* is recommended for charcoal drawing, since the paper has a tooth, a raised texture, that collects and holds the powdery medium. Charcoal paper is more expensive than bond paper and is recommended only for a few problems, those in which extensive rubbing or tonal blending is emphasized.

A few sheets of black *construction paper* are a good investment. Using white media on black paper makes you more aware of line quality and of the reversal of values. A few pieces of toned charcoal paper would likewise furnish variety. Only the neutral tones of gray or tan are recommended.

All paper should be at least 18 by 24 inches (46 × 61 cm). If you draw on a smaller format, you can cut the paper to size.

An inexpensive way to buy paper is to purchase it in rolls. End rolls of newsprint can be bought from newspaper offices at a discount. Photographic backdrop paper is another inexpensive rolled paper. It comes in 36-foot (10.98 m) lengths and 10-foot (3.05 m) widths. The paper must be cut to size, but the savings may be worth the inconvenience. The advantage to buying rolls of paper is that you can make oversize drawings at minimal cost. Brown wrapping paper also comes in rolls and is a suitable surface, especially for gesture drawings.

Another inexpensive source of paper is scrap paper from printing companies. The quality of the paper varies as do the size and color, but it would be worthwhile to visit a local printing firm and see what is available.

Shopping for drawing papers can be a real treat. You need to examine the paper for its color, texture, thickness, and surface quality—whether it is grainy or smooth. In addition to these characteristics you need to know how stable the paper will be. Paper is, of course, affected by the materials from which it is made, by temperature, and by humidity. Paper that has a high acid or a high alkaline content is less stable than a paper made from unbleached rag or cotton; such papers are not lightfast, for example. The selected papers listed on the following page are more expensive than the newsprint, bond, and charcoal paper that are recommended for most of the exercises in this text. Remember to select a paper that seems to you to be right for a given project. Becoming acquainted with various papers and learning their inherent qualities are among the joys of drawing.

Selected Papers for Drawing (high rag content)

All papers below (except Index) are appropriate for any art media, including wash. Index is a slicker paper and is good for pen-and-ink drawing. Rives BFK and Italia are especially good for transfer drawings.

Arches	22 × 30″; 25 × 40″	(56 × 76; 64 × 102 cm)
Copperplate Deluxe	30 × 42″	(76 × 107 cm)
Fabriano Book	19 × 26″	(49 × 66 cm)
Fabriano Cover	20 × 26″; 26 × 40″	(51 × 66; 66 × 102 cm)
German Etching	31½ × 42½″	(80 × 105 cm)
Index	26 × 40″	(66 × 102 cm)
Italia	20 × 28″; 28 × 40″	(51 × 71; 71 × 102 cm)
Murillo	27 × 39″	(69 × 100 cm)
Rives BFK	22½ × 30″; 29⅓ × 41⅓″	(57 × 76; 74 × 105 cm)
Strathmore Artists	Various sizes	
Manila Paper	Various sizes	

Some Suggested Oriental Papers (plant fiber content)

Hosho	16 × 22″	(41 × 56 cm)
Kochi	20 × 26″	(51 × 66 cm)
Moriki 1009	25 × 36″	(64 × 92 cm)
Mulberry	24 × 33″	(61 × 84 cm)
Okawara	3 × 6′	(.92 × 1.83 m)
Suzuki	3 × 6′	(.92 × 1.83 m)

The sketchbook pad is discussed in the Practical Guide to Keeping a Sketchbook. Size is optional. You should choose one that feels comfortable to you and is easily portable, no larger than 11 by 14 inches (28 × 36 cm).

CHARCOAL, CRAYONS, AND CHALKS

Charcoal is produced in three forms: vine charcoal, compressed charcoal, and charcoal pencil.

Vine charcoal, as its name indicates, is made from processed vine. It is the least permanent of the three forms. It is recommended for use in quick gestures since you can remove the marks with a chamois skin and reuse the paper. The highly correctable quality of vine charcoal makes it a good choice for use early in the drawing, when you are establishing the organizational pattern. If vine charcoal is used on charcoal paper for a longer, more permanent drawing, it must be carefully sprayed several times with fixative.

Compressed charcoal comes in stick form and a block shape. With compressed charcoal you can achieve a full value range rather easily. You can draw with both the broad side and the edge, creating both mass and line.

Charcoal pencil is a wooden pencil with a charcoal point. It can be sharpened and will produce a much finer, more incisive line than compressed charcoal.

Charcoal is easily smudged; it can be erased, blurred, or smeared with a chamois skin or kneaded eraser. All charcoal comes in soft, medium, and hard grades. Soft charcoal is recommended for the problems in this book.

Conté crayons, too, can produce both line and tone. They come in soft, medium, and hard grades. Experiment to see which you prefer. Conté comes in both stick and pencil form. It has a clay base and is made of compressed pigments. Conté is available in white, black, sanguine, and sepia.

Water or turpentine will dissolve charcoal or conté if a wash effect is desired.

Colored chalks, or *pastels,* can be used to layer colors. These are manufactured either with or without an oil base.

Another medium in stick and pencil form is the *lithographic crayon* or *lithographic pencil.* Lithographic crayons have a grease base and are soluble in turpentine. They, too, can be smudged, smeared, and blurred and are an effective tool for establishing both line and tone. The line produced by a lithographic crayon or pencil is grainy; lithographic prints are readily identified by the grainy quality of the marks. (Lithographic crayons and pencils are specially made for drawing on lithographic stone, a type of limestone.) Lithographic crayons are produced in varying degrees of softness. Again, you should experiment to find the degree of softness or hardness you prefer.

China markers, like lithographic pencils, have a grease base and are readily smudged. Their advantage is that they are manufactured in a wide variety of colors.

Colored oil sticks are an inexpensive color medium that can be dissolved in turpentine to create wash effects.

PENCILS AND GRAPHITE STICKS

Pencils and *graphite sticks* come in varying degrees of hardness, from 9H, the hardest, to 7B, the softest. The harder the pencil, the lighter the line; conversely, the softer the pencil, the darker the tone. 2B, 4B, and 6B pencils and a soft graphite stick are recommended. Graphite sticks produce tonal quality easily and are a time-saver for establishing broad areas of value. Pencil and graphite marks can be smudged, smeared, erased, or dissolved by a turpentine wash.

Colored pencils come in a wide range of colors, and water-soluble pencils can be combined with water for wash effects.

ERASERS

Erasers are not suggested as a correctional tool, but erasure can contribute to a drawing. There are four basic types of erasers. The *kneaded eraser* is pliable and can be kneaded like clay into a point or shape; it is self-cleaning when it has been kneaded. *Gum erasers* are soft and do not damage the paper. A *pink rubber pencil eraser* is recommended for use with graphite pencils or sticks; it is more abrasive than the gum eraser. A *white plastic eraser* is less abrasive than the pink eraser and works well with graphite. A *barrel refillable eraser* feeds the eraser down a tube. It provides more control than a slab eraser.

While a *chamois skin* is not technically an eraser, it is included here because it can be used to erase marks made by vine charcoal. It also can be used

on charcoal and conté to lighten values or to blend tones. As its name indicates, it is made of leather. The chamois skin can be cleaned by washing it in warm, soapy water.

INKS AND PENS

Any good drawing ink is suitable for the problems in this book. Perhaps the most widely known is black *India ink*. It is waterproof and is used in wash drawings to build layers of value. Both black and sepia ink are recommended.

Pen points come in a wide range of sizes and shapes. Again, experimentation is the only way to find the ones that best suit you. A crow-quill pen, a very delicate pen that makes a fine line, is recommended.

Felt-tip markers come with either felt or nylon tips. They are produced with both waterproof and water-soluble ink. Water-soluble ink is recommended, since the addition of water will create tone. Invest in both broad and fine tips. Discarded markers can be dipped in ink, so you can purchase different-sized tips and collect an array of sizes.

PAINT AND BRUSHES

A water-soluble *acrylic paint* is useful. You should buy tubes of white and black. You might wish to supplement these two tubes with an accent color and with some earth colors—for example, burnt umber, raw umber, or yellow ochre.

Brushes are important drawing tools. For the problems in this book you need a 1-inch (2.5 cm) and a 2-inch (5 cm) varnish brush, which you can purchase at the dime store; a number 8 nylon bristle brush with a flat end; and a number 6 Japanese bamboo brush, an inexpensive reed-handled brush.

OTHER MATERIALS

A small can or jar of *turpentine* should be kept in your supply box. Turpentine is a solvent that can be used with a number of media—charcoal, graphite, conté, and grease crayons. Other solvents are alcohol, for photocopy transfers, and gasoline or Nazdar, for transfer of magazine images.

Rubber cement and *white glue* are useful, especially when working on collage. Rubber cement is practical, since it does not set immediately and you can shift your collage pieces without damage to the paper. However, rubber cement discolors with age. White glue dries transparent, it is long lasting, and it does not discolor.

Sponges are convenient. They can be used to dampen paper, apply washes, and create interesting texture. They are also useful for cleaning up your work area.

Workable fixative protects against smearing and helps prevent powdery media from dusting off. Fixative comes in a spray can. It deposits uniform mist on the paper surface, and a light coating is sufficient. The term *workable*

means that drawing can continue without interference from the hard surface left by some fixatives.

The purchase of a *drawing board* is strongly recommended. It should be made from Masonite and be large enough to accommodate the size of your paper. You can clip the drawing paper onto the board with large metal clips. The board will furnish a stable surface; it will keep paper unwrinkled and prevent it from falling off the easel.

Masking tape, gummed paper tape, a mat knife and blades, single-edge razor blades, scissors, a small piece of sandpaper (for keeping your pencil point sharp), and a metal container for water also should be kept in your supply box.

NONART IMPLEMENTS

Throughout the book experimentation with different tools and media has been recommended. This is not experimentation just for experimentation's sake. A new tool does not necessarily result in a good drawing. Frequently a new tool will help you break old habits; it will force you to use your hands differently or to approach the drawing from a different way than you might have with more predictable and familiar drawing media. Sticks, vegetables (potatoes or carrots, for example), pieces of Styrofoam, a piece of crushed paper, pipe cleaners, and cotton-tipped sticks are implements that can be found easily and used to good effect.

Keep your supply box well stocked. Add to it newly found materials and drawing tools. Keep alert to the assets and liabilities of the materials you use. Experiment and enjoy the development of your understanding of materials.

WARNING: Remember to read all warning labels on all products and to work in a well-ventilated room!

GUIDE B

KEEPING A SKETCHBOOK

AT THE ENDS OF CHAPTERS 2 THROUGH 10 you will find a section called "Sketchbook Projects"; projects related to the topic discussed and to the studio problems contained in that chapter are detailed in this segment. They are designed to help you solve the formal and conceptual problems encountered in the text. Keeping a sketchbook is an essential extension of studio activity.

It has been observed that the secret life of art is led in drawing. That being so, it can validly be claimed that the secret life of drawing is led in the sketchbook.

Paul Klee observed that the way we perceive form is the way we perceive the world, and nowhere is this more strikingly visible than in the well-kept sketchbook. The sketchbook takes art out of the studio and brings it into daily life. Through the sketchbook, actual experience is introduced into the making of art. This is a vital cycle, infusing your work with direct experience and at the same time incorporating newly acquired abilities learned in the studio.

The first consideration in choosing a sketchbook is that it be portable, a comfortable size to carry. A good alternative to a sketchbook is a spring binder with a firm backing to hold loose-leaf papers securely. This device will allow you to use a variety of papers, permitting you to remove individual sheets to post in your studio or to rework in some way; it will provide a means for grouping drawings out of sequence; bulky collages may easily be removed

and stored; and it will encourage you to keep a file of drawings, catalogued to suit your needs. If you choose to use a spring binder in lieu of a sketchbook, it is advisable also to carry a small notebook in which you can jot down both verbal and visual notes.

Any medium is appropriate for a sketchbook, but a small portable drawing kit should be outfitted to accompany the sketchbook. Some useful contents would be crayons, water-soluble felt-tip markers, pencils, pen and ink, a glue stick, a roll of masking tape, a 6-inch (15 cm) straightedge, along with a variety of erasers, found implements, a small plastic container with a lid, a couple of large clips for holding paper in place, and a small, efficient pencil sharpener or several sharp single-edged razor blades.

Although it may seem artificial and awkward in the beginning, you should use your sketchbook daily—365 days a year. You will soon develop a reliance on it that will prove profitable. The sketchbook will become a dependable outlet for your creativity. In it you can experiment freely; your sensitivity and abilities will become keener with every page.

WHY KEEP A SKETCHBOOK?

Two of the most valuable assets for an artist are a retentive memory and the ability to tap into the unconscious. The memory and the unconscious are both generators of imagery and ideas for the artist. So, by developing your memory and recording your dreams you have a built-in image-making source. Keeping records of your dreams and events in your life can jolt your memory, reminding you of important information you might otherwise have forgotten.

Jonathan Borofsky is only one of the many artists who use dream images to bring important insights to his work (Figure PG.1). Shakespeare summed up these observations succinctly: "We are such stuff as dreams are made on."

In the sketchbook, germs of potential forms or ideas take hold. Quick notations can be like storyboards recording nonverbal, nonnarrative concepts, worksheets on which ideas can be amplified, transformed, multiplied, enlarged, and extended. It would be impossible for us to carry out all our ideas. The sketchbook is the ideal place to record ideas for selection and development at a later time. Over the years, sketchbooks become a valuable repository. Through these records your growth as an artist can be traced.

An example of how a faithful commitment to keeping a sketchbook can pay off is seen in a work by William Anastasi in which he has photocopied pages from his sketchbooks and journals kept for over twenty years to use as collage on large canvases (Figure PG.2). He has amplified and extended the journals' visual themes by the addition of colored pencil, crayon, Cray-Pas (oil-based crayons), and ink.

Sketchbooks are, in the long run, time-savers. Quickly conceived ideas are often the most valid ones. Having a place to jot down notations is important. Preliminary ideas for Robert Smithson's earthwork *The Spiral Jetty* (constructed on the Great Salt Lake in Utah) were rapidly stated in notational, schematic drawings. The verbal notes are minimal; the drawing style is hasty, yet the finished earthwork demanded exacting technical and

PG.1. JONATHAN BOROFSKY. *I Dreamed a Dog Was Walking a Tightrope...at 2,445,667 & 2,544,044.* 1978. Ink and pencil on paper, 12 × 13″ (30 × 33 cm). Private Collection, New York. Paula Cooper Gallery.

PG.2. WILLIAM ANASTASI. *The Invention of Romance.* 1982. Collage at Ericson. 5′8″ × 4′8″ (1.73 × 1.42 m). Collection of Drs. Barry and Cheryl Goldberg. Courtesy of the artist.

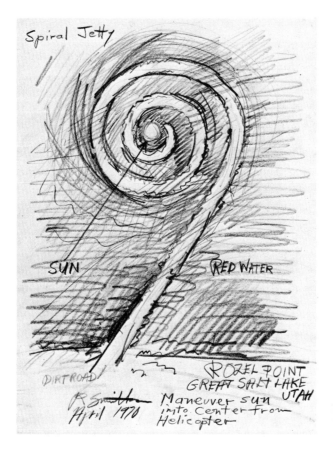

PG.3. ROBERT SMITHSON. *The Spiral Jetty.* 1970. Pencil, 11⅞ × 9″ (30 × 23 cm). Estate of Robert Smithson; John Weber Gallery.

mechanical facility to construct (Figure PG.3). Great ideas have modest beginnings.

As is evident in the work by Smithson, the sketchbook can function both as a verbal and visual journal. It serves as a memory bank for elusive feelings and information. It is an appropriate place to record critical and personal comments on what you have read, seen, and experienced. Verbal and visual analogies can be quickly noted for possible use later on. Claes Oldenburg's voluminous notebooks record his ingenuous visual analogical thinking (Figure PG.4). His cleverly drawn equation of ketchup, french fries, and Coke with the Pisa cathedral, tower, and baptistry is accompanied by verbal amplification and ideas for possible materials if he should decide to convert the grouping into a sculpture. Oldenburg employs another time-saving device in his sketchbook drawings, that of drawing over a photograph.

Picasso, who was rigorous in keeping sketchbooks—volumes of them— showed us the value of playful improvisation. In his drawings titled *An Anatomy* (see Figure 8.26) he presents 22 playful variations on a form. Quick thinking, responsive drawing, sensitivity to visual stimuli, heightened analytical abilities, enhanced memory and immediacy of response—these are only a few of the many benefits of daily sketchbook practice. In Eugene Leroy's gesture studies (Figure PG.5), we see how skills acquired in the studio can be translated to the sketchbook.

Many times the way artists revitalize their work after a period of inactivity is to use the sketchbook as a place of new beginnings. Even an old

PG.4. CLAES OLDENBURG. *Ketchup + Coke Too?* from *Notes in Hand.* 1965. Ballpoint pen, 11 × 8½" (28 × 21.6 cm). Courtesy of the artist.

sketchbook when reviewed after a while offers fresh new ideas. Seeds of ideas take longer than we think to germinate. It is exciting to trace our preferences for certain forms and relationships over an extended period, and there is no place better to find those thoughts embedded than in the sketchbook.

APPROPRIATE SUBJECTS FOR A SKETCHBOOK

We could make a one-word entry under the heading of what is appropriate subject matter for sketchbooks: Everything. Every experience in your life, your musings about them, your joy, your despair, your frustrations, your dreams, your fears, your body responses, your spiritual searches—all have a place in your sketchbook. Fill it up with your life.

Sketchbook activity should not be strictly confined to making marks in a notebook. Idea gathering on a wider scale is really the goal. There are limitless methods of finding subjects and infusing them with ideas.

Art history, as we have seen throughout this text, is a never-ending source for new ideas or old ideas reworked with fresh insights.

Landscape is a powerful source for allegory and metaphorical thinking. Francesco Clemente commented on the expansiveness of landscape: "You know, there is a landscape of the world and there is also an inner landscape of the world. It changes as much as the face of the earth has been changing

PG.5. **(right)** EUGENE LEROY. *Untitled.* 1990. Charcoal on paper, nine panels 24¾ × 19" (63 × 48 cm). Michael Werner Gallery.

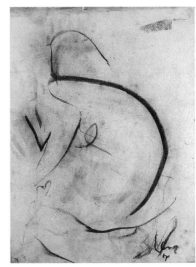
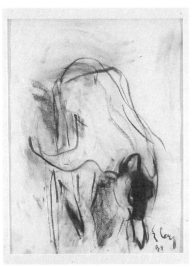
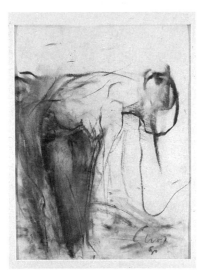
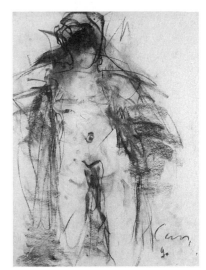
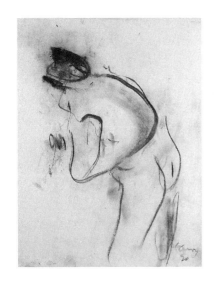
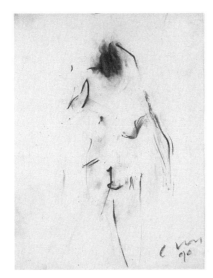
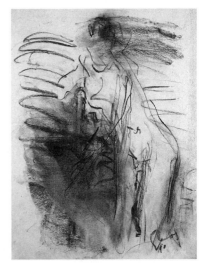

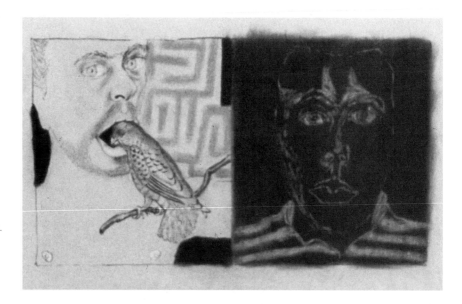

PG.6. FRANCESCO CLEMENTE. *Codice 1.* 1980. Pastel and tint, 24 × 18″ (61 × 45.8 cm) (for all three codices). Collection of the artist, Rome and New York.

throughout all these thousands of years. The landscape we see inside us in our own imagination changes also, it is not the same."

Clemente's work deals with introspection and mystical intimations. The constant in his work is the human body, more specifically his own body. His search for identity binds him to himself. From a group of pastel studies (Figure PG.6), we see two of the many self-portraits that form a part of his quest. Self-portraits present us with the chance to look in two directions at once as we depict our external as well as our internal selves.

Everyday objects can even be stand-ins for the self. Common objects present themselves as familiar companions capable of being transformed, as in Oldenburg's work.

Geographic locales, both familiar and exotic, can provide a world of subject matter. David Hockney's subject is taken from the much-traversed route to his studio (Figure PG.7). Influenced by Chinese landscape with its

PG.7. DAVID HOCKNEY. *Mulholland Drive: The Road to the Studio.* 1980. Acrylic on canvas, 86 × 243″ (218 × 617 cm). Los Angeles County Museum of Art, purchased with funds provided by F. Patrick Burnes Bequest.

"moving focus," he has combined in one picture plane multiple scenes and shifting perspectives. You could, like Hockney, record your travels in memory pictures in your sketchbook.

Travel affords graphic insights and also provides memorabilia, such as tickets, stubs, and stamps, that can find a home in your sketchbook in the form of collage. Motherwell's *London Collage* (Figure PG.8) has as its central focus an envelope with British stamps, mementos of a London sojourn. Motherwell is well known for his collages that incorporate the famous blue French Gauloises cigarette pack and seals.

The studio itself has always been a rich source of imagery for artists. The studio is the artist's contained world; it is a private and personal space, so work using this subject will have an autobiographical overtone. Figures PG.9 and PG.10 show us the kind of metamorphosis that can take place in an artist's studio. Cluttered interiors provide an amazing stock of images.

Every object and image has the potentiality of being transformed into art. The objects that we choose to live with are revelatory on many levels. You might make a series of sketchbook drawings that are based on contents—contents of billfolds, purses, medicine cabinets, closets, tool chests, refrigerators, or pantries, for example.

The watercolor kit taken on treks to exotic places comes from a now-faded tradition. The "studio-in-the-wild" with its accompanying field journals

PG.8. ROBERT MOTHERWELL. *London Collage.* 1975. Acrylic and paper collage, 41½ × 24" (16.3 × 9.4 cm). Collection of Stephens Inc., Little Rock, AR. © 1997 Dedalus Foundation, Inc./Licensed by VAGA, New York.

PG.9. WILLIAM T. WILEY. *Nothing Conforms.* 1978. Watercolor on paper, 29½ × 22½" (74.9 × 57.2 cm). Collection of the Whitney Museum of American Art. Purchased with funds from the Neysa McMain Purchase Award.

PG.10. GREGORY GILLESPIE. *Myself Painting a Self-Portrait.* 1980–1981. Mixed media on wood, 4'10⅛" × 5'8¾" (1.47 × 1.75 m). Hirshhorn Museum and Sculpture Garden, Smithsonian Institution, museum purchase with funds donated by the Board of Trustees, 1981.

remains an effective sketchbook project. Descriptive drawing of flora and fauna will enhance your ability to inspect forms intently and to analyze relationships. Twigs, feathers, leaves, or flowers could be added attractions in the sketchbook's reservoir.

Subjects for sketchbook need not be found in the real world. Pierre Alechinsky, a Belgian artist, has copied in handwriting a poem by another poet. It is contained within the body of an imaginary creature (Figure PG.11). Alechinsky has surrounded the figure with erratic squiggles, reversing the lines to white on black. You can use your own or other's writing and respond to the written words by marks or shapes that connect you to the work. You can use imagined, conceptual subjects, or invented, abstracted, or nonobjective forms as in the Picasso series (see Figure 8.26). You might think of some categories that could encompass nonobjective forms, such as vertical horizontals, or horizontal verticals. Explorations of pure form are ideal sketchbook endeavors (see Figure 1.35).

The sketchbook's best companion, however, may be music. Draw while listening to music. Let the music, the drawing implement, and your feelings control your decisions. Strange and wondrous forms can evolve.

Some suggestions for sketchbook drawings:

1. Experiment with form and variations.
2. Note quick visual and verbal ideas.
3. Experiment with different techniques, tools, or media.
4. Develop an object or an idea through several pages of sketches.
5. Experiment with different compositions; place objects and shapes in different juxtapositions.
6. Record objects through sustained observation.
7. Investigate. Make preparatory drawings.

PG.11. PIERRE ALECHINSKY. *Was It Snowing?* (in-text plate, folio 4) from 21 *Etchings and Poems*, with "Poem" by Christine Dotremont. New York, Morris Gallery, 1960. (Print executed 1952.) Etching and engraving (with etched manuscript by Pierre Alechinsky), print in black, plate; 13¹¹⁄₁₆ × 9¹¹⁄₁₆″ (34.7 × 24.6 cm). The Museum of Modern Art, New York. Gift of Mrs. Jacquelynn Shlaes.

8. Use your sketchbook as a diary or journal, recording your interests and activities.
9. Make comments on artwork (your own or others').
10. Attach clippings that interest you.
11. Draw from memory.
12. Draw your feelings.
13. Draw from nature.
14. Record your dreams, both visually and verbally.
15. Experiment with new and playful imagery.

CONCLUSION

The important thing to keep in mind about a sketchbook is that you are keeping it for yourself, not for your instructor or anyone else. It is as personal as a diary. You are the one who benefits from it. Both process and progress are the rewards of dedication to keeping a sketchbook.

Looking back through your daily drawings can give you direction when you are stuck and provide a source of ideas for new work. Germs of potential forms and ideas are embedded in sketchbooks. When you use an idea from the sketchbook, you have the advantage of having chosen an idea that has some continuity to it; you have already done some work with that idea. A new viewpoint adds yet another dimension. The sketchbook is a place where your art communicates with itself. It is a book of possibilities.

Who would believe that so small a space could contain all the images of the universe? The sketchbook can hold all the images of your universe, in abbreviated form, of course.

GUIDE C

BREAKING
ARTISTIC
BLOCKS

GENERALLY, THERE ARE TWO TIMES WHEN artists are susceptible to artistic blocks: in an individual piece when they feel something is wrong and do not know what to do about it, and when they cannot begin to work at all. These are problems that all artists, even the most experienced, must face. They are common problems that you should move quickly to correct.

CORRECTING THE PROBLEM DRAWING

What can you do with a drawing you cannot seem to complete? The initial step in the corrective process is to separate yourself, physically and mentally, from the drawing in order to look at it objectively. You, the artist/maker, become the critic/viewer. This transformation is essential in assessing your work. The original act of drawing was probably on the intuitive level; now you begin the process of critical analysis. You are going to learn to bring into consciousness what has been intuitively stated.

Turn away from your work for a few minutes. Occupy your mind with some simple task such as straightening equipment or sharpening pencils. Then pin the drawing on the wall, upside down or sideways. Have a mirror handy to view the drawing. The mirror's reversal of the image and the new perspective of placement will give you a new orientation so that you can see the drawing with fresh eyes. This fresh viewpoint allows you to be more aware of the drawing's formal qualities, regardless of the subject you have chosen.

When you can see how line, value, shape, volume, texture, and color are used, you are not so tied to the subject matter. Frequently the problem area will jump out at you. The drawing itself tells you what it needs. Be sensitive to the communication that now exists between you and your work. Before, *you* were in command of the drawing; now *it* is directing you to look at it in a new way. At this stage you are not required to pass judgment on the drawing. You simply need to ask yourself some nonjudgmental questions about the piece. The time for critical judgments comes later. What you need to discover now is strictly some *information* about the drawing.

Questions Dealing with Form

Here are some beginning questions dealing with form to ask yourself.

1. What is the subject being drawn?
2. Which media are used and on what surface?
3. How is the composition related to the page? Is it a small drawing on a large page? A large drawing on a small page? Is there a lot of negative space? Does the image fill the page? What kind of space is being used in the drawing?
4. What kinds of shapes predominate? Amoeboid? Geometric? Do the shapes exist all in the positive space, all in the negative space, or in both? Are they large or small? Are they the same size? Are there repeated shapes? How have shapes been made? By line? By value? By a combination of these two? Where is the greatest weight in the drawing? Are there volumes in the drawing? Do the shapes define planes or the sides of a form? Are the shapes flat or volumetric?
5. Can you divide value into three groups: lightest light, darkest dark, and mid-gray? How are these values distributed throughout the drawing? Is value used in the positive space only? In the negative space only? In both? Do the values cross over objects or shapes, or are they contained within the object or shape? Is value used to indicate a single light source or multiple light sources? Does value define planes? Does it define space? Does it define mass or weight? Is it used ambiguously?
6. What is the organizational line? Is it a curve, a diagonal, a horizontal, or a vertical? What type of line is used—contour, scribble, calligraphic? Where is line concentrated? Does it create mass? Does it create value? Does it define edges? Does it restate the shape of a value? Again, note the distribution of different types of line in the drawing; ignore the other elements.
7. Is invented, simulated, or actual texture used in the drawing? Are there repeated textures, or only one kind? Is the texture created

by the tool the same throughout the drawing? Have you used more than one medium? If so, does each medium remain separate from the other media? Are they integrated?

This list of questions looks long and intimidating at first glance, but you can learn quickly to make these assessments—make them almost automatically, in fact. Of course, many of these questions may not apply to each specific piece, and you may think of other questions that will help you in making this first compilation of information about your drawing.

Critical Assessment

After letting the drawing speak to you and after having asked some non-judgmental questions about it, you are ready to make a *critical assessment*. It is time to ask questions that pass judgments on the piece.

To communicate your ideas and feelings in a clearer way, you should know what statements you want to make. Does the drawing do what you meant it to do? Does it say something different—but perhaps equally important—from what you meant it to say? Is there confusion or a contradiction between your intent and what the drawing actually says? There may be a conflict here because the drawing has been done on an intuitive level, while the meaning you are trying to verbalize is on a conscious level. Might the drawing have a better message than your originally intended message?

Can you change or improve the form to help the meaning become clearer? Remember, form is the carrier of meaning. Separate the two functions of making and viewing. What is the message to you as viewer?

An important reminder: Go with your feelings. If you have any doubts about the drawing, wait until a solution strikes you; however, do not use this delay to avoid doing what you must to improve the drawing. Try something—even if the solution becomes a failure and the drawing is "ruined," you have sharpened your skills and provided yourself with new experiences. The fear of ruining what might be a good drawing can become a real block to later work. Be assertive; experiment; do not be afraid to fail.

Problems in an individual piece tend to fall within these five categories:

- inconsistency of style, idea, or feeling
- failure to determine basic structure
- tendency to ignore negative space
- inability to develop value range and transitions
- failure to observe accurately

Inconsistency refers to the use of various styles, ideas, or feelings within a single work. A number of techniques and several types of line may be employed within a single drawing, but the techniques and elements must be compatible with one another and with the overall idea of the drawing. Frequently an artist will unintentionally use unrelated styles in the same drawing; this results in an inconsistency that can be disturbing to the viewer. For example, a figure drawing may begin in a loose and gestural manner and seem to be going well. Suddenly, however, when details are stated, the artist feels insecure, panics, tightens up, and begins to conceptualize areas such as the face and hands. The style of the drawing changes—the free-flowing lines give way to a tighter, more constricted approach. As conceptualization takes the

place of observation, the smooth, almost intuitive interrelationship of the elements is lost. The moment of panic is a signal for you to stop, look, analyze, and relax before continuing.

A frequent problem encountered in drawing is the *failure to determine basic structure*, to distinguish between major and minor themes. For example, dark geometric shapes may dominate a drawing, while light amoeboid shapes are subordinate. Although it is not necessary for every drawing to have a major and minor theme, in which some parts dominate and others are subordinate, it is important for the artist to consider such distinctions in the light of the subject and intent of a particular drawing. Details should overshadow the basic structure of a drawing only if the artist intends it. The organization of a drawing is not necessarily predetermined; however, at some point in its development, you should give consideration to the drawing's basic structure.

Human beings are object oriented and have a *tendency to ignore negative space*. We focus our attention on objects. A problem arises for the artist when the space around the object is ignored and becomes merely leftover space. It takes conscious effort to consider positive and negative space simultaneously. Sometimes it is necessary to train ourselves by first looking at and drawing the negative space. When we draw the negative space first, or when positive and negative space are dealt with simultaneously, there is an adjustment in both. In other words, the positive and negative shapes are altered to create interrelationships. There are times when only one object is drawn on an empty page. In these instances, the placement of the drawing on the page should be determined by the relationship of the negative space to the object.

One way to organize a drawing is by the distribution of values. Problems arise when students are *unable to develop value range and transitions*. For many students, developing a value range and gradual value transitions is difficult. The problem sometimes is a lack of ability to see value as differentiated from hue. At other times, it is failure to consider the range of value distribution most appropriate for the idea of the drawing. Too wide a range can result in a confusing complexity or a fractured, spotty drawing. Too narrow a range can result in an uninteresting sameness.

The final problem, *failure to observe accurately*, involves lack of concentration on the subject and commitment to the drawing. If you are not interested in your subject, or if you are not committed to the drawing you are making, this will be apparent in the work.

Once you have pinpointed the problem area, think of three or more solutions. If you are still afraid of ruining the drawing, do three drawings exactly like the problem drawing and employ a different solution for each. This should lead to an entirely new series of drawings, triggering dozens of ideas.

The failure to deal with this first category of problems—being unable to correct an individual drawing—can lead to an even greater problem—not being able to get started at all.

GETTING STARTED

There is a second type of artistic blockage, in some ways more serious than the first: the condition in which you cannot seem to get started at all. There

are a number of possible solutions to this problem. You should spread out all the drawings you did over the period of a month and analyze them. It is likely that you are repeating yourself by using the same medium, employing the same scale, or using the same size paper. In other words, your work has become predictable.

When you break a habit and introduce change into the work, you will find that you are more interested in executing the drawing. The resulting piece reflects your new interest. A valid cure for being stuck is to adopt a playful attitude.

An artist, being sensitive to materials, responds to new materials, new media. This is a good time to come up with some inventive, new, nonart drawing tools. Frequently you are under too much pressure, usually self-imposed, to produce "art," and you need to rid yourself of this stifling condition. Set yourself the task of producing one hundred drawings over a 48-hour period. Use any size paper, any medium, any approach—and before you get started, promise yourself to throw them all away. This will ease the pressure of producing a finished product and will furnish many new directions for even more drawings. It may also assist you in getting over the feeling that every drawing is precious.

All techniques and judgments you have been learning are pushed back in your mind while your conscious self thinks of solutions to the directions. Your intuitive self, having been conditioned by some good solid drawing problems, has the resource of past drawing experience to fall back on. Art is constantly a play between what you already know and the introduction of something new, between old and new experience, the conscious and the intuitive, the objective and the subjective.

Art does not exist in a vacuum, and while it is true that art comes from art, more to the point is that art comes from everything. If you immerse yourself totally in doing, thinking, and seeing art, the wellsprings soon dry up and you run out of new ideas. Exhausting physical exercise is an excellent remedy, as is reading a good novel, scientific journals, or a weekly news magazine. A visit to a natural history museum, a science library, a construction site, a zoo, a cemetery, a concert, a political rally—these will all provide grist for the art mill sooner or later. Relax; "invite your soul." Contact with the physical world will result in fresh experiences from which to extract ideas, not only to improve your art but to sharpen your knowledge of yourself and your relation to the world.

Keep a journal—a visual and verbal one—in which you place notes and sketches of ideas, of quotes, of what occupies your mind. After a week reread the journal and see how you spend your time. How does the way you spend your time relate to your artistic block?

Lack of authentic experience is damning. Doing anything, just existing in our complex society, is risky. Art is especially risky. What do we as artists risk? We risk confronting things unknown to us; we risk failure. Making art is painful because the artist must constantly challenge old ideas and experiences. Out of this conflict comes the power that feeds the work.

An artistic block is not necessarily negative. It generally means that you are having growing pains. You are questioning yourself and are dissatisfied with your previous work. The blockage may be a sign of good things to come. It is probably an indication that you are ready to begin on a new level of

commitment or concentration, or that you may be ready to begin a new tack entirely. When you realize this, your fear—the fear of failure, which is what caused the artistic block in the first place—is reduced, converted, and put to use in constructive new work.

GUIDE D

PRESENTATION

The selection of drawings to represent your work is an important undertaking. Your portfolio should show a range of techniques and abilities. The four most important criteria to keep in mind are accuracy of observation, an understanding of the formal elements of drawing, media variety and exploration, and expressive content.

After you have chosen the pieces that best incorporate these considerations, your next concern is how to present them. The presentation must be portable and keep the works clean and whole, free from tears and bends. Since framing stands in the way of portability, that option will not be discussed.

Some possible ways of presenting your work are backing and covering with acetate, stitching in clear plastic envelopes, laminating, dry mounting, and matting. Each method of presentation has advantages.

ACETATE

A widely used way of presenting work is to apply a firm backing to the drawing and then cover both drawing and backing with a layer of acetate, a clear thin plastic that holds the drawing and backing together. More importantly, the covering provides protection against scuffing, tearing, and soiling. (Mat-

ted drawings can also be covered with acetate.) Backing is a good option if a work is too large for matting or if the composition goes all the way to the edge and you cannot afford to lose any of the drawing behind a mat.

Another option is to attach the drawing with gummed linen tape to a larger piece of paper and cover it with acetate. The drawing then has a border of paper around it and can retain its edges. The drawing lies on top; it is loose, not pinned back by a mat. The size of the backing paper is an important consideration. The drawing might need a border of an inch (2.5 cm); it might need one several inches wide. Experiment with border sizes before cutting the backing paper and attaching it to the drawing.

Paper comes in more varieties and neutral colors than does mat board. The choice of paper is important. The drawing and the paper it is done on should be compatible with the texture, weight, value, and color of the backing paper. Backing paper should not dominate the drawing.

A disadvantage to acetate as a protective cover is its shiny surface. This interferes with the texture of the drawing and with subtleties within the drawing.

PLASTIC ENVELOPES

If flexibility or the idea of looseness is important to the drawing, there is another simple means of presentation: stitching the drawing in an envelope of clear plastic. For a drawing of irregular shape—for example, one that does not have square corners—a plastic envelope might be an appropriate choice. A plastic casing would allow a drawing done on fabric to retain its looseness and support the idea of flexibility.

A disadvantage to clear plastic is its watery appearance and highly reflective surface, which distorts the drawing. The greatest advantage to this method of presentation is that large drawings can be rolled, shipped, and stored easily.

LAMINATION

Lamination is midway in stiffness between drawing paper and a loosely stitched plastic envelope. You are familiar with laminated drivers' licenses and credit cards.

Laminating must be done commercially. It is inexpensive, but cost should not be the most important consideration. The means of presentation must be suited to the concept in the drawing. Laminating is a highly limiting way of presenting work—once sealed, the drawing cannot be reworked in any way.

DRY MOUNTING

If the likelihood of soiling and scuffing is minimal, you might want to *dry mount* the drawing. You do this in exactly the same way as you dry mount a

photograph, sealing the drawing to a rigid backing and leaving the surface uncovered. Dry-mount tissue is placed between drawing and backing. Heat is then applied by means of an electric dry-mount press, or if done at home, by a warm iron. Dry-mount tissue comes in a variety of sizes; rolled tissue can be found for large drawings. This tissue must be the same size as the drawing. Wrinkling can occur, and since a drawing sealed to backing is not easily removed, extreme care should be taken in the process. Carefully read and follow the instructions on the dry-mount tissue package before you start.

Since dry mounting is done with heat, it is important that the medium used in the drawing not run or melt when it comes in contact with heat. Greasy media such as china markers, lithographic sticks, or wax crayons should not be put under the dry press for mounting.

MATTING

Matting is the most popular and traditional choice for presentation. The mat separates the drawing from the wall on which it is hung and provides an interval of rest before the eye reaches the drawing. Secondly, a mat gives the drawing room to "breathe." Like a rest in music, it offers a stop between the drawing and the environment; it allows for uncluttered viewing of the drawing.

For this reason mats should not call attention to themselves or they will detract from the drawing. A colored mat screams for attention and diminishes a drawing's impact. White or off-white mats are recommended at this stage, especially since most of the problems in this book do not use color. An additional argument for white mats is that art is usually displayed on white or neutrally colored walls, and the mat furnishes a gradual transition from the wall to the drawing.

Materials for Matting

The materials needed for matting are:

- a mat knife with a sharp blade
- all-rag mounting board
- gummed linen tape
- a 36-inch-long (96-cm-long) metal straightedge
- a pencil
- a gum or vinyl eraser
- a heavy piece of cardboard for cutting surface

Change or sharpen the blade in your knife often. A ragged edge is often the result of a dull blade. A continuous stroke will produce the cleanest edge. Mat blades should not be used for cutting more than one mat before being discarded. The expense of a blade is minimal in comparison with the cost of mat board, so be generous in your use of new, sharp blades.

Do not use illustration board or other kinds of board for your mat. Cheaper varieties of backing materials, being made from wood pulp, contain

acid; they will harm a drawing by staining the fibers of the paper and making them brittle. Use white or off-white, all-rag mat board, sometimes called museum board, unless special circumstances dictate otherwise. A heavy-weight, hot-pressed watercolor paper can be used as a substitute for rag board.

Masking tape, clear tape, gummed tape, and rubber cement will likewise discolor the paper and should be avoided. They will lose their adhesive quality within a year or so. Use gummed linen tape because it is acid free.

Instructions for Matting

Use the following procedure for matting. Work on a clean surface. Wash your hands before you begin.

1. Carefully measure the drawing to be matted. The edges of the mat's opening will overlap the drawing by ⅜ inch (1 cm) on all sides.
2. For an 18 by 24–inch (46 × 61 cm) drawing, the mat should have a 4-inch (10 cm) width on top and sides and a 5-inch (13 cm) width at the bottom. Note that the bottom border is slightly wider—up to 20 percent—than the top and sides.
3. On the front surface of the mat board, mark lightly with a pencil the opening to be cut. You can erase later.
4. Place a straightedge on the mat just inside the penciled line toward the opening and cut. Hold down both ends of the straightedge. You may have to use your knee. Better still, enlist a friend's help. If the blade slips, the error will be on the part that is to be discarded and can, therefore, be corrected. Cut the entire line in one continuous movement. Do not start and stop. Make several single passes from top to bottom; do not try to cut through completely on your first stroke (Figure PG.12).
5. Cut a rigid backing ⅛ inch (.3 cm) smaller on all sides than the mat.
6. Lay the mat facedown and align the backing so that the two tops are adjoining. Cut four or five short pieces of linen tape, and at the top, hinge the backing to the mat (Figures PG.13, PG.14).
7. Minor ragged edges of the mat can be corrected with fine sandpaper rubbed lightly along the edge of the cut surface.
8. Erase the pencil line and other smudges on the mat with a gum or vinyl eraser.
9. Hinge the drawing to the backing *at the top only.* This allows the paper to stretch and contract with changes in humidity (Figure PG.15).
10. You may cover the matted drawing with acetate, which will protect both the drawing and mat. Place the backed, matted drawing face down on a sheet of acetate 2 inches (5 cm) wider on all sides than the mat. Cut 2-inch (5 cm) squares from each corner of the acetate (Figure PG.16). Fold the acetate over, pulling lightly and evenly on all sides. Attach the acetate to the backing with tape.

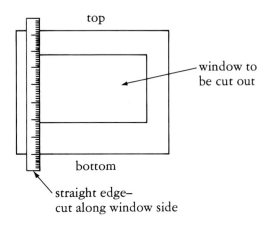

top

window to
be cut out

bottom

straight edge–
cut along window side

PG.12. Cutting mat board.

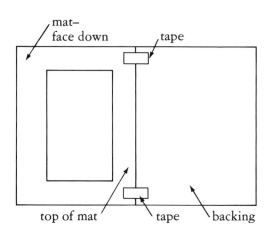

mat–
face down

tape

top of mat

tape

backing

PG.13. Hinging the mat.

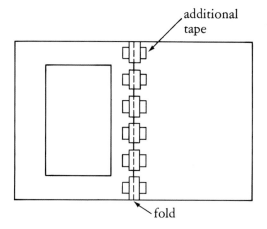

additional
tape

fold

PG.14. Hinging the mat.

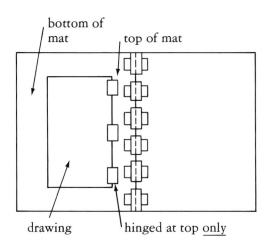

bottom of
mat

top of mat

drawing

hinged at top <u>only</u>

PG.15. Hinging drawing at the top.

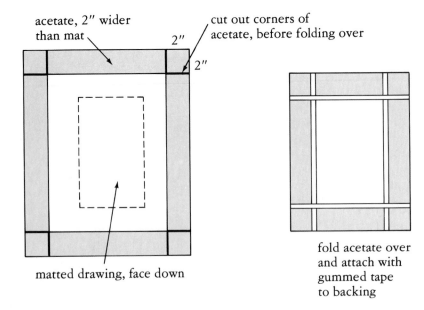

acetate, 2″ wider
than mat

cut out corners of
acetate, before folding over

2″

2″

matted drawing, face down

fold acetate over
and attach with
gummed tape
to backing

PG.16. Cutting acetate.

SUMMARY

SELECTING A METHOD OF PRESENTATION

In making your decision about the most suitable presentation, you should first try to visualize the piece in a variety of ways. If you are attentive, the work itself will probably suggest an appropriate presentation. Matting is generally the safest. Stitching in plastic and lamination should be reserved for only those pieces that absolutely demand that type of presentation. Whatever your choice, remember that compatibility between drawing and method of presentation is essential.

If the manner of presentation is not clear to you, experiment with the piece. Place it in a discarded mat, or use some L-frames to crop the composition exactly right. Assess the drawing without a mat. Lay it on a larger piece of paper. Does the drawing go to the edge? Can you afford to lose half an inch (1 cm) on the borders? Is the idea of looseness or flexibility important to the drawing? Would a reflective covering detract from or enhance the drawing? What kind of surface and media are used in the drawing? What kind of backing would best complement the piece? What size mat or paper backing is the most appropriate? Does a cool white, a warm white, an off-white, a neutral, or a gray look best with the drawing? Does the size of the drawing present a problem?

The care and storage of individual drawings is another professional concern. Minimal good care is simple. You should spray-fix your drawings as soon as they are finished. Remove any smudges and store the drawings in a flat, rigid container slightly larger than the largest drawing. This ensures that the drawings will not become dog-eared, soiled, bent, or smudged. You should place a clean piece of paper between drawings so that the medium from one does not transfer onto the white of another.

Your attitude toward your work influences others' attitudes. A bad drawing can be improved by good presentation, while a good drawing can be destroyed by poor presentation. Each drawing does not have to be regarded as a precious monument, but proper care and handling of your work are good habits to establish early in your career.

GLOSSARY

Italicized terms within the definitions are themselves defined in the Glossary.

abstraction An alteration of *forms*, derived from observation or experience, in such a way as to present essential rather than particular qualities.

achromatic Relating to light and dark, the absence of *color*, as opposed to *chromatic* (relating to color).

actual texture The *tactile* quality of a surface, including the mark made by a tool, the surface on which it is made, and any foreign material added to the surface. See also *invented texture, simulated texture*.

aerial perspective The means by which atmospheric illusion is created.

aggressive line An emphatically stated *line*.

ambiguous space Space that is neither clearly flat nor clearly volumetric, containing a combination of both two- and three-dimensional elements.

amoeboid shape See *organic shape*.

analogous colors Colors adjacent to one another on the color wheel.

analytical line A probing *line* that penetrates space, locating objects in relation to one another and to the space they occupy.

anthropomorphism Ascribing human form or attributes to nonhuman forms.

appropriation A process used by Post-Modern artists employing ready made ideas or images from high and low culture as subject matter in their own works.

arbitrary value *Value* that does not necessarily conform to the actual appearance of an object; the use of value based on intuitive responses or the need to comply with compositional demands.

assemblage A work of art composed of fragments of objects or *three-dimensional* materials originally intended for other purposes; the art of making such a work.

axonometric projection A method of projection in which objects are drawn with their horizontal and vertical axes to scale.

background See *negative space*.

base line The imaginary *line* on which an object or group of objects sits.

biomorphic shape See *organic shape*.

345

blind contour A contour exercise in which the artist never looks at the paper.

blurred line Smudged, erased, or destroyed *line*.

calligraphic line Free-flowing *line* that resembles handwriting, making use of gradual and graceful transitions.

cast shadow One of the six categories of *light*.

chiaroscuro Modeling, the gradual blending of light to dark to create a *three-dimensional* illusion.

chromatic Relating to *color*, as opposed to *achromatic* (relating to light and dark).

collage Any flat material, such as newspapers, cloth, or wallpaper, pasted on the *picture plane*.

color Visual assessment of the quality of light that is determined by its spectral composition.

color wheel A circular arrangement of twelve hues.

complementary colors Contrasting colors that lie opposite each other on the color wheel.

composition The organization or arrangement of the *elements of art* in a given work.

conceptual drawing A drawing that in its essential *form* is conceived in the artist's mind, rather than derived from immediate visual stimuli.

cone of vision Angle of sight.

constricted line A *crabbed*, angular, tense *line*, frequently aggressively stated.

content The subject matter of a work of art, including its emotional, intellectual, *symbolic*, thematic, and narrative connotations, which together give the work its total meaning.

contour line *Line* that delineates both the outside edge of an object and the edges of *planes*, as opposed to *outline*, which delineates only the outside edge of an object.

core of shadow One of the six categories of *light*.

crabbed line See *constricted line*.

cross-contour line *Line* that describes an object's horizontal or cross-contours rather than its vertical contours. Cross-contour line emphasizes the volumetric aspects of an object.

diptych A work in two parts.

directional line See *organizational line*.

elements of art The principal graphic and *plastic* devices by which an artist composes a physical work of art. The elements are *color*, *line*, *shape*, *texture*, *value*, and *volume*.

empty space See *negative space*.

expressive Dealing with feelings and emotions, as opposed to *objective* and *subjective*.

eye level An imaginary horizontal *line* parallel to the viewer's eyes.

facture The hand-made quality in a one-of-a-kind drawing.

field See *negative space*.

figure/field See *positive shape*.

figure/ground See *positive shape*.

foreground/background See *positive shape*.

foreshortening A technique for producing the illusion of an object's extension into space by contracting its form.

form In its broadest sense, the total structure of a work of art—that is, the relation of the *elements of art* and the distinctive character of the work. In a narrower sense, the *shape*, configuration, or substance of an object.

frottage A *textural* transfer technique; the process of making rubbings with graphite or crayon on paper laid over a textured surface.

fumage A *textural* technique that uses smoke as a medium.

geometric shape *Shape* created by mathematical laws and measurements, such as a circle or a square.

gestural approach A quick, all-encompassing statement of *forms*. In gesture the hand duplicates the movement of the eyes, quickly defining the subject's general characteristics—movement, weight, *shape*, tension, *scale*, and *proportion*. See *mass gesture*, *line gesture*, *mass and line gesture*, and *sustained gesture*.

grattage A textural technique that incises or scratches marks into a surface prepared with a coating, for example, gesso.

ground See *negative space*.

group theme Development of related works by members of the same schools and movements of art who share common philosophical, formal, stylistic, and subject interests.

highlight One of the six categories of *light*.

hue The characteristic of a *color* that causes it to be classified as red, green, blue, or another color.

iconography The study of symbols used in works of art.

illusionistic space In the graphic arts, a representation of *three-dimensional space*.

implied line A *line* that stops and starts again; the viewer's eye completes the movement that the line suggests.

implied shape A suggested or incomplete *shape* that is "filled in" by the viewer.

incised line A *line* cut into a surface with a sharp implement.

indicative line See *organizational line*.

informational drawing A category of objective drawing, including diagrammatic, architectural, and

mechanical drawing. Informational drawing clarifies concepts and ideas that may not be actually visible, such as a chemist's drawings of molecular structure.

intensity The saturation, strength, or purity of a color.

interspace See *negative space.*

invented texture An invented, nonrepresentational patterning that may derive from *actual texture* but does not imitate it. Invented texture may be highly stylized.

light In the graphic arts, the relationship of light and dark patterns on a *form*, determined by the actual appearance of an object and by the type and direction of light falling on it. There are six categories of light as it falls over a form: *highlight, light tone, shadow, core of shadow, reflected light,* and *cast shadow.*

light tone One of the six categories of *light.*

line A mark made by an implement as it is drawn across a surface. See also *aggressive, analytical, blurred, calligraphic, constricted, contour, crabbed, implied, lyrical, mechanical,* and *organizational* line.

line gesture A type of gesture drawing that describes interior forms, utilizing *line* rather than *mass.* See *gestural approach.*

local color The known color of an object regardless of the amount or quality of light on it.

lyrical line A *subjective* line that is gracefully ornate and decorative.

mass In the graphic arts, the illusion of weight or density.

mass and line gesture A type of gesture drawing that combines broad marks with thick and thin lines. See *gestural approach.*

mass gesture A type of gesture drawing in which the drawing medium is used to make broad marks to create *mass* rather than line. See *gestural approach.*

mechanical line An *objective* line that maintains its width unvaryingly along its full length.

modeling The change from light to dark across a surface; a technique for creating spatial illusion.

monochromatic A color scheme using only one color with its various hues and intensities.

montage A technique that uses pictures to create a composition.

multiple perspective Different *eye levels* and perspectives used in the same drawing.

negative space The space surrounding a *positive shape;* sometimes referred to as *ground, empty space, interspace, field,* or *void.*

nonobjective In the visual arts, work that intends no reference to concrete objects or persons, unlike *abstraction,* in which observed forms are sometimes altered to seem nonobjective.

objective Free from personal feelings; the emphasis is on the descriptive and factual rather than the *expressive* or *subjective.*

one-point perspective A system for depicting *three-dimensional* depth on a *two-dimensional* surface, dependent upon the illusion that all parallel lines that recede into space converge at a single point on the horizon, called the *vanishing point.*

optical color Perceived color modified by the quality of light on it.

organic shape Free-form, irregular *shape.* Also called *biomorphic* or *amoeboid shape.*

organizational line The *line* that provides the structure and basic organization for a drawing. Also called *indicative* or *directional line.*

outline *Line* that delineates only the outside edge of an object, unlike *contour line,* which also delineates the edges of *planes.*

papier collé The French term for pasted paper; a technique consisting of pasting and gluing paper materials to the *picture plane.*

perspective A technique for giving an illusion of space to a flat surface.

photomontage A technique that uses photographs to create a composition.

pictorial space In the graphic arts, the illusion of space. It may be relatively flat or *two-dimensional,* illusionistically *three-dimensional,* or *ambiguous space.*

picture plane The *two-dimensional* surface on which the artist works.

planar analysis An approach in which *shape* functions as *plane,* as a component of *volume.*

plane A *two-dimensional,* continuous surface with only one direction. See also *picture plane.*

plastic The appearance of volume and space in a two-dimensional painting or drawing.

positive shape The *shape* of an object that serves as the subject for a drawing. The relationship between positive shape and *negative space* is sometimes called *figure/field, figure/ground, foreground/background,* or *solid/void* relationship.

predella A series of small paintings, sculpture, or drawings that form the lower edge of an altarpiece.

primary colors Red, blue, and yellow.

private theme Development by an individual artist of a personal, sustained, related series of works.

proportion Comparative relationship between parts of a whole and between the parts and the whole.

reflected light One of the six categories of *light.*

saturation See *intensity.*

scale Size and weight relationships between *forms.*

schematic drawing A drawing derived from a mental construct as opposed to visual information.

scribbled-line gesture A type of gesture drawing using a tight network of tangled *line*. See *gestural approach*.

secondary colors Colors achieved by mixing primary colors; green, orange, and violet.

semantics A branch of linguistics that deals with the study of meaning and the relationships between signs and symbols and what they represent.

semiotics A program whose goal is to identify the conventions and strategies used by art and literature to produce their effects of meaning.

shadow One of the six categories of *light*.

shallow space A relatively flat space, having height and width but limited depth.

shape A *two-dimensional*, closed, or implicitly closed configuration. The two categories of shape are *organic* and *geometric shape*.

shared theme Thematic work in which the same images or subjects are used by different artists over a long period of time.

sighting The visual measurements of objects and spaces between objects.

simulated texture The imitation of the *tactile* quality of a surface; can range from a suggested imitation to a highly illusionistic duplication of the subject's texture. See also *actual texture* and *invented texture*.

simultaneity Multiple, overlapping views of an object.

solid/void See *positive shape*.

stacked perspective The use of stacked parallel base lines in the same composition.

structural line *Line* that helps locate objects in relation to other objects and to the space they occupy. Structural lines follow the direction of the *planes* they locate.

stylistic eclecticism The use side by side of varying philosophies, styles, techniques, materials, and subjects.

subjective Emphasizing the artist's emotions or personal viewpoint rather than informational content; compare *objective*.

sustained gesture A type of gesture drawing that begins with a quick notation of the subject and extends into a longer analysis and correction. See *gestural approach*.

symbol A *form* or image that stands for something more than its obvious, immediate meaning.

tactile Having to do with the sense of touch. In the graphic arts, the representation of *texture*.

tertiary colors Colors that result when a primary and a secondary color are mixed.

texture The *tactile* quality of a surface or its representation. The three basic types of texture are *actual, simulated,* and *invented texture*.

theme The development of a sustained series of works that are related by subject, that have an idea or image in common. See *private theme, group theme,* and *shared theme*.

three-dimensional Having height, width, and depth.

three-dimensional space In the graphic arts, the illusion of *volume* or volumetric space—that is, of space that has height, width, and depth.

three-point perspective A system for depicting *three-dimensional* depth on a *two-dimensional surface*. In addition to lines receding to two points on the horizon, lines parallel and vertical to the ground appear to converge to a third, vertical *vanishing point*.

triptych A work in three parts.

trompe-l'oeil The French term for trick-the-eye illusionistic techniques. See also *simulated texture*.

two-dimensional Having height and width.

two-dimensional space Space that has height and width with little or no illusion of depth, or *three-dimensional* space.

two-point perspective A system for depicting *three-dimensional* depth on a *two-dimensional* surface, dependent upon the illusion that all parallel lines converge at two points on the horizon.

value The gradation of tone from light to dark, from white through gray to black.

value scale The gradual range from white through gray to black.

vanishing point In *one-point perspective*, the single spot on the horizon where all parallel lines converge.

vanitas Still lifes which underscore the transitory nature of life itself.

void See *negative space*.

volume The quality of a *form* that has height, width, and depth; the representation of this quality. See also *mass*.

SUGGESTED READINGS

Suggested Readings concentrate on contemporary art and artists.

Students may also find helpful such periodicals as *Art Forum, Art in America, Art International, Art Journal, Art News, Artweek, Contemporanea, Drawing, Flash Art, New Art Examiner,* and *October.*

SURVEYS AND CRITICISM

Ades, Dawn et al. *Art in Latin America: The Modern Era, 1920–1980.* New Haven: Yale University Press, 1993.

Alloway, Lawrence. *American Pop Art.* New York: Macmillan, 1974.

American Abstract Drawing, 1930–1987. Little Rock: The Arkansas Arts Center, 1987.

American Drawings 1963–1973. New York: Whitney Museum of American Art, 1973.

Atkins, Robert. *Artspeak. A Guide to Contemporary Ideas, Movements and Buzzwords.* New York: Hacker Books, 1990.

Battcock, Gregory. *The New Art: A Critical Anthology.* New York: Dutton, 1973.

Battcock, Gregory. *Super Realism.* New York: Dutton, 1975.

Behr, Shulamith. *Women Expressionists.* New York: Abbeville Press: n.p., 1988.

Beier, Ulli. *Contemporary Art in Africa.* New York: Praeger, 1968.

Berman, Patricia. *Modern Hieroglyphs: Gestural Drawing and the European Vanguard.* Philadelphia: University of Pennsylvania Press, 1995.

Bown, Matthew Culleme. *Contemporary Russian Art.* New York: Philosophical Library, 1990.

Cahan, Susan, and Kocur, Zoya, eds. *Contemporary Art and Multicultural Education.* New York: Routledge Press, 1995.

Casslman, Bart, ed. *The Sublime Void: On the Memory of the Imagination.* New York: Ludion, 1995.

Cathcart, Linda L. *American Still Life 1945–1983.* New York: Contemporary Arts Museum, Houston, 1983.

Clay, Jean. *Modern Art, 1890 to 1990.* New York: B.K., Sales, 1989.

Cole, Robert. *Their Eyes Meeting the World: The Drawings and Paintings of Children.* Boston: Houghton Mifflin, 1995.

Colpitt, Frances. *Minimal Art, The Critical Perspective.* Seattle: University of Washington Press, 1993.

The Comic Art Show. New York: Whitney Museum of American Art, 1983.

Cooper, Douglas. *The Cubist Epoch.* New York: Praeger, 1971.

Danto, Arthur C. *The Philosophical Disenfranchisement of Art.* New York: Columbia University Press, 1986.

Danto, Arthur C. *The State of the Art.* New York: Columbia University Press, 1987.

Davis, Douglas. *Artculture: Essays on the Post-Modern.* New York: Harper & Row, 1977.

Dennison, Lisa. *New Horizons in American Art.* New York: Solomon R. Guggenheim Museum, 1989.

Dietich-Boorsch, Dorothea. *German Drawings of the 60s.* Yale University Press, 1982.

Directions '86. Washington, D.C.: Hirshhorn Museum and Sculpture Gardens, 1986.

Dowell, M., and Robbins, D. *Cubist Drawings, 1907–1929.* Janie C. Lee Gallery. Houston: 1982.

Drawings from the Permanent Collection. Modern Art Museum of Fort Worth.

Drawings: Recent Acquisitions. New York: Museum of Modern Art, 1967.

Drawn-Out. Washington, D.C.: The Corcoran Gallery of Art, 1987.

Elderfield, John. *The Modern Drawing: 100 Works on Paper from the Museum of Modern Art.* Thames and Hudson. London: 1984.

Face. Little Rock, Arkansas: Arkansas Arts Center, 1988.

The Figure. Little Rock, Arkansas: Arkansas Arts Center, 1988.

A Forest of Signs, Art in the Crisis of Representation. New York: The Museum of Contemporary Art, 1989.

Foster, Hal, ed. *The Anti-Aesthetic: Essays on Postmodern Culture.* Port Townsend, Washington: Bay Press, 1983.

Fox, Howard N., Miranda McClintic, and Phyllis Roxenzweig. *Content, A Contemporary Focus 1974–1984.* Washington, D.C.: Smithsonian Institution Press, 1984.

Frascina, Francis et al. *Modernity and Modernism: French Painting in the Nineteenth Century.* New Haven: Yale University Press, 1993.

Fusco, Coco. *English is Broken Here: Notes on Cultural Fusion in the Americas.* New York: New Press, 1995.

Gablik, Suzi. *Conversations Before the End of Time.* New York: Thames and Hudson, 1995.

Garcia, Rupert. *Aspects of Resistance.* New York: Alternative Museum, 1994.

Gilmour, Pat, and Anne Willsford. *Paperwork.* Sidney: Australian National Gallery, 1990.

Godfrey, Tony. *Drawing Today, Draughtsmen in the Eighties.* Oxford: Phaidon, 1990.

Godfrey, Tony. *The New Image: Painting in the 1980's.* New York: Abbeville Press, 1986.

Gottlieb, Carla. *Beyond Modern Art.* New York: Dutton, 1976.

Graham, Susan. *Michael Parkes, Drawings and Stone Litho.* Seattle: University of Washington Press, 1993.

Great Drawings of All Time, III. French 13th Century to 1919. New York: Shorewood, 1962.

Grynsztejn, Madeleine. *About Place: Recent Art of the Americas.* Chicago: The Art Institute of Chicago, 1995.

Hartz, Jill, ed. *Agnes Denes.* Seattle: University of Washington Press, 1995.

Heller, Reinhold. *Art in Germany 1909–1936. From Expressionism to Resistance.* New York: Milwaukee Art Museum, 1990.

Heller, Reinhold. *Brucke, German Expressionists Prints from the Granvil and Marcia Specks Collection.* Evanston, Ill.: Northwestern University, 1989.

Horst, De la Croix, and Richard G. Tansey. *Gardner's Art Through the Ages,* 8th Ed. New York: Harcourt Brace Jovanovich, 1986.

Humphries, Lloyd. *Art of Our Time: The Saatchi Collection,* Vols. 1-4. New York: International Publishing, Inc., 1985.

Joachimides, Christos M., and Rosenthal, Norman, eds. *American Art in the 20th Century: Painting and Sculpture 1913–1993.* Berlin: Prestel/te Neues, 1995.

Krantz, Les, ed. *American Artists.* Chicago: American References, 1989.

Krantz, Les, ed. *The Chicago Art Review.* Chicago: American References, 1989.

Krantz, Les, ed. *The California Art Review.* Chicago: American References, 1989.

Krantz, Les, ed. *The New York Art Review.* Chicago: American References, 1989.

Kurtz, Bruce D. *Contemporary Art, 1965–1990.* Englewood Cliffs, N.J.: Prentice-Hall, 1992.

Kuspit, Donald. *Donald Kuspit: The Dialectic of Decadence.* Boston: M.I.T. Press, 1995.

Lauter, Estella. *Women as Mythmakers.* Bloomington, Ill.: Indiana University Press, 1984.

Leslie, Clare Walker. *Nature Drawing: A Tool for Learning.* New York: Simon & Schuster, 1980.

Lipman, Jean, and Richard Marshall. *Art about Art.* New York: Dutton/Whitney Museum of American Art, 1968.

Lippard, Lucy. *From the Center.* New York: Dutton, 1976.

Lippard, Lucy. *Six Years: The Dematerialization of the Art Object from 1966 to 1972.* New York: Praeger, 1973.

Maresca, Frank, and Ricco, Roger. *American Self-Taught: Paintings and Drawings by Outsider Artists.* New York: Alfred A. Knopf, 1995.

Martin, Marianne. *Futurism Art and Theory, 1909–1915.* London: Oxford University Press, 1968.

Marx, Sammburg. *Beuys, Rauschenberg, Twombly, Warhol.* Munich: Prestel Verlag, 1982.

McQuiston, Liz. *Graphic Agitation: Social and Political Graphics Since the Sixties.* New York: Phaidon Press, 1993.

Modern Latin American Painting, Drawings and Sculpture. New York: Sotheby, 1989.

The Monumental Image. Rohnert Park, Calif.: Sonoma State University, n.d.

Moore, Sylvia, ed. *Yesterday and Tomorrow, California Women Artists.* New York: Midmarch Arts Press, 1989.

Newman, Charles. *The Post-Modern Aura.* Evanston, Ill.: Northwestern University Press, 1985.

Norris and Benjamin. *What Is Deconstruction?* London: St. Martin's Press, 1988.

100 European Drawings. New York: Metropolitan Museum of Art, 1964.

Perry, Gill et al. *Primitivism, Cubism, Abstraction: The Early Twentieth Century.* New Haven: Yale University Press, 1993.

Pincus-Witten, Robert. *Postminimalism.* New York: Out of London Press, 1977.

Plagens, Peter. *Sunshine Muse.* New York: Praeger, 1974.

Plous, Phyllis, and Mary Looker. *Neo York.* Santa Barbara: University Art Museum, 1989.

The Primal Spirit: Ten Contemporary Japanese Sculptors. L.A. County Museum of Art. Los Angeles: 1990.

Raven, Arlene et al., eds. *Feminist Art Criticism: An Anthology.* Ann Arbor, Mich.: UMI Research Press, 1988.

Revelations. Little Rock: Arkansas Arts Center, 1984.

Risatti, Howard, ed. *Postmodern Perspective: Issues in Contemporary Art.* Englewood Cliffs, N.J.: Prentice-Hall, 1990.

Rose, Barbara. *Drawing Now.* New York: Museum of Modern Art, 1976.

Rubin, William S. *Dada and Surrealist Art.* Abrams. New York: 1969.

Selz, Peter. *Art in Our Times: A Pictorial History 1890–1980.* New York: Harcourt Brace Jovanovich, Inc./Abrams, 1981.

75th American Exhibition. Chicago: The Art Institute of Chicago, 1986.

Smagula, Howard. *Currents: Contemporary Directions in the Visual Arts.* Englewood Cliffs, N.J.: Prentice-Hall, 1983.

Stebbins, Theodore E. *American Master Drawings and Watercolors: A History of Works on Paper from Colonial Times to the Present.* New York: The Drawing Society, 1976.

Shedletsky, Stuart, ed. *Still Working/ Underknown Artists of Age in America.* New York: Parsons School of Design, 1995.

Steinberg, Leo. *Other Criteria: Confrontations with Twentieth-Century Art.* New York: Oxford University Press, 1979.

Szabo, George et al. *Landscape Drawings of Five Centuries, 1400–1900.* New York: Metropolitan Museum of Art, 1989.

Sussman, Elisabeth et al. *1993 Biennial.* New York: Whitney/Abrams, 1995.

Tomkins, Calvin. *Post-to-Neo, The Art World of the 1980's.* New York: Henry Holt, 1989.

Tiberghien, Gilles A. *Land Art.* Princeton, N.J.: Princeton Architectural Press, 1995.

Tuchman, Maurice, ed. *The Spiritual in Art—Abstract Painting 1890–1985.* New York: Abbeville Press, 1986.

Tucker, Marcia. *Bad Painting in "Bad" Painting.* New York: New Museum, 1978.

Tupitsyn, Margarita, Curator. *After Perestroika: Kitchenmaids or Stateswomen.* New York: Independent Curators, Inc., 1993.

Varnedoe, Kirk, and Adam Copnick. *High and Low: Modern Art and Popular Culture.* New York: Abrams, 1990.

Varnedoe, Kirk, and Adam Copnick, eds. *Modern Art and Popular Culture: Readings in High and Low Art.* New York: Abrams, 1990.

Vogel, Susan. *Africa Explores: 20th Century African Art.* New York: The Center for African Art, Munich: Prestel Verlag, 1991.

Von Blum, Peter. *Women Political Artists in Greater Los Angeles.* Lanham, MD: University Press of America, 1994.

Waldman, Diane. *British Art Now: An American Perspective.* New York: Solomon R. Guggenheim Museum, 1980.

Waldman, Diane. *Collage, Assemblage, and the Found Object.* New York: Abrams, 1995.

Waldman, Diane. *New Perspectives in American Art.* New York: Solomon R. Guggenheim Museum, 1983.

Wallis, Brian, ed. *Art After Modernism. Rethinking Representation.* Boston: New Museum of Contemporary Art, 1985.

Whitney Museum's Biennial Catalogs. New York: Whitney Museum of Art, 1981, 1983, 1985, 1987, 1989, 1991.

Wilkins, David G., and Bernard Schultz. *Art Past/Art Present:* New York: Abrams, 1990.

Works on Paper. Washington, D.C.: Smithsonian Institution Press, 1977.

Women Choose Women. New York: Worldwide Books, 1973.

COLOR

Albers, Josef. *Interaction of Color,* rev. ed. New Haven: Yale University Press, 1972.

Birren, Faber. *Principles of Color.* New York: Van Nostrand Reinhold, 1969.

Doyle, Michael E. *Color Drawing.* New York: Van Nostrand Reinhold, 1981.

Fabri, Frank. *Color: A Complete Guide for Artists.* New York: Watson-Guptill, 1967.

Itten, Johannes. *The Art of Color.* New York: Van Nostrand Reinhold, 1974.

Poling, Clark V. *Kandinsky's Teaching at the Bauhaus: Color Theory and Analytical Drawing.* New York: n.p., 1986.

PERSPECTIVE

D'Amelio, Joseph. *Perspective Drawing Handbook.* New York: Leon Amiel, 1964.

Cole, Rex Vicat. *Perspective as Applied to Pictures.* Philadelphia: Lippincott, n.d.

Dubery, Fred, and John Willats. *Perspective and Other Drawing Systems.* New York: n.p., 1983.

Montague, John. *Basic Perspective Drawing/ A Visual Approach.* New York: Van Nostrand Reinhold, 1985.

Norton, Dora M. *Freehand Perspective and Sketching.* New York: Bridgman Publishers, 1929.

Powell, William. *Perspective.* New York: W. Foster, 1989.

Walters, Nigel V., and John Bromham. *Principles of Perspective.* New York: Watson-Guptill, 1974.

WORKS ON INDIVIDUAL ARTISTS

Laurie Anderson
Anderson, Laurie. *United States.* New York: Harper & Row, 1984.

John Baldessari
Tucker, Marcia, and Robert Pincus-Witten. *John Baldessari.* New York: The New Museum, 1981.
Van Bruggen, Coosje. *John Baldessari.* New York: Rizzoli, 1990.

Jennifer Bartlett
Goldwater, Marge. *Jennifer Bartlett.* New York: Abbeville Press, 1990.
Russell, John. *Jennifer Bartlett: In the Garden.* New York: Abrams, 1982.

Georg Baselitz
Corral, Maria, and Elvira Maluquer. *Georg Baselitz.* Madrid: Fundacion Caja de Pensiones, 1990.
Waldman, Diane. *George Baselitz.* New York: Guggenheim/Abrams, 1995.

Leonard Baskin
Baskin: Sculpture, Drawings and Prints. New York: Braziller, 1970.

Jean Michel Basquiat
Marshall, Richard. *Jean Michel Basquiat.* New York: Whitney/Abrams, 1995.

Romare Bearden
Romare Bearden: The Prevalence of Ritual. New York: Museum of Modern Art, 1971.

Linda Benglis
Linda Benglis 3-Dimensional Painting. Chicago: Museum of Contemporary Art, 1980.

Joseph Beuys

Adriani, Götz, Winfried Konnertz, and Karin Thomas. *Joseph Beuys: Life and Works.* Woodbury, N.Y.: Barron's Educational Series, 1979.

Adriani, Götz. *Joseph Beuys: Drawings, Objects and Prints.* Berlin: Institute for Foreign Cultural Relations and the Goethe Institute, 1995.

Schade, Werner. *Joseph Beuys: The Early Drawings.* New York: Shirmer/ Mosel/Norton, 1995.

Temkin, Anne, and Rose, Bernice. *Thinking Is Form: The Drawings of Joseph Beuys.* Philadelphia: Philadelphia Museum of Art/Thames and Hudson, 1995.

Jonathan Boròfsky

Rosenthal, Mark, and Marshall, Richard. *Jonathan Borofsky.* New York: Philadelphia Museum of Art/Whitney, 1984.

Paul Cézanne

Chappeuis, Adrien. *The Drawings of Paul Cézanne.* Greenwich, Conn.: New York Graphic Society, 1973.

Christo

Schellman, Jorg, and Josephine Benecke, eds. *Christo Prints and Objects.* New York: Abbeville Press, 1987.

Francesco Clemente

Bastian, H., and W. M. Faust. *Clemente, Chia, Cucchi.* White Chapel Art Gallery, London. Bielefeld, 1983.

Percy, Ann, and Raymond Foye. *Francesco Clemente, Three Worlds.* New York: Rizzoli, 1990.

Chuck Close

Guare, John. *Chuck Close: Life and Work 1988–1995.* London: Thames and Hudson, 1995.

Yau, John. *Chuck Close: Recent Paintings.* Los Angeles: Pace Wildenstein Gallery, 1995.

Joseph Cornell

Joseph Cornell. Museum of Modern Art. 1990.

Waldman, Diane. *Joseph Cornell.* New York: Braziller, 1977.

Jóse Luís Cuevas

Carlos Fuentes. *El Mundo de Jóse Luís Cuevas.* New York: Tudor, 1969.

Richard Diebenkorn

Norland, Gerald. *Richard Diebenkorn Monotypes.* Los Angeles: Frederick S. Wight Art Gallery, University of California, 1976.

Richard Diebenkorn, Paintings and Drawings, 1943–1980. Buffalo, N.Y.: Rizzoli for Albright-Knox Art Gallery, 1980.

Jim Dine

Gordon, John. *Jim Dine.* New York: Praeger/Whitney Museum of American Art, 1970.

Shapiro, David. *Jim Dine: Painting What One Is.* New York: Abrams, 1981.

Jean Dubuffet

Drawings, Jean Dubuffet. New York: Museum of Modern Art, 1968.

Rowell, Margit. *Jean Dubuffet: A Retrospective.* New York: Guggenheim Museum, 1973.

Marcel Duchamp

Marcel Duchamp. New York: Museum of Modern Art and Philadelphia Museum of Art, 1973.

Baruchello, Gianfranco, and Henry Martin. *The Imagination of Art (How to Imagine and Why Duchamp).* Kingston, N.Y.: McPherson, 1986.

Baruchello, Gianfranco, and Henry Martin. *Why Duchamp: An Essay on Aesthetic Impact.* Kingston, N.Y.: McPherson, 1985.

Vernon Fisher

Vernon Fisher. La Jolla, Calif.: La Jolla Museum of Contemporary Art, 1989.

Lucian Freud

Lampert, Catherine. *Lucian Freud.* New York: Rizzoli, 1993.

Penny, Nicolas, and Johnson, Robert. *Lucian Freud: Works on Paper.* London: Thames and Hudson, 1988.

Alberto Giacometti

Bonnefoy, Yves. *Giacometti.* New York: Abbeville, 1995.

Fletcher, Valerie J. *Giacometti.* Washington, D.C.: Smithsonian Institution Press, 1988.

Giacometti, Alberto. *Giacometti, A Sketchbook of Interpretive Drawings.* New York: Abrams, 1967.

Lamarche-Vadel, Bernard. *Alberto Giacometti.* Secaucus, N.J.: n.p., 1984.

Gilbert and George

Rosenblum, Robert, and Ratcliff, Carter. *Gilbert & George: The Singing Sculpture.* New York: Anthony McCall Publishers/D.A.P., 1995.

Richardson, Brenda. *Gilbert & George.* Baltimore, Md.: the Baltimore Museum of Art Exhibition Catalogue, 1984.

Robert Gober

Marta, Karen, ed. *Robert Gober.* New York: Dia Center for the Arts/D.A.P., 1995.

Juan Gris

Rosenthal, Mark. *Juan Gris.* Berkeley, 1983.

Red Grooms

Tully, Judd. *Red Grooms and Ruckus Manhattan.* New York: Braziller, 1977.

George Grosz

George Grosz. Love Above All, and Other Drawings: 120 Works by George Grosz. New York: Dover, 1971.

Philip Guston

Dabrowski, Magdalena. *The Drawings of Philip Guston.* New York: Museum of Modern Art, 1988.

Keith Haring

Keith Haring: Future Primeval. New York: Illinois State University/Abbeville Press, 1990.

David Hockney

Melia, Paul, ed. *David Hockney.* New York: St. Martin's Press, 1995.

Tuchman, Maurice, and Stephanie Barron. *David Hockney: A Retrospective.* New York: Museum of Modern Art, 1988.

Jenny Holzer

Waldman, Diane. *Jenny Holzer.* New York: Abrams, 1990.

Yvonne Jacquette

Yvonne Jacquette. Catalog with essay by Carter Ratcliff. New York: Museum of Modern Art, 1990.

Neil Jenney

Rosenthal, Mark. *Neil Jenney.* Berkeley: University Art Museum, 1981.

Jasper Johns

Castleman, Riva. *Jasper Johns: A Print Retrospective.* New York: Museum of Modern Art, 1986.

Francis, Richard. *Jasper Johns.* New York: Abbeville Press, 1984.

Rosenthal, Mark. *Jasper Johns Work Since 1974.* Philadelphia: Philadelphia Museum of Art, 1988.

Shapiro, David. *Jasper Johns: Drawings, 1954–84.* New York: Abrams, 1984.

Anselm Kiefer

Rosenthal, Mark. *Anselm Kiefer.* New York: Te Neues, 1988.

Paul Klee

Grohmann, Will. *Paul Klee.* New York: Abrams, 1945.

Käthe Kollwitz
Hinz, Renate, ed. *Käthe Kollwitz: Graphics, Posters, Drawings.* New York: Pantheon, 1987.

Barbara Kruger
Linker, Kate. *Love for Sale: The Words and Pictures of Barbara Kruger.* New York: Abrams, 1990.

Rico Lebrun
Rico Lebrun: Drawings. Berkeley: University of California Press, 1968.

Fernand Léger
Fabre, Gladys C., Barbara Rose, and Marie-Odile Briot. *Léger and the Modern Spirit, An Avant-Garde Alternative to Non-Objective Art.* Houston: Museum of Fine Arts, 1983.
Fernand Léger. New York: The Museum of Modern Art (International Council), 1976.

Sol LeWitt
Minimalism. Seattle: University of Washington Press, 1990.
Reynolds, Jack, and Miller-Keller, Andrea. *Sol LeWitt: Twenty-Five Years of Wall Drawings, 1968–1993.* Seattle: University of Washington Press, 1995.

Roy Lichtenstein
Waldman, Diane. *Roy Lichtenstein.* New York: Rizzoli/Guggenheim Museum, 1993.

Richard Long
Fuchs, Rudi. *Richard Long.* London: Thames and Hudson, 1986.
Seymour, Anne, and Fulton, Hamish. *Richard Long: Walking in Circles.* New York: Braziller, 1995.

Robert Longo
Fox, Howard N. *Robert Longo.* New York: L.A. County Museum/Rizzoli, 1989.

David Macaulay
Macaulay, David. *Great Moments of Architecture.* Boston: Houghton Mifflin, 1978.

Henri Matisse
Matisse as a Draughtsman. Greenwich, Conn./New York: Graphic Society/Baltimore Museum of Art, 1971.

Brice Marden
Kertess, Klaus. *Seeing in Imaging: Brice Marden, Paintings and Drawings.* New York: Abrams, 1992.

Mario Merz
Eccher, Danilo. *Mario Merz.* New York: Hopeful Moster, 1995.

Helmut Middendorf
Wildermuth, A., and W. M. Faust. *Helmut Middendorf.* Groninger, 1983.

Joan Miró
Rowell, Margit. *The Captured Imagination: Drawings by Joan Miró from the Fundacio Joan Miró, Barcelona.* New York: American Federation of the Arts, 1987.

Piet Mondrian
Hammacher, A.M. *Mondrian, De Stijl and Their Impact.* New York: Marlborough, 1964.

Henry Moore
Garroued, Ann, ed. *Henry Moore Drawings.* New York: n.p., 1988.
Henry Moore's Sheep Sketchbook. London: Thames and Hudson, 1980.

Giorgia Morandi
Vitale, Lamberto. *Giorgia Morandi.* 2 vols. Florence, Italy: Ufizzi, 1983.

Robert Morris
Minimalism. Seattle: University of Washington Press, 1990.

Alice Neel
Hills, Patricia. *Alice Neel.* New York: Abrams, 1983.

Bruce Nauman
Bruce Nauman Drawings, 1965–86. Basel: Museum für Gegenwartskunst, 1986.
Van Bruggen, Coosje. *Bruce Nauman.* New York: Rizzoli, 1987.

Claes Oldenburg
Baro, Gene. *Claes Oldenburg: Prints and Drawings.* London: Chelsea House, 1969.
Celant, Germano, and Rosenthal, Mark. *Claes Oldenburg: An Anthology.* New York: Guggenheim/Abrams, 1995.
Haskell, Barbara. *Claes Oldenburg: Objects into Monument.* Pasadena, Calif.: Pasadena Art Museum, 1971.
Oldenburg, Claes. *Notes in Hand.* New York: Dutton, 1971.

Philip Pearlstein
Philip Pearlstein Watercolors and Drawings. New York: Alan Frumkin Gallery, n.d.

A.R. Penck
Grisebach, Lucius, ed. *A.R. Penck.* Munich: Berlin National Galerie. Prestel Verlag, 1988.
Yau, John. *A.R. Penck.* New York: Abrams, 1995.

Pablo Picasso
Picasso: His Recent Drawings 1966–68. New York: Abrams, 1969.
Rose, Bernice. *Picasso and Drawing.* New York: Pace Wildenstein, n.d.

Sigmar Polke
Sigmar Polke Drawings 1962–1988. Bonn: Kunstmuseum, 1988.

Jackson Pollock
Friedman, B.H. *Jackson Pollock: Energy Made Visible.* New York: McGraw-Hill, 1972.

Robert Rauschenberg
Kotz, Mary Lynn. *Rauschenberg: Art and Life.* New York: Abrams, 1990.
Robert Rauschenberg: Work from Four Series. Houston: University of Washington Press for Contemporary Arts Museum, 1990.

Gerhard Richter
Gidal, Peter. *Gerhard Richter, Painting in the Nineties.* London: Anthony d'Offay, 1995.
Obrist, Hans Ulrich, ed. *Gerhard Richter, The Daily Practice of Painting, Writings 1962–1993.* Cambridge, Mass.: Anthony d'Offay/MIT, 1995.

Larry Rivers
Hunter, Sam. *Larry Rivers.* New York: Abrams, 1969.
Rivers, Larry. *Drawings and Digressions.* New York: Clarkson Potter, 1979.

Kurt Schwitters
Elderfield, John. *Kurt Schwitters.* London: Thames and Hudson, 1985.

Robert Smithson
Robert Smithson: Drawings. New York: The New York Cultural Center, 1974.
Robert Smithson Unearthed: Drawings, Collages, Writings. New York: Columbia University Press, 1991.

Saul Steinberg
Rosenberg, Harold. *Saul Steinberg.* New York: Knopf, 1978.

Pat Steir
Arbitrary Order: Paintings by Pat Steir. Houston: Contemporary Arts Museum, 1983.
Steir, Pat. *Pat Steir.* New York: Abrams, 1986.

Donald Sultan
Donald Sultan. New York: Museum of Contemporary Art, Chicago, and Abrams, 1987.

Mark Tansey
Robbe-Grillet, Alain. *Mark Tansey.* Los
 Angeles: L.A. County Museum, 1995.
Wayne Thiebaud
Tsujimoto, Karen. *Wayne Thiebaud.* San
 Francisco: San Francisco Museum of
 Modern Art, 1985.
Wayne Thiebaud Survey 1947–1976. Phoenix,
 Ariz.: Phoenix Art Museum, 1976.
Jean Tinguely
Hulten, K. G. Pontus. *Jean Tinguely: Meta.*
 Greenwich, Conn.: New York
 Graphic Society, 1975.
Mark Tobey
Rathbone, Eliza E. *Mark Tobey.*
 Washington, D.C.: National Gallery
 of Art, 1986.

Cy Twombly
Bastian, Heiner, ed. *Cy Twombly: Catalogue
 Raisonné of the Paintings Volume IV
 1972–1995.* Berlin: Schirmer/Mosel,
 1995.
Andy Warhol
McShine, Kynaston. *Andy Warhol: A
 Retrospective.* New York: Museum of
 Modern Art, 1989.
Paul Weighardt
Paul Weighardt Retrospective. Ludenscheid:
 Gemälde Aquarelle Zeichnungen
 Druck Druckhaus Maack G., 1972.
Tom Wesselmann
*Tom Wesselmann: The Early Years/Collages
 1959–62.* Long Beach: California
 State University Art Galleries, 1974.

Terry Winters
Phillips, Lisa. *Terry Winters.* New York:
 Whitney Museum of American Art,
 1991.
Plous, Phyllis. *Terry Winters, Painting and
 Drawing.* Santa Barbara: University
 Art Museum, 1987.
John Wesley
Bloem, Marja, and Hentschel, Martin.
 *John Wesley: Paintings 1963–1992, Gouaches,
 1961–1992.* Oktagon Verlag. Munich,
 Stuttgart: 1993.
William T. Wiley
Wiley Territory. Minneapolis, Minn.: Walker
 Art Center, 1979.

PHOTOGRAPHIC SOURCES

1.1 © By permission of NHK (Japanese Broadcasting Corp.) and Hiroshima Peace Culture Foundation.; 1.2 © Photo Archives, Editions Arthaud, Paris. By permission of Libraririe Ernest Flammarion.; 1.3 © 1996 Kenny Scharf / Artists Rights Society (ARS), NY.; 1.4 Gift of the artist.; 1.7 Photo by Gianfranco Gorgone. © Douglas M. Parker Studio; 1.8 © Photo RMN, Paris.; 1.9 Photograph © 1997 The Museum of Modern Art, New York.; 1.11 © 1996 Estate of Pablo Picasso, Paris / Artists Rights Society (ARS), NY. Photograph © 1997 The Museum of Modern Art, New York.; 1.12 Art Resource, New York. 1975-87-1.; 1.13 Reprinted with permission of McGraw-Hill Book Company from *Morris' Human Anatomy*, Schaeffer, 10th edition, Philadelphia: The Blackiston Co., 1942.; 1.14 © 1996 Artists Rights Society (ARS), NY / ADAGP, Paris. Robert Miller Gallery, BASQ-1124.; 1.15 Photo: Harry Shunk. © Christo 1969-1981.;

1.16 Photo: San Francisco Art Commission.; 1.17 Photograph © 1997 The Museum of Modern Art, New York.; 1.18 © The Estate of Keith Haring, 1991. Photo: Ivan Dalla-Tana.; 1.19 © Chuck Close; 1.21 © Photo: Geoffrey Clements.; 1.22 © Artists Rights Society (ARS), NY / ADAGP, Paris. Photograph Ivan Dalla-Tana.; 1.23 © 1996 Estate of Pablo Picasso, Paris / Artists Rights Society (ARS), NY.; 1.24 Constance Lebrun Crown, Santa Barbara, California.; 1.25 Estate of Robert Smithson, Courtesy of John Weber Gallery; 1.28 Photo: Arthur Siegel.; 1.29 Photo: Bob Hsiang; 1.30 Photograph © 1995, The Art Institute of Chicago. All Rights Reserved. 1993.176 Photo: Robert E. Mates and Paul Katz.; 1.31 © Roy Lichtenstein / VAGA New York 1990.; 1.32 © Roy Lichtenstein / VAGA New York 1990.; 1.33 © Roy Lichtenstein / VAGA New York 1990.; 1.34 Photograph © 1997 The Museum of Modern Art, New York

2.1 Photo: Mates and Katz. Paula Cooper Gallery, JS 48.; 2.2 © 1992 VAGA, NY / Bilde-Kunst, Germany.; 2.7 The Pierpont Morgan Library, 1979.49.; 2.8 Photograph by Martin Buhler.; 2.10 Photograph by Angelo Pinto.; 2.11 © Hronn Axlesdottir; 2.12 Photographs by Danielle Fagan, Austin, Texas.; 2.13 Photographs by Danielle Fagan, Austin, Texas.; 2.14 Photographs by Danielle Fagan, Austin, Texas.; 2.15 Photographs by Danielle Fagan, Austin, Texas.; 2.16 Photographs by Danielle Fagan, Austin, Texas.; 2.17 Photographs by Danielle Fagan, Austin, Texas.; 2.18 Photographs by Danielle Fagan, Austin, Texas.; 2.19 Photographs by Danielle Fagan, Austin, Texas.; 2.20 Photographs by Danielle Fagan, Austin, Texas.; 2.21 Photographs by Danielle Fagan, Austin, Texas.; 2.22 © The Henry Moore Foundation; 2.25 Walker Art Center, Minneapolis.; 2.27 ©1996 Artists Rights Society (ARS), NY / ADAGP, Paris.; 2.29 Acc. no. 85.62.; 2.30 Photograph

Rudolph Burkhardt, New York.; **2.31** Photograph by Danielle Fagan, Austin, Texas.; **2.32** ©1996 Artists Rights Society (ARS), NY / ADAGP, Paris. Photo by Danielle Fagan, Austin, Texas.; **2.33** 81.23; **2.34** Photograph by Danielle Fagan, Austin, Texas.; **2.35** Photograph by Danielle Fagan, Austin, Texas.

II.1 <u>Their Eyes Meeting the World</u>, p. 77. Copyright © 1992 by Robert Coles. Reprinted by permission of Houghton Mifflin Company. All rights reserved.; **II.5** AP1984.23; **II.6** 1926.224. Photograph ©1995, The Art Institute of Chicago. All rights reserved.; **II.7** © 1996 Artists Rights Society (ARS), NY / ADAGP, Paris. Photograph © 1997 The Museum of Modern Art, New York.; **II.8** © 1996 Sol LeWitt / Artists Rights Society (ARS), NY.; **II.9** © 1996 Robert Morris / Artists Rights Society (ARS), NY. Acc. no. 83.829. Photograph Jon Abbot.; **II.10** © Whitney Museum of American Art, 1992. Hirshhorn Museum and Sculpture Garden, Smithsonian Institution, Museum Purchase with Funds Donated by the Board of Trustees, 1981.; **II.11** Photo: Vatican Library.; **II.12** Pierpont Morgan Library, New York. 1973.29.; **II.16** Photo by Ken Showell.; **II.17** © 1996 Artists Rights Society (ARS), NY / ADAGP, Paris.; **II.18** © 1996 Artists Rights Society (ARS), NY / ADAGP, Paris.; **II.21** Photo: Zindman / Fremont; **II.23** © 1996 Frank Stella / Artists Rights Society (ARS), NY.; **II.24** photo courtesy Paula Cooper Gallery, New York.

3.1 © David Heald © The Solomon R. Guggenheim Foundation, New York.; **3.2** © 1996 Dorothea Rockburne / Artists Rights Society (ARS), NY. Photograph Rick Gardner, Texas Gallery, Houston.; **3.10** © University Art Museum, University of California, Santa Barbara.; **3.11** Reprinted with permission of Mrs. Nelli Wieghardt.; **3.12** Acc. 74.183; **3.13** © By permission of Donald Sultan. BH 3551; **3.14** Photograph by Photosmith; **3.15** 84.49; **3.17** 86.63.5; **3.18** 84.43; **3.23** Photo: eeva-inkeri.

JS 243.; **3.24** By permission of the artist.; **3.25** © The Henry Moore Foundation. Photograph Robin Smith Photography Ltd., Christchurch, New Zealand.; **3.26** © 1992 Edward Ruscha / VAGA, NY; **3.27** © 1996 Artists Rights Society (ARS), NY / ADAGP, Paris.; **3.30** Photo: Andre Morain; **3.31** I: EL 4.1.1986, 95.26.1, Anonymous Loan from Andre Simon, 1986. II: EL 4.2.1986, 95.26.2, Bequest of Andre Simon, 1995. III: EL 4.3.1986, Bequest of Andre Simon, 1995. 95.26.3. IV: EL 4.4 1986, Bequest of Andre Simon, 1995, 95.26.4. V: EL 8.1.86, Lent by Andre Simon, 1986. VI: EL 8.2.1986, Bequest of Andre Simon, 1995, 95.26.6.

4.2 Photograph by David Browne.; **4.3** Photograph by Spike Mafford.; **4.4** Photograph © 1996 The Museum of Modern Art, New York.; **4.7** Acc. 72.121.1.; **4.8** Photo by M. Lee Fatheree / Beth Van Hoesen.; **4.9** National Multiple Sclerosis Society juried exhibition "Shared Visions: Artists With MS."; **4.10** Courtesy Allan Stone Gallery, New York; **4.11** Photograph by Robert E. Mates © The Solomon R. Guggenheim Foundation, New York. (FN 65.1774); **4.12** Photo by Eric Pollitzer, Hempstead, NY; **4.13** © 1992 Robert Rauschenberg / VAGA, NY; **4.14** Photograph © 1997 The Museum of Modern Art, New York; **4.16** By permission of Marilys B. de Downey. Photo: Harry Shunk; **4.17** Courtesy André Emmerich Gallery.; **4.18** Constance Lebrun Crown, Santa Barbara, California.; **4.20** 82.3.2; **4.22** © 1996 Luis Jimenez / Artists Rights Society (ARS), NY.; **4.23** Courtesy Robert Miller Gallery, NY; **4.24** Photo: Andre Morain.; **4.26** Allan Frumkin Gallery, New York.; **4.28** © Rupert Garcia, 1996.; **4.29** Photograph © 1997 The Museum of Modern Art, New York.; **4.34** Photo by Geoffrey Clements, Staten Island, NY; **4.35** 81.24; **4.37** Arkansas Arts Center

5.2 © eeva-inkeri; **5.5** 5658 © SPADEM.; **5.7** © Joseph Szaszfai, 1941.354; **5.8** 83.9; **5.11** © 1996 Sol LeWitt / Artists Rights Society (ARS), NY.;

5.14 Walker Art Center, Minneapolis.; **5.15** Photograph © 1997 The Museum of Modern Art, New York; **5.16** 87.47.2; **5.17** ©1975 by David Levine. Originally appeared in *The New York Review of Books.*; **5.18** © 1996 The Milton Avery Trust / Artists Rights Society (ARS), NY.; **5.19** © 1996 Artists Rights Society (ARS), NY / VG Bild-Kunst, Bonn.; **5.20** © The Henry Moore Foundation.; **5.21** Photo by Dale Laster.; **5.23** © 1992 Succession H. Matisse, Paris / Artists Rights Society (ARS), NY.; **5.24** © 1996 Artists Rights Society (ARS), NY / ADAGP, Paris. Photograph Philippe Migeat, Centre G. Pompidou. ©1992 ARS, NY / ADAGP, Paris.; **5.25** © 1996 Artists Rights Society (ARS), NY / ADAGP, Paris. Photograph © 1997 The Museum of Modern Art, New York.; **5.27** © 1996 Artists Rights Society (ARS), NY / Prolitteris, Zurich. Photograph © 1997 The Museum of Modern Art, New York.; **5.29** © David Hockney / Gemini G. E. L.; **5.30** © 1996 The Willem de Kooning Revocable Trust / Artists Rights Society (ARS), NY. Photograph Barney Burstein, Boston.; **5.31** © 1996 Red Grooms / Artists Rights Society (ARS), NY. Acc. no. 1976.1.P.S.

6.2 Prudence Cuming Associates Limited; **6.3** © 1996 Whitney Museum of American Art, 66.2; **6.5** Photo: Bevan Davies; **6.7** © The Museum of Fine Arts, Houston; Museum purchase with funds provided by Len E. Kowitz; **6.8** © acc. no. 76-10a&b.; **6.9** © Photo: eeva-inkeri; **6.10** Pace Editions, New York 172-24; **6.11** © Photo: Bruce Weber.; **6.12** © Joseph Szaszfai; **6.13** © 1996 Artists Rights Society (ARS), NY / ADAGP, Paris.; **6.14** Photograph © 1997 The Museum of Modern Art, New York.; **6.15** Photo: eeva-inkeri. Printed by Simca Print Artists, Inc., NY. JB 8prt.; **6.17** © 1996 Frank Stella / Artists Rights Society (ARS), NY. Photograph Steven Sloman. Printed and published by Tyler Graphics Ltd. 1982, impression no. 24/30.; **6.18** Photo by Pramuan Burusphat.; **6.20** © David Hockney; **6.21** © Artists Rights Society (ARS), NY / VG Bild-Kunst, Bonn.

Photograph David Heald © The Solomon R. Guggenheim Foundation, New York. (FN 76.2553 PG85).; **6.26** Photograph by D. James Dee, courtesy Ronald Feldman Fine Art, N.Y. c Ilya Kabakov / VAGA, N.Y., 1994.; **6.27** Photograph by Tracye Saar.; **6.29** Photograph © 1997 The Museum of Modern Art, New York.

7.1 © Hickey-Robertson, Houston; **7.3** 74.11.e; **7.6** © 1996 Bruce Nauman / Artists Rights Society (ARS), NY.; **7.7** © Photo by Schopplein Studio SFCA / Morgan Gallery, Kansas City, Missouri; **7.8** Courtesy M. Knoedler & Co., Inc., New York. Photo © Douglas M. Parker studio

8.4 Photograph from Sherman Galleries.; **8.5** Photo by Danielle Fagan, Austin, Texas.; **8.6** Photo by Danielle Fagan, Austin, Texas.; **8.7** Photo by Danielle Fagan, Austin, Texas.; **8.8** Photo by Danielle Fagan, Austin, Texas.; **8.9** © M. Lee Fatherree; **8.10** Steve Tucker; **8.11** © 1996 M. C. Escher / Cordon Art - Baarn - Holland. All rights reserved. ARCO Center for Visual Art, Los Angeles.; **8.12** From *Great Moments in Architecture* by David Macaulay. Copyright © 1978 by David Macaulay. Reprinted with permission of Houghton Mifflin Company. All rights reserved.; **8.13** From *Great Moments in Architecture* by David Macaulay. Copyright © 1978 by David Macaulay. Reprinted with permission of Houghton Mifflin Company. All rights reserved.; **8.15** © Edward Ruscha / VAGA, New York, 1991; **8.16** © VAGA; **8.19** © Metropolitan Museum of Art, Museum Excavations, 1928-29, and Rogers Fund, 1930. (30.3.31); **8.20** By permission of Sharon Avery-Fahlstrom.; **8.21** Hirshhorn Museum and Sculpture Garden, Smithsonian Institution. Museum Purchase with Funds Donated by Edward R. Downe, Jr., 1980. Lee Stalsworth, photographer. Acc. 80.66.; **8.22** From *Great Moments in Architecture* by David Macaulay. Copyright © 1978 by David Macaulay. Reprinted with permission of Houghton Mifflin Company. All rights reserved.; **8.23** © 1996 Artists Rights Society (ARS), NY / ADAGP, Paris.; **8.24** © 1996 Estate of Pablo Picasso, Paris / Artists Rights Society (ARS), NY.; **8.25** Art Resource, New York. 1969-137-4.

9.1 © Photograph courtesy Frank Kolbert Gallery, New York.; **9.5** © 1992 ARS, NY / ADAGP, Paris; **9.6** © 1996 The Pollack-Krasner Foundation / Artists Rights Society (ARS), NY.; **9.10** Photo: Michael Tropea.; **9.11** Courtesy of Todd Bockley, Minneapolis.; **9.13** Photo by Pramuan Burusphat.; **9.15** Photo by Bevan Davies, New York.; **9.17** Photo: D. James Dee, New York.

10.1 © Courtesy Holly Solomon Gallery, New York. M. Tropea; **10.2** © 1996 Artists Rights Society (ARS), NY / VG Bild-Kunst, Bonn. Photograph Rudolph Burkhardt.; **10.3** © Courtesy Holly Solomon Gallery, New York; **10.4** © Paul Ruscha; **10.7** Photo: D. James Dee, New York.; **10.8** Giraudon / Art Resource, New York.; **10.10** Robert Miller Gallery, New York. © the Estate of Alice Neel.; **10.12** Photo by Dottie Allen.; **10.14** Leo Castelli Gallery, New York.; **10.15** Photo by Susan Einstein / Hunsaker-Schlesinger Gallery, Los Angeles.; **10.16** Photo by Dottie Allen.; **10.17** © 1996 Estate of Pablo Picasso, Paris / Artists Rights Society (ARS), NY. © 1992 ARS, NY / ADAGP, Paris.; **10.19** © 1996 The Andy Warhol Foundation for the Visual Arts / Artists Rights Society (ARS), NY.; **10.20** Photo: Steve Lopez.

11.1 Erma Estwick; **11.2** © Courtesy Sperone Westwater.; **11.3** © 1996 Robert Morris / Artists Rights Society (ARS), NY.; **11.4** © Collection Paine Webber Group Inc., New York, PW 1395.; **11.5** © photo Steven Sloman, New York. © 1992 Robert Morris / VAGA, N.Y.; **11.7** © Courtesy Mary Boone Gallery, New York, MBG #1094.; **11.8** © 1996 Artists Rights Society (ARS), NY / VG Bilde-Kunst, Bonn.; **11.9** Peter Muscato © Guerilla Girls West, San Francisco.; **11.10** © Mark Tansey 1992. Photo: Orcutt and Van Der Putten. MT 2890.; **11.12** Photograph by David Heald. © The Solomon R. Guggenheim Foundation, New York. (FN 89.3631.a.g); **11.15** © Jenny Holzer; **11.16** © 1989 Sue Coe. Porkopolis Stamp #79.; **11.17** Photo: The Brooklyn Museum, courtesy Ronald Feldman Fine Arts.; **11.18** © P.P.O.W. Gallery, New York and the Estate of David Wojnarowicz.; **11.19** Photo courtesy Sonnabend Gallery. Photo: David Reynolds.; **11.22** © Courtesy Cesar A. Martinez; **11.23** Acc. no. 1985.35.33.; **11.25** Photo: Manuel "Memo" Cavada.; **11.26** © D. James Dee; **11.27** Photograph © 1997 The Museum of Modern Art, New York.; **11.28** Photo © 1993 Geoffrey Clements, courtesy of the artist.; **11.31** © Photograph courtesy The Museum of Modern Art, New York.; **11.32** SW 94422. © Douglas M. Parker Studio, Los Angeles.

PG.8 Estate of Robert Smithson, Courtesy of John Weber Gallery; **PG.10** © LRZ 150; **PG.11** © LRZ 127; **PG.19** ©1996 Museum Associates, Los Angeles County Museum of Art.; **PG.21** © 1996 Artists Rights Society (ARS), NY / ADAGP, Paris. Photograph © 1997 The Museum of Modern Art, New York.; **PG.23** © 1996: Whitney Museum of American Art; 79.25; **PG.24** © Lee Stalsworth

INDEX